Worshipping Athena

WISCONSIN STUDIES IN CLASSICS

General Editors
Richard Daniel De Puma and Barbara Hughes Fowler

Worshipping Athena

Panathenaia and Parthenon

Edited by
Jenifer Neils

THE UNIVERSITY OF WISCONSIN PRESS

The University of Wisconsin Press
114 North Murray Street
Madison, Wisconsin 53715

3 Henrietta Street
London WC2E 8LU, England

5 4 3 2 1

Printed in the United States of America

Library of Congress Cataloging-in-Publication Data
 Worshipping Athena: Panathenaia and Parthenon / edited by Jenifer Neils.
 262 p. cm. — (Wisconsin studies in classics)
 Includes bibliographical references and index.
 ISBN 0-299-15110-7 (cloth: alk. paper).
 ISBN 0-299-15114-X (pbk.: alk. paper).
 1. Athens (Greece)—Religious life and customs. 2. Panathenaia—Greece—Athens.
 3. Arts, Greek. 4. Parthenon (Athens, Greece)—Frieze. 5. Festivals—Greece.
 I. Neils, Jenifer, 1950–
 DF123.N46 1996
 292.3'6'09385—dc20 96-8274

Contents

Part III. Art and Politics

Illustrations

Acknowledgments

The symposia at Dartmouth and Princeton would not have taken place without the creative efforts and organizational skills of two individuals: Timothy Rub, director of the Hood Museum of Art in Hanover, and J. Michael Padgett, associate curator of ancient art at the Art Museum in Princeton. Professors Jeremy Rutter of Dartmouth and W. A. P. Childs of Princeton also contributed immeasurably to the success of these events. I warmly thank all the participants, including those whose papers are not published here (E. J. W. Barber, Joan B. Connelly, W. Robert Connor, Leslie Kurke, Gloria Pinney, Jerome J. Pollitt, T. Leslie Shear, Jr., and Matthew Wiencke), and especially Brunilde S. Ridgway, who gave a stunning summation of the symposium at Dartmouth.

I am also grateful to the many generous individuals who helped in the production of this volume, namely, my students Elisha Dumser and Evelyn LaFave; my department assistant, Deborah Tenenbaum; the Wisconsin series editor, Richard De Puma; and especially our meticulous copy-editor, Jane Barry. I also thank the artist Martin Boyle.

This volume is dedicated to all the friends, students, teachers, scholars, and curators who attended the symposia and contributed so much to their success.

Jenifer Neils
Cleveland, 1996

Contributors

Alan L. Boegehold is a professor of classics and chairman of the managing committee of the American School of Classical Studies at Athens. Recently he co-edited with Adele C. Scafuro the volume entitled *Athenian Identity and Civic ideology* (1994). His publication of the law courts in Athens (*Agora* 23 [1995]) has just appeared.

Richard Hamilton is Paul Shorey Professor of Greek at Bryn Mawr College as well as the founding editor of the *Bryn Mawr Classical Review* and the Bryn Mawr Commentaries. His recent *Choes and Anthesteria: Athenian Iconography and Ritual* (1992) examines the complex relationship between ancient testimonia and vase-painting imagery in a study of Athenian cult.

Evelyn B. Harrison is professor emerita of Greek art at the Institute of Fine Arts, New York University. She continues to publish the sculpture found in the excavations of the Athenian Agora by the American School of Classical Studies at Athens, and has written numerous groundbreaking articles in the field of Archaic and Classical sculpture.

Donald G. Kyle, an ancient historian at the University of Texas at Arlington, is an authority on Greek athletics. Author of *Athletics in Ancient Athens* (2nd ed. 1993), he has written and lectured widely on the relationship between political history and sports in ancient Greece.

Mary R. Lefkowitz is Andrew W. Mellon Professor in the Humanities at Wellesley College. Among her many books dealing with ancient Greek women are *Women in Greek Myth* (1986) and *Heroines and Hysterics* (1981). She co-authored with Maureen B. Fant a source book on women's life in Greece and Rome (2nd ed. 1992).

Jenifer Neils is a professor of art history and chair of the department at Case Western Reserve University. She organized the exhibition *Goddess and Polis: The Panathenaic Festival in Ancient Athens* and edited its catalogue (1992). She has also written a book on the Athenian hero Theseus and contributes to the *Lexicon Iconographicum Mythologiae Classicae*.

Noel Robertson is a professor of classics at Brock University in Ontario. An authority on Greek religion, he has written extensively on Attic cults and festivals. His most recent book is entitled *Festivals and Legends: The Formation of Greek Cities in the Light of Public Ritual* (1992).

H. A. Shapiro, professor of classics at the University of Canterbury, Christchurch, New Zealand, has published extensively in the field of Athenian iconography. Among his many publications are *Art and Cult under the Tyrants in Athens* (1989), *Personifications in Greek Art* (1993), and *Myth into Art: Poet and Painter in Classical Greece* (1994).

Erika Simon is professor emerita of classical archaeology at the University of Würzburg. World-renowned for her work on Greek and Roman iconography and religion, she is the author of *Festivals of Attica: An Archaeological Commentary*, published in the Wisconsin Studies in Classics series (1983).

Michalis Tiverios is professor of classical archaeology at the University of Thessaloniki. He and his students have written on many aspects of the Panathenaia and on Greek vases in general, and he is the author of a large new monograph on the history of Greek vase-painting, *Greek Art—Ancient Vases* (1996).

Worshipping Athena

Introduction

Jenifer Neils

In the fall of 1992, the exhibition *Goddess and Polis: The Panathenaic Festival in Ancient Athens* opened at the Hood Museum of Dartmouth College. At that time an interdisciplinary symposium entitled "Athens and Beyond" was held with the purpose of exploring the role of this festival in Athenian life and considering it in comparison with similar festivals held throughout the ancient Greek world. Historians, classicists, archaeologists, and art historians came together to present papers on various topics, from the Panathenaia's mythical origins to the technology involved in weaving the robe (*peplos*) which was presented to the cult statue of Athena. After the exhibition was shown at the Tampa Museum of Art and the Virginia Museum of Fine Arts, it opened at the Art Museum of Princeton University. Here another symposium, entitled "Parthenon and Panathenaia," focused more closely on the architecture, sculpture, and vase-painting related to the festival.[1] A selection of the papers presented at Dartmouth and Princeton, augmented by a chapter by H. A. Shapiro and a translation from the Greek of an article by Michalis Tiverios, makes up the contents of this volume.

It is timely to consider the Panathenaia in greater depth. Not only did it play an important role in the social and political history of Athens, but for nearly ten centuries it affected artistic production. The most impressive and well-known monument is the Parthenon frieze, which has

3

recently been the subject of a radical new interpretation. Joan Connelly, who delivered a paper at Princeton, has interpreted the central scene of the east frieze, the so-called peplos incident, as preparations for the sacrifice of a daughter of King Erechtheus which will insure success in war. In her view the frieze represents a specific mythological narrative, rather than a generic religious procession, and one that foregrounds the role of women in Athenian society.[2] While this view has not gained wide acceptance, it has stimulated closer scrutiny of the details of the frieze, as for example in Evelyn Harrison's chapter in this volume.

Since Theseus was credited with the foundation of the Panathenaia, it is appropriate that the first chapter deal with the Athenian hero and protégé of the goddess Athena. Erika Simon examines the relationship of Theseus not only to Athena, but to other Greek deities as well, and explains how this Bronze Age hero is intimately linked to the religious calendar of Athens and to other cult sites throughout Attika. Using topographical, literary, and artistic evidence, she demonstrates the rationale for the positioning of Apollo, Poseidon, Artemis, and Aphrodite together on the east frieze of the Parthenon: they are all old tutelary gods of Theseus.

Chapter 2, by Noel Robertson, also deals with topography and cult, but is restricted to the Acropolis. He looks closely at the three main cult festivals of Athena: the Plynteria, during which her cult statue was cleaned; the Skira or threshing festival; and the Panathenaia. In relating these festivals to the important cult places on the Athenian Acropolis, he makes a convincing case for a new identification of the shrine of the early Athenian king Erechtheus. While not absolutely provable, his "Erechtheion" solves many of the problems which have plagued scholars in trying to make the account in Pausanias jibe with the remains on the Acropolis.

Other *parthenoi* who had cult places on the Acropolis were Aglauros and Pandrosos. The narratives of these daughters of Kekrops act as mythological paradigms for the important but often dangerous roles of women in Greek cult, a topic explored by Mary Lefkowitz. The Panathenaia, with its production of a new peplos for the cult statue, offered special opportunities and honors for Athenian girls and women which were not usually available in other cults. However, the ultimate honor for women came from bearing sons who would fight for the glory of the city.

Training to be a warrior was the origin of the athletic and equestrian contests which form a prominent part of many Greek festivals. Contests restricted to Athenian male citizens are the subject of Alan Boegehold's chapter, which looks specifically at the tribal contest known as the

euandria, a competition in manly excellence. Although there are no definitive depictions of this event, Boegehold suggests that the less well known half of the relief dedicated on the Acropolis by Atarbos may show the contest; in contrast to the pyrrhic dancing on one half, the *euandria* consists of solemn synchronized movements executed by older draped men, rather than young nude warriors.

An important aspect of the Panathenaia, and one that distinguished it from other festivals, was its emphasis on material (olive oil) rather than symbolic (wreath) prizes. Donald Kyle traces the history of prize giving and concludes that the Athenian state, by giving valuable prizes, was laying claim to the attendant prestige, which in an earlier epoch had belonged to the aristocracy.

These inscribed state prizes, ceramic amphoras which once contained olive oil, are the subject of Richard Hamilton's chapter. He highlights the discrepancies between the literary and epigraphic testimonia about the various contests and the prize vases themselves, and suggests that the victors may not necessarily have received vases depicting their particular event. In other words we should not rely unequivocally on the vase-painting imagery to tell us which events took place at any given Panathenaia.

An as-yet unresolved problem in the iconography of the Panathenaic prize vases is the significance of the ever-changing insignia (*episema*) on the shield of Athena. While most vase-painting scholars have seen it as a mark of the potter's workshop, Michalis Tiverios suggests plausibly that it had a function similar to the statues on the columns which appear on the fourth-century prize amphoras. Namely, both served as labels for the origin of the olive oil, and were derived in the early sixth century from aristocratic family crests.

The next two chapters deal with the Parthenon frieze, a band of relief decoration that many scholars consider to be the ideal embodiment of the Panathenaic procession. Since this assumption has been challenged recently, these chapters serve to bring new evidence to bear in favor of the "traditional" interpretation. My contribution adduces evidence from vase-painting to support the identification of the frieze as the Panathenaic procession—not just the obvious representation of processions, but more subtle scenes of textile working and dressing-up. The attitude of *Pompe*, the personification of procession, is one of dressing, and this is echoed in many figures of the frieze, who by gesture and stance indicate their preparations for *Pompe*. These allusions to dress can in turn be seen in other sculptures on the eastern side of the Parthenon.

In her close reading of the east frieze, Evelyn Harrison highlights key details which argue against Connelly's interpretation of the scene as one

of impending sacrifice. From the dress of the child (male himation) to the undress of Athena (absence of helmet and arms), she argues that the scene cannot represent the sacrifice of an Athenian princess before battle. She goes on to articulate her view of the entire frieze as an allegorical statement about the evolution of Athenian society and government, with the four sides alluding to different historical moments. The whole is unified by the overarching theme of procession and the mood of expectation and destination.

In the concluding chapter, Alan Shapiro demonstrates how the Panathenaic festival was subject to change, especially in relation to political events. In the time of Perikles, the Panathenaia could express the political duality of Athens, which was both a democratic polis and the capital of an empire.

As the grandest public spectacle which took place in ancient Athens, the Panathenaic festival is worthy of consideration from many points of view. These chapters not only sum up recent scholarship on this event and its impact on the art of Athens; they add new insights and challenge old assumptions. This book is hardly the final word on the Panathenaia, and one hopes that its essays will continue to inspire new ideas and interpretations in the decades to come.

Notes

All dates are B.C. unless otherwise indicated.

1. These two symposia were reviewed respectively in the *Bryn Mawr Classical Review* for 1993 (vol. 4.1, 82–86) by Margaret C. Miller, and for 1994 (vol. 5.1, 75–83) by Sarah Peirce and Ann Steiner.

2. An abstract of her theory was published in *AJA* 97 (1993) 309–10; the article appeared in *AJA* 100 (1996) 53–80, while this volume was being prepared for publication.

PART I
MYTH AND CULT

1

Theseus and Athenian Festivals

Erika Simon

In our mythical tradition the kings Kekrops and Erechtheus are put
into the earliest dawn of Athenian civilization. Theseus belonged to a
later phase of that sunrise; and he did not emerge from Attic soil like
those first autochthonous kings, but came from abroad, the Pelopon-
nese, the cradle of Mycenaean culture. Nevertheless, in Attic tradition,
the outsider Theseus became the representative of all that is typically
Athenian, representative even of democracy.[1] Of course, his persona
became involved also in the religious life of Athens, in her cults and
rites.[2] Several festivals that were founded by him, according to our
literary sources, were in reality from the time of Solon, Peisistratos, or
Kleisthenes. Other festivals, however, were rooted in the Bronze Age, or,
to put it in mythical terms, in the heroic age of Greece. Theseus belonged
to that age; he was counted among the crew of the *Argo*, a generation
of heroes before the Trojan War, and he was the father of two sons who
took part in the Ilioupersis.[3] In this chapter I document the earliest traits
in Athenian festivals that can be ascribed to him; they can be defined,
we shall see, as Mycenaean.

Historians of religion like Walter Burkert emphasize Mycenaean
relics in Athenian cults.[4] The most famous visible relic is the Pelasgian
wall on the Acropolis, which was protected by law.[5] In my opinion
Athenian festivals of Bronze Age origin concentrate on that part of the

9

Theseus myth which is agreed to be the oldest, the Minotaur adventure. In our literary tradition different rites and festivals are connected with the departure of Theseus and the fourteen Athenian children to Crete and with their return to Athens via Naxos and Delos. We shall try to understand the Bronze Age background of these rites as well as their survival in Archaic and Classical times.

Properly speaking the Minotaur adventure is Minoan-Mycenaean by definition.[6] The historical context for the bull-daimon in the labyrinth was excavated by Sir Arthur Evans, who revealed the great importance of the bull in Cretan religion and the high development of Minoan architecture. Furthermore, the dependence of Athens on Crete that led to the tribute of the Athenian children—seven boys and seven girls— may

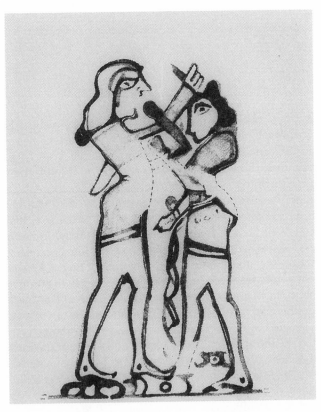

Fig. 1.1. Theseus and the Minotaur. Drawing of a detail of a stamnos from Megara Hyblaea, seventh century. Basel, Antikenmuseum BS 1432

be explained by Minos' famous thalassocracy (Thucydides 1.4.1), which also led him to conquer Megara northwest of Athens.[7] The Megarid became Doric in the late second millennium, but earlier, in the heroic age, it had formed a unity with Attika.[8] The tradition about Theseus as well as about Kekrops, Pandion, and Theseus' father Aigeus was a common heritage in Athens and Megara. Of the youthful deeds of Theseus so well studied by Jenifer Neils, several even took place in the Megarid.[9] Thus we should not be surprised that his successful fight against the Minotaur was first represented by Megarian artists. Their paintings on huge stamnoid vases of the second quarter of the seventh century were produced in Megara Hyblaea, the Sicilian foundation of Megara.[10] In one of these paintings now in the Antikenmuseum, Basel (Fig. 1.1), young Theseus is fighting against the fettered Minotaur; the chain from his arm to his feet defines the monster as a guard, a kind of Kerberos of the labyrinth.[11]

In our extant material Attic representations of this adventure begin a century later, but this may be by chance. How well known the Cretan expedition was in earlier Archaic Athens is shown by the famous frieze with so many inscribed names on the François vase in Florence (Fig. 1.2).[12] To Alan Shapiro's new interpretation I should like to add that for the Greeks dancing was *mimesis*. For me the frieze of this krater shows the "model," the fearsome first disembarkation in Crete, and at the same time the "imitation," the Delian *geranos*-dance. The right end of this frieze depicts the first encounter of Theseus and Ariadne, who is falling in love with the Apollo-like Athenian prince.[13] She is about to hand him the ball of wool that will lead him and the children safely out of the labyrinth.

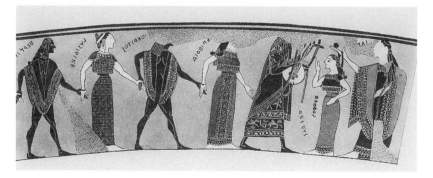

Fig. 1.2. Theseus and Ariadne. Detail of the François vase, Attic, ca. 570. Florence, Museo Archeologico Nazionale 4209 (drawing after Furtwängler-Reichhold)

In our literary tradition Theseus embarked for Crete from Phaleron. The Bronze Age harbor of Athens for the Cyclades and Crete, however, was the bay of Porto Raphti on the east coast of Attika, the region of the ancient demos of Prasiai with its Apollo sanctuary (Pausanias 1.31.2). Excavations at the hill, Perati, north of the bay have shown that the region was densely inhabited in late Mycenaean times.[14] Thus we may ask: was there an earlier stratum in the Theseus myth in which the Athenian expedition to Crete started from eastern Attika?

I think there is a positive answer. The figure of Theseus is so prevalent in the east of the Attic peninsula, the Diakria, that in nineteenth-century research, in Hans Herter's fundamental article of 1973, and still in John Walker's recent book *Theseus and Athens* the hero is even thought to have originated there.[15] This is surely wrong, because Troizen, the small town on the east coast of the Peloponnese, in antiquity was unanimously considered his native place, and this tradition corresponds to the historical background, the superiority of Mycenaean culture in the pre-Dorian Argolid. In my opinion Theseus is connected with the east coast of Attika and its harbors not because of his origin, but because he is a seafaring hero. In this respect he is the opposite of his great model Herakles, a typical pedestrian.[16] This difference between the two heroes, who are in many respects related, is derived from their different divine fathers: Zeus and Poseidon. Theseus' seafaring character, which connects him with Apollo Hyperpontios[17] and with Poseidon, will help us to clarify the oldest parts of his myth and cult.

In Herter's opinion the Cretan expedition also seems to have started from the east of the Attic peninsula and not from Phaleron in the west.[18] Moreover, the boat with thirty oars that was shown at Phaleron and was said to be the boat of Theseus[19] could not have been a Bronze Age ship. In Classical times this boat carried the Athenian *theoria* each year to the main festival at Delos. For this reason it had to be seaworthy and not eight hundred years old.

Therefore, Phaleron as Theseus' harbor is post-Mycenaean. The myth was changed in the Iron Age when Athens began to prefer Phaleron as her harbor. Plutarch, who gives us a coherent story of the Cretan adventure in his *Life of Theseus* (15–23), only writes of vows "to the gods" that Theseus had to fulfill after returning from Crete (21). Pherekydes (*FGrHist* 3 F 149), however, reports that Theseus had vowed the yearly *theoria* to Delos in honor of Apollo and Artemis. I should like to stress the importance of Artemis in addition to Apollo for the original Cretan expedition.

Artemis or her forerunners belong to the main deities of the Bronze Age pantheon. Think of the important Mycenaean finds from the Artem-

ision at Delos or of the lentoid gem from Crete showing her shooting
with the bow.[20] Furthermore, Artemis was the main goddess of the
Boeotian and the Attic east coast from Aulis in the north, where the
Achaeans set off for Troy, to Brauron. The two harbors and cult places
were connected by the figure of Iphigeneia, hypostasis, victim, and/or
priestess of Artemis.[21] In a mythical tradition as early as Stesichoros,
Theseus is even called Iphigeneia's father,[22] which also shows his near-
ness to the realm of Artemis. Iphigeneia, on the other hand, was also a
name for Hekate, a prehistoric and specially Thessalian-Boeotian fore-
runner and equivalent of Artemis. According to the "Hekate-hymn" in
Hesiod's *Theogony* (440–43), seafaring and fishing people would pray to
Hekate and Poseidon. That Artemis "rescued" Theseus from the dangers
of his Cretan adventure is shown by the temple for Artemis Soteira,
which he built in his native town, Troizen (Pausanias 2.31.1). In this
respect Theseus was the forerunner of another great naval Athenian,
Themistokles, whose veneration for Artemis is known.[23]

Last but not least Theseus embarked with the children on the sixth
day of the spring month, Mounychion (Plutarch, *Theseus* 18), and the
sixth of each month was for the Greeks the holy day of Artemis.[24] For
their return from Crete, the sixth, seventh, or eighth day of the autumn
month, Pyanepsion, is reported.[25] This month was named after the
cooking of pulse in honor of Apollo on the seventh, which in each Greek
month was Apollo's day.[26] The eighth, on the other hand, belonged to
Poseidon (Plutarch, *Theseus* 36). Instead of Poseidon, his son Theseus
had his great festival, the Theseia, on the eighth of Pyanepsion,[27] while
another memorial day for Theseus, his arrival in Athens from Troizen,
was celebrated on the eighth of Hekatombaion.[28]

In Archaic Athens, Apollo and Poseidon were, to use Shapiro's term,[29]
"Ionian gods *par excellence*." Both were also seafaring gods and helpers
of Theseus, who was an Ionian himself and said to be Poseidon's son. To
be sure, he was also the son of Aigeus—already in Homer (*Iliad* 1.265)—
which is not a different version. Greek heroes like Herakles and Theseus
would have two fathers, a mortal and an immortal one. By the latter
they were demigods, whereas by their human fathers they belonged to
specific generations and times.

Poseidon, the owner of the central Ionian sanctuary on Mount Mykale
in Asia Minor, was already known to Homer with his surname Heliko-
nios (*Iliad* 20.404).[30] Helike was an Achaean town on the Corinthian
gulf.[31] The Achaeans who emigrated from the Peloponnese toward the
end of the Bronze Age were called Ionians in Anatolia, whereas in their
homeland they continued to be called Achaeans. In our literary sources
the Ionian migration to Asia Minor was funneled through Attika.[32]

This tradition must be taken seriously because from the east coast of the Attic peninsula in the Bronze Age not only Athenians, but also Peloponnesians, had to set off for the east; think of Aulis, the harbor for the Achaeans in the Trojan expedition. A very close neighbor is the west coast of Euboea, which remained important for seafaring also in the Iron Age. Theseus and Euboea would be another fascinating theme that must be left out here.[33]

Another Bronze Age harbor farther north was Iolkos (modern Volos), the harbor of the Argonauts.[34] With Theseus and Thessaly I can here deal only briefly.[35] Our earliest literary tradition about Theseus, son of Aigeus (*Iliad* 1.265), connects him with the Thessalian tribe of the Lapiths in the fight against the Centaurs.[36] Herter thought that this tradition reached back to the first Greek immigration[37] that is, to Middle Helladic times— but I do not think so. The figure of Theseus is not rooted in the earlier but in the later Bronze Age, the generation before the Trojan War. He comes from the coast of the Mycenaean Argolid and is connected with Mycenaean Thessaly because that region was famous for the expedition of the Argonauts. The tradition about Theseus the Argonaut is not secondary, as Herter and others thought,[38] because seafaring was his essential attribute.

The most important Thessalian connection in the Theseus myth is his proverbial friendship with the Lapith Perithous. At the marriage feast of the latter, the fight between Lapiths and Centaurs began. Theseus is present at it not as a Thessalian, as Herter thought,[39] but as an Athenian, a member of the royal house of Athens. Perithous after all married an Athenian princess, Hippodameia, daughter of Boutes,[40] who was the ancestor of the famous Attic clan of the Eteoboutadai. Not by chance, Boutes, as well as Theseus and Perithous, is an Argonaut in our literary sources.[41]

On the frieze of the François vase (see Fig. 1.2), the connection between the Athens of Theseus and the Thessalian Lapiths is manifest. Among the Athenian girls, all inscribed with names, there is Hippodameia, daughter of Boutes, the future bride of Perithous.[42] And there is Lysidike, daughter of the Lapith Koronos. She became in Athens the ancestress of the Philaids, another famous Attic clan. This indicates that Athenian and Thessalian noble families were related to each other. Immediately beneath this frieze is painted the battle between the Lapiths and Centaurs at the marriage feast of Perithous and Hippodameia. There, on the left end, Theseus turned up a second time: his name is preserved.[43]

Thessaly in Mycenaean times was inhabited by Aeolians. At the end of the Bronze Age, Aeolian tribes emigrated to Asia Minor. They

founded Smyrna, an Aeolian town that later became Ionian. Theseus is among the founders of Smyrna (Tacitus, *Annals* 4.56), I think because of his Thessalian connections. The literary tradition is of Roman times, but architectural terracottas of the sixth century from Sardis (Fig. 1.3) and Gordion (Fig. 1.4) show that Theseus was well known at that time in that region of Anatolia.[44] In both cases he is represented in his most famous adventure, the fight against the Minotaur. Because mythological representations in architectural terracottas are rather rare, finding the Theseus myth in the hinterland of Smyrna is spectacular. Furthermore, in Smyrna as well as in Miletos, one of the Ionian *phylai* carried the name Theseis.[45]

Beside Artemis, Apollo, and Poseidon, a deity of very different character plays an important role in the Cretan expedition: Aphrodite. Plutarch in his *Life of Theseus* (18) writes that Apollo's oracle advised the hero to take Aphrodite as a tutelary goddess on his way to Crete. Returning from there Theseus founded the cult of this goddess at Delos with an idol Ariadne had given to him (21). That Ariadne had fallen in love with Theseus came about, of course through Aphrodite's power, but she helped him also in other respects. On his return from Crete Theseus unified Attika by the cult of Aphrodite Pandemos—that is, the common

Fig. 1.3. Theseus and the Minotaur. Terracotta plaque from Sardis, sixth century. New York, Metropolitan Museum of Art 26.164.32, gift of the American Society for the Exploration of Sardis, 1926

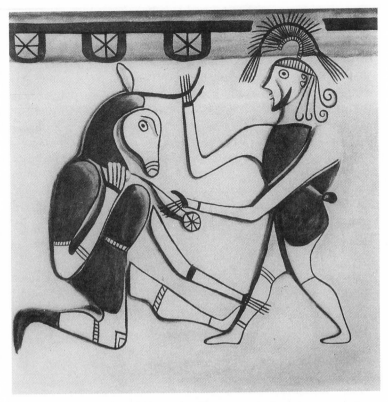

Fig. 1.4. Theseus and the Minotaur. Drawing of an architectural terracotta plaque from Gordion, sixth century (drawing after Åkerström)

Aphrodite of the whole people.[46] This goddess was represented with a he-goat, her preferred victim, about which Plutarch (18) tells a nice story: Theseus before sailing to Crete wanted to offer Aphrodite a she-goat, which the goddess turned into the male animal. Originally, I think, this was the Cretan ibex, an attribute of Minoan deities.

Because Theseus managed the unification of Attika peacefully, by persuasion, Peitho was venerated along with Aphrodite Pandemos. They had a common sanctuary on the southwestern slope of the Acropolis. Pausanias, who visited it, writes (1.22.3) that the cult was founded by Theseus. The exact day of the state festival for Pandemos and Peitho is not reported; there are good arguments for believing that it was celebrated at the beginning of the Attic year, on the fourth day of Hekatombaion, because the fourth of each month was Aphrodite's day.[47]

Small, late Archaic silver coins from Athens have Athena's head on one side and on the other a female janiform head that perhaps is to be interpreted as Aphrodite Pandemos and Peitho, as I have shown elsewhere.[48]

What about Theseus and Athena? In Attic art of Archaic and Classical times, she is often his divine companion.[49] Here literature and visual art partly go different ways: we have seen here that Artemis, Apollo, Poseidon, and Aphrodite, not Athena, are Theseus' tutelary gods in the literary tradition. This is understandable because his divine father was Poseidon, Athena's opponent in the struggle for Attika. The more the outsider Theseus became the main Athenian hero, however, the more he was accompanied by Athena. In programmed form they are shown together in a metope of the Athenian Treasury at Delphi (Fig. 1.5).[50] Goddess and hero meet in a *sacra conversazione*, "which had earlier been reserved for the pair Athena and Herakles," as Shapiro rightly remarks. In late Archaic and Classical vase-painting (Fig. 1.6), Athena even follows the young hero into the depths of the sea[51]—this myth is connected with the Cretan adventure.

Attic artists from the earlier fifth century on combine Athena also with a dark point in Theseus' life, the abandoning of Ariadne. On a lekythos from the workshop of the Pan Painter in Taranto,[52] Athena rouses him from the side of Ariadne, who is sleeping deeply with the help of Hypnos, who sits on her head. On a calyx-krater by the Kadmos Painter in Syracuse,[53] Athena is sending Theseus to the boat for Athens while Dionysos is approaching Ariadne. This picture was shown by T. B. L. Webster and myself to be an illustration of a scene in the lost drama *Theseus* by Euripides.[54] Above Theseus his divine father, Poseidon, turns up behind a "Polygnotan" rock. He and Athena agree that Theseus must abandon Ariadne because of his duties in Athens. This is the Classical Attic belief, but there are many other versions of the Ariadne myth, according to Plutarch (*Theseus* 19–20).

Most of them seem to be aetiological—that is to say, they try to explain a religious fact. For this Martin Nilsson had the following explanation: he saw in Ariadne an original Minoan vegetation goddess.[55] Because Ariadne is already a Minoan princess in our earliest tradition, however, she may have been a priestess in the vegetation cult, and perhaps a substitute for a goddess of that type. Vegetation deities rise with the flowers in spring and die off with the life of nature to resurrect in the following year. Ariadne's tomb was shown in Argos in the temple of "Cretan Dionysos" (Pausanias 2.23.8), who was himself a vegetation god, perhaps the greatest of all. From this perspective Theseus, who seduced Ariadne, was an intruder into the god's realm, and Ariadne—

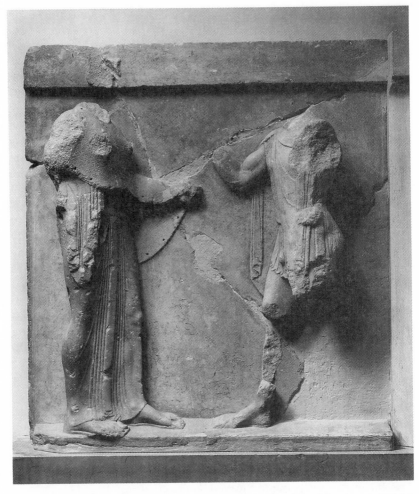

Fig. 1.5. Theseus and Athena. Metope from the Treasury of the Athenians at Delphi, ca. 500–490. Delphi Museum (Photo: DAI, Athens)

goddess and/or priestess of his cult—was disloyal to Dionysos. This interpretation corresponds with the oldest version of the myth, which is handed down to us in the *Nekyia* of the *Odyssey* (11.321–25).[56] In Hades Odysseus meets Minos' daughter, Ariadne, "with whom Theseus had eloped from Crete but did not reach holy Athens, because Artemis killed her on the island Dia after Dionysos had witnessed against her." The juridical term "witnessed" used here by Homer shows that Theseus and Ariadne had broken by their love a sacred law. Ariadne was there-

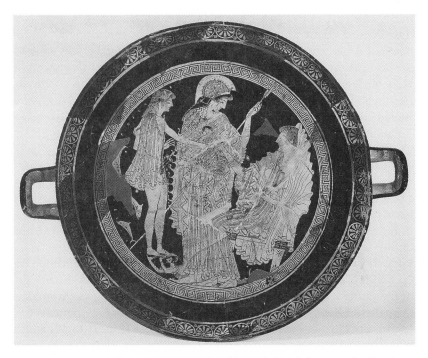

Fig. 1.6. Theseus with Triton, Athena, and Amphitrite. Attic red-figure cup by Onesimos, ca. 490. Paris, Louvre G 140 (Photo: M. Chuzeville)

fore punished, and Dionysos and Theseus became opponents. In religious terms, Theseus had to reconcile the god's anger about the seduction of his companion. In post-Homeric times the story about Ariadne abandoned by Theseus and married by Dionysos superseded the *Nekyia* tradition in Greece, but not in Etruria. There are representations in Etruscan art in which Artemis is carrying Ariadne to the netherworld.[57]

This version of the *Odyssey*, not the Classical belief, can help us to understand certain early traits in the Dionysiac festivals of Athens. On the seventh day of Pyanepsion, when Theseus came back from Crete, not only the Apolline Pyanepsia but also the Dionysiac Oschophoria festival was celebrated.[58] Plutarch in his *Life of Theseus* (22) gives the fullest description of this Athenian festival for Dionysos founded by the hero. It was named after the *oschoi,* vines with bunches of grapes. They were carried by two noble youths, clad in long Ionian chitons, at the head of a procession that started from the Oschophorion within Athena's *temenos* at Phaleron. The hymns sung by the participants were

partly cheerful, partly sad. Plutarch attributes this change of mood to the gladness about the return from Crete and the mourning about the death of Aigeus on the same day. But this is aetiological myth, whereas the succession of joyful and sorrowful songs is typical of vegetation cults, such as celebrations for Adonis. The same explanation is valid for the vines carried by the pair of youths, and their long chitons reveal the Ionian character of the festival.

Not long ago Guy M. Hedreen defined the "Naxian" offspring of the Oschophoria. New excavations on Naxos by Vassilis Lambrinoudakis and Gottfried Gruben corroborated the belief in the high antiquity of the cult of Dionysos at Naxos to which Ariadne belongs.[59] The island Dia where she died in the *Odyssey* was another name, a holy name, for Naxos. Excavations and literary sources further testify to the influence of Bronze Age Crete on the Cyclades.[60] Minos himself performed rites of the vegetation cult at Paros, the neighboring island of Naxos, as we know from Kallimachos (*Scholion Flor.* = fr. 7 Pfeiffer). The same poet (fr. 67 Pfeiffer) is used by Hedreen to explain the frieze in the interior of the Phineus cup in Würzburg.[61] He is right in calling the woman at the side of Dionysos in this famous frieze Ariadne (Fig 1.7). Recently Martin Boss has discovered the inscription of her name, which had not been read hitherto.[62]

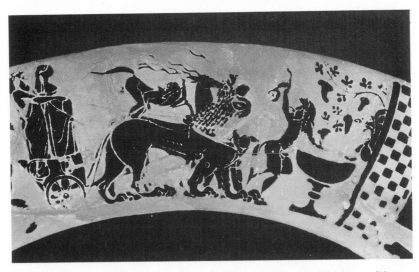

Fig. 1.7. Dionysos and Ariadne. Phineus cup, Chalcidian, ca. 530. Martin von Wagner-Museum, Universität Würzburg L 164 (Photo: K. Oehrlein)

With the Oschophoria Theseus after all introduced a Cycladic-Minoan vegetation festival into Athens. By this he tried to appease the grudge of Dionysos, who was angry about Ariadne's seduction. Reconciliation of angry deities was a frequent reason for founding a cult: consider the *Homeric Hymn to Demeter* or the Aeschylean *Oresteia*. Because the Dionysiac procession went to a sanctuary of Athena, this goddess was sometimes thought to be the main focus of the festival. In my opinion she only helped Theseus in the difficult task of reconciling himself with her brother Dionysos.[63] He was one of the main deities of Athens and could not remain in conflict with her main hero.

The Oschophoria in autumn marked the end of the Dionysiac cycle, which began in early spring with the flower festival, the Anthesteria.[64] No other Athenian festival preserved the character of Bronze Age vegetation cults better than those three-day spring celebrations. Because the Ionians in Asia Minor had the same festival, Thucydides (2.15.4) argued for the high antiquity of the Anthesteria, which he called the Older Dionysia. One of the rites combined with this festival was a *hieros gamos*,[65] a typical component of vegetation cults—think of Aphrodite and Adonis. In the Anthesteria the wife of the Archon Basileus, the so-called Basilinna, was married to Dionysos. The archon was a successor to Theseus, his wife a substitute for Ariadne, in order to reconcile the god whose consort was seduced by the hero. Thus the Athenians tried to turn the anger of the powerful god into the well-being of their community. It is understandable that the Classical version of the story about Ariadne and Theseus—the hero abandoning her for the benefit of Athens—could develop from the rite of the *hieros gamos* at the Anthesteria.

In conclusion, we have seen that the figure of Theseus is present in several Attic religious traditions that can be connected with the Bronze Age. Most of those traditions center on the Minoan-Mycenaean kernel of the Theseus myth, the Cretan adventure. Theseus had to travel to Crete by boat, which was natural for him because he was Poseidon's son. His paternity was proved by the famous dive into the sea that Minos extorted from him (Bakchylides, *Dithyrambos* 17 = 3.76–116 Snell). Amphitrite, Poseidon's wife, and thus the hero's stepmother, as well as his half-brother Triton, helped him to find his identity—that of a seafaring hero and representative of naval Athens. Athenian vase-painters added the goddess Athena to this scene (see Fig. 1.6),[66] but this is secondary. The earliest tutelary deity for seafaring Theseus was Artemis, the goddess of the Attic east coast from Aulis to Brauron. From there the Greeks in the Bronze Age set off for Anatolia as well as for the Cyclades and Crete. Another goddess helpful to Theseus was Aphrodite, who was seaborn

and invoked by sailors (cf. Sappho fr. 5.1 Lobel/Page), and whose cult Theseus founded at Delos as well as in Athens. There he succeeded in the unification of Attika with the help of Aphrodite Pandemos. Her festival together with Peitho was celebrated at the beginning of the same month toward the end of which followed the Panathenaia.

The important role of Aphrodite for the unified Attic people that celebrated the Panathenaia is stressed on the east side of the Parthenon. On the frieze she is seated near Artemis and Apollo, who is in conversation with Poseidon (Fig 1.8).[67] Artemis is shown arm in arm with Aphrodite—Georgios Despinis has found the crucial fragment.[68] Thus we have the four old tutelary gods of Theseus side by side: Poseidon, Apollo, Artemis, and Aphrodite. Above this scene, in the east pediment, Aphrodite and Artemis are again a closely connected pair, as Ernst Berger has shown.[69] Both representations are unusual, because the powers of the two goddesses are in many respects different and even contradictory, as for instance in the tragedy *Hippolytos* by Euripides. The closeness of Artemis and Aphrodite on the east side of the Parthenon in my opinion is to be seen in the light of the Theseus myth. Theseus had taken Aphrodite's idol from Crete to Delos, the island of Artemis and Apollo.

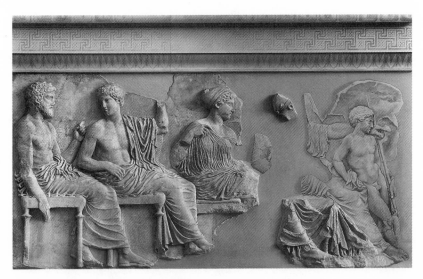

Fig. 1.8. Poseidon, Apollo, Artemis, Aphrodite, and Eros. East frieze of the Parthenon (38–40). Athens, Acropolis Museum (Photo: Alison Frantz Collection, American School of Classical Studies at Athens)

The festival of the Panathenaia, celebrated in honor of Athena, was surely of Bronze Age origin.[70] Its main rite, the offering of a garment, is repeatedly represented in Mycenaean frescoes, and Homer describes the procession of Trojan women putting a peplos on Athena's knees (*Iliad* 6.288–304). The unification of Attika by Theseus was the virtual prerequisite for the Panathenaia, but the Athenians ascribed the foundation of their main festival to Erichthonios-Erechtheus. Since that celebration, however, was reorganized several times—for example, in 566—Theseus could be thought to have been its first reorganizer.

Notes

1. For the transformation of Theseus in Classical art, see now Morris, 1992, 336–61, esp. 349–51; *LIMC* VII (1994) s.v. Theseus (J. Neils), *passim*; Walker, 1995 *passim*.

2. Herter, 1973, 1220–31; Shapiro, 1989, 143–49.

3. *Argo* earlier than the Trojan War: *Odyssey* 12.69–72. The names of Theseus' sons, Akamas and Demophon, do not appear in the *Iliad*, but in Cyclic epic: Neils, 1987, 8; *LIMC* I (1981) 435–46 s.v. Akamas et Demophon (U. Kron); Olmos, 1992, 103 (A. Bernabé). Another Demophon turns up as a royal prince in Eleusis: *ML* 1 (1884/90) 988–89 s.v. Demophon 1 (H. W. Stoll); H. Metzger, *Xanthos* 9 (1992) 30 ff.; E. Simon, *Grazer Beiträge* Suppl. 5 *Festschrift W. Pötscher* (1993) 40–41.

4. Burkert, 1977, 359; Simon, 1983, 106–8.

5. Travlos, 1971, 52, 60, fig. 70.

6. Ward, 1970, 113–35 and *passim*; Herter, 1973, 1093–1149; Buchholz, 1987, 388–405 (St. Hiller); Morris, 1992, 172, stresses the un-"Minoan" character of Minos in ancient literature. The Cretan thalassocracy, however, is a Bronze Age phenomenon that is corroborated by excavations—e.g. on the islands of Keos, Melos, Naxos (see below n. 59), and Thera.

7. Literary sources in *RE* 15.2 (1932) 1907–27 s.v. Minos (F. Poland); *ibid.* 1912–15: Megara and Athens conquered by Minos.

8. Kron, 1976, 107–9.

9. Neils, 1987, 14 and *passim*: Skiron, Kerkyon, Prokroustes. Sources for Theseus and Megara: Olmos, 1992, 107–8 (A. Bernabé).

10. Basel, Antikenmuseum. BS 1432; P. Blome, *AntK* 34 (1991) 156–68, pls. 24.1, 26.1. The other Megarian vase is in Paris, Louvre CA 3837; Neils, 1987, 23 n. 93. Both vases: *LIMC* VI (1992) 575 s.v. Minotauros, nos. 6, 6a (S. Woodford).

11. The Minotaur was also fettered on the Amyklaion throne: Pausanias 3.18.11.

12. Ward, 1970, 29–30, fig. 29 (R. B. Edwards); Simon and Hirmer, 1981, 72–74, pls. 52, 54, 1; Neils, 1987, 25–27, fig. 4; Shapiro, 1989, 146–47, pl. 66a; *LIMC* VII (1994) 943, no. 264.

13. For Theseus with lyre see Neils, 1987, 21; Shapiro, 1989, 147; cf. Pausanias 5.19.1.

14. S. E. Iakovides, *Perati* II (Athens 1970); Buchholz, 1987, 437–77 (S. E. Iakovides).

15. Herter, 1973, 1052–53; Walker, 1995, 14–15.

16. Herakles, who left the Argonauts, is shown seafaring only rarely: e.g. on a cup in the manner of Douris in the Vatican (*ARV*² 449,2).

17. Shapiro, 1989, 58–59.

18. Herter, 1973, 1104–5.

19. Herter, 1973, 1103–4.

20. Berlin FG 2. *Antike Gemmen in deutschen Sammlungen* II (Munich 1969) 30, no. 20, pl. 6 (E. Zwierlein-Diehl). For Artemis in the Bronze Age: Vermeule, 1974, 144–50; Buchholz, 1987, 487 (B. C. Dietrich).

21. H. Lloyd Jones, "Artemis and Iphigeneia," *JHS* 103 (1983), 87–102; *LIMC* V (1990) 706–17 s.v. Iphigeneia (L. Kahil).

22. Her mother, Helen, gave the baby girl to her sister, Klytaimestra, to raise: Stesichoros fr. 191. D. L. Page, ed., *Poetae Melici Graeci* (Oxford 1962) = Pausanias 2.22.6f. For the marriage of Theseus and Helen, see H. A. Shapiro, "The Marriage of Theseus and Helen," in *Kotinos: Festschrift E. Simon* (Mainz 1992) 232–36.

23. Simon, 1985, 176–78.

24. Parke, 1977, 146.

25. Sources in Herter, 1973, 1146–47, 1226.

26. Parke, 1977, 75–87.

27. Deubner, 1932, 224–26; Herter, 1973, 1226–29; Parke, 1977, 81–82; Walker, 1995, 20–24, 57, and *passim*.

28. Herter, 1973, 1080.

29. Shapiro, 1989, 104.

30. Simon, 1985, 73–77. Poseidon in Mycenaean Greece: Vermeule, 1974, 60, 62 ff. 83–84; *LIMC* VII (1994) 446–48 s.v. Poseidon (E. Simon).

31. *RE* 7.2 (1912) 2855–58 (F. Bölte); Shapiro, 1989, 102–3.

32. F. Prinz, *Gründungsmythen und Sagenchronologie. Zetemata* 72 (Munich 1979) 347 ff. and 373 ff., wrongly thinks that this tradition is not earlier than the seventh century.

33. Only some hints: his sons Akamas and Demophon (above n. 3) grew up in Euboea at Chalkodon's court and went with the son of the latter to Troy. For Chalkodon, friend of Theseus, see *LIMC* III (1986) 187–88 s.v. Chalkodon (E. Simon). Theseus is the main hero in the west pediment of the Apollo temple of Eretria: E. Touloupa, "Die Giebelskulpturen des Apollon Daphnephorostempels in Eretria," in Kyrieleis, 1986, 143–50; Morris, 1992, 343–44, fig. 52. For Theseus in the Classical pediment of the Apollo Sosianus temple in Rome, probably from Eretria: E. La Rocca, *Amazzonomachia* (Rome 1985) 27–32; Olmos, 1992, 123–29 (E. Simon).

34. *RE* 9.2 (1916) 1850–55 (F. Stählin).

35. His divine father Poseidon was especially important in Thessaly; see A. Moustaka, *Kulte und Mythen auf thessalischen Münzen* (Würzburg 1983) 20–23.

36. Neils, 1987, 6–7, *LIMC* VII (1994) 943–45.

37. Herter, 1973, 1157–58, following I. Toepffer, *Attische Genealogie* (Berlin 1889); both are of the "Historical School"; see Walker, 1995, 10.

38. Herter, 1973, 1201, 1206–7.

39. Herter, 1973, 1158–59.

40. *LIMC* III (1986) 152–53 s.v. Boutes; *LIMC* V (1990) 440–43 s.v. Hippodameia II (E. Simon).

41. Robert, 1921, 789, 791. Robert, Herter, and others think that Theseus was a "latecomer" among the Argonauts. His seafaring qualities, however, destined him for the *Argo*.

42. See above nn. 12 and 40. Hippodameia is the first girl near the boat, Lysidike the second girl behind Theseus.

43. Simon and Hirmer, 1981, 74; Neils, 1987, 26.

44. Ake Åkerström, *Die architektonischen Terrakotten Kleinasiens* (Lund 1966) 70, 1, pl. 37 (New York, Metropolitan Museum of Art 26.164.32, from Sardis); *ibid.* 153 ff., 156, fig. 45, pl. 79, from Gordion (Theseus bearded, with helmet).

45. L. Robert, *Gnomon* 31 (1959) 673.

46. Sources in Simon, *Schweizerische Numismatische Rundschau* 49 (1970) 11 ff. Aphrodite and he-goat: *LIMC* II (1984) 98–100 s.v. Aphrodite (A. Delivorrias).

47. Simon, 1983, 49–51.

48. See above n. 46.

49. Attic black-figure vases: Neils, 1987, 24–25, fig. 3 and nos. 29–34. Late Archaic red-figure vases: Neils, 1987, nos. 10, 15, 19, 21, 27, 55, 59. Classical red-figure vases: Neils, 1987, nos. 80, 89, 108, 126, 129, 144; for no. 129 (cup Madrid 11265), see Olmos, 1992, 9 ff., pls. 1–16 (R. Olmos). The goddess is also present in the Naxian adventure: e.g., on the hydria by the Syleus Painter Berlin F 2179 (*ARV²* 252, 52; *AntK* 6, 1963, pl. 4, 2), on the lekythos in Taranto (below n. 52), and on the krater Syracuse 17427 (below n. 53). Athena helps him also in the rape of Antiope: e.g. in the Eretria pediment (above n. 33). The statue of Athena Parthenos by Pheidias had the Attic Amazonomachy (with Theseus) on her shield.

50. Neils, 1987, 49, fig. 22; Shapiro, 1989, 144, pl. 65 e; Morris, 1992, 343; *LIMC* VII (1994) no. 54, pl. 634 (all Treasury metopes).

51. Cup, Paris, Louvre G 104 by the potter Euphronios, attributed to Onesimos (*ARV²* 318, 1); Ward, 1970, 40, fig. 46 (R. B. Edwards); Neils, 1987, no. 15; *Euphronios der Maler*, exh. cat. (Berlin 1991) 229–33; Morris, 1992, fig. 56; *LIMC* VII (1994) no. 36, pl. 624.

52. *ARV²* 560, 5 and 1659; Ward, 1970, 39, figs. 43–45 (R. B. Edwards); Hedreen, 1992, 32 n. 18.

53. *ARV²* 1184, 4; M. Vojatzi, *Frühe Argonautenbilder* (Würzburg 1982) 149–50; Hedreen, 1992, 39.

54. *AntK* 6 (1963) 14; Webster, 1967, 107.

55. Nilsson, 1955, 315.

56. Hedreen, 1992, 32–33.

57. F. Jurgeit in H. A. Cahn and E. Simon, eds., *Tainia: Festschrift R. Hampe* (Mainz 1980) 275–79, fig. 1 (Etruscan mirror in Bologna Mus. Civ.), pl. 59, 3–4 (feet of cistae); *eadem, Ciste Praenestine* II (Rome 1986) 51–52, K 20, pl. 29.

58. Parke, 1977, 77–81; Simon, 1983, 89–92.

59. Hedreen, 1992, 83–85. Excavations at Naxos: V. Lambrinoudakis and G. Gruben, *AA* (1987) 569–621.

60. See above n. 7.

61. Hedreen, 1992, 78–79, pl. 22.

62. M. Boss, "Antike Inschriften neu sichtbar gemacht," *AA* (1992) 537–38, fig. 65a.

63. As she is reconciling the Erinyes toward the end of the *Oresteia*, turning them into Eumenides.

64. Parke, 1977, 107–20; Simon, 1983, 92–99.

65. A. Lezzi-Hafter, "Anthesterien und Hieros Gamos: Ein Choenbild des Methyse-Malers," in *Proceedings of the Third Symposium on Ancient Greek and Related Pottery*, Copenhagen August 31–September 4, 1987 (1988) 325–31 with earlier literature.

66. See above n. 51.

67. Brommer, 1977, pls. 178–79.

68. G. Despinis in *Kernos: Festschrift G. Bakalakis* (Salonica 1972) 35 ff., pl. 14 ff.

69. E. Berger, *Die Geburt der Athena im Ostgiebel des Parthenon* (Basel 1974) 42–43, 72.

70. See E. J. W. Barber in *G & P* 103–4.

2

Athena's Shrines and Festivals

Noel Robertson

The temples and statues of the Acropolis are admired as monuments of the wealth and taste of fifth-century Athens, and were meant to be. They were also meant for use, or to enhance the occasions when other parts of the Acropolis were put to use. To explore this use is interesting in itself and indispensable to a full appreciation of the monuments. Temples and statues served for the performance of age-old ritual at Athena's festivals. Like other sanctuaries, the Acropolis at festival time was crowded with worshippers intent on prayer and sacrifice and omens.

The Greek gods were honored for the help they gave the community in all practical concerns, different gods helping in different ways. A festival was celebrated for a given god at the usual time his help was needed. Athena's festivals took place in early and mid-summer: there were three of them, which we may call the cleansing festival (Plynteria and Kallynteria), the festival of the threshing (Skira), and the festival of games (Panathenaia). The second Athena shared with the grain goddess Demeter, but the first and third were addressed to her alone.

The first, the cleansing festival, came round in late May or early June. The most sacred object on the Acropolis was an ancient wooden image that embodied Athena's power as daughter of the sky god. In the dark of the moon (for the festival calendar was intended to run with the moon), the image was bathed, and its robe was washed, by a few

attendants. The second, the festival of the threshing, came at the next full moon. A procession went out from the Acropolis to the farmland west of Athens to inaugurate the threshing of the grain, the last great labor of the farmer's year. Since the threshing was followed by the ingathering, the cleansing of the image was a magic preparation for the new crop and the new year. The third, the festival of games, came a full two months after the cleansing, in late July or early August, when the grain had all been harvested, and summer heat brought a lull. The whole city joined in the games and in a grand parade to the Acropolis.

Thus the sequence of Athena's festivals depends on the grain cycle. Apollo too, another protecting deity, has a somewhat similar sequence of summer festivals. Grain-growing was the staple activity and livelihood of most Greek cities. Within this pattern early Athens derived her wealth and power from the farmland of the Kephisos valley. After the resources of Eleusis were added to those of Athens, Eleusinian Demeter came to stand for the agriculture of the whole area, and the threshing festival declined. The sequence outlined above goes back to the early Dark Age, the time when grain-growing was generally adopted by newly formed communities.

Athena's festivals are projected in myth. The strange but solemn actions of ritual are always thought of as repeating great events of the distant past. The oldest myths are of the rise and triumph of the gods who uphold the present order. Athena has a large part in this: the cleansing festival commemorates her birth, and the festival of games commemorates her role in the war between the gods and the primordial Giants. Myths of the gods were told everywhere in the ancient world, but the Greeks originated another kind of explanation: the deeds of "heroes," local kings and warriors and princesses. On this outlook, the cleansing festival and the festival of games go back to several Athenian princesses who in some fashion or other first enacted the ritual of Athena and also its magic purposes, such as bringing the north wind to allay the heat of summer. Since the festival of games marks a new year and a like renewal of society, we also hear of the birth of a marvelous child, Erichthonios.

The threshing festival inspires the proudest myth of all, about King Erechtheus and his victory over almost irresistible enemies. Erechtheus personifies Athenian agriculture: he springs up from the farmland, and is established in his own shrine on the Acropolis, and finally returns to the farmland to overcome those enemies. The hero-shrine on the Acropolis is a striking feature of the festival ceremony, almost unparalleled in Greek religion, and correspondingly famous. Erechtheus may be described as a very early sign of Athens' imaginative originality.

Later, with the advent of Eleusinian Demeter, the threshing festival lost much of its significance, and the festival of games, now called Panathenaia, "Rites of all Athenians," took its place as the premier celebration. This festival reflects the physical growth of the city. In the sixth century, the route of the grand parade was shifted from the southeast, the area of the earliest settlement, to the northwest, the newest part of Athens, and various innovations were made in the ceremony. The festival as we know it was largely created then.

The three festivals were accommodated in the several shrines of Athena and in that of Erechtheus.[1] We shall take the shrines first, as the most immediate and visible evidence. When they come into focus, the main business of each festival will be more readily understood. See the schematic plan of the early Acropolis (Fig. 2.1).

The Oldest Shrine of Athena

Athena's oldest shrine, the setting for the oldest magic rites performed on the Acropolis, housed a magic image of the goddess, an almost featureless piece of wood that was fabled to have fallen from the sky. The image expresses the relationship between Athena and Zeus, the two deities of the Acropolis. Whereas the sky god Zeus looks down from above, and is worshipped at an open-air precinct on the highest point of the rock, his daughter Athena—whose original name is Pallas, "Girl"—is close at hand as the wooden image, standing inside a room. The image embodies fire from heaven, Zeus' lightning, for fire dwells in wood. The story of its falling from the sky is equivalent to the other story that the sky god's head was cleft with an ax to produce his daughter— that is, the wooden image; this event was shown on the east pediment of the Parthenon. An actual fire was kept alight beside the image.

The wooden image is not depicted in Athenian art, since there was little for an artist to depict. In Archaic and Classical times, Athena came to be represented by other, more lifelike statues, and a few of them were honored with sacrifice at adjacent altars. Another wooden image, of Athena Nike near the west entrance, was perhaps the earliest. A cult statue of Athena Hygieia also stood nearby; it may be the famous striding figure on Panathenaic vases. The statue best known to us was at one time the occupant of the great Doric temple on the north side, and the recipient of the copious sacrifices that were made at the great altar in front: a figure wearing the aegis, and holding an owl and libation bowl. In modern studies, this statue is often confused with the wooden image, for both were later kept in the same shrine.

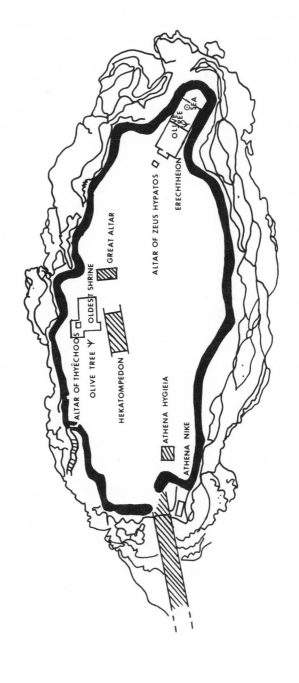

ALTAR OF THYÉCHOOS

OLIVE TREE

OLDEST SHRINE

GREAT ALTAR

HEKATOMPEDON

ALTAR OF ZEUS HYPATOS

ERECHTHEION

OLIVE TREE

SEA

ATHENA HYGIEIA

ATHENA NIKE

Fig. 2.1. Plan of the Acropolis: Athena's shrines before the fifth century (sixth-century additions are indicated by hatching). (N. Robertson, E. LaFave)

30

The image was cherished with magic rites at the turning of the year. First, at the cleansing festival, the woolen robe in which it was wrapped was removed so that the image could be bathed and the robe washed; while the robe dried in the sun, the image was decently veiled; afterward it was anointed and perhaps painted a little and dressed again in the robe. All this was done by girls of like age and mind with the wooden "Girl." Soon after, at the festival of the threshing, first fruits of grain were brought from the farmland. Later still, at the festival of games, other offerings were carried in a grand parade, and an anxious prognostic sacrifice was made at an altar indoors, close to the image. Among these rites, the cleansing festival is the original Acropolis ceremony. Unlike the other two, it is rather widely paralleled in other cities, and must have been handed down from very early times.

The shrine that housed the image is not in doubt, being so indicated in Athenian inscriptions and by Pausanias. It is the Ionic temple on the north side of the Acropolis, now miscalled "the Erechtheion," with two chambers at different levels facing east and west respectively, the latter also having porches at the north and south: a strange irregular plan, without analogy in Greek architecture. Although the temple we see, the temple known also to Pausanias and inscriptions, was built in the late fifth century, there can be no doubt whatever that a similar shrine always stood here. Ritual never changes, nor does the site—the room with the image fallen from the sky, the altar for that anxious prognostic sacrifice. And of course the Ionic temple is irregular just because its predecessors were. In other cities, other Archaic and Classical temples were straightened out as Greek architecture formed its canons. But the Athenians, so innovative in some respects, were in others unshakably attached to the past.

Pausanias lists some of the temple contents (there was undoubtedly much else). In reading Pausanias, it is important to grasp the difference between the shrine of Erechtheus, which he describes first in about half a page (1.26.5), and the temple of Athena, which he describes next in about a page (26.6–27.1). The temple is introduced by a general remark about Athena's worship in Athens and Attika. Among the contents, the ancient image is naturally mentioned first, and the ever-burning lamp beside it, and a bronze palm-tree standing above the lamp and serving to funnel the smoke up to the roof (26.6–7). Then Pausanias turns to offerings "laid up in the temple of the Polias," among which he singles out two ancient items, a wooden herm ascribed to Kekrops and a folding stool ascribed to Daidalos, and two historical items, arms taken from the Persians (27.1). That is all, before he enters the precinct of Pandrosos to the west of the temple, with its olive tree and its cella (27.2).

Pausanias does not assign the contents to their respective chambers. Which is the chamber with the image? Now it is the west chamber that makes the building irregular, with its two side porches and almost blind front and elevated colonnade. Furthermore, the floor goes down almost to bedrock, as does the north porch, whereas the east chamber has been filled in to match the prevailing level round the temple. And the west chamber is much larger, both in height and floor area. We must conclude that the west chamber housed the image and with its porches was the focus of the ancient ritual. The east chamber is an appendage in a conventional style.

In the long history of Athena's worship, the original shrine was doubtless confined to the area of the west chamber and the porches. Then an east chamber was added, perhaps to hold the offerings. Next, a whole new temple, a monumental one, was built close by on the south, the Doric temple of the early or mid-sixth century. Finally, when this temple was replaced, the site was shifted to the south, and it became the Parthenon.

The importance of the west chamber is confirmed by a detail which we owe to inscriptions. In the Lykourgan law on the Lesser Panathenaia (*IG* II² 334), a certain form of sacrifice is to be offered "in the old temple"—that is, in our Ionic temple, which is so called in Athenian documents. The phrase quoted is partly restored, but with full certainty. A sacrifice within a temple is an oddity; furthermore, this old custom is distinguished from a more recent one, a very opulent sacrifice "at the great altar of Athena"—that is, the altar which has been traced in rock cuttings east of the great Doric temple.

The altar used for the old form of sacrifice appears in the construction records of the Ionic temple under the name "the altar of the *thyêchoos*."[2] The records show that it was a fairly large altar, with at least four orthostate blocks, and stood in the north porch beside the great door into the west chamber. More exactly, it stood east of the door, under an opening in the roof which vented smoke from the sacrifice, and above an opening in the pavement which gave on some cracks in the native rock. Liquid from the sacrifice was meant to run into the cracks—perhaps the blood when the victim was slaughtered, perhaps the bile from the gall-bladder when it was examined for omens.

The officiant at the altar is called *thyêchoos*; he has a seat in the theater (*IG* II² 5026). The title is usually explained as "offering-pourer," from *thyos* and *cheô*, as if his task was to pour libations, which might then be destined for the cracks. But the first element, *thyos*, is the generic term for a burnt offering, so that "pouring" cannot be meant. The second element, here deformed by popular etymology, comes instead from the iterative

verb *koeô* "watch," "regard." Hesychios preserves the true form *thyêkoos*, and also gives us *pyrkooi*, "fire-gazers," as a class of Delphic priests who took omens from the sacrificial fire. The title is therefore a variant of the Homeric *thyoskoos*, which attests a form of the verb beginning with s-, as in Germanic languages (Anglo-Saxon *skauwon*, English *show*).[3] "The watcher of the burnt offering" was a seer; Homer once uses the word as an epithet of *mantis* (*Iliad* 24.221). This ancient title survived at Athens together with an ancient rite, the taking of omens at the new year during a sacrifice to Athena.

At the cleansing festival, the image was bathed, anointed, and dressed again in a freshly laundered robe. In discussing the festival, we shall see that these operations took place at the shrine; a notion found in some older books, that the image was removed from the Acropolis and bathed in the sea, has been disproved. Water was available for the washing and the bathing in the limestone springs at the foot of the Acropolis. Two springs come into question, both on the north side and both, at one time or another, directly accessible from the shrine. Two sets of stairs are found a short way west of the north porch. The north porch is itself the likely place for the washing and the bathing. These are secret rites, performed by special ministers away from ordinary eyes. The north porch is suitably withdrawn, but spacious enough, with the altar set in one corner. As the cleansing festival is the principal ceremony addressed to the image, we may conjecture that at the very outset it determined the location of the image and the shrine.

The nearer stairs are about 40 m. away. They once descended through a deep dark cleft in the rock, in several flights of wooden stairs and ramps and finally steps of stone, to a hidden well.[4] This extraordinary resource was constructed in late Mycenaean times and seemingly used for just a short time before the well was filled up.

The other stairs, about 15 m. further west, lead out through the circuit wall and westward down the slope to the caves of Pan and Apollo; they were often in use, in the Mycenaean period and later and indeed down to Turkish times.[5] A little further on is the Klepsydra spring. So this too can be reached by a direct route from the area of Athena's shrine; and from time to time, when the Acropolis was threatened, provision was made to secure the route.[6] But normally it would be much easier to go round to Klepsydra from the regular west entrance. In historical times, Klepsydra was doubtless the source for the cleansing festival. When Antony was preparing for the Parthian war, he obtained two powerful talismans at Athens, a wreath from the sacred olive tree and a jar of water from Klepsydra; the latter was the subject of an oracle (Plutarch, *Antony* 34.1).

The girls who did the washing and the bathing must have fetched the water from the spring. The south porch of the Ionic temple features six caryatids, stately girls who carry the architrave on their heads as they might carry objects in a ceremonial procession. The notional objects are generally taken to be baskets; but perhaps they are rather water jars for the cleansing festival.

Other jars were needed for pouring water at the bath. In the excavation of the Acropolis north slope, jars of a class hitherto unknown, dating from the late fifth century, were discovered in a patch of detritus about 7 m. east of the Klepsydra spring, having been washed down from above.[7] The jars were discarded all at once, ca. 200; before this, they had been kept in some sacred place for two hundred years. The shape has been labeled "oinochoe," but it is acknowledged that the neck and lip are more like a hydria or loutrophoros, as if for pouring water.

The decoration is peculiar. On the front are two molded "breasts," a feature otherwise found only in the Geometric period, on different kinds of vases. The painted scenes are of Athena mounting her chariot, and in one instance driving across the sea. But she wears only her robe, not her panoply as in Panathenaic scenes (except for two renderings of Athena on the neck). They might illustrate the cleansing festival, if this renewal of the image were imagined as the advent of the goddess. It is striking that the jars, all from the same workshop, are dated on stylistic grounds to ca. 410, the very moment when the Ionic temple was completed. It appears that a new set of jars was produced for the occasion.

Thus far we have seen that the Ionic temple was designed to accommodate two ancient rites, the cleansing ceremony and the omen-taking. It undoubtedly had predecessors on the site. Definite evidence comes from two sources, the "*hekatompedon* inscription" and Archaic limestone sculpture. The very fragmentary "*hekatompedon* inscription" of 485/4 has been debated for so long without agreed results that it may seem futile to come back to it again (*IG* I³ 4). But we should be aware that on a few points the inscription yields a plain meaning, and that difficulty has arisen mainly because this meaning is not acceptable to the usual range of opinion about Acropolis topography.

The inscription refers to two sacred places in the same area, a crowded area at festival time; rules for behavior are posted on the stone. One place is the *neos*, "temple" (B 11, 12, cf. A 16), the other the *hekatompedon*, "hundred-footer" (B 10–11, 18).[8] Surely "*the* temple" is the oldest shrine of Athena, the predecessor of the Ionic temple, which in its time will be called either "the temple with the image" or "the old temple." And surely "the hundred-footer," admired for its size, is the great Doric

temple just south of the oldest shrine: for the length of the foundations inside the peristyle is in fact a hundred feet.

This rather obvious meaning was pointed out long ago, but has mostly been rejected because of certain prepossessions. According to orthodox opinion, the Ionic temple is the composite "Erechtheion," a hybrid shrine of Erechtheus and Athena: so it had no predecessor, or none that could be referred to simply as *"the* temple."[9] It will follow that *"the* temple" is the great Doric temple. And it will follow next that "the hundred-footer," a term which perfectly describes the Doric temple, is something else. Let it be a hypothetical temple on the Parthenon site— even though no trace exists of a building here with this dimension. Or let it be a precinct rather than a temple—as if such a place deserved such a name.

The inscription contains other clues pointing to the same obvious meaning. It prohibits doing something with "the fire" (B 6). As others have seen, this is likely to be the sacred fire of Athena's temple; it must not be used for cooking or the like.[10] Surely this fire always burned at the same spot, beside the wooden image in the oldest shrine. A place near "the temple" is indicated in the phrase "south of [*or* outside *or* below] the temple, inside the Kekropion" (B 9–10). Admittedly, "Kekropion" depends on restoration, proceeding from the single letter *k-*.[11] But no one has devised another supplement to fit the space; and this one is entirely plausible, for the Kekropion is later found on the south side of the Ionic temple, next to the south porch (*IG* I[3] 474 line 9, etc.). Finally, "the treasurers are to open the rooms in the *hekatompedon* for show" during certain days (B 17–21).[12] What else can these rooms be but the two smaller rooms between the east and west chambers of the great Doric temple?

On a straightforward reading, then, the *"hekatompedon* inscription" indicates that in 485 two important temples stood close together on the Acropolis: the hundred-foot Doric temple and a temple corresponding to the later Ionic temple. As everyone knows, considerable fragments of Archaic limestone and marble sculpture have been assigned to the pediments of the Doric temple (or else to the pediments of the hypothetical "hundred-foot" temple on the site of the Parthenon). Still other limestone fragments probably derive from the temple corresponding to the Ionic temple.

Four smallish pediments, ranging from about 5.5 to 6.5 m. wide, are usually envisaged, with the following subjects: Herakles fighting the Hydra, Herakles fighting Triton, Herakles entering Olympos, and, more enigmatically, a group of figures standing in front of a certain building, itself rendered in great detail.[13] Sculptural authorities disagree about

their respective dates, and architectural authorities disagree about the number and form of the buildings to which they might be respectively assigned.[14] No one, however, is ready to postulate several small Archaic temples on the Acropolis.

Instead, we are told to think of "treasuries"—that is, small temple-like buildings as found at Panhellenic sanctuaries, where they were meant to serve the purposes of the different cities which joined in the reunion. It has never been explained how "treasuries" might be appropriate to the Archaic Acropolis. The *oikemata* mentioned twice in the "*hekatompedon* inscription" can hardly be relevant.[15] Almost certainly, they are temple chambers used to store offerings and other valuables, as were, in later days, the two chambers of the Parthenon, and one or both chambers of the Ionic temple. But even if they were separate buildings, they would not take the architectural form of those Panhellenic display pieces. The talk of "treasuries" must be dismissed.[16]

Any Archaic predecessor of the Ionic temple was most likely Doric and may have carried sculpture in the pediments. With the same irregular plan, two fronts and two porches, the pediments were four. The four sculptural groups are thus accounted for, if they were added at different times.

The sculptural decoration of several Acropolis buildings is unusual in depicting ritual scenes. The caryatids of the south porch of the Ionic temple probably depict the girls who fetched water for Athena's bath; otherwise they are basket-bearers. The Parthenon frieze depicts the main elements of the Panathenaic parade. The parapet frieze of the Nike temple depicts the fierce blood-letting of the threshing festival. The fourth pedimental group mentioned above is yet another unusual rendering of ritual; for the scene does not match any mythical episode, but seems rather a slow and solemn ceremony.[17]

As others have said, the olive tree seen behind a low wall must be the olive tree in the precinct of Pandrosos. It is likely that all three female figures once carried water jars: as with the caryatids, the scene is best interpreted as the cleansing festival. The water-carriers stand in front of the temple, one of them in the doorway. The precinct with the olive tree is on the left; so the view is from the south.[18] The pediment is suited to the south porch as an earlier counterpart of the caryatids.

It should be mentioned at the last that certain traces of a very early shrine have been detected by topographers who believe in the composite "Erechtheion." G. P. Stevens found rock cuttings in the line of the south wall of the terrace that was later occupied by the great Doric temple, right on the axis of the south porch of the Ionic temple. Here he placed a formal entrance way leading north toward the "Erechtheion" site in

the days before the Doric temple.[19] S. E. Iakovides reconstructs two prehistoric terrace walls running parallel and close together along the north side of the "Erechtheion" site, walls which he thinks enclosed the most ancient items of "chthonian" worship.[20] Inevitably, these traces must remain somewhat doubtful.

The Shrine of Erechtheus

In the Archaic period and even in the fifth century, the "temple" or "precinct" of Erechtheus was about the most famous shrine in Athens, vying with Athena's own. It is signaled twice by Homer, more admiringly than any other shrine in any part of Greece. Erechtheus as the symbol of Athenian agriculture is established by Athena "in his own rich temple" (*Iliad* 2.549). Athena herself, on leaving the Phaeacians, flew over the sea to Athens and "entered the strong house of Erechtheus" (*Odyssey* 7.81). Athenian writers are proud to echo Homer. For Aeschylus, "the house of Erechtheus" typifies the Acropolis (*Eumenides* 855). In Euripides' *Erechtheus*, Athena establishes "a precinct, with enclosure walls of stone, in the middle of the city" (ed. Austin, fr. 65 lines 90–91). "The temple of Erechtheus" is prominent in Herodotos' account of the fall of the Acropolis in 480 (8.55). It is also indicated by a term he uses elsewhere, "the *megaron* facing west" (5.77.3, interpreted below).

As we might expect, the shrine is little noticed after the fifth century, when the Acropolis had assumed the form it has for us, and the eye dwelt on the Propylaia, the Parthenon, and the two Ionic temples of Athena. It is of interest only to antiquarian writers—to Dionysios of Halikarnassos, who repeats Herodotos but substitutes "precinct" for "temple" (*Roman Antiquities* 14.2.1); to Pausanias, who saw a "double-chambered building" well stocked with ancient memorials (1.26.5); and to Himerios, who juxtaposes Athena's "temple" and Poseidon's—that is, Erechtheus'—"precinct" (*Oration* 5.30).

Strange to say, this premier shrine has long been shrouded in dark misunderstanding. The very site remains unknown, or rather unrecognized. Instead, Erechtheus' temple is conflated with Athena's, with the Ionic temple at the north (or its predecessor), the so-called Erechtheion.[21] Generations of scholars have labored over ingenious conjectural plans of the interior furnishings, but none has ever found much acceptance. It is time to give up this unprofitable exercise and to acknowledge the misunderstanding, which has three principal sources.[22]

First, Homer is thought to say that Athena established Erechtheus "in *her* own rich temple"—as if Erechtheus were one with Erichthonios, the other earth-born ancestor, who has no shrine or cult, but is snaky like

Kekrops and may therefore be deemed to inhabit Athena's temple as its actual guardian snake. The confusion here extends to the two festivals, Skira and Panathenaia, of which Erechtheus and Erichthonios are the respective founding heroes.

Second, Pausanias in his tour of the Acropolis mentions the shrine of Erechtheus and the temple of Athena Polias one after the other, and evidently at a certain distance from the Parthenon, which he mentioned earlier. Though a closer reading of Pausanias shows that the shrine of Erechtheus and this temple of Athena are indeed distinct, and also at a certain distance from each other, the visual imagination of modern scholars was for long constrained by the more conspicuous ruins. When the Acropolis was first explored and studied, the only two temples that could be distinguished were the Parthenon and the Ionic temple at the north. Therefore the Ionic temple did duty for both Erechtheus and Athena.

Third, ancient writers use different terms for Erechtheus' shrine. We hear now of a "temple," *nêos* (Homer, Herodotos) or of a "house," *domos* (Homer, Aeschylus), and now of an open-air "precinct," *sêkos* or *temenos* (Euripides, Dionysios, Himerios). Note, however, that both "house" and "precinct" are described as strong or well-built (Homer and Euripides respectively). Pausanias speaks more precisely of a "double-chambered building," *oikêma . . . diploun*. Why the same shrine should appear to some eyes as a building, to other eyes as an open-air precinct, needs to be explained. It is not explained, however, by the usual notion of the Ionic temple as a composite shrine of Erechtheus and Athena; for the composite shrine is different again from the open-air precinct of Pandrosos on the west, where no one looks for Erechtheus.

Let us also be aware of the wandering olive tree, another matter that cries out for explanation. In Herodotos, the tree stands "in" the temple of Erechtheus, near the curious "sea-water," *thalassa*, attributed to Poseidon (in Dionysios, it stands in the precinct of Erechtheus). In Philochoros, it stands in the precinct of Pandrosos, above an altar of Zeus "of-the-courtyard," *herkeios* (*FGrHist* 328 F 67). The contradiction is simply ignored in the usual notion of the composite shrine, whether the tree goes into the composite shrine or into the adjacent precinct of Pandrosos.

To identify the sources of misunderstanding is to see that the conventional "Erechtheion" of Acropolis topography cannot be reconciled with the evidence.[23] We must look again at the remains on the ground; Pausanias will be our guide. A new candidate has already been suggested— the solid square building set against the north wall of the Acropolis some way west of the Ionic temple, conventionally labeled "house of

the *arrhêphoroi*."[24] But it does not satisfy any of Pausanias' indications. It does not lie on the route he takes from the Parthenon toward the east end of the Acropolis, or from thence to the Ionic temple at the north. Nor does it match his description of the shrine of Erechtheus as a double-chambered building with various contents.[25] The suggestion can be firmly rejected.

Pausanias beckons. It is only lately, as a few great sites have been thoroughly excavated and studied, that we have learned to read Pausanias properly, to follow his signals. The excavations of the Athenian Agora have greatly helped; but an understanding of the Acropolis has not followed, no doubt because Pausanias here refers to a great many statues, which are untraceable on the ground. To encompass all the sights, he makes two distinct promenades, just as he does in the Agora. In both places, each promenade goes in a fairly straight line in one direction, but the first is much longer and fuller than the second; the two promenades either begin or end at the same point.[26] In the Agora, the first promenade goes across the square from the northwest corner to the southeast environs (1.3.1–14.5); the second starts again from the northwest corner, but goes east across the north side of the square (14.6–16.3). Thus the starting point is the same for both. On the Acropolis, the first promenade goes along the south side from the entrance at the west to the southeast corner (22.4–26.5); the second goes along the north side in the opposite direction, from the Ionic temple to the entrance at the west (26.6–28.2). Thus the second ends where the first began.

It is essential to recognize the transition from the first promenade to the second. In the Agora, where the two promenades start from the same point, Pausanias signals the transition by repeating the same terms, "the Kerameikos" and "the King's Stoa" (3.1, 14.6). Even so, the signal is sometimes missed. On a maverick view, the last item on the first promenade, the temple of Eukleia—which was somewhere beyond the Eleusinion at the southeast—becomes the first item on the second promenade: that is, the temple on Kolonos, which is in truth the temple of Hephaistos, mentioned in its proper place by Pausanias.[27] On the Acropolis, the second promenade begins at a new point, the Ionic temple of Athena as the easternmost building on the north side. Pausanias signals the transition with a general comment about Athena's preeminence everywhere in Athens and in Attika (26.6).[28] Even so, the signal has always been missed, and as a consequence the Ionic temple is conflated with the last item of the first promenade, the Erechtheion (26.5).

Our task then is to follow Pausanias on his first promenade, step by step up to the very last, where we shall find the Erechtheion. He goes east from the Propylaia along the south side of the Acropolis, past the

shrine of Brauronian Artemis (23.7); then he skirts the north side of the Parthenon, and notes the monument of Ge, still marked for us by a rock-cut inscription (24.3); after reaching the precinct of Zeus Polieus at the northeast corner of the Parthenon, he turns to the east front of the temple (24.4–5); thereafter, he comes to four statue groups dedicated by Attalos I of Pergamon, displayed in a row along the south wall of the Acropolis (25.2). The groups depicted battles, three mythical ones and Attalos against the Gauls. The figures were numerous and must have taken up almost the whole stretch of wall east of the Parthenon; for a figure in the very first group, Dionysos in the Gigantomachy, was already far enough east to fall into the theater when toppled by a storm (Plutarch, *Antony* 60.4). After the battle groups, Pausanias notes three individual statues, all close together (25.2, 26.4). At this point, we have reached the southeast corner of the Acropolis. The promenade has taken us in a fairly straight line in one direction, from west to east.[29]

It is at the southeast corner of the Acropolis that Pausanias saw the Erechtheion (26.5). He describes it as a "building," *oikêma*, with two chambers. The first chamber has three altars, and on the walls are paintings of members of the *genos* Boutadai. In the second chamber is a "well" containing sea-water. From these details we can deduce something more about the aspect of the building: it was unroofed.

The three altars, assigned to different gods and heroes, were of course used for burnt offerings. The principal altar was no doubt the first, shared by Poseidon and Erechtheus, and must have been of considerable size, to judge from the large and numerous victims we hear of elsewhere.[30] Any altar, let alone these three, would be intolerable in a closed room. The paintings too need light; paintings are normally displayed in a stoa, open at the front. The well was obviously open to the sky; for whenever the south wind blew, it gave out a sound of waves, a marvelous sign. The building then had fairly high walls, to accommodate the paintings, but no roof. This will explain why Pausanias does not say "temple" but employs the indefinite term *oikêma*.

We turn to the excavated remains at the southeast corner of the Acropolis.[31] A rectangular building about 40 by 17 m., and so of temple size, faces west-northwest, toward the temple of Athena Polias. It was a sacred place, entered through a projecting portico; and yet it was unroofed, for the walls are only a foot thick. It is divided into two almost equal chambers; the rear chamber, which was out of sight, is more lightly built. The construction can be dated to the later fifth century, after the ground had been leveled behind the massive new circuit wall.

This important building has been strangely neglected in studies of the Acropolis. It was at first thought to be a mere "workshop." Stevens, to

whom we owe the above details, made it the shrine of Pandion, and it is thus labeled on most modern plans. Yet nothing suggests that the shrine of Pandion was so large and so well situated; it is not even mentioned by Pausanias. It should probably be sought rather on the high ground close to the precinct of Zeus Polieus;[32] for the spring festival Pandia was addressed to Zeus as god of the brightening sky.[33] The shrine of Pandion was also the destination of inscribed decrees of the *phylê* Pandionis, but the recorded provenance of these decrees only points to the eastern half of the Acropolis.[34]

Accordingly, we need not hesitate to identify the double-chambered building on the ground with Pausanias' Erechtheion. To be sure, there is no report of a well—but then a well does not exist anywhere on top of the Acropolis.[35] We can only suppose that this strange well with sea-water did not go down very far; perhaps it was more of a basin.[36]

The southeast corner of the Acropolis is a prominent spot; it looks out over the earliest part of the city, the southeast sector reaching to the Ilissos. It was even more prominent in the days before the fifth-century circuit wall straightened the Acropolis contours. Right at the corner is a jutting outcrop of native rock; in following this outcrop, the Mycenaean fortress wall made an elongated loop; the Erechtheion site lies within the loop. The site was occupied by earlier buildings, but the remains are too fragmentary to show any pattern or any continuity of use.[37] It can only be said that the earliest remains, dwellings and graves of the late Mycenaean period, are incompatible with a shrine, and that the later remains, including a quite substantial piece of wall, are not. On this showing, the shrine of Erechtheus might be a creation of the Dark Age, when the southeast sector of the city was first marked out.

This identification of the Erechtheion is imposed by Pausanias. It also happily agrees with all the other mentions of the shrine.[38] For they indicate that the site was indeed conspicuous. The east side of the Acropolis is the "front," as Herodotos says (8.53.1). Right below lay the earlier agora of Athens and such public buildings as the archons' quarters.[39] This was "the middle of the city," a traditional phrase used of both the agora and the adjoining Theseion (Statius, *Thebaid* 12.481; Plutarch, *Theseus* 36.4). Euripides says the same of the shrine of Erechtheus: it was "in the middle of the city."

We now see why the shrine could be called either a "temple" or a "precinct": the structure seen by Pausanias and traceable on the ground had four solid walls but was open to the sky. Its predecessor undoubtedly had the same form. "I command the building of a precinct with enclosure walls of stone," says Athena at the end of Euripides' play. His

audience knew that the shrine then standing, which was doubtless the excavated shrine, was faithful to the original.[40]

The Erechtheion can also be recognized in Herodotos' term "the *megaron* facing west" (5.77.3). The double-chambered building is thus distinguished from all the other buildings on the Acropolis. The term has hitherto been taken, *faute de mieux*, as denoting the west chamber of the Archaic Doric temple of Athena.[41] But *megaron* in Herodotos means a "temple," simple and entire, not a room within a temple—it is used of this very temple of Athena as the last refuge of the Acropolis defenders (8.53.2). And only the double-chambered building will satisfy the topographic indications. For "the *megaron* facing west" stood opposite "the walls scorched by fire" in the Persian sack, on which were hung the fetters used on captive Boeotians and Chalcidians in ca. 506. There are no walls west of the Archaic temple of Athena, unless they are a terrace wall.[42] But the terrace wall itself faces west, and is more truly opposite the Acropolis entrance, just where Herodotos saw a votive chariot commemorating the same victory: yet the locations of the chariot and of the fetters are contrasted by Herodotos. Now the double-chambered building is far from the entrance and the chariot, but is opposite the large precinct of Zeus Polieus; and the extensive unencumbered precinct walls were well suited for the display of numerous fetters.[43]

Finally, there is the matter of the olive tree—or the olive trees. "In" the temple of Erechtheus, says Herodotos, are both an olive tree and sea-water, tokens of the strife between Athena and Poseidon; the tree was burnt by the Persians together with the rest of the shrine, but sprouted again almost at once (8.55). Yet according to Philochoros, the olive tree stood in the precinct of Pandrosos, above the altar of Zeus "of-the-courtyard" (*FGrHist* 328 F 67).

Other writers agree with Philochoros about the site of the olive tree, and also separate the tree and the sea-water. The mythographer Apollodoros, speaking of the tokens of strife, says that the sea-water, called "Erechthean," was produced by Poseidon "in the middle of the Acropolis," whereas the olive produced by Athena "is now shown in the Pandroseion" (*Library* 3.178). If the sea-water is "Erechthean," if it is situated "in the middle of the Acropolis"—an echo of Euripides' memorable words—it can only be in the shrine of Erechtheus.

Pausanias too speaks of both the tree and the sea-water as the tokens of strife, and like Herodotos describes the tree as burnt but sprouting in 480. Yet he does not mention the tree and the sea-water in the same passage. He found the sea-water in the rear chamber of the Erechtheion (1.26.5). He notices the olive tree only after listing the contents of the Ionic temple, and just before pointing to the "temple of Pandrosos,"

which was somewhere in the precinct, probably at the southwest corner (27.1–2).

Long before Philochoros, two scenes in Athenian art appear to locate an olive tree in the precinct of Pandrosos.[44] The Archaic limestone pediment discussed above, and assigned to a predecessor of the Ionic temple, shows a building on the right, and on the left a low wall with an olive tree behind—surely the temple of Athena and the precinct of Pandrosos, viewed from the south. And a vase-painting of ca. 400 shows the chest with Erichthonios resting beneath an olive tree, while Athena and Kekrops offer sacrifice, and Pandrosos and her sisters look on.[45] Since the myth of Erichthonios goes with the *pannychis* of the Panathenaia (as we shall see in due course), the olive tree is likely to be in the precinct of Pandrosos.

These two locations for the olive tree cannot be merged or reconciled by any line of argument. A. Furtwängler in the Heroic Age of scholarship simply substituted *sêkos*, "precinct," for *nêos*, "temple," in the text of Herodotos; and commentators since have sometimes confessed to a sneaking sympathy.[46] But although Dionysios of Halikarnassos, while closely following Herodotos, does indeed say *sêkos* instead of *nêos* (*Roman Antiquities* 14.2.1), this does not signify, for the shrine of Erechtheus was always apt to be called either a temple or a precinct. Dionysios uses the other term as a learned variation, perhaps with an eye on Euripides' play. More importantly, the precinct of Erechtheus is still not the same as the precinct of Pandrosos. And even on the traditional reading of Pausanias, which conflates the Erechtheion and the temple of Athena Polias, it is still perfectly clear that Pausanias did not find the sea-water close beside the olive tree, as Herodotos did.[47]

The conclusion is inescapable that we have two olive trees, one in the unroofed shrine of Erechtheus, another in the precinct of Pandrosos, which were successively the center of attention. The same stories, about the strife and the sprouting, were told of both. The question is why the tree in the shrine of Erechtheus was given up in favor of the one in the precinct of Pandrosos.

In Herodotos' tale of very early relations between Athens and Epidauros, before the rise of Aegina, Erechtheus is linked with the olive tree as follows (5.82). To increase their crops, the Epidaurians resort to magic: they cut wood from Athenian olive trees and make statues of their native grain goddesses, Damia and Auxesia.[48] It works, and ever after, in return for the wood, they send offerings each year to Athena Polias and Erechtheus—that is, at the Skira, the Athenian threshing festival. Why does olive wood help the grain harvest? Because olive trees thrive and indeed blossom just at this season, in the parching heat

of summer. Why fetch the wood from Athens? Because, says Herodotos, Athenian olive trees were deemed the holiest, or else they grew nowhere else. Whichever it was, the belief is implicit that the first olive tree was produced by Athena at Athens, doubtless in the shrine of Erechtheus, hero of the threshing festival.

Pandrosos, on the other hand, has no discernible connection in cult or myth with the olive tree which stood in her precinct for many centuries.[49] She belongs not to the Skira but to the Panathenaia, being associated with Athena in sacrifice and in dedications by the *arrhêphoroi* who were active at the festival. Her name, "All-dew," perhaps evokes the *pannychis*, the "all-night" ceremony that was conducted mainly by girls, older and younger.

In early Athens, then, the olive tree was emblematic of the Skira, but by the fifth century this festival had fallen far behind the Panathenaia in popular esteem. Round the mid-century, the ground level at the rear of the Erechtheion site was raised behind the new circuit wall of the Acropolis.[50] The olive tree could not survive this operation.[51] To judge from those scenes on the pediment and on the vase, another olive tree existed already in the precinct of Pandrosos. It now became the sacred token.

The Shrine of Athena Nike

The shrine of Athena Nike, "Victory," on the southwest bastion over-looks the west approach to the Acropolis. This position also matches that of Erechtheus' shrine at the southeast. What ritual was conducted here? The question has never been clearly put. Instead, it is assumed that Athena Nike somehow goes with the Panathenaia, perhaps especially with the games. But the assumption does not hold up.

In the Lykourgan law on the Lesser Panathenaia, one cow out of many is reserved for sacrifice at the altar of Athena Nike (*IG* II² 334). Yet this is one of the provisions that draw on a special source of revenue and are distinguished from others of long standing.[52] It may or may not originate at just this time; in any case, it cannot be the principal occasion for Athena Nike. In the actual shrine, the earliest levels that can be distinguished are of the sixth century, and so perhaps contemporary with the expansion of the Panathenaic games. But just before this the top of the bastion was demolished, or had collapsed; earlier levels have vanished, and no conclusion can be drawn.[53]

There are two reasons for taking the shrine further back. First, the cult statue, as described by literary sources and as rendered in a fourth-century relief (*G & P* fig. 87), was a stiffly standing figure of wood

holding an unusual pair of attributes, a helmet and a pomegranate.[54] It is likely to be early. Second, Kallimachos and others preserve a popular name for the bastion, Glaukopion, "Gray-eyes' shrine," which was already current ca. 600, when it was applied to a derivative shrine in the Athenian settlement at Sigeion.[55]

Now the Skira are a professed "victory" festival. "The victory rites (*nikêtêria*) of Athena" is Proclus' term for a festival marking her victory over Poseidon, which can only be the Skira (whether he thinks of Erechtheus and Eumolpos, or of the olive and the salt sea, makes no difference).[56] When Athena announces the festival program at the end of Euripides' *Erechtheus*, the last item is a sacrifice emphatically located "at my own altar" and placed in charge of the priestess of Athena Polias (fr. 65 lines 95–97).[57] An ephebic decree of 123/2 happens to mention a separate festival with a sacrifice at the altar of Athena Nike: an ox is led by processioners up to the Acropolis (*IG* II[2] 1006 lines 14–15).[58] *Erechtheus* and the ephebic decree refer to the same festival and sacrifice. It is the Skira, and this is the ritual which the shrine was meant for.

It is remarkable how the festival aetiology, the battle between Erechtheus and Eumolpos, insists on the word *nikê*, "victory." It is repeated several times in the fragments of Euripides' *Erechtheus*, and appears twice in the brief passage of *Phoenician Women* which represents Teiresias as just returned from helping Athens in the war.[59] Teiresias, moreover, came on stage wearing a golden crown, the emblem of victory that appears as a dedication to Athena Nike in the Parthenon inventories.[60] Erechtheus himself enacts the victor's customary gesture of setting up a trophy on the field (*Erechtheus* fr. 65 lines 12–13).

At the end of *Erechtheus*, Athena also describes a drastic kind of sacrifice that takes place at the other terminus of the Skira, the farmland west of Athens. Oxen are slaughtered inside a forbidden precinct, *abaton*, reputedly the grave of Erechtheus' daughters (fr. 65 lines 75–89). Euripides speaks of the rite as *sphagai bouktonoi*, "a blood-letting of slain oxen." Though part of the festival, it is assimilated in the following lines to the military practice of killing an animal just before battle is joined, a form of magical anticipation.[61] It is even said that the recinct is closed off in order to prevent an enemy from conducting the rite and thus ensuring "victory" for himself. To warrant this analogy, the animals must have been slaughtered in the same way as on the battlefield, by stabbing through the neck. The threshing was an anxious time, no less so than a battle.

The festival explains both the features of Athena Nike and the decoration of her shrine. The wooden image holds a helmet and a pomegranate, in token of war and of natural abundance. Battles are depicted on

the temple frieze, and on the parapet frieze personified Nikai set up trophies and sacrifice oxen. In one version of this repeated scene, on the prominent west face of the parapet, a Nike raises a sword in her right hand, and wrenches back the animal's head with her left.[62] The ox is being slaughtered in the fashion prescribed for the *abaton*. The parapet frieze was carved, seemingly in haste, about the same time as *Erechtheus* was performed.[63] In the tense days of the Peloponnesian War, Athens found reassurance in the myth and ritual of the Skira.

Until the fifth century, Athenians living in the old city to the south saw the Acropolis contours defined by the matching shrines of Erechtheus and Athena Nike. It is likely though unprovable that the two shrines are coeval, since both were created for the Skira as a distinctive Athenian festival.

Other Shrines of Athena

The oldest shrine, on the site of the Ionic temple, was used for both the cleansing festival and the festival of games, the annual Panathenaia, when omens were taken at the altar in the north porch. Later this festival includes sacrifice at other altars on the Acropolis, especially at "the great altar." "The great altar" of inscriptions, or simply "*the* altar," can be traced in rock cuttings just east of the Archaic Doric temple; it seems to have spanned the full width of the temple.[64] Here the oxen were slaughtered for the general feast that was shared by all the worshippers, the principal sacrifice from a secular point of view. The sacrifice continued after the Doric temple had been ruined and dismantled. The Parthenon never had an altar of its own: a sure sign that it was intended as a replacement for the Archaic Doric temple.

The Doric temple and its altar presuppose a cult statue. This can only be "the goddess" whose precious accoutrements are listed in fourth-century inventories of the Ionic temple, and who is also depicted on certain Hellenistic coins—an Archaic standing figure with the usual aegis and Gorgon's head, but holding an owl and a libation bowl.[65] On the conventional view, the statue of the inventories is none other than the ancient wooden image fallen from the sky. We should think again. The wooden image was always admired, or derided, as a relic of the very earliest time on earth, the time of Kekrops or Erichthonios, when men sprang up from the ground. Such an image, also described as a mere log, can hardly be a sculptural work of the Archaic period.[66] Furthermore, two statues are needed, one for the Doric temple and another for the predecessor of the Ionic temple. It was natural that the statue of the Doric temple should afterward be kept in the Ionic temple, since this

was fairly close to the altar, and since the Parthenon had its own modern statue.[67]

Thus the oldest shrine came to be overshadowed by another temple right beside it, a huge temple with a huge altar, and with a statue that was doubtless considered exquisite in its day. The second temple served the expanding festival of games. When this addition was made we cannot say with any confidence. The only remnants that are datable at all, the limestone pediments of the first version of the Doric temple, are perhaps no earlier than the reorganization of the Panathenaia in 566.[68]

It was inevitable that when the worship grew, it should spread to the south. Until the fifth-century circuit wall was built, the cult site occupied by the Ionic temple was closely bounded on the east, where it faces a Mycenaean path ascending the north slope. The Mycenaean fortress wall that blocked this path runs north to south only 10 m. east of the Ionic temple.[69] Thus the Doric temple and the great altar were installed on the nearest available ground.

The shrine of Athena Hygieia, "Health," at the west entrance of the Acropolis was also prominent in Panathenaic ceremony. In the Lykourgan law, the sacrifice here is the first of all, preceding the sacrifice in the north porch of the Ionic temple. Traces at the site, of an altar and offering table and statue bases, are all later than the Periklean Propylaia, which must have encroached on the earlier shrine. It is carried back to the early fifth century by two dedications, on a marble column and a red-figure vase (*IG* I³ 824; *ARV*² 1556). Aristeides grandly says that the altar of Athena Hygieia was set up by the very first Athenians (37 *Athena* 20). There is reason to think that the cult statue is rendered by a famous figure on Athenian vases, the striding Athena of Panathenaic amphoras and derivative scenes, usually called "Athena Promachos."

The statue was renowned, for on a later day it gave the Athenians a terrible omen in the war between Antony, whom Athens favored, and Octavian, who won. In the words of Cassius Dio, a statue of Athena, "which was set up on the Acropolis to face the east, turned round to the west and spat blood" (54.7.3). Rather oddly, this statue has always been identified, if at all, with either Athena Parthenos or Athena Polias (and, if the latter, is taken to show that the statue stood in the east chamber of the Ionic temple, facing east). Yet a statue which turns from east to west, and so prefers Octavian to Antony, is a statue standing out of doors. Inside a room, our sense of direction is not determined by the points of the compass; if a statue facing the room turned round to face the wall, it would not occur to anyone to say that it had turned from east to west.[70] Furthermore, spitting blood is the surest sign of fatal illness (Herodotos 7.88.1, etc.). Other statues may sweat or weep as an omen, but only

Athena Hygieia will spit blood. It is also noteworthy that the Athenians a little later resorted to this shrine in order to flatter Augustus, as we see from the statue base of Sebaste Hygieia—that is, Salus Augusta, perhaps meaning Livia, as on Roman coins (*IG* II² 3240).

The cult statue cannot be located on the ground. But we know something of another statue of Athena Hygieia. It stood on a surviving base against the corner column of the Propylaia on the south side, a bronze by the sculptor Pyrrhos, dedicated by the Athenian people, and probably the starting point of an anecdote about the construction of the Propylaia (Plutarch, *Perikles* 13.13). We might expect it to be an up-to-date, realistic rendering of the same figure as the cult statue. The cuttings on the base reveal the pose: feet well apart, with the left drawn back and turned outward.[71] "Athena Promachos," the striding Athena of vase-painting, comes to mind.[72] Because the type appears on every Panathenaic vase early and late with no significant change, and because it is associated with sacrifice and adoring athletes, it has often been thought to represent some Archaic cult statue on the Acropolis. Here too it is the left foot that is drawn back; after the earliest instances the heel is shown lifted from the ground. Admittedly, Pyrrhos' statue, with the foot turned outward, was not in stride but standing still, nor were the feet planted so far apart. Everyone agrees, however, that the painted figure must be livelier than any Archaic cult statue.[73] Perhaps then what the vase-painters took to be a stride, Pyrrhos took to be a resting pose.

The correspondence goes further. It has been remarked of the painted figure that the original must have stood out of doors, for sometimes it is shown close to an altar (and recognizably the same one), and very often between two free-standing columns. Athena Hygieia was always out of doors and close to her altar, and before the construction of the Propylaia may well have stood between two columns—indeed, this might explain why Pyrrhos' statue was set up right against the corner column of the Propylaia. The painted figure is always seen striding to the left. Such was the usual view of Athena Hygieia, as the worshippers arrived on the Acropolis by the west entrance and looked to the right toward the shrine.

We may conjecture that Athena Hygieia (and not Athena Nike) was first established at the entrance in the mid-sixth century, when the Panathenaic games were reorganized.

The Cleansing Festival (Plynteria and Kallynteria)

In the cleansing festival, Athena's wooden image receives several kinds of attention. At Athens there are two stages, the Plynteria, "Washing (rites)," and the Kallynteria, "Adorning (rites)." Similar festivals are

attested, or can be inferred, elsewhere in Attika and in other parts of Greece. The demes Erchia and Thorikos had their own versions of the Plynteria. A month Plynterion, named for the festival, appears on some Ionian islands: Ios, Paros, Thasos, Chios. At Tegea in Arcadia, a mythical "washing" of Athena's robe implies a corresponding ritual. At Dorian Argos and Delphi, we hear rather of "bathing" rites, *loutra* or *lôtis*, the former described in Kallimachos' fifth *Hymn*. Since any information about Greek ritual is extremely scarce, this range is impressive, and puts it beyond doubt that the festival was ancient and widespread. Furthermore, all the mainland sites have Mycenaean traces. To be sure, the ritual is not uniform; differences as well as similarities between Athens and the other places will be mentioned in due course.

This elaborate ceremonial cleansing is peculiar to Athena, to the image on the citadel that is both a scion of Zeus and a talisman for the community. Statues of other deities are cherished and solicited in many ways, but any cleaning and adorning do not constitute a whole festival.

For the Athenian festival, the following actions are either reported or indicated by the ritual nomenclature: removing the robe and other "adornment" from the image; placing a veil over the naked image; washing the robe; bathing the image; putting the robe back on the image; "adorning" the image.[74] The image's "adornment," *kosmos*, is chiefly the robe; so "adorning" the image, *kosmeô*, is in part putting the robe back on, but will include also some cosmetic procedures, perhaps anointing the image with oil, attested at Argos, and adding (say) a crown and a necklace, attested at Delphi.

The Plynteria are reliably dated to 25 Thargelion, together with the associated actions of undressing and veiling the image (Plutarch, *Alkibiades* 34.1).[75] Surprisingly, the Kallynteria have been thought to precede the Plynteria. There is indeed an entry *kallyntêria kai plyntêria* in the lexica (it gives plainly false dates for both stages, at an interval of ten days). But since the purpose of the entry is to explain the *kallyntêria*, we may suppose that the second name, which is much better known, was added in order to amplify the first, not to show the sequence. On any realistic view, the washing is prior to the adorning.[76] The month name Plynterion says as much, if we assume that the month is named after its first notable ceremony. The festival can therefore be reconstructed as follows.[77] On 25 Thargelion, the image was undressed and veiled, and the robe was washed. A day or two later, on 26 or 27 Thargelion, when the robe had dried, the image was bathed and then dressed again and adorned. The likely setting for the ritual, the north porch of the Ionic temple, was discussed above, among the Acropolis shrines.

The site of the washing and bathing depends on local conditions. At Tegea as at Athens a spring was close at hand. A papyrus argument to Euripides' *Auge* says that Auge as priestess of Alea Athena was "washing the robe of Athena near a fountain" when Herakles suddenly took her (fr. 323a Mette).[78] Pausanias locates the fountain just north of the temple (8.47.4), where the excavators found a large basin with marble sides and steps.[79] Pompeian wall-paintings inspired by Euripides show instead a natural spring, suited to days of old.[80] Auge and another girl kneel on a rocky bank and dip the robe in the water. They are the counterparts of Athens' *plyntrides*.

At one point the papyrus has been misunderstood: it is restored so that the washing takes place at "the *pa[nnychis*," an all-night revel.[81] This is not the right occasion. It is true that in later sources the rape does occur at a virtual *pannychis*, while Auge leads her companions in the dance; and she would never have known who assailed her in the dark, were it not for a ring that Herakles gave her.[82] This version is, however, quite distinct from Euripides', and belongs to one of the comic poets who treated the subject, Eubulos or more likely Philyllios.[83] In comedy a *pannychis* is the favorite setting for seduction, and has been adopted willy-nilly for Auge; it says nothing for the ritual at Tegea. The papyrus must have referred to "the ancestral festival," *pa[tria heortê*.[84]

At Argos, on the other hand, the bathing rite was a sudden, exciting effort, at the moment when the river Inachos rose in spate. The image probably stood in the main temple of Athena on the Larisa, otherwise in a temple on the ridge to the north; in either case, there was no spring anywhere about. Of the springs for which Argos was famous, Amymone was in the southwest district near Lerna, and so perhaps were all the others.[85] Accordingly, the custom was to bathe the image in the Inachos—which flows only when fed by rainfall in the mountains (Pausanias 2.15.5). This accounts for the bustle and clamor of Kallimachos' fifth *Hymn*. When rain comes, after a certain period of waiting, a horse-drawn wagon is brought to the foot of the Larisa, the image is carried down by the women, and the horses make for the rushing waters filled with sand and vegetation: "After mixing his waters with gold and flowers, Inachos will arrive from the mountains, bringing Athena her bath, a fine one" (lines 49–51).[86]

The image must have been divested of its robe beforehand, within the temple. Argive men are warned away at the outset, lest they see the goddess naked and go blind (lines 51–54); the warning is enforced at length with the example of Teiresias. At the river, there is no mention of Athena's undressing, or of any washing of clothes, only of bathing and anointing and combing. We may be sure that the robe was washed before

it was put back on; but the washing probably took place on the Larisa, and more at leisure. A class of officiants called *gerairades* are defined as "those who dress the statue of Athena at Argos."[87]

A final question is whether different cities celebrated the cleansing festival at the same time of year. The evidence admits only a tentative answer; but it seems likely that the customary times were different for the Ionian and the Dorian versions.

At Athens, the cleansing festival comes near the end of the month Thargelion, just before the threshing and ingathering, and is followed a full two months later by the festival of games. At Thorikos, it comes in the next month, Skirophorion. At Erchia, where the festival is not named but can be identified from the offerings and the recipients, the date is happily fixed to 3 Skirophorion.[88] On Thasos and probably on Paros, the month Plynterion corresponds to Attic Skirophorion.[89] If then the festivals outside Athens all come at the beginning of the next month, the cleansing is still notionally done at the dark of the moon; for the festival calendar is meant to run with the moon, even though it often goes awry.

One might have expected Attic demes to join in Athens' celebration of the cleansing festival. But as the dates are different, this was not intended. Moreover, the Erchians have their own citadel where the festival takes place; even in the fourth century, when the sacrificial calendar was inscribed, it was still called by the ancient term *polis*, just as the presiding goddess was called Polias. And since Athena is partnered by Aglauros at both Erchia and Thorikos, it is very likely that this figure was generally current in the Ionian version of the festival. She personifies the "clear water" of the washing and the bath (linguists are agreed on this meaning for Aglauros).

Elsewhere the only datable instance is the Delphian. The Amphictyonic law that was ratified at Athens in 380/79 fixes the cost of several items of dress and armor to be offered to a goddess, undoubtedly Athena *pronaia*, at a ceremony called *lôtis*, "bathing."[90] Since the law appears to be concerned with preparations for the Pythian games, these will be items offered by the Amphictyony at the games. The bathing rite was doubtless conducted every year on a smaller scale, without the Amphictyonic offerings, but at the same season. Now the Pythian games fall in the month Boukatios = Metageitnion, late summer.[91] The Delphian festival is therefore much later than the Ionian instances. This season also suits the river bath at Argos; for a sudden heavy rain may fall in late summer, but hardly ever in early summer. If anyone is rash enough to generalize, he will conclude that the Dorian version was not linked with the ingathering of the grain; it must have had some other significance for the community.[92]

At Tegea in Arcadia, the story of Auge gives no hint of when the washing festival took place. It was surely distinct from the agonistic festival Aleaia, which though first attested in the third century must be ancient.[93] Perhaps it was at the Aleaia that a fine new robe was dedicated to Alea Athena (Pausanias 8.5.3). If so, the washing festival and the Aleaia stood in the same relation as the Plynteria and the Panathenaia at Athens.

The Threshing Festival (Skira)

At Athens and probably at other Ionian cities, the cleansing festival comes in early summer, just before the threshing of the grain. Athens' threshing festival, the Skira, appears to be unique in associating Demeter and Athena, and in producing a notable hero, Erechtheus. The festival has been neglected or misunderstood. This is not the place for a full investigation, but we must understand the farmer's need of certain weather conditions, for it is on these that the festival turns, and the story of Erechtheus as its aetiology.

The seasonal round of Demeter's festivals begins with the plowing and sowing a full nine months before, and continues with the sprouting, earing, and reaping, up to the threshing. In Athens and rural Attika, the names are Thesmophoria (with the sequel Proerosia), Chloaia, Antheia, Kalamaia, and Skira. The first and last of the series, Thesmophoria and Skira, are by far the most important, because the ensuing labors are difficult and prolonged and dependent on the weather. Threshing and winnowing require sunny skies, and winnowing further requires a constant wind.

The sun ripens the cut grain; any rain or damp will ruin it. The priest of Helios, "Sun," goes in procession from the Acropolis to the place Skiron, together with the priestess of Athena and the priest of Poseidon (Lysimachides, *FGrHist* 366 F 3). The actual Acropolis cult is not of Helios, a literary name, but of Zeus *hypatos*, "highest," whose altar stood right in front of the shrine of Erechtheus (Pausanias 1.26.2). The epithet denotes the sun's position in the bright sky; "Hyperion" is an equivalent form. In Pausanias Zeus *hypatos* receives the same kind of offering, cakes and no wine, as Helios does in other sources.[94]

The winnower must toss the threshed grain into a steady wind, producing separate piles of kernels and chaff. At this season it can only be the west (or northwest) wind. The farmer's almanac tells him to rely on Zephyr or Favonius, and to situate his threshing floor accordingly. A literary epigram professedly records a temple built for Zephyr after a prolific winnowing.[95] Somewhere round Skiron, beside the shrine of

the several Skira deities, Demeter and Athena and Poseidon, Pausanias saw an altar of Zephyr (1.37.2).[96]

The west wind supplies the festival nomenclature. From its role in the winnowing it is called Argestes or, a name peculiar to Athens and Attika, Skiron. Argestes is an agent noun meaning "Whitener," from *argos* or rather from the kindred form **arges* (cf. *enargês*). The name was later understood as "brightening" or "freshening," but the original sense was more practical: it is the effect of the wind at the winnowing. "White" is the formular epithet for both barley grains and barley meal, *kri leukon, alphita leuka*; the barley is "white" as it is trodden out on the threshing floor (*Iliad* 20.496).[97] At Athens, the same wind was called Skiron, as on the Tower of the Winds. The meaning is seen in a Germanic word for "white" or "bright" (Gothic *skeirs*, English *sheer*).[98] Again, it is "Whitener," another agent noun like Argestes.[99] The threshed grain is *skira*, "white (objects)." The tract of ground set aside for a ceremonial threshing is Skiron, "White (place)." Such auspicious names have a cumulative power to produce the desired result.

The time when the west wind blows is signaled by the morning rising of the Hyades, around June 5.[100] The Hyades like the neighboring Pleiades and Orion were observed by the Greeks from of old (Homer, *Iliad* 18.486 = Hesiod, *Works and Days* 615), and called by the names of so many girls or nymphs ([Hesiod], *Astronomy* fr. 291, etc.). In one story, they are mourning their brother Hyas; in another, they are the nurses of Dionysos. The Athenian story was different again: they are the daughters of King Erechtheus.

The story appears in Euripides' *Erechtheus*, near the end of Athena's speech from the machine (fr. 65 lines 107–8). As long as Euripides' mention was known only from a scholiast on Aratos, it was natural to suppose that Euripides invented the story. Now that the papyrus speech has come to light, we can see that the catasterism is referred to only in passing, as a traditional element which Euripides did not use but could not quite omit. There were other versions before and after Euripides. For the Hyades as a constellation have just one bright star in their midst, Aldebaran, so that the total number reckoned by observers varied from two to seven. The number of Erechtheus' daughters varied, so far as the record shows, from three to six (Euripides made three). We may suppose that as a rule the daughter who offered herself as a sacrifice was Aldebaran, and those who killed themselves in sympathy were the obscurer stars.[101] Over long ages, Athenian farmers looked to the sky in June and counted, or miscounted, the daughters of their threshing hero.

Erechtheus himself, in name and story, typifies the threshing. The name is the agent noun of the verb *erechthô*, a frequentative form of

ereikô.[102] The latter can mean to "split" or "rend" or "smash" various materials; but to judge from the many derivative terms for food products, its original sphere is "cracking" or "bruising" or "grinding" vegetables, especially legumes.[103] If *ereikô* means "crack," etc., with a single blow or effort, *erechthô* will mean "flail," "thresh," as with repeated blows. And so it does, though surviving only in poetry, and in a figurative sense, being used of a ship "flailed by the winds" (*Iliad* 23.317), and of Odysseus "flailing his heart with tears and groans and sorrows" (*Odyssey* 5.83, 157).

Erechtheus then means "Thresher." The meaning was lost sight of at a very early date, long before the festival Skira declined in esteem. The reason for this is a technical change. When history begins, the Greeks are found using oxen or mules or horses to tread out the grain. No earlier practice was remembered; for Kallimachos says that the treading of grain by oxen was taught to Triptolemos by Demeter (*Hymn to Demeter* 19–21). The presiding *genos* at the Skira are the Boutadai, "Oxherd family," named for the oxen. It was probably in the early Dark Age that Athenian ritual was entrusted to the various *genê* as groups of hereditary specialists; so the treading by oxen goes back at least so far.

Yet the old way is not in doubt. Erechtheus' name and story, and the range of the verbs *ereikô*, *erechthô*, show that the threshing was once done by hand, with sticks or the like. This is evident even from the regular word for "threshing," *aloaô*, which with its derivatives denotes the treading under hoof. But in poetry, and in the old term *patraloias* "father-beater," it means to "smite" with the hand or a hand-held object. We infer that to "thresh" was once to "smite." The prehistoric threshers who inspired the Erechtheus story were a file of men wielding sticks or some more special implement.

Erechtheus' stature did not diminish. He was always remembered as Athens' greatest king and champion, his preeminence reflecting that of the threshing festival. This hero is self-born from the fertile plowland, and adopted by Athena and established on the Acropolis. As king, he goes forth again to the plowland and does battle, a virtual threshing: everywhere in the ancient world, threshing gives rise to images and stories of violent conflict. His enemy is the wet weather that spoils the grain, personified by foes from the north and by Poseidon's anger. Erechtheus is victorious, and the crop is safe. But immediately afterward come rain and wet: Erechtheus is thunderbolted.

The story like the festival has been generally misunderstood. It is regarded as a legend, a traditional tale preserving a memory of the past—of a time when Athens and Eleusis were separate states and went to war, whether this was the Mycenaean period or the Dark Age or even Archaic times (the story also gives us invading Thracians, whom it is

harder to situate in Athens' past). Now it is true that Eleusis, as a large walled town close to Athens, could always pose a threat, as it did in 403–401. If it posed a threat at any earlier time, and the chances are high that it did, this would give added point to the story. But the question is rather how the story originated, and why it gained such currency. The answer cannot be in doubt. This is no legend, but a ritual myth.

The story does not give any picture at all of relations between Athens and Eleusis, as a legend surely would. The war itself has no motive, such as a quarrel between the kings. Athens' victory has no consequence: it does not entail the subjection of Eleusis, or even any change in its royal line, or in the conduct of the Mysteries, or in any other matter.[104] Instead, the story focuses entirely on Athens—on Erechtheus and Praxithea as representing Acropolis cults, and on events at Skiron as representing the Skira ritual.

Neighboring Eleusis is not the only enemy. Thrace, that great northern land, is sometimes the quarter from which invaders come; otherwise it is the quarter from which Eleusis gets effective aid. The emphasis is on the north, and also on the god Poseidon. Eumolpos as the enemy champion may be either an Eleusinian or a Thracian; he is always son of Poseidon, and the mother when named is Chione, "Snow." His allies Phorbas and Immarados are also sons of Poseidon, unless Immarados is a grandson, being son of Eumolpos. In Euripides, Poseidon very likely spoke the prologue, and certainly told of saving Eumolpos after his mother threw him into the sea; the infant was then carried to Aethiopia (that is, to another point on the stream of Ocean), and entrusted to Poseidon's daughter Benthesikyme, "Waves-on-the-deep-sea" (fr. 39). In all this, the enemy personifies the power of cold and wet.

Eumolpos, we should remember, has a more positive role to play at Demeter's autumn festival. As eponym of the *genos* Eumolpidai and archetypal hierophant, he is the "Sweet-singer" who chants a spell to make the grain grow. From a Mediterranean point of view, Thrace is the land of winter, the source of fertilizing rain and snow. At the sowing, the ritual personified by Eumolpos summons rain.[105] At the threshing, however, there is an equal effort to avert it; for rain will ruin the crop. Eumolpos and Thrace are the enemy.

Erechtheus kills the enemy chiefs singlehandedly—not only Eumolpos, but Phorbas and Immarados too. Yet immediately after, Poseidon destroys Erechtheus with a blow of the trident, and "hides" him inside the riven earth. Another version has Erechtheus struck by Zeus' lightning. In real life, Zeus brings rain, and Poseidon brings rushing waters out of the earth. In either case, the wet element now prevails, but only after Athens has gained the victory.[106]

This will suffice to place Erechtheus and the Skira in their agricultural context. It will also be clear that the threshing festival was once among the most important in the whole calendar of Athenian festivals.[107]

The Festival of Games (Panathenaia)

In mid-summer, a month and a half after the threshing festival, Athena was honored again with a festival of games, the Panathenaia. After 566, this was Athens' greatest festival. Every four years, it was celebrated on a Panhellenic scale, with a program of events and a schedule of prizes that drew competitors and spectators from far and wide. The very name Panathenaia seems to mark this development. Athenaia, "Rites of Athena," would be normal, and we are told that this was the earlier name, though the statement is not above suspicion.[108] Panathenaia presumably means "Rites of all Athenians," after the analogy of Pamboiotia and Panionia, but unlike those names can hardly go back to a time when people were newly united for the purpose of conducting the festival.[109] More likely, it was meant to sound imposing.

Before 566, the festival was very much smaller, but still of the same kind, with traditional games. In the later program, which is all we know, two events have the appearance of ancient custom, and must be earlier than the rest: the *pyrrhichê*, "red dance," in which naked dancers leapt and whirled with shield and spear, and the *apobatês*, "dismounter," which somehow comprised both a race of four-horse chariots and an interval of running on foot by the passengers, the "dismounters," who dismounted from, and then remounted, the moving chariots. Both events were distinctive of Athens and were restricted, even at the fourth-yearly celebration, to Athenian citizens.[110] The *apobatês* (and perhaps the *pyrrhichê* as well, but we are not informed) had a special time and setting: on the day of the grand parade, no doubt in the following afternoon, and along the parade route through the Agora.[111] Most of the fourth-yearly program took place on other days, at the stadium and the hippodrome, and at the theater and the Odeion.

Athens' festival of games is said to commemorate the war between the gods and the Giants, and especially Athena's part in it, her slaying of Enkelados or Aster or the Gorgon. Combat scenes were enwoven in the robe that was carried in the parade as an offering to Athena. More importantly, those traditional events were seen as evoking the war. We are told that the *pyrrhichê* was first danced by Athena herself, jubilant in victory (Dionysios of Halikarnassos, *Roman Antiquities* 7.72.7). The *apobatês* too was enacted by the gods, as we may deduce from a series of black-figure vases which follow a standard composition.

Amid the various figures of gods and Giants joined in single combat, a central group is constant: Zeus and Herakles together in a chariot.[112] Although the fighting is well advanced, and one of the Giants is already fallen, Zeus is just in the act of mounting the chariot—his right foot is still on the ground. He takes the reins, while Herakles, who must have relinquished them, stands at the front of the chariot, shooting with his bow. Zeus is a virtual *apobatês*. Other vases depicting the war show two ordinary figures in the chariot, a hoplite warrior (once it is Herakles) and a driver.[113] And apart from scenes of the war with the Giants, still other vases illustrate the *apobatês* in a more literal fashion: either Athena or an armed man runs beside a speeding chariot, and sometimes the turning-post is in sight (e.g. *G&P* fig. 6).[114]

This mythical aetiology is very old, much older than the bare assertion that the chariot was invented, and the *apobatês* was instituted, by the hero Erichthonios (*Marmor Parium*, *FGrHist* 239 A 10, etc.). It is true that the war between gods and Giants, as an episode of the Greek creation story, is largely due to Archaic poetry, being modeled on the war with the Titans, which was itself largely due to Hesiod. But the two wars, vying in excitement with those of the Heroic Age, are derived from much earlier stories about the weather god and monstrous foes in the form of snakes or Giants. These primordial struggles are in fact the commonest theme of ritual myth throughout the ancient Near East: the myths explain or embellish the festivals of the weather god at the main seasonal transitions of spring and autumn.[115] The snakes (e.g. Hedammu, Yam, Python), dwelling in the sea or at a spring, embody winter wet and cold. The Giants (e.g. Ullikummi, Mot, Typhon), looming up from the earth almost to the sky, embody summer heat and drought. Greek Giants are all at home in Phlegra, "Burning (land)."

The Panathenaia come round in the worst heat of summer. The Athenian year begins just after the solstice, and the end of the first month, the time of the Panathenaia, will fall in late July or early August. It is the season when the Dog-star rules the sky—"that mighty star which is recognized by all mankind" (Pliny, *Natural History* 18.269). In Greek, it is often referred to simply as "*the* star," *astêr* or *astron*. In one version, Aster, "Star" (i.e. the Dog-star), is the Giant whose slaying is commemorated by the Panathenaia. In another, it is Enkelados, "With-a-great-din," a name which describes the clamor of those warlike games, the *pyrrhichê* and the *apobatês*. The games are a form of weather magic, inspired by the belief that the spirits of bad weather, whether visible Dog-star or notional Giant, can be overcome by a display of intimidating violence.[116]

If we ask when the festival began, the only feasible answer is the Mycenaean period. Both the *pyrrhichê* and the *apobatês* are warlike: they

are derived from styles of warfare that were once in current use (it does not matter whether the games served only as spectacle or also as useful exercise). Of the *pyrrhichê* one can only say that the style antedates any kind of hoplite armor and tactics. The *apobatês* is more revealing. We are carried back to a time when pairs of warriors rode out to battle in chariots, and one of them, the better man, would dismount to fight. Such is the warfare that Homer describes, and not from recent experience, but as a main component of the epic tradition. It belongs to the Late Bronze Age, after which chariots played no further part in Greek warfare.

Another important element of the festival is the grand parade, representing the whole community, from a city gate to the Acropolis. The starting point was called Leokoreion, "Marshaling of the host," an old word that survived a radical change in the festival topography.[117] The Leokoreion which we know was at a city gate at the northwest, where the parade started throughout recorded times, and at least as early as 510, when Hipparchos was assassinated here. Yet this side of the city, the northwest sector, was only developed in the sixth century, and mostly in the second half, under the tyrants. Early Athens lay elsewhere, and until the sixth century the Panathenaic parade took quite a different route.

When the survivors of Mycenaean Athens finally moved away from the Acropolis and its environs, a new settlement was marked out at the southeast, between the Acropolis and the Ilissos. This area, together with the opposite bank of the Ilissos, called Agrai, "Fields," contains virtually all the ancient shrines in the lower city: it was a long time before the Dark Age community spread any further.[118] The original parade started from a point at the edge of this settlement. It can still be traced through the myth of Oreithyia, a basket-bearer in the parade.

Oreithyia's father is Erechtheus, hero of the threshing festival—appropriately so, since basket-bearers bring barley for the sacrificial rite. She was carried off from Athens to Thrace by Boreas, the north wind; several children came of this union, including Zetes and Kalaïs, lesser wind gods, and Chione, "Snow," who was loved by Poseidon. Boreas was shown with his prey, and also with snaky tails instead of feet, on the Chest of Kypselos, about the earliest known rendering of any Attic myth (Pausanias 5.19.1). We must consider where, and on what occasion, Boreas took her. Literary sources differ on both points, but the original story can still be recovered.

As to the place, it was undoubtedly the Ilissos bank, at the edge of the early settlement.[119] A shrine of Boreas was established here shortly after 480, when the north wind helped Athens by wrecking the Persian fleet (Herodotos 7.189.3). The story of the abduction now became more popular than ever; it was taken up in red-figure painting

and relief sculpture, in a hymn of Simonides and plays of Aeschylus and Sophokles. On the vases, which alone survive, an array of other figures are often present at the abduction: Athena, Kekrops, Erechtheus, Praxithea may look on, and the three girls Aglauros, Pandrosos, Herse may run away in alarm.[120] An altar and columns sometimes indicate a shrine. The scene has been generally taken as the Acropolis. This cannot be: the scene must agree with the usual form of the story. The pictorial shrine is that of Boreas beside the Ilissos; the pictorial figures are assembled for some business at the shrine.

As to the occasion, literary sources mostly say that Oreithyia was "playing" beside the Ilissos; in another setting, she is said to be "picking flowers"; once she is "twirling in the dance."[121] None of this can be accepted as the original story. The vase-paintings, which are earlier, show that Oreithyia and the others were engaged in a ceremony at a shrine. Now a scholion on Homer offers a general summary of the story, which may or may not come from Akusilaos, named as authority at the end, after the fashion of these scholia (*FGrHist* 2 F 30). Erechtheus, says the scholion, arrayed his beautiful daughter as a *kanêphoros*, "basket-bearer," so that she might parade to the Acropolis and sacrifice to Athena Polias. It does not follow, as usually thought, that Boreas snatched her on the Acropolis. On the contrary, we can be sure that the source of the scholion gave the usual setting, on the bank of the Ilissos. Moreover, the scholion says that in seizing Oreithyia Boreas "eluded those who were looking on and protecting her." It is a ceremonial gathering, as on the vases.

Our conclusion must be that in the original story Oreithyia was indeed a basket-bearer in the Panathenaic parade, and was abducted as the parade was being marshaled beside the Ilissos. Afterward, the parade route was changed. But a ceremony of some kind was still conducted at the original site, and it was later marked by the shrine of Boreas.[122]

The story gives us Boreas, the north wind, Oreithyia, "Storming-on-the-mountain," and equally transparent offspring, the wind gods and "Snow": it shows the same seasonal concern as the story of a fiery Giant overcome by Athena. As a basket-bearer, Oreithyia embodies the hope that nubile girls will draw the cooling wind from the north. In 480, when Boreas actually answered Athens' prayers, it was shortly after the Panathenaic festival; for the battle of Thermopylai took place about the time of the Karneia (Herodotos 7.206.1)—that is, in the middle of the following month.

Besides the altar of Boreas, the procession has left another landmark in the same area, the city gate named for Athena *itônia*. Athena's epithet *itônia* recurs in Boeotia and in Thessaly, which has also a festival Itonia

and the corresponding month-name Itonios. Although the experts have given up, such a word ought to be explicable, since it undoubtedly refers to some leading feature of Athena's ritual. Now the iterative verb *itaô* (so Hesychios), from *eimi*, "go," produces ceremonial terms like *eisitêtêria*, "rites of entering," and *exitêtêria*, "rites of leaving." We may safely postulate a noun **itôn* with the meaning "going always," "procession" (as to the form, cf. *klôn* < *klaô* or *chlidôn* < *chlidaô*). The *itônia* are "processional rites."[123] At Athens the goddess takes her name from the Panathenaic parade of early days.

On the night before the grand parade, other officiants went from the Acropolis to southeast Athens in a ceremony reported by Pausanias as belonging to the Panathenaic festival (1.27.3).[124] Two small girls called *arrhêphoroi* carried a secret burden in the basket for which they were named. It was not the rectangular basket called *kanoun*, but the circular one often called *kistê*. The name for the bearer, however, is not *kistophoros* (the term hardly occurs in any ritual context) but *arrhêphoros*, formed from the stem of *arrhichos*, another common word for basket. *Arrhêphoroi* appear in other cults besides Athena's, and Dionysios of Halikarnassos brackets *kanêphoroi* and *arrhêphoroi*, that is, bearers of both rectangular and circular baskets, as a general category of processional basket-bearers in the Greek world, corresponding to Roman girls and women with the conical headdress called *tutulus* (*Roman Antiquities* 2.22.2). At the Panathenaia, the *arrhêphoroi* performed their mission in the night, and the *kanêphoroi* paraded the next day.

In Pausanias' time, the mission of the *arrhêphoroi* was a curious relic, "not generally known"; indeed it had been a relic ever since the grand parade was transferred to the northwest. The very term *arrhêphoroi* puzzled the latest commentators on Attic literature, and according to their wont they compensated with fantastic explanations.[125] The *arrhêphoroi*, they said, "carried unspeakable objects," *arrhêta*, and "mysteries," *mystêria*. The objects or mysteries, they also said, were phallic shapes (what else would they be?), and the occasion was the same as the Skirophoria and the Thesmophoria, when women notoriously did something secret. And they said again that another name for the occasion was *Arrhêtophoria*, "Carrying of unspeakables," or else *Arrhêphoria*, to agree with the term *arrhêphoroi*, from which the discussion started. So at the last the basket-bearing becomes a festival in its own right, and being identified with the "Skirophoria" is said to fall in the month "Skirophorion"—the commentators have no inkling of the actual dates of either Skirophoria or Thesmophoria.

This preposterous yarning has been adopted in modern chapters and articles on the "festival" Arrhephoria. Indeed it has been improved. We

are told to imagine the girls as descending through the secret cleft in the Acropolis rock that once led to the Mycenaean well, and then as proceeding along the north slope to the nearby shrine of Aphrodite and Eros. And so they come to a thrilling confrontation with the mystery of sex—they are close to puberty, and must undergo an "initiation rite."[126]

Rejecting all such theosophy, ancient and modern, we ask what the two girls truly did. Pausanias says that in southeast Athens they descended into a natural underground passage within a separate precinct, "not far from Aphrodite-in-the-Gardens," a famous shrine at the edge of the city which was mentioned in Pausanias' tour of the area (1.19.2). Here, in the underground passage, they left what they had carried from the Acropolis, and received "something else which was wrapped up," and carried it back to the Acropolis. Pausanias also says that the girls did not know what it was they carried from the Acropolis, nor did the priestess of Athena, who gave it to them. This too must have been wrapped up, and on the Acropolis as in the underground passage some other hand was engaged in the wrapping.

Elsewhere, girls who enter an underground passage do so in order to feed a sacred snake—or rather to offer the honey-cakes which were supposedly relished by snakes, but would in fact do better for mice, as they in turn for snakes. If the cakes were wrapped up, they would last longer and draw more mice: an excellent offering for the snake. A sacred snake also dwelt on the Acropolis in the Ionic temple, probably in the so-called Kekropion; so the burden which the girls carried back may have been a reciprocal offering.

This understanding of the ritual is strongly supported by the story of Erichthonios and the three daughters of Kekrops. Erichthonios as the founding hero of the Panathenaia is the subject of an aetiological myth which was much elaborated over the years, but which starts from the mission of the *arrhêphoroi*. In outline, the story says that a basket containing a marvelous child, Erichthonios, was given by Athena into the care of the three girls. The child was produced by a bizarre encounter between Athena and Hephaistos: this we shall leave aside for the moment. The girls were told to guard the basket without looking into it. Two of them disobeyed, and went mad, and perished. Erichthonios grew up to invent the chariot and everything else that goes with the Panathenaia.

Let us see how the story matches the mission of the *arrhêphoroi*. The basket containing Erichthonios is a large circular one, as we see from red-figure vases, which depict the basket as it is opened, or just before. It is given to the girls by Athena, just as the ceremonial basket is given to the *arrhêphoroi* by the priestess of Athena. The basket with Erichthonios is

sometimes shown resting on rocky ground, which might be the precinct in southeast Athens.[127] The narrative and the ritual go in step as nearly as they can. The girls are warned not to open the basket and peer inside; the *arrhêphoroi* are unaware of what they carry in the basket, since it is wrapped up. The girls pry, and disaster follows; the *arrhêphoroi* conduct the rite with anxious punctilio, for if the sacred snake does not appear, this portends disaster.[128]

The principals of the story are snakes. The girls' father is a snake, and their task is to tend another one. Kekrops, whose name is a differentiated form of *kerkops*, "tail-face," is often shown or described as half a snake, and is earth-born and the common ancestor of all Athenians: that is, he personifies the sacred snake on the Acropolis. When the basket is opened, a snake darts out, or snakes are seen coiling round the infant, or the infant is said to be half a snake or a snake entire: that is, he personifies the sacred snake in southeast Athens. The name Erichthonios, "He-of-the-very-earth" (*eri-*, *chthôn*), suits a snake no less than the name Kekrops; for snakes come out of the earth, or are sought in underground passages. Thus the story like the ritual forges a link between the father snake on the Acropolis, Kekrops, and the infant snake in southeast Athens, Erichthonios. Both Kekrops and Erichthonios can be regarded as autochthonous ancestors of the Athenians. But it is for Erichthonios to found the Panathenaic festival, the magic ritual which binds the Acropolis to the new community in southeast Athens.

Thus far the mission of the *arrhêphoroi* and its aetiology. There is more to the story of Erichthonios. It testifies to the great change in the route of the Panathenaic procession, from the southeast sector to the northwest. Before taking up the details, let us pause over Erichthonios' name and person and the notion of earth-born ancestors.

In ancient sources Erichthonios is occasionally confused with Erechtheus, and in modern books the confusion is sanctified as doctrine.[129] Erechtheus too is an earth-born ancestor, but of a different kind. As we saw, "Thresher" sprang up from the plowland, and was established by Athena in his own shrine on the Acropolis, and returned to the plowland to do battle against the enemies of the threshing. He personifies the agriculture of the Kephisos valley, the source of Athens' wealth and fame in early days. He is a much more distinctive figure than Kekrops or Erichthonios. Indeed, as a full-bodied hero of both myth and cult, he is nearly unique, a tribute to the imaginative power of Athenian religion. He does not deserve to be confused with Erichthonios.

The earth-born ancestor is a self-evident beginning.[130] Since Erichthonios' name and person are so obvious, and are so neatly accounted for at Athens by the story of a snaky infant in a basket, the wild details

which we come to now are all the more surprising. The god Hephaistos, always a burlesque figure, chased Athena with dishonorable intent, and when they struggled, he ejaculated onto the ground: whence the earth-born Erichthonios. The transparent name is forced into agreement. The first element is absurdly said to be either *eris*, "strife," because there was a struggle, or *erion*, "wool," because Athena's leg was soiled and she wiped it with a piece of wool. It is also significant that the details about Kekrops' daughters, about who pried and who survived, are variously given. In short, the story of Erichthonios has been turned to a different purpose. It is still an aetiology of the Panathenaic festival, but of the festival as it was after that radical change in the topography.

In the festival we know, all the great ceremony takes place in the northwest sector of the city. The grand parade starts from a gate on this side, and goes across the new Agora up to a ramp on the west side of the Acropolis. On the evening before the parade, a torch race is run from the grove of the Academy north of Athens over the road to the gate and then along the same route to the Acropolis. Some of the facilities can be assigned with confidence either to the years around 566 when the Panhellenic games were first organized, or to the ensuing period of the tyrant family who made Athens so powerful and prosperous.[131] It was under the tyranny that the northwest sector was rapidly improved, with the excavated Agora as the new seat of government. This is the newest part of Athens, much newer than the southeast sector, and newer too than the area east of the Acropolis, which has an older agora and the older quarters of the board of archons.

One would like to know when the ceremony was first shifted to the northwest sector. The ceremony here includes two striking innovations: the torch race, and also the carrying of the peplos, a fine robe inwoven with scenes of gods fighting Giants, which was presented to Athena on the Acropolis. The peplos and its problems must be passed over as admitting no firm conclusions for our purpose, save that the custom cannot well be earlier than the sixth century, since the very first peplos is credited to two historical weavers (Zenobios 1.56, etc.). The torch race is more illuminating.

A ritual fire-bringing of some kind can be postulated for the northwest sector long before the Panathenaic torch race. In those days, the area round the later Agora and further out was occupied exclusively by potters and smiths, as we see from the huddled remains of their houses and shops and from the name Kerameikos. Such people use fire (it is the main reason why they are always placed apart),[132] and since fire is staled by use, it must be ceremonially renewed. In the fifth century, the Athenian festivals in which torch races were run include

the Promethia and the Hephaistia, festivals for potters and smiths. But
the earlier industrial fire-bringing was not a torch race, for it is reflected
in Hesiod's story of how Prometheus stole fire, in which we find nothing
that resembles a torch or a race. Torch races are not indigenous to Greece.
They come from the northeast Aegean—as does also the equestrian torch
race of Bendis—being associated with the cult of the non-Greek god
Hephaistos (Herodotos 8.98.2).

Hephaistos arrived in Athens together with the torch race. At the
Academy, where the torches were lit and the race started, an Archaic
relief showed Prometheus and Hephaistos as the elder and younger
deities of fire (Apollodoros, *FGrHist* 244 F 147). The Academy, we may
infer, had always been the starting point for the industrial fire-bringing.
Fire is produced from wood, and this pleasant grove was a fine source
of fresh fire.

The question of when the Panathenaic ceremony was shifted to this
part of the city is therefore the question of when Hephaistos and the torch
race were brought here from their homeland in the northeast Aegean.
Around 600, Athens gained control of Sigeion after hard fighting. Later
it was lost again, and recovered under Peisistratos, in the period ca. 540–
535. The second juncture is too late; it must have been around 600 that
Athens adopted Hephaistos. The intention was to honor the chief deity
of this new territory. Though Lemnos happens to be famous as Hephais-
tos' home, the Troad shared the native culture of the offshore islands.
In Homer, Hephaistos intervenes in favor of his Trojan priest Dares (a
native name), whose two sons fell foul of Diomedes (*Iliad* 5.9–24).

Athens was almost certainly the first city in the Greek homeland
to honor Hephaistos; traces of his cult are very few anywhere in the
peninsula. He is found mainly on the eastern Aegean islands, from
Lesbos to Rhodes, and also on Euboea, as indicated by personal names
formed from his.[133] And he is duly celebrated in early Aeolian and
Ionian poetry—if celebration is the word for his comic misadventures.
Accordingly, when he arrived in Athens, another characteristic story
was invented. We may suppose that even in 600 the earth-born baby in
the basket had long been familiar; for the mission of the *arrhêphoroi* was
an important matter in early days. It was a sudden happy thought to
say that the baby was produced when the ever-rejected lover turned his
attention to the ever-unyielding virgin.

The encounter took place at the Academy, the starting point for
the torch race.[134] So the infant now personifies the fresh fire that is
carried by the runners. The two ends of the track, at the Academy and
the Acropolis, are marked by altars of Eros and Anteros respectively,
"Desire" and "Opposite-desire." Eros sometimes attends the birth of

Erichthonios in vase-painting. In one jubilee scene, where the basket is saluted by snaky Kekrops and a whole assembly of gods, Hephaistos reclines on a couch, looking much handsomer than usual, and accepting a bowl of wine from Eros.[135]

By making Hephaistos father of Erichthonios, the story signals the great change in Panathenaic ceremony. Before this, both the grand parade and the business of the previous night belonged to the southeast; now they belong to the northwest. Before this, Erichthonios evoked the girls and the snake at the southeast; now he evokes the torch race at the northwest. Such a purposeful revision is probably due to a poet performing at the festival. Later, the story was taken up in the epic *Danais*, and was depicted on the base of the Amyklaion throne. It must have first gained currency through some Athenian hymn or epic.[136]

Thus the history of the Panathenaia mirrors the development of the city. It also complements the history of the Skira, for the festival of games grew in popularity as the threshing festival declined.

Notes

1. The only other deity worshipped from of old on the Acropolis was Zeus, at the highest point of the rock. His two festivals, Pandia and Dipolieia, were of less renown, and the respective shrines were modest.

2. *IG* I³ 474 lines 77–79, 202–8; 476 lines 218–20.

3. Eustathios on *Odyssey* 8.362 correctly explains *thyoskoos* as *hieroskopos*, while distinguishing *thyêchoos* as a priest who sacrificed on behalf of others—a bogus definition which does not obscure the essential point: that *thyoskoos* and *thyêchoos* had previously been associated by some ancient commentator. Dionysios of Halikarnassos derives "Tuscan" from *thyoskoos* (*Roman Antiquities* 1.30.3), obviously with an eye on the *haruspices*, a virtual synonym. On the derivation and meaning of *thyoskoos*, see Casabona, 1966,118–19, who does not, however, mention *thyêchoos*. Euripides, as Casabona remarks, gives a quite fanciful turn to the familiar word *thyoskoos* (*Bacchae* 224); so we should not be surprised by the distorted form *thyêchoos*. Linear B has produced *e-pi-ko-wo*—i.e. *epikooi*, "watchers" (PY An 657, KN As 4493?)—the former is the famous tablet about watchers on the coast).

4. Iakovides, 1962, 128–31; Bundgaard, 1976, 32–35, with pl. E; Jeppesen, 1987, 13, 90–94.

5. Iakovides, 1962, 99–101,124–26; Bundgaard, 1976, 25–26, with pl. K.

6. Camp, 1984, 37–41, argues that this was done at the very end of the Mycenaean period, after the hidden well was given up. But evidence is lacking, for the Mycenaean outworks traced by Iakovides do not extend to Klepsydra.

7. Green, 1962.

8. At *IG* I³ 4 A 16 Jameson prints the text as *en te[i to neo perib]olei*. Other restorations, he says, do not fit the space.

9. Ziehen, 1906, 5, who is fullest on this question, says that an earlier shrine of Erechtheus and Athena could only be referred to as *"the* temple" if the inscription were posted at this very shrine, but that in fact it must have been posted elsewhere, most likely at the Acropolis entrance.

10. So Jameson on *IG* I³ 4 B 6, after Ziehen and Sokolowski. Németh, 1994, 216–17, upholds the reading *pyr* in A 10 as well, but the context is beyond recovery.

11. *no]tothen / ek]tothen / ka]tothen t[o n]eo entos to K[ekropio.* "Kekropion" is generally accepted, as by Jameson.

12. The preposition "in" is restored: *[ta en toi hekat]ompedoi.* Dinsmoor proposed *[para—]* or *[pros—]* to suit his theory of the *hekatompedon* as Ur-Parthenon; but *ta* cannot be omitted

13. Heberdey, 1919, 10–45, nos. I–IV.

14. Boersma, 1970, 239, gives a survey of opinion on both points, with cross-references to his catalogue, which includes the notional buildings. See Floren, 1987, 242–43, for recent work. It has been suggested lately that Herakles entering Olympos is part of a pediment of the great Doric temple, but this is meeting some resistance.

15. *IG* I³ 4B 17–18, "the *oikemata* in the *hekatompedon,*" discussed above; B 2, *sesem]asmenois oikemasi,* "sealed chambers" (there is little attraction in the alternative proposals of Ziehen, 1906, 3, *esteg]asmenois* and *kateskeu]asmenois*).

16. The difficulty caused Boardman, 1978, 153–54, to adopt an unusual view—that these buildings belonged to Peisistratos and his family, perhaps as dwellings rather than shrines, and were ruthlessly destroyed after the overthrow of the tyranny.

17. Kiilerich, 1989, re-studies the fragments and arrives at an interpretation combining myth and ritual: the three daughters of Kekrops are shown outside a mythical temple of Athena, but with reference to the actual service of the *arrhêphoroi.*

18. Heberdey, 1919, 27–28, suggests a view from either the south or the north. If it were from the north, as he thinks more likely, the building would be a predecessor of the cella of Pandrosos. Kiilerich, 1989, 18–21, posits such a predecessor as the building to which the pediment belonged.

19. Stevens, 1940, 42 ("digging and removal of blocks might settle this point").

20. Iakovides, 1962, 87–93.

21. Exponents of this view put great stock in the two marble thrones belonging to the priests of Boutes and Hephaistos respectively, which were found, the former as early as the eighteenth century, near the Ionic temple. Likewise Jeppesen, 1987, 23, 92–93, 97, arguing for another site nearby (see below n. 24). But these useful objects were surely returned to use in Turkish times, when the Ionic temple was a residence; they may have been carried here from any part of the Acropolis.

22. The first dissenting voice was Jeppesen's, 1987 (including articles of 1979 and 1983); cf. Robertson, 1983, 252–53; *idem,* 1985, 255–56.

23. Another kind of evidence is the construction records of the Ionic temple (*IG* I³ 474–79). Until lately, a term *prostomiaion* doubtfully listed among the contents was held to refer to the well containing sea-water which Pausanias saw in Erechtheus' shrine. Jeppesen, 1987, 10–11, 99–107, has shown that the correct reading is *prostoion*, probably the west corridor. Now there is nothing that can be associated with the shrine of Erechtheus.

24. Jeppesen, 1987, 12–24, 90–98.

25. Jeppesen, 1987, 18–23, holds that the contents of the square building and of the court adjoining it on the west have been misleadingly combined by Pausanias: a very strained argument.

26. For Pausanias' route in the Agora, see Thompson and Wycherley, 1972, 206, fig. 52 (but several items on the north side are now better known). For his route on the Acropolis, Stevens, 1940, 2, fig. 1.

27. For this view, see Harrison, 1977, 139 n. 14. If the temple of Eukleia is the temple on top of Kolonos, then the temple of Hephaistos will be another building nearby, perhaps the so called Arsenal: Harrison, 1977, 422–24. This is fully comparable to the conventional view which juxtaposes the shrine of Erechtheus and the temple of Athena.

28. Athena is worshipped throughout the city and the demes, says Pausanias, but the holiest object of all is an image of the goddess "on what is now called the Acropolis, but was once called the *polis*." This is a ceremonial beginning for the second Acropolis promenade. He makes a similar beginning when he leaves the Agora in the northwest sector ("the Kerameikos") and flies away to the old city center east of the Acropolis ("the agora" proper). Athens, he says, has "in its agora" many curious sights, above all the Altar of Pity (17.1).

29. In Stevens' plan (see above n. 26), Pausanias goes due east as far as the statue of Dionysos on the south wall—and then veers off on a long, unbroken circuit to the north and west, to the traditional "Erechtheion."

30. Bulls and rams for Erechtheus (*Iliad* 2.550); an "ox sacrifice" at the festival (Euripides, *Erechtheus* fr. 65 line 94); "a ram for Erechtheus" (*IG* II² 1357); "an [ox] or bull and a [ram?]" (*IG* II² 1146).

31. Stevens, 1946, 21–25.

32. East of the precinct of Zeus Polieus are some rock cuttings where Stevens, 1946, 13–15, restored a small cella facing north. The supposed cella supersedes, at least for the time after the construction of the Parthenon, the supposed cattle barn which Stevens, 1940, 83–86, restored in the same area. If the cella is more nearly right, it could be the shrine of Pandion.

33. Robertson, 1991b, 5.

34. So Lewis 1955, 22–23, after compiling a list of eighteen inscriptions set up in the shrine. Kron, 1976, 110, wrongly says that Stevens' identification is confirmed by the inscriptions.

35. No other writer but Pausanias describes the "sea-water" in any fashion, though Apollodoros too places it within the shrine of Erechtheus (*Library* 3.178, interpreted below). It can hardly be the same as the trident marks produced by the blasting of Erechtheus. This event, or the earthquake which followed, was

related at length by Euripides (*Erechtheus* fr. 65 lines 45–60), but is not linked with the siting of the shrine (lines 90–94). In the past, the eye of faith has seen the sea-water or the marks here or there in the traditional "Erechtheion"—in the cracks in the rock at the southeast corner of the north porch (but the altar of the *thyêchoos* stood above them); in even slighter marks at an adjacent point inside the west chamber; in the medieval cistern cut into the floor of the west corridor; in a hypothetical well in the east chamber. Jeppesen, 1987, 13–18, 90–98, having discounted the traditional "Erechtheion," points to the great cleft, with cuttings for stairs, leading to a hidden well far below—which might be the trident marks, but certainly not the well seen by Pausanias; cf. Robertson, 1983, 253 n. 40.

36. Bundgaard, 1976, 110–11, calculates the dimensions of the well as 2 m. wide and at least 3 m. deep, on the ground that the sound of waves caused by the south wind "can only arise within a deep tube." But the sound of waves is a professed miracle; the reality must have been somewhat different, perhaps a weather omen at the time of the Skira. In any case, the actual well which Bundgaard postulates has never been detected in the traditional "Erechtheion."

37. Iakovides, 1962, 150–56, gives a full description. The later Mycenaean period is represented by two small buildings—one beside the north wall of the loop, the other beside the south wall—and by four graves, three of them for children. Remains of the historical period were mostly swept away in the construction of the circuit wall and the two-chambered building. The one substantial wall fragment is isolated and undatable: Iakovides, 1962, 152, fig. 31, no. 7.

38. Note in passing that fragments of inscriptions pertaining to Erechtheus or the *phylê* Erechtheis give no real help, for they were found in various spots, including the neighborhood of the Ionic temple, where there was always much activity. For some, the provenance recorded in *IG* is only *in arce*; one might learn a little more by scanning the first publications, as Lewis did for decrees of Pandionis (see above n. 34). Cf. Kron, 1976, 48, 52 n. 215; Jeppesen, 1987, 32.

39. See Robertson, 1986, 157–68; *idem*, 1992, 32–37, 43–57.

40. The southeast corner was leveled, and any earlier shrine was removed, when the fifth-century circuit wall was built. Presumably the excavated shrine is not much later. There is no reason to suppose that the construction was contemporary with the play (for the date of *Erechtheus*, see below n. 63).

41. For Meiggs and Lewis, 1969, 29, this is the agreed interpretation. Bundgaard, 1976, 118, prefers the west chamber of the predecessor of the Ionic temple; Jeppesen, 1987, 38–39, the west chamber of the Parthenon.

42. Bundgaard and Jeppesen (see above n. 41) point to other walls—the west wall of the precinct of Pandrosos, or the Mycenaean fortress wall where it bends round the southwest corner of the Parthenon. Yet these are both shortish stretches of wall, and there must have been a great many fetters.

43. The precinct is about 26 m. east–west by 17 m. north–south. The western side was shortened slightly, spoiling the rectangle, when the Parthenon was built: Stevens, 1946, 3, fig. 3, 12–13.

44. From a later time, Cook, 1940, 759, figs. 547–48, illustrates two Athenian bronze coins, respectively showing an altar beside an olive tree and an altar with

bucrania between two olive trees, and identifies the scene as the sacred olive and the altar of Zeus *herkeios*. But since the coin with two olives cannot be so interpreted, neither can the other.

45. *ARV²* 1346, 1 = *LIMC* I (1981) s.v. Aglauros, Herse, Pandrosos no. 8. Jeppesen, 1987, 46–52, 59–62, 76–80, figs. 15–16, studies details of the vase with somewhat fanciful conclusions. We shall come back to the figure of Hephaistos on the vase (see below n. 135).

46. So, e.g., Austin, 1970, 58; Kron, 1976, 40 n. 142. Jeppesen, 1987, 44, now conjectures *neios*, "fallow land," with such further changes as the feminine gender requires.

47. Bundgaard, 1976, 85–102 with pl. L, envisages an enormous spreading tree—several stems shooting up in different parts of the Ionic temple of Athena through apertures cut in the marble from a tangle of roots beneath the floor, with the furthest branches extending over the altar of Zeus in the precinct of Pandrosos. This arrangement, could we believe it, might possibly serve to reconcile Herodotos, Philochoros, and Pausanias in terms of the traditional "Erechtheion." But it still does not respect Apollodoros, who says that the tree originally planted by Athena was in the precinct.

48. The statues also have a magic shape: they are kneeling, the posture of childbirth. The grain goddesses will bear crops as women bear children.

49. Pausanias in his disquisition on the Charites says that Thallo, "Sprouter," as one of two Athenian Horai is worshipped together with Pandrosos (9.35.2). This odd combination was perhaps suggested to the mind of Pausanias' learned source by the olive tree; if so, it is the exception that proves the rule.

50. Stevens, 1946, 24–25; Iakovides, 1962, 150–51.

51. Aristophanes referred to an Acropolis olive tree as *pankyphos*, "all bent over"; it was very low on the ground (fr. 747 *PCG*).

52. Rosivach, 1991, holds that the provisions for sacrificing many cows are entirely new, and that the only victims hitherto were those offered to Athena Hygieia or within the old temple. The matter can hardly be so simple. There must always have been a general sacrifice "at the great altar," the destination of the many cows apart from Athena Nike's.

53. Mark, 1993, 15–19, 31–32, 56–57, 69–71, 128, reconstructs the history of the bastion so far as excavation records allow. Like many others before him, Mark, 125–28, holds that the cult was first instituted, or else very much enlarged, toward the mid-sixth century.

54. Heliodoros, *FGrHist* 373 F 2; Pausanias 3.15.7, 5.26.6; Nikarchos, *Greek Anthology* 9.576. The relief, which shows the statue standing inside the Nike temple, is studied by Beschi, 1969, 531–36. Mark, 1993, 24–28, 93–98, 123–25, holds a different view: "a seated work of marble, under lifesize, dating from *ca.* 580–560 B.C." Now Heliodoros and Pausanias both speak of a *xoanon*, "wooden image"; Pausanias says that it was the reputed model for Kalamis' statue of Nike at Olympia, undoubtedly a standing figure; Pausanias also says that in Athenian belief the image was sure to stay put because, unlike other Nike statues, it had

no wings, which again implies a standing figure. Yet Heliodoros, according to Mark, did not really mean a wooden image, and Pausanias (whose notion of a *xoanon* is not in doubt) had all his information at second hand, probably from Heliodoros, so that it can be discounted. Pausanias has not been so badly bullied since the lawless nineteenth century. As for the relief, Mark does not mention it.

55. Alkaios' shield was hung up as spoil in the Glaukopion at Sigeion (fr. 428 E. Lobel and D. Page, *Poetarum Lesbiorum Fragmenta* [Oxford 1955]). The scholiast on Euripides, *Hippolytos* 29–33, cites Kallimachos' *Hekale* as showing that the name designates the southwest corner of the Acropolis. The passage has come to light in a papyrus fragment in which Theseus calls on Athena at the Glaukopion for help against the Marathonian bull (*Hekale*, ed. Hollis, fr. 17 lines 10–11). The appeal is somewhat ironic, for Theseus' father Aigeus, who is now asked to sanction the adventure, will hereafter throw himself to his death from the bastion, as the *aition* of another cult on the rock terrace below. Herse too leaps from the Glaukopion (Euphorion fr. 9 Powell).

56. Proclus on Plato, *Timaios* 53 D (ed. Diehl, p. 173). Cf. Treu, 1971, 121.

57. The verb is *prothyein*, "sacrifice before (an undertaking)"—i.e. for the success of the undertaking; cf. Casabona, 1966, 104–6. Athena Nike did not acquire a priestess of her own until the mid-fifth century.

58. The usual round of festivals attended by the ephebes runs from Boedromion through Skirophorion. This occasion has been identified as either the Panathenaia, or a festival Niketeria (i.e. Proclus' term understood as a name), or a contemporary victory by the Romans, all unsatisfactory; see Pélékidis, 1962, 253–54.

59. *Erechtheus* fr. 50 line 51, fr. 65 lines 6, 18, 89; *Phoenician Women* 855, 858. Whenever the story is briefly told, Erechtheus is promised "victory" by an oracle: Lykougos, *Leokrates* 98; Demaratos, *FGrHist* 42 F 4; Plutarch, *Greek and Roman Parallels* 310 D; Apollodoros, *Library* 3.203.

60. *Phoenician Women* 856–58; *IG* I³ 351–59.

61. For the military practice, see Jameson, 1991. Commentators on *Erechtheus* seem to think that Euripides reports or invents a custom of performing the battlefield sacrifice, whenever it is needed, here in the *abaton*: e.g. Austin, 1970, 57; Treu, 1971, 123. That would be very odd.

62. See Carpenter, 1929, plan I, for the placement of trophies and oxen in his standard reconstruction. Trophies: east face (above the stairs) Museum no. 4; north face no. 10; west face no. 24; south face nos. 17–18. Oxen: north face no. 11; west face no. 27; south face no. 3. Jameson, 1994, interprets the ox-slaying scenes as the common military practice, which he has expounded elsewhere (see above n. 61). But the battlefield victims were as a rule sheep or goats, not oxen. It is only in the ritual of the Skira that oxen are slain as if before a battle. Some have discerned an altar edge beside one or other of the Nikai: see Carpenter, 1929, 25 (north face no. 15), 49 (west face no. 9). Both instances are very dubious, but if either should be right, it will follow that the ox sacrifice at the Acropolis shrine was also depicted.

63. For the frieze, most authorities prefer the latest possible date in the course of the Peloponnesian War, after 420 and toward 410. *Erechtheus* is conventionally dated to ca. 421 because Plutarch quotes a line to illustrate the relief which Athens felt at the Peace of Nikias (*Nikias* 9.7); the date then jibes with the construction of the Ionic temple *qua* "Erechtheion." But this is merely wishful, for it is obvious that Plutarch's use of the line derives not from any contemporary source, but from some fanciful interpreter of Euripides (we know from Stobaios 4.14.4 that the passage was famous in its own right). Aristophanes parodies *Erechtheus* in two plays of 411 (*Lysistrata* 1135; *Thesmophoriazousai* 120), and we can hardly suppose that he had waited a decade. The much resolved iambics, as we see them in the papyrus fragments, point to a similar date.

64. Judeich, 1931, 269–70; Stevens, 1940, 86. Bundgaard, 1976, 81–82, with pl. A, returns to the older view that the altar belongs at the highest point on the rock, near the northeast corner of the Parthenon; but the traces here are better taken as the precinct of Zeus Polieus.

65. Kroll, 1982, 70–72, with pl. 11, adds the coins to other evidence for the statue.

66. Kroll, 1982, 72–76, holds that the Archaic statue was a reworking of "the olive-wood core" by Endoios, who added a face or "fine mask," extended arms, and other features. Such a procedure is impossible to credit, and in any case irreconcilable with the notoriety of the crude wooden image. Nor is there any warrant for the ascription to Endoios.

67. Kroll, 1982, 73, will not believe that the Ionic temple "housed two images of the goddess," partly on the ground that Pausanias would have mentioned both (his other argument, that all ancient sources refer to the same statue, is circular). This is quite misguided. Pausanias is everywhere selective, and we can point to very similar omissions. The wooden image of Athena Nike is not mentioned in his notice of the temple (1.22.4), though he refers to it elsewhere. At Argos, in the temple of Athena on the citadel Larisa, he mentions only a strange wooden image of Zeus, also referred to elsewhere (2.24.3–4, 25.10, 8.46.2). Yet there must have been a statue of Athena as well, almost certainly the statue that figures in the bathing ritual of Kallimachos' *Hymn.* If, however, this statue stood in the temple of "Sharp-eyed" Athena on the adjacent ridge, it is not mentioned there either (24.2).

68. So Boardman, 1978, 154–55.

69. For the path and the wall, see Iakovides, 1962, 66–68, 71–78, 93–99.

70. When a statue turns from west to east to signify that Vespasian will defeat his rivals, the statue, of the Deified Julius, stands in the open air on a column on the Tiber island; our sources remark that it was a clear, calm day (Suetonius, *Vespasian* 5.7; Tacitus, *Histories* 1.86; Plutarch, *Otho* 4.8). Conversely, when a statue of Mars inside a temple gives an omen, it stands upon its head (Julius Obsequens, *Prodigies* 42). Or again, within the temple of Athena at Elis, a statue of Nike facing the statue of Athena turns about to face the door (Caesar, *Civil War* 3.105.3).

71. Jahn and Michaelis, 1901, pl. 38.4, show the cuttings in a drawing.

72. *LIMC* II (1984) s.v. Athena nos. 118–73 (P. Demargne).

73. But a red-figure amphora of ca. 480 depicts a more lifelike standing Athena with feet placed much as they are on the statue base: *ARV*2 249, 7 = *LIMC* II (1984) s.v. Athena no. 122.

74. The Praxiergidai "remove the *kosmos* and veil the image": Plutarch, *Alkibiades* 34.1; cf. Xenophon, *Hellenika* 1.4.12. "Two girls occupied with Athena's image" serve as *plyntrides*, "washers," and *loutrides*, "bathers": Aristophanes fr. 849 *PCG* (the lexica assert that both titles were given to the same two girls, a patent error, unless the same two performed both tasks successively). The Praxiergidai "dress the goddess in her robe": *IG* I^3 7 lines 10–11, cf. 23–24, doubtfully restored; also Hesychios s.v. Praxiergidai. Aglauros as priestess of Athena "was the first to adorn the gods": Photios s.v. *kallyntêria kai plyntêria; Lexeis rhêtorikai* p. 270 Bekker (the entry also says that robes were not washed for a year after Aglauros' death, whence the festival Plynteria). Another entry in the lexica, puzzling on any view, is *kataniptês*, "one who washes the soiled edge of Athena's robe." Perhaps the robe in question is the one offered at the Panathenaia, after it was displayed for a time and before it was laid away in the *peplothêkê.*

75. Hansen, 1990, xxvii–xxxi, gives up an earlier suggestion that the Plynteria should be dated to 29 Thargelion on the strength of a passage in the civic calendar of sacrifice which prescribes the offering of "a cloak of fresh [wool]" on this day.

76. It may have been to counter this objection that Deubner interpreted the Kallynteria quite perversely as a "sweeping" of the temple.

77. There is an older reconstruction of the festival that has been refuted more than once, but still rises up again from time to time out of sepulchral handbooks. It was supposed that Athena's image was taken from the Acropolis and conveyed in a chariot to the shore at Phaleron, in order to be bathed in the sea or perhaps with a basin of sea-water. The warrant was chiefly a passage of Philochoros and some ephebic inscriptions. But these sources refer to an entirely different ceremony. It was not the image on the Acropolis that was taken to the seashore, but the Palladion of southeast Athens. And it was not for the purpose of bathing the statue, but of staging in front of it a mock combat by Athens' cavalry on the sandy flats of the hippodrome. The Palladion enjoyed the spectacle, and was magically reinvigorated, just like Dionysos' statue in the theater. The two ceremonies, the escorting of "Pallas" and of Dionysos, go together in the ephebic inscriptions. See Robertson, 1992, 141–43; *idem,* 1996.

78. The first publication by Koenen, 1969, is somewhat improved by Luppe, 1983.

79. Dugas, 1924, 69–71.

80. Koenen, 1969, 12–14, with Reinach's drawings.

81. *tês pa[nnychidos tês têi Aleai | teloumenês epi]stasês,* Koenen; *tês pa[nny-chidos tês têi | Aleai para]stasês,* Luppe. Koenen, 1969, 14–18, after Fehrle, interprets the Plynteria at Athens and Tegea as a "sacred marriage" ceremony in which the priestess stands in for the goddess.

82. Seneca, *Hercules on Oeta* 366–68; Moses of Choren, *Progymnasmata* 3 ex. 3.

83. Cf. Philyllios, *Auge* fr. 3 *PCG*, about preparing for the revel.

84. *tês pa[trias heortês têi | Aleai para]stasês*, to fit the length of line established by Luppe, 1983.

85. Pfeiffer on Kallimachos, *Aitia* fr. 66 lines 7–8, is plainly misguided in identifying the famous springs as "wells" in or near the city.

86. When the horses reach the Inachos, they are covered with grime and sweat and foam, to judge from the mythical parallel (lines 5–12). Commentators on the *Hymn* seem unaware of the urgency of Athena's bath.

87. *Lexeis rhêtorikai* p. 231 Bekker; Hesychios s.v. *gerêrai*. Note that the Argive festival Endymatia, "Investiture," mentioned by Plutarch, *On Music* 9, 1134 C, is shown by the context to be an arming of ephebes. Servius on *Aeneid* 3.284 gives an *aition* of this ceremony, about a youth who put on the ancient arms of Abas and went forth to rout the enemy.

88. On Thorikos and Erchia, see Robertson, 1983, 281–83.

89. See Lambrinudakis and Wörrle, 1983, 354.

90. *IG* II2 1126 = *Corpus des inscriptions de Delphes* 1.10 lines 26–31. For the interpretation, see Roux, 1982.

91. Rougemont, 1973, 91–93.

92. Roux, 1982, 234, points to Athens' Praxiergidai decree, which cites a Delphic oracle (*IG* I^3 7); he suggests that the Athenian festival was modeled on the Delphian. This is unwarranted. It is common for Delphi to be consulted on any ritual matter, and at the same time for Delphi to name a string of gods as requiring sacrifice, as do on this occasion Apollo's partners the Moirai, Zeus Moiragetes, and Ge. The Delphic deities have no continuing role in the Plynteria.

93. Koenen, 1969, 14, 18, thinks of equating the Aleaia with the washing festival.

94. Athens' cult of Zeus *hypatos* was distinctive enough to be transplanted to Elea, which also has a cult of Zephyr, a kindred deity of the Skira. *Zêno[s] hypatou Ath(ênaiou)*: M. Guarducci, *Parola del Passato* 25 (1970) 254–56, no. 2. *Zephy[rou]*: E. Miranda, *Mélanges d'Archéologie et d'Histoire de l'École Française de Rome* 94 (1982) 172–74, no. 5.

95. Virgil, *Georgics* 3.134; Columella, *Agriculture* 2.19.2, 20.5; [Bakchylides], *Greek Anthology* 6.53.

96. The shrine is also known to Plutarch, *Symposiaka* 9.6.1, 741 A–B, where it appears as a temple, and probably to certain scholia and lexica (see below n. 99). Jacoby, n. 80 to Philochoros, *FGrHist* 328 F 14–16, would separate Pausanias' temple from the area of Skiron, for no good reason. Jeppesen, 1987, 25–27, locates Plutarch's temple at Kolonos Hippios. But for Plutarch an Athenian temple shared by Poseidon and Athena is a paradox, and he knows of only one, which is therefore the shrine at Skiron.

97. In another Homeric simile it is the pile of chaff that "whitens" as it grows (*Iliad* 5.502); so the wind is a "Whitener" in a double sense, whitening both the grain and the chaff.

98. The Germanic word has often been linked with Greek *skiron*, supposedly meaning "white umbrella": see the dictionaries of Frisk or Chantraine s.v. The "umbrella" word, however, is only a figment of ancient commentators apropos

of the festival Skira; nor is it even said to be white—that is a modern confusion with one or two other Greek words.

99. The ancient explanation of the name, as a wind blowing from the Skironian Rocks in the Megarid, can be dismissed out of hand. The wind is also indicated by the epithet Skiras given to Athena at Skiron and again at Phaleron and on Cape Arapis on Salamis. On the coast she is a patron of seafarers, and comes into the story of Theseus' voyage to Crete. But in several scholia and lexica Athena Skiras is said to be worshipped at Skiron, presumably at the shrine known to Plutarch and Pausanias. The scholia and lexica are not demonstrably confused or tendentious; on the contrary, they seem to preserve a substantial notice by some Attic chronicler (so Jacoby on Philochoros, *FGrHist* 328 F 14–16, after Rohde). The only reason for discounting them is the fixed idea that Athena Skiras cannot be worshipped in such different milieus, on the coast and at Skiron. Now the west wind, blowing steady at this season, is also good for sailing. Zephyr and Argestes are often so commended; for the same purpose, Skiron is the name favored in Attic or Atticist writers (Sosikrates fr. 2 *PCG*; [Aischines], *Epistle* 1.1). Athena Skiras is therefore useful to both sailors and farmers.

100. In Ovid's *Fasti*, the morning rising of the Hyades is registered no fewer than five times (once it is mistakenly called the evening rising), at various dates between May 2 and June 15—i.e. on different calculations of the true and apparent risings: see Bömer on *Fasti* 5.164. The west wind is prominently mentioned on the first and last occasions, *Fasti* 5.161–66 and 6.711–12, 715–16.

101. Two, three, four, five, or seven Hyades: Gundel, *RE* 8.2 (1913) 2618, s.v. Hyaden. Three, four, or six daughters of Erechtheus: Austin, 1970, 54. Versions existed in which two sisters, or all the sisters, are sacrificed; whether they were told with an eye on the stars is hard to say.

102. *Erechthô* belongs to the large class of present stems in -*th*- , of which many are frequentatives: see Schwyzer, 1939, 703–4. Yet the dictionaries of Frisk and Chantraine do not connect *erechthô* with *ereikô* nor *Erechtheus* with *erechthô*, except by way of "folk-etymology."

103. See the various nouns in Liddell-Scott-Jones' *Greek-English Lexicon* beginning *eregm-*, *erigm-*, *ereik-*, and *erik-*: all of them household words referring to pounded wheat, barley, peas, beans, and lentils.

104. In Euripides' *Erechtheus*, the Mysteries are mentioned in Athena's closing dispositions, but only as a future development, after several generations (fr. 65 lines 100–114). For Thucydides, the war illustrates the complete independence of Attic *poleis* in the days before Theseus' synoecism (2.15.1). We must wait until Pausanias to hear it said that "the war was concluded on these terms, that Eleusis should be subject to Athens in all but the conduct of the Mysteries" (1.38.3).

105. Cf. Robertson, 1991a, 66.

106. Another myth inspired by the threshing festival, but on Aegina, has the same conclusion. Herodotos tells how the Athenians, while attempting to carry off the cult statues of Damia and Auxesia—which resisted by falling on

their knees, a posture they have kept ever since—were suddenly assailed by thunder and earthquake: i.e. by weather change in both sky and earth (5.85.2, 86.4).

107. We do not know how Athens' celebration of the Skira was related to celebrations in the countryside. The festival is fairly prominent in deme calendars, and the local rites which they attest may or may not be supplementary to those at Athens.

108. For Athenaia as the earlier name, see Jacoby on Istros, *FGrHist* 334 F 4 (he regards it as a fiction).

109. The festival name Pandia is sometimes thought to mean "Common festival of Zeus"—i.e. one celebrated jointly by several communities, which would provide a different analogy. But the true meaning is surely "Rites of the all-bright sky," referring to the first full moon of spring; by one account, the festival is named for Pandia, daughter of Selene.

110. It is sometimes said or implied that the *apobatês* was a Panhellenic event, but [Demosthenes] 61 *Erotikos* 23, 27–29, shows that it was for Athenians only and also, since the admired youth competes very often, that it was annual. Cf. Crowther, 1991.

111. The *apobatai* would not join the Panathenaic parade, as they do on the Parthenon frieze, unless they were to perform shortly after. For the Agora setting, see Thompson, 1961.

112. Vian, 1951, nos. 104–22; *idem*, 1952, 35–41, 96–97. Vian interprets the group unconvincingly as an iconographic motif borrowed from Eastern art.

113. Vian, 1951, nos. 123–33; *idem*, 1952, 102.

114. These vases are associated with the *apobatês* by Vian, 1952, 103–4, 248. Vian also suggests that when Athena is seen driving a chariot in three-quarters view, she represents a victorious *apobatês*.

115. Cf. Robertson, 1991a, 58–61.

116. At some places it was the custom to keep vigil for the rising of the Dog-star round July 20, so as to counter its effect straightway. In Thessaly, processioners went up Mount Pelion thickly wrapped in fleeces; they were said to be "men in their prime" (Herakleides, *Cities of Greece*, ed. Pfister, 2.8). On Keos, where the curious Dog-star rites were traced back to the hero Aristaios, "they wait for the rising of the Dog-star under arms" (scholiast on Apollonios, *Argonautika* 2.498–527 a, w). On Keos it is certain, and on Pelion it is likely, that the Dog-star was greeted with an alarming show of force. The Panathenaic games, and some other games at the same season, originate as a more elaborate effort of the same kind.

117. Robertson, 1992, 98–105.

118. See Robertson, 1992, 11–31; *idem*, 1993, 242–44, 249; *idem*, 1996, on the Palladion shrine and the Pelasgian conspiracy as an *aition*.

119. So Plato, Apollonios, Apollodoros, Pausanias. Otherwise it is the Areiopagos (Plato again), or Brilessos (Simonides), or the source of the Kephisos (Choirilos).

120. *LIMC* III (1986) s.v. Boreas nos. 19–56, 62–64 (S. Kaempf-Dimitriadou).

121. "Playing": Plato, *Phaidros* 229 C; Apollodoros, *Library* 3.199; Pausanias 1.19.5. "Picking flowers," at the source of the Kephisos: Choirilos, *Supplementum Hellenisticum* fr. 321. "Twirling in the dance": Apollonios, *Argonautika* 1.215.

122. The curious portrayal of Boreas as a flute-player in Aeschylus' play (fr. 281 Radt) will be somehow inspired by the ceremony at the shrine.

123. Processions are depicted on the Boeotian black-figure vases which have been associated with the cult of Athena *itônia* at Koroneia: Schachter, 1981,122.

124. Cf. Robertson, 1983; *idem*, 1985, 256–58; *idem*, 1992, 15–16.

125. Clement, *Protreptika* 2.17; scholiast on Lucian, *Dialogues of Courtesans* 2.1, p. 275 Rabe; Etymologicum Magnum s.v. *arrhêphoroi kai Arrhêphoria*; scholiast on Aristophanes, *Lysistrata* 642; etc.

126. The "Arrhephoria" *qua* initiation rite is usually supposed to be a festival of Skirophorion unrelated to the Skirophoria, but the latest contributor I know of (G. J. Baudy) joins hands once more with ancient commentators by interpreting the Arrhephoria and the Skirophoria as two concurrent initiation rites for girls and boys respectively.

127. *ARV*[2] 585, 35 = *LIMC* I (1981) s.v. Aglauros, Herse, Pandrosos no. 16; *ARV*[2] 1218, 1 = *ibid.* no. 18.

128. When the sacred snake on the Acropolis did not eat its honey-cake, the Athenians knew that the city was doomed to fall to the Persians (Herodotos 8.41.2–3). The feeding of a sacred snake at Ambracia and Lanuvium is represented as an omen-taking for the community.

129. "Erechtheus," the more familiar name, is sometimes used in place of "Erichthonios" to denote the offspring of Earth and Hephaistos and the nursling of Athena: this is the extent of ancient confusion (the reverse does not occur), and it is mostly a very late development, confined to scholia and lexica. It is also understandable, since Homer refers to Erechtheus as springing up from the plowland, and the significance of this was subsequently lost. In a list of mythical themes, Xenophon has "the nurturing and begetting of Erechtheus, and the war that occurred in his day against the whole adjoining mainland" (*Memorabilia* 3.5.10)—in which the first item might almost be the Homeric Erechtheus, but is more likely the earliest instance of confusion. Wilamowitz conjectured, and it has sometimes been stated as fact, that Euripides' *Erechtheus* showed Erechtheus turning into a snake, as if he were Erichthonios. The papyrus fragments have exploded this idea: Austin, 1970, 52. Among modern scholars, only Ermatinger, 1897, 37–62, tries to demonstrate the equivalence of the two names in early use. He does not succeed: his table of mythical episodes (57) shows that none is attributed to both save only the springing from the earth and the attentions of Boreas—but the latter does not in fact hold for Athens' Erichthonios (see below n. 130). In Athenian vase-painting, which is by far the best evidence, Erechtheus and Erichthonios are always completely distinct. Yet in *LIMC* IV (1988) both are subsumed in the single entry "Erechtheus"!

130. The transparent name occurs elsewhere, notably as the forebear of the royal house of Troy and the first possessor of the immense Trojan herds of horses (*Iliad* 20.219–30). He was originally the earth-born *capostipite* of a line

which descends through eponyms like Tros to legendary kings and princes: a counterpart to Athens' Erichthonios, or to Kekrops. In the genealogy already known to Homer, or invented by him, he becomes a son of Dardanos, so that the Trojan line is set within a larger ethnic context. According to Ermatinger, 1897, 40–44, "a common folk-belief" among the early Ionians gave rise to the two stories that Boreas mates with the mares of Trojan Erichthonios, and that he abducts the daughter of Athenian Erechtheus. But it is rather that both these and other stories illustrate a general belief in the fertilizing power of wind. There need be no connection between the Trojan and the Athenian Erichthonios.

131. Robertson, 1985, 270–74, 281–95; *idem*, 1992, 90–97,105–19.

132. Cf. Robertson, 1978.

133. Fraser and Matthews, 1987, give thirty instances of Hephaistion and similar names from this area.

134. Hephaistos "hid at a certain place in Attika, which they say was called Hephaisteion on that account" (Euripides fr. 1246a Mette, cf. 1246b). This can only be the Academy, since Hephaistos was worshipped nowhere else in the countryside.

135. *ARV*[2] 1346, 1 = *LIMC* IV (1988) s.v. Hephaistos no. 220.

136. Other details of the story as we know it point to the same conclusion: that it was deliberately revised. The daughters of Kekrops are three; yet the *arrhêphoroi* would be more suitably prefigured by two. The names of the three are chosen for their kindred meaning: Aglauros, "Clear water"; Pandrosos, "All-dew"; Herse, "Dew." It is a pretty threesome, but not a natural one for a ritual myth, since Aglauros and Pandrosos have separate Acropolis shrines, and Herse is quite imaginary. Aglauros, moreover, appears in other roles, and as Kekrops' wife instead of daughter. If the original story was about a pair of daughters, they were surely Pandrosos and Herse.

I thank Jenifer Neils for much helpful advice.

3

Women in the Panathenaic and Other Festivals

Mary R. Lefkowitz

In recent literature about women in ancient Athens, it has become commonplace to emphasize the restrictions and limitations of their lives—their confinement within the sphere of the *oikos*, and their exclusion from political life—and to point out how these limitations were defined and even celebrated in Athenian myths.[1] But in such assessments of the status of Athenian women, curiously little has been said about the one area of Athenian life in which women played a prominent role in both public and private matters, which was, of course, religion.[2] Yet it is a feature of women's lives that ancient women themselves were well aware of, at least to judge from a speech by one of Euripides' women characters that was quoted by later writers as evidence that Euripides could and did speak in defense of women.[3] The context is lost, but we know that the speaker of these lines is Melanippe, the daughter of Aeolos:

Women run households and protect within their homes what has been carried across the sea, and without a woman no home is clean or prosperous. Consider their role in religion, for that, in my opinion, comes first. We women play the most important part, because women prophesy the will of Loxias in the oracles of Phoibos. And at the holy site of Dodona near the Sacred Oak, females convey the will of Zeus to inquirers from Greece. As for the sacred rituals for the Fates and the Nameless goddesses [i.e. the Furies], all these would not be holy if

78

performed by men, but prosper in women's hands. In this way women have a rightful share (*dike*) in the service of the gods. (Fr. 13.5–17 *Greek Literary Papyri* = fr. 499 Nauck, lines 5–17)

Melanippe can claim that religion "comes first" because in antiquity religion was—aside from survival—the central aspect of human life. As Peleus says in Euripides' lost drama, "no mortal can prosper without a god's [assistance]" (fr. 617a Nauck-Snell),[4] and there was virtually no ceremony or public or private occasion at which the gods' presence was not invoked. Athenian women were no exception to Melanippe's rule. What John Graham has observed about women in Greek colonies is also true of that most autochthonous of cities, Athens: "Greek women were essential to a well-ordered Greek community," and therefore, "if we wish to find out the truth about [Greek] women, we only need to think about the gods."[5]

In no civic festival do women play a more prominent role than in the Panathenaia. Young women's ritual cries (*ololygmata*)[6] and choral dances were an established feature of the *pannychis* the night before the great procession (Euripides, *Herakleidai* 781–83).[7] Women were responsible for the creation and presentation to Athena of the peplos with a tapestry portraying her victory over the Giants (e.g. Plato, *Euthyphro* 6b-c).[8] The peplos, which was offered as a birthday gift to the goddess, was the goal and principal feature of the ceremony.[9] The warp for the peplos was set on the loom by the priestesses of Athena, along with the *arrhephoroi* (scholion Euripides, *Hecuba* 467), the young girls selected for special service to the goddess (*IG* II[2] 1034).[10] The *arrhephoroi* were considered sufficiently important to be housed, during the term of their service, near the temple of Athena Polias on the Acropolis (Pausanias 1.27.3).[11] Once the warp was set on the loom, the peplos tapestry itself was woven by a specially chosen group of maidens from aristocratic families, the *ergastinai*.[12] Some of the *ergastinai*, along with other aristocratic women, might also serve as *kanephoroi*, bearers of the baskets of barley in which the knives used for sacrifice were hidden, both in the *pannychis* held the night before the procession (*IG* II[2] 334.15) and in the procession itself. It is almost certainly the *kanephoroi* who are portrayed on the right half of the east frieze of the Parthenon.[13]

In the fifth century, serving as a *kanephoros* was an important indication of a woman's status; the chorus of old women in Aristophanes' *Lysistrata* boast that after they served as *arrhephoroi*, and performed as "bears" in the festival of Artemis at Brauron, they "were basket-carriers (*kanephoroi*)—a lovely girl with a basket of figs" (640–45).[14] That the *kanephoroi* were not in any way peripheral—at least in the

fourth century—is clear from an inscription that designates the portions of sacrificial meat accorded to various officials: *kanephoroi* receive the same share as male participants in the procession (*IG* II² 334.11–16).[15] In 305/4 providing golden ornaments for the *kanephoroi* was a noteworthy liturgy (Pausanias 1.29.16).[16] By the middle of the century, the wives and daughters of metics also participated in the procession, not as *kanephoroi*, since that role was reserved for Athenian women, but as carriers of water jars (*hydriai*) and sun-shades (*skiadia*) for the *kanephoroi* (Demetrios of Phaleron, 228 *FGrHist* F 5; Pollux III.55 s.v. *skiadophoros*; scholion Aristophanes, *Birds* 1551).[17]

From a modern point of view it is easy to dismiss woolworking as a routine chore that limits women's freedom of movement. But to the ancient Athenians, to be selected to work on the peplos was a significant civic honor; even as late as the first century B.C., maidens who worked the wool, took part in the procession, and dedicated (at their own expense) a silver cup to the goddess were honored at their fathers' request by a public decree (*IG* II² 1034). The purpose of offering a precious woven garment to the goddess is explained in *Iliad* 6, where the priestess of Athena, Theano, selects a peplos and places it on the knees of the goddess's statue, and asks her to save the city from harm and to take pity on the city of Troy and the wives of the Trojans and their innocent children (6.302–10). It is an indication of the honor conferred by participating in the Athenian version of this peplos ritual that votive statues were set up for *arrhephoroi* on the Acropolis, and at least one *arrhephoros* was named for the Trojan priestess (*IG* II² 3634).[18] A third-century inscription (*IG* II² 3477) indicates that service as a *kanephoros* was noteworthy—but we would have known that from a famous incident: when in 514 Hippias and his brother Hipparchos refused to allow Harmodios' sister to serve as a *kanephoros* in the Panathenaic procession, it provided Harmodios with sufficient motivation to assassinate Hipparchos (Thucydides 6.56.1).

Why were these honors taken so seriously? I do not think it is sufficient to assume that the weaving of the peplos and service as an *arrhephoros* were *rites de passage* that helped young girls mark the transition from girlhood to womanhood.[19] Even if the Panathenaic rites marked a significant development in the lives of some women, they are not particularly female in character. In practical terms, women may have been chosen to make the peplos because females ordinarily did the weaving in the household, but there must have been a particular reason why the ritual peplos was woven by the aristocratic *ergastinai* themselves, rather than by slaves.[20] The reason is surely that these women were by definition citizens with known ancestry; as the orator Apollodoros

points out in his speech *Against Neaira*, to allow a noncitizen to perform secret rites is an act of impiety ([Demosthenes] 69.77).

Also, if coming of age—that is, personal development—was the primary purpose of the Panathenaia and Arrhephoria, why were *public* honors consistently conferred on the participants? The very route chosen for the Panathenaic procession shows that the presentation of the peplos was the most public and civic of rituals. The procession started from the Kerameikos district, both the site of the city cemetery and a thriving center of trade, and then proceeded through the Agora, the political and religious center of the city, past the shine of the twelve gods and the courtroom to the Eleusinion, the starting point of another great civic event, the procession to Eleusis (scholion Aristophanes, *Knights* 566c p. 142 Jones-Wilson), before continuing on to the sacred *temenos* of Athena, the Acropolis.[21] Whatever personal significance there may have been for female participants in other rituals, such as the Brauronia, in the Panathenaia the priestesses are concerned not for themselves, but for the city. It is the ritual that distinguishes the women of Athens from the women of other states, such as Delos (Euripides, *Hecuba* 466–74). And it is significant that it is a ritual in which women and men both play important roles.

As so often, no evidence survives that can tell us what the *ergastinai* and *arrhephoroi* themselves would have said about what they were doing, but it is possible to get a sense of the larger significance of these rituals from what was written about and for these women, even if by men. For example, in a second-century A.C. epigram the *arrhephoros* named after the Trojan priestess Theano is represented as saying that her five brothers and sisters have dedicated her to the goddess, and prays, "Grant that they may reach maturity, and that my parents reach old age" (*IG* II2 3634 = Kaibel 861). In other words, such priestly service is a form of insurance or protection; the original Theano offered the peplos to Athena for the protection of the city of Troy as a whole; the wife of the Athenian Archon Basileus performs a secret sacrifice on behalf of the city ([Demosthenes] 69.73). In religion, even if in no other aspect of civic life, women could and did act on behalf of the state.

To understand the reason why women could assume in the religion of the polis a role equal in importance to that played by men, we need only look at Athenian foundation myths. In these, as in cult practice, women are concerned with the welfare of the state. Athena entrusted the care of the baby Erichthonios, who was to become king of Athens, to Pandrosos, the daughter of Kekrops, who had judged the contest with Poseidon in Athena's favor, with instructions not to open the chest in which the baby was kept. But Pandrosos' sisters Aglauros and

Herse opened the chest, saw the baby surrounded by snakes, or even that Erichthonios himself was part snake, and threw themselves off the side of the Acropolis. Athena then raised Erichthonios herself, and he became king of Athens and set up the wooden image of Athena on the Acropolis, and instituted the festival of the Panathenaia (Apollodoros, *Library* 3.14.6).[22] The custom that women of distinction would play an important role at the Panathenaia and other festivals as *kanephoroi*, bearers of sacrificial baskets, was also believed to go back to the time of Erichthonios' reign (Philochoros *FGrHist* 328 F 8).

The sisters were afterwards worshipped as heroines: Aglauros (and Herse?) in a sanctuary in a cave at the east end of the Acropolis, Pandrosos near the Erechtheion,[23] and the celebration of the Arrhephoria was connected with this story, though Pausanias is reluctant to say precisely how (1.27.3). In his day (second century A.C.), neither the priestess of Athena nor the *arrhephoroi* knew what it was they were carrying, but they brought something down to the precinct of the gardens of Aphrodite, and took something else back up, after which they were replaced by new *arrhephoroi*.[24] Noel Robertson, in his careful study of all the evidence about this strange ritual, has suggested that the, *arrhephoroi* carried honey-cakes to the sacred snakes in the Ilissos region, and brought back a stone wrapped in swaddling clothes, which they placed in the Parthenon.[25] In other words, the ritual reenacts in outline the story of the myth, and demonstrates to the goddess that the community has not forgotten Athena's gift to the city, and so secures her protection for another year.[26]

The *arrhephoroi*, the two young girls who perform the service, must carry out the frightening task of offering food to the snakes, and so experience (at least in ritual terms) some degree of danger, in the course of caring for the goddess's foster child, or the stone that represents him. It is clear from other myths that there is a significant risk involved for mortals who are required to look after the children of gods, or the mortals whom they favor.[27] Another such incident is celebrated in the myth and ritual associated with the other great Athenian festival, the Eleusinian mysteries. The *Homeric Hymn to Demeter* describes how the goddess Demeter, while searching for her daughter Persephone, disguised herself as an old woman and came to Eleusis, where she was taken into the household of Keleos as a nurse for their infant son Demophoon (235–91). In order to make the child immortal the goddess anointed him with ambrosia and breathed on him, and at night hid him "like a log in the fire, without his parents' knowledge" (239–40). She would have succeeded in making him immortal if the child's mother had not discovered what she was doing and thought that the nurse was destroying her precious

child, with the result that he lost his opportunity to become immortal and ageless. The goddess became enraged and took the child from the fire and threw him on the ground, leaving him to his sisters to look after.

The incident makes a dramatic statement about the difference between gods and mortals: mortals are ignorant of their fate, and concern themselves with the immediate moment rather than the long-range future.[28] Moreover, the infant is suddenly cast out from the goddess's care into a harsh and cold environment, and he immediately recognizes the difference: "his heart was not consoled, for inferior nurses held him now" (290–91). As Robert Parker observes in his article on myths of early Athens, Apollodoros in his account of the Erichthonios myth says that Athena had hoped to make the baby immortal, but presumably as a result of the intervention of Kekrops' daughters, like Demophoon, he lost his chance.[29] Even if this version of the story does not go back to earliest times, and was only assimilated later to the story of Demeter and Demophoon, the story of the goddess's anger and the death of the interfering sisters warns of the dangers involved in incurring the wrath of the goddess, and suggests the means by which that anger might be avoided—that is, by retelling the myth, and reenacting it in ritual. Parker calls attention to a vase that portrays the daughters of Kekrops, Athena, and Erichthonios in the company of Soteria, the goddess of safety or salvation.[30]

I would also suggest that this association of the birth and nursing of infants with potential danger and even death for the nurses *and* infants helps to explains why the *arrhephoroi* and other women are honored for their service to the goddess. According to Euripides, it was the custom for Athenian mothers to protect their babies with golden amulets in the form of snakes (*Ion* 25–26).[31] The practice was started by Kreousa, the youngest daughter of Erechtheus. When Kreousa abandoned Ion, her infant son by Apollo, to die, she put around his neck two golden chains in the form of snakes (20–21). Kreousa had inherited the golden snakes from her father, Erechtheus, who had in turn received them from Erichthonios. Each contained a drop of the Gorgon's blood, one causing death, and the other offering protection from disease (1002–7).

The myths of Erichthonios and of Demophoon testify to the risk involved in bearing and nursing young children, and to the danger involved both for mother and for child. They demonstrate the human capacity for frustrating, through curiosity, jealousy, or ignorance, even the best intentions of the gods: Herse and Aglauros want to see what is in the casket; Metaneira stops Demeter from putting her child in the fire. The stories also show that even well-intentioned human behavior cannot restore the damage done: despite the kindly care of his sisters,

Demophoon will never be immortal. But at the same time the *Homeric Hymn to Demeter* testifies to the positive side of human experience: the sisters and their mother display great kindness to the old lady who comes to look after their brother, as well as to one another, and despite Metaneira's failure to understand what the goddess was doing, Demeter entrusts to her husband Keleos and his descendants the performance of her secret rites and ceremonies at Eleusis (473–79). By having given birth to Demophoon, even though he must remain mortal, Metaneira has ensured that Demeter's cult will be perpetuated, and his sisters, by caring for him, have assisted in that important process.

Women's potential for doing good and evil (as one might expect) was never forgotten by the society at large. The *Homeric Hymn to Demeter* offers a moving account of women's best potential for caring for and serving the gods. The narrative also suggests ways in which females have the potential for causing serious damage. In addition to the inadvertent wrong done by Metaneira, in the hymn the goddess herself demonstrates a terrifying capacity for destruction. She holds the seed within the earth so that no crops can grow, and so that men starve and have no sacrifices to offer the gods. Mortal women's capacity for damage is proportionately smaller, but nonetheless present. A mother has the power deliberately to destroy the life of a child, as in the myths of Medea or Ino, or of abandoned babies like Ion, not to mention the many foundlings whose names were not recorded in myth.

Medea, in famous lines given to her by Euripides, describes the dangers involved in mothering, for both parent and child: "they say that we [women] lead a life without danger inside our homes, while the men fight in war; but they are wrong. I would rather serve three times in battle than give birth once" (*Medea* 248–51). We are not meant to infer from her lines that ordinary Athenian men thought that women had a safe and easy life, because, as fourth-century gravestones attest, they witnessed and commemorated deaths in childbirth (e.g. *IG* II/III² 11907 = 548 Peek, 12067 = 1387 Peek).[32] Even though women did not die in war, this did not mean that their service to family and state was not commemorated or appreciated.[33] And in Athens, as in Sparta, the principal service that free-born women performed for the state was that of producing and raising children.[34] In effect, the cult at Eleusis, with its great emphasis on the nurturing of the young, celebrates women's positive potential: the birth of Demophoon brings great joy both to Keleos and his family and to the goddess, whose cult will thus be continued. Presumably this event was reflected also in the aspect of the Eleusinian ritual that celebrated the birth of the divine male child who represents the wealth of the Earth.[35]

Because they were guardians of the young, aristocratic Athenian women regarded themselves as public servants, since it was only by their efforts as parents that the cults of the gods could be continued, and the safety of the state ensured. The first offering of the Panathenaia was given to the goddess Ge (Earth) in her role as *kourotrophos*, "nurse of children" (Suda s.v. *kourotrophos ge*, I 3 p. 167 Adler).[36] The importance of motherhood is celebrated in Athenian literature, particularly in writing that is both public and patriotic in character. Euripides' *Erechtheus* told the story of how Erechtheus,[37] king of Athens, asked the oracle at Delphi how he might win the war against the Eleusinians, and was told that he must sacrifice one of his daughters. Although the oracle placed Erechtheus in essentially the same situation as Agamemnon when he was told that he must sacrifice Iphigeneia if the Greek fleet was to be able to sail to Troy, Erechtheus' family responds to the god's command differently from Agamemnon's, perhaps because in their case it was their homeland and not an international expedition that was involved.

Only fragments of the *Erechtheus* survive, but fortunately a long excerpt from his wife's speech is among them (fr. 50 Austin). In this speech, unlike Klyaimnestra in the *Agamemnon*, Praxithea speaks not as an autocrat, but as a citizen concerned primarily for the welfare and honor of the polis.[38] She regards her children as the property of the state, and sees herself, almost as a Spartan mother might, as having made a contribution to the state by bearing them.[39] She agrees without hesitation to give up her child for Erechtheus to kill and gives her reasoning (fr. 50.4–5). First, she is proud to be an autochthonous citizen of Athens (5–13). Second, "it was because of this that I gave birth to children, to protect the altars of the gods and my fatherland" (14–15)—note that in this statement she makes no distinction between male and female children. Third, it would be selfish to refuse to give one life if many others could be saved (16–21).[40] Fourth, if she had had a son instead of daughters, she would not have hesitated to send him into battle because she was afraid that he would be killed (22–25). Finally, women should encourage their children to be brave and not hesitate to send them off to battle, since if they die they will win lasting fame and glory (25–34).

The action of the play allows Praxithea opportunity to show that she can live up to her ideals. At the end of the play, she has lost all but one of her daughters, because the others took an oath to die with the sister who was sacrificed (Apollodoros, *Library* 3.15.4) and her husband, who was killed in the battle. The daughter who is sacrificed (we do not know her name)[41] is buried where she died (fr. 65.67),[42] like Tellos the Athenian in Herodotos' story of Solon and Kroisos (1.30.5), or the Athenians who died at Marathon (Pausanias 1.32.4).[43] As her mother had predicted,

like a male she won—all by herself—the crown of victory (fr. 50.34–35). The goddess Athena explains *ex machina* at the end of the play that the girl and her sisters, who committed suicide so as not to abandon their oath to die with her, shall all be honored along with her in cult, because of their nobility (fr. 65.68–74). The goddess also sees that their mother is rewarded for her service to the state, by making her priestess of her own cult in Athens (96–97), a significant honor, as we can judge from the long career of Lysimakhe (Pliny, *Natural History* 34.76), who was honored by a commemorative statue,[44] and who probably served as the model for Aristophanes' *Lysistrata*.[45] The goddess's speech makes it clear that in this case the city has been saved not only by the heroism of men but by the noble self-sacrifice and civic-mindedness of women. There is no suggestion, at least in the surviving text, that the lives of women are in any way less valuable or helpful to the city than those of men;[46] in fact, Praxithea's speech is used by the orator Lykourgos as a paradigm for patriotic behavior: "if women have the courage to do this, then *men* ought to have an incomparable devotion to their country" (*Against Leokrates* 101).[47]

On the basis of what survives of the *Erechtheus* it is not possible to learn what the daughters of Erechtheus and Praxithea thought about the sacrifice, but we can supply the kind of arguments they might have made from the lines Euripides gives to Herakles' daughter Makaria in his drama the *Herakleidai*. In this patriotic and idealistic play,[48] in response to an oracle young Makaria offers her own life without hesitation so that the Athenians can win the victory (381–499).

Makaria in a long speech explains why she should die to save the city of Athens. If the Athenians were ready to fight on her behalf, how could she refuse to die on theirs? To fear death would not be worthy of a child of Herakles. If she were to refuse, and then go into exile again, no other city would be willing to receive her on account of her cowardice. Her final and most telling point is that if she did survive, no one would want to marry her and have children by her, and that would not be an appropriate fate for someone distinguished like herself. At that point she asks to be led off to where she must die, to be wreathed in the sacrificial crown and begin the ritual. Her message to her siblings is that she is dying on their behalf, and that she has made the most glorious discovery of a heroic death (500–534). When Iolaos objects, and proposes instead that at least she and her sisters should draw lots to see who is to die, Makaria replies that it is better to have a willing victim like herself than one who is compelled; in a sacrifice the victim must always seem to be willing, so that no pollution results from the sacrifice (547–51).[49] In her final speech to Iolaos, she claims that she will have her heroic death

as a possession beneath the ground instead of children and maidenhood (591–92).

For our purposes—that is, for understanding the significance for women of Athenian foundation myths—it is interesting that Makaria in this speech twice speaks of dying on behalf of the state and bearing children as if they were alternatives: stating first that if she refused to die for Athens, no one would marry her (523–24), and then that her death would be a substitute for children and marriageable maidenhood (591–92). Like Praxithea, she does not hesitate to serve the state because she is female, nor for that reason does she face death any less bravely than a man would in similar circumstances.[50] A clear indication that female heroism "counts" as much as male is provided by Demosthenes in his *Funeral Oration*, which was delivered in honor of the Athenians who died in the battle of Khaironeia in 338. There the orator claims that the courageous behavior of Erechtheus and his daughters sets an example for the young men of the Athenian tribe Erechtheidai (Demosthenes 60.27), that the tribe Pandionidai had wished to show the same spirit as the daughters of Pandion, Prokne and Philomela, who avenged the outrage done to them (60.28). Similarly, Demosthenes claims that the tribe Leontidai was inspired by the example of the daughters of Leos (60.29), who offered themselves as a sacrifice to save their country from a plague (Suda s.v. L 261–62 p. 247 Adler) and whose heroon seems to have been in the northwest corner of the Agora, where it would have been on the route of the Panathenaic procession.[51] Therefore the willingness of maidens like Makaria and the daughters of Erechtheus to sacrifice themselves is no less heroic than self-sacrifice by males, such as Menoikeus, the son of Kreon, who killed himself so that Thebes could defeat the Argives, or Kodros, the Athenian king, who contrived to be killed by the enemy even though they knew that if he died their expedition would be defeated (Lykourgos, *Against Leokrates* 83–86).[52]

Of course we have no direct way of knowing what precisely the *arrhephoroi*, the *kanephoroi*, and the other participants had in mind as they enacted their roles in the Panathenaic procession. Since rituals are commemorative as well as practical, and if as Joan Connelly has recently argued, it is the sacrifice of the Erectheids that is the subject of the Parthenon frieze, it is clear that all the women in the Panathenaic procession were aware of the heroism of the Erechtheids, and of the other services performed by women on behalf of the city, and particularly by Praxithea, the first priestess of Athena Polias. And perhaps they, like their fathers, regarded their participation in the procession as a significant public and religious service, without which the state could not enjoy the full protection of the goddess.[53] Undoubtedly also some

share of their attention was turned to practical considerations, such as how they looked, and who saw them. In Aristophanes' *Frogs* the participants in the procession of Eleusis intend to have fun in the process of the ritual (407). But participation in the great procession to Eleusis was open to everyone, while to be chosen for the Panathenaic procession was an honor.

There is another significant respect in which participation in the Panathenaia differed from participation in Eleusinian ritual. The rites at Eleusis were directed toward the individual, as the concluding *makarismoi* of the *Homeric Hymn* indicate: watching the rites—even if only from the sidelines—guarantees the individual a better life after death;[54] in addition, initiation was also thought to offer individual protection from hunger and want.[55] The personal nature of these *makarismoi* can be seen by contrast with the prayers offered by women celebrating the Thesmophoria (at least to the extent that we can get a sense of what their prayers were like from Aristophanes' *Thesmophoriazousai*).[56] Women celebrating the Thesmophoria pray for the city of Athens, and for themselves (304–5),[57] and for the city and its people (*demos*, 352–53).[58] The purpose of participation in the Panathenaia likewise is to seek protection of the deity for the city as a whole. In these two important rituals, each of which serves deities without whose support the city would cease to exist, women play a critical role, and in the Thesmophoria the only role. Melanippe's claim stands up in Athens, as in every other part of Greece: "in the service of the gods we women play a most important part."[59]

Notes

1. E.g. Tyrrell and Brown, 1991, 114–15.
2. Humphreys, 1983, xiii.
3. Cf. Satyrus' *Life of Euripides* 39.xi, and the Euripides Vita 6 (ed. Schwartz).
4. The saying became proverbial; cf. Menander, *Monostikoi* 344 Jäkel; cf. Aristotle, *Constitution of the Athenians* 10.107; cf. Arrian, *Anabasis* 1.26.2; cf. *idem*, *Cynegeticus* 35.1.
5. J. Graham, "Religion, Women, and Greek Colonization," *Centro Ricerche e Documentazione sull'Antichità Classica, Atti* 11 (1, 1981) 314.
6. Cf. Calame, 1977, 151 n. 211.
7. Pearson, 1907, 146; Calame, 1977, 235–36.
8. Parker, 1987b, 192.
9. Perhaps it is this significant moment, the presentation of the peplos, that is portrayed in the central action of the east frieze of the Parthenon; Smarczyk, 1984, 550 n. 15; Simon, 1983, 66–67; Connelly, 1996.
10. Ziehen, 1949, 460.

11. D. Musti, ed., *Pausania: Guida della Grecia, Libro I, L'Attica* (Rome 1982) 364.

12. Parke, 1977, 38–39; Deubner, 1932, 31; on the making of the peplos, see esp. E. J. W. Barber, "The Peplos of Athena," in *G&P* 112–17.

13. Simon, 1983, 60 and pl. 22.1.

14. Henderson, 1987, 155.

15. Shares of meat are distributed as follows: *prytaneis*, 5 shares; archons, 3; *tamiai* of Athena and *hieropoioi*, 1; *strategoi* and *taxiarchoi*, 3; participants in the procession and *kanephoroi*, "as customary" (*IG* II2 334 11–16; Jacoby on *FGrHist* 328 F 8).

16. Frazer, 1898, II 387.

17. Simon, 1983, 65; Smarczyk, 1984, 551.

18. Robertson, 1983, 142; Nagy, 1979, 361.

19. Contrast Loraux, 1981, 47–49.

20. Robertson, 1983, 280.

21. Wycherley, 1978, 71.

22. Loraux, 1981, 59; on the various versions of this myth, cf. A. S. Hollis, *Callimachus: Hecale* (Oxford 1990) 226–31.

23. Kearns, 1990, 392.

24. Kearns, 1989, 139, 161.

25. Robertson, 1983, 241–88. See also his chapter in this volume.

26. Cf. how in second-century A.C. Ephesos, the Kouretes reenacted the birth of Artemis as a "vital contribution to the very existence of the Greek city" under Roman rule; G. Rogers, *The Sacred Identity of Ephesos* (London 1991) 145.

27. In the Hesiodic *Aegimios* (the earliest version of the story), the goddess Thetis put her children by her mortal husband, Peleus, into a kettle of boiling water to see if they were immortal, but Peleus stopped her from testing their seventh son, Achilles, in this way (fr. 300 M-W). In other stories Thetis tries to make Achilles immortal by burning him in the fire, but is interrupted by Peleus; cf. E. Livrea, *Argonauticon Liber Quartus* (Florence 1973) on Apollonios 4.816.

28. Parker, 1991, 8.

29. Parker, 1987b, 196–97.

30. Red-figure pyxis, Athens, National Museum A8922. See Shapiro, 1993, 37 fig. 4, 231. no. 4. Parker, 1987b, 196 n. 40; cf. Shapiro, 1986, 135; cf. O. Alexandri, "Athina-Attiki," *Archaiologikon Deltion* 31 (1976) 30, 135 pl. 35. On the birth of a monster child as a form of salvation, cf. Kearns, 1990, 323–26.

31. Wilamowitz, 1926, 87.

32. The circumstances of death outside of battle are not usually described in fifth-century inscriptions, but fourth-century inscriptions also make explicit the importance of ordinary domestic virtues; cf. Humphreys, 1983, 93, 121. For some poignant Hellenistic examples, cf. Lefkowitz and Fant, 1992, 263–64.

33. Contrast the protestations of Loraux, 1987, 1–5.

34. Vernant, 1980, 50.

35. Richardson, 1974, 27; Zeitlin, 1989, 159; Parker, 1991, 9–10.

36. Simon, 1983, 69; *LIMC* IV (1988) 926 (U. Kron).

37. Sometimes Erechtheus and Erichthonios are identified (e.g. Parker,

1987b, 193–94), but in Euripides' *Ion* 999–1009 Erichthonios is a snake-like figure, like Kekrops, distinct from Erechtheus; cf. Wilamowitz, 1926, 131–32; Robertson, 1985, 254–54; and *idem* in this volume.

38. Cf. H. Lloyd-Jones, *Academic Papers: Greek Comedy, Hellenistic Literature, Greek Religion, and Miscellanea* (Oxford 1990) 269; Sissa and Detienne, 1989, 241–42.

39. Lykourgos thought that childbearing was the most important function of free women; cf. Xenophon, *Constitution of the Lacedaemonians* 1.4.

40. Cf. what Iphigeneia says to Klytaimnestra, as an argument in favor of her self-sacrifice: "you bore me for all the Hellenes, not for yourself alone" (1386). Statements such as these seem to argue strongly against an ambiguous role or virtual nonexistence of women in Athenian life, as formulated by P. Brulé, *La fille d'Athènes* (Paris 1987) 135, and Loraux, 1993, 10–11.

41. According to the Atthidographer Phanodemos, *FGrHist* 325 F 4 (cited by Photios s.v. *parthenoi*), the eldest two daughters Protogeneia and Pandora offered themselves as sacrifice when their country was invaded by Boiotia (!); in Euripides' *Ion* Kreousa explains that when Erechtheus sacrificed her sisters, she alone was spared because she was still an infant (279–80).

42. Unfortunately the reference to this cult in *IG* II² 1262.52 does not specify its location, but according to the Atthidographer Phanodemos (*FGrHist* 325 F 4) and the comic poet Phrynichos (fr. 32 *PCG*), they were sacrificed on the hill Hyakinthos at Sphendonai; cf. Kearns, 1989, 201.

43. Cf. Loraux, 1987, 46.

44. *IG* II² 3453 is probably its base; cf. Lewis, 1955, 5.

45. Henderson, 1987, xxxviii–xxxix.

46. Contrast Loraux, 1987, 47, who imagines that Euripides may be commenting on the savagery involved in sacrificing virgins on behalf of armies of men (to "expose to the judgment of the spectators these armies of men who find their salvation in the blood of virgins") and Kearns, 1990, 337–44, who goes to some length to explain the apparent paradox of choosing girls as role models for males (e.g. because of the transsexual nature of ephebic puberty rites, 331).

47. Kearns, 1990, 331.

48. Zuntz, 1955, 30; cf. Pearson, 1907, xxvii: "this [Athenian] sense of justice springs from a conspicuous devotion to religion," and Mikalson, 1991, 233.

49. Cf. E. Fraenkel, *Aeschylus: Agamemnon* (Oxford 1950) on Aeschylus, *Agamemnon* 1297.

50. E.g. Menoikeus in Euripides, *Phoenissai* 998–1005; cf. Lefkowitz, 1986, 101–2.

51. Wycherley, 1978, 63–64; but cf. Suda s.v. L 262, which locates it "in the middle of the Kerameikos."

52. Curiously, no surviving Athenian poetry tells the story of Kodros, cf. Wilamowitz, 1893, II 130. On the modes chosen for self-sacrifice, cf. Versnel, 1980, 140 n. 2, 155 n. 1.

53. Connelly, 1996. Contrast Parke, 1977, 56: "the participants would not need to [participate in the Panathenaia] with religious feeling, nor would they

be expected to acquire any personal merit or spiritual reward from their performance." But for the Greeks, all public festivals, such as athletic competitions, secular as they may seem to us, are religious in character.

54. E.g. the Eleusinian priestess who ca. A.D. 176 initiated Marcus Aurelius and Commodus is led by the goddess away from every kind of sorrow to the isles of the blessed: "she brought her a death sweeter than sleep, far better than that of the Argive heroes" (*IG* II² 3632.12–16). Cf. Richardson, 1974, 311.

55. A rule-proving exception: the initiation of the Emperor Hadrian, "who lavishes the cities with his boundless wealth (*ploutos*), and above all these the famous land of Kekrops" (*IG* II² 3575 = Kaibel 863.11–12); cf. Richardson, 1974, 317.

56. On aspects likely to be inauthentic, cf. Parke, 1977, 87.

57. This significant religious aspect of the festival is not discussed by Kraemer, 1992, 27.

58. Contrast the absurdly selfish prayer to Demeter and Persephone offered by the woman impersonated by Euripides' relative, who asks that they send her daughter a rich husband or a stupid one (289–91).

59. Fr. 13 *Greek Literary Papyri* = fr. 499 Nauck, lines 8–9. Cf. Sissa and Detienne, 1989, 251–52, despite the reservations of Loraux, 1993, 247–48.

PART II
CONTESTS AND PRIZES

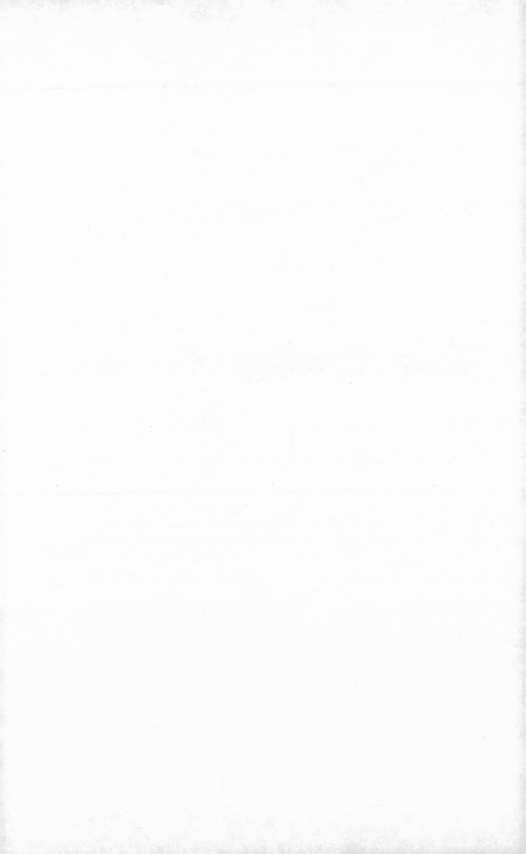

4

Group and Single Competitions at the Panathenaia

Alan L. Boegehold

For group and single competitions at the Panathenaia we have lists, officially inscribed in stone, that name competitions and stipulate prizes as well. We have pictures, poems, and prose, the poetry mainly praise, the prose including some blame. If obscurities or questions persist, that is to be expected in all of our inquiries into Hellenic antiquity. In hope of promoting discussion, I note a few formulations where congruence is wanting between ancient usages and modern attempts at translation and interpretation. *Panathenaia*, *Euandria*, notions of beauty, and *demosion* when translated as "civic" are the items in question.

Panathenaia

When an Athenian said the word *Panathenaia*, what did he think of? Athena, surely, and then all of Athens, including, in the days of the Athenian empire, various tributary states along with Athenian colonies and cleruchies; not, however, a "Panathena," a singular sort of divinity whose existence more than one modern scholar has been willing to entertain as possibility.[1] But then what did it mean to say that Erichthonios founded the Panathenaia?[2] Or Theseus?[3] The name Theseus immediately entails *synoikismos*, the union of Attica, and the name *Panathenaia* can then be understood to commemorate that legendary happening.

But why should Erichthonios be invoked? Since he did not play a role in the unification of Attica, he is associated with the Panathenaia for some other reason: a sacred aetiology, for instance, one that tells of Athena defeating a Giant and of the goddess's birthday. One effect of the two names, Erichthonios and Theseus, is to set the beginnings of the festival almost a millennium before Classical times, which is to say, in the heroic Bronze Age.

The Panathenaia was in fact ranked oldest festival, or second-oldest (after the Eleusinia), in Greece. And because of its grand old age, whatever amplifications came about with the archonship of Hippokleides in 566/5, and whatever innovations and splendors Peisistratos added in 530, all were components of a worshipful tradition. But because the amplifications were late, Greeks, in ranking prestige, placed the Panathenaia just below the competitions of the Circuit (as the games at Olympia, Delphi, Isthmia, and Nemea were styled when taken all together). The festival seems also to have been ranked once at least after Sikyon.[4] Pindar in single *epinikia* cited victories won at various games throughout Greece, the Panathenaia among them, but not with any obvious intention of exalting one over another. Still, there is no body of Panathenaic *epinikia* to compare with Pindar's Olympian, Pythian, Nemean, and Isthmian odes. Prizes on the Circuit were distinctive in that victors were crowned with different wreaths at each of the four sanctuaries: olive at Olympia, laurel at Delphi, pine at Isthmia, and celery at Nemea. At Athens, the oil and shields, the oxen and drachmas of the Panathenaia constituted another dimension of award.[5]

There may have been a "sacred" founding story, which told of Athena's victory over the Giant, and this was originally separate from a "political" founding story, which included Theseus' unification of Attika. The two stories in that case would give the Panathenaia and all of its variegated events a sacred and a political reason for being. The celebration therefore was neither wholly sacred nor wholly political but a mix of the two, one embodying a pervasive and recurrent feature of ancient Greek communal life, that of inheriting or inventing sacred stories which were turned to political uses. And certainly the sudden magnification of the festival in 566/5 or 530 has the look of a politically motivated happening. I shall return to the combination of sacred and political toward the end of this chapter.

The festival was celebrated on 28 Hekatombaion. Its administrative boards and list of events underwent changes over the course of the centuries, but a tentative reconstruction of the schedule can be attempted as follows. The Panathenaic procession started out from the Pompeion and ended at the temple on the Acropolis, where the peplos was presented.

In the evening, a torch race (*lampadephoria*) brought fire to the altar. Sacrifices then preceded an all-night celebration (*pannychis*)[6] which may have included musical competitions and dancing.

Next day, the athletic contests began with gymnastic events. Of these, the foot races were distinguished from one another by distance: they were called *stadion, diaulos, dolichos,* and perhaps the *hippios,* all individual competitions and fixtures in the Panathenaia from the beginning. Next, there came the pentathlon, five contests: the jump, a foot race called *dromos,* the discus throw, the javelin throw, and wrestling, all individual competitions and early and standard fixtures. Next, the hoplite race in armor, which may not have been in the program from the very start and was possibly included during some periods and left out during others, was integral in the second half of the fourth century, again an individual competition. The so-called heavy events—boxing, wrestling, and pankration—have a place throughout the life of the festival. Classes for boys and youths are attested from the late fifth century on. Under the rubric "equestrian events," from the sixth century on there was a horse race (*keles*), and there were four-horse chariot races (*tethrippon, harma*) for colts and full-grown horses by the early fourth century. A javelin throw from horseback is known from the late fifth century. A race in which two horses or mules pulled a cart (*synoris*) is known from the sixth century. *Apobatai*—that is, hoplites whose function it was to get on and off a moving chariot—were in the program during the fifth and fourth centuries. In all of these events, individual competed with individual.

There were in addition team events: the *euandria,* the *euoplia,* the *anthippasia,* and the regatta. In the fourth century and in the second century, the teams were made up from *phylai.* The *anthippasia* "was a mock battle in which the whole cavalry force took part, five tribes lining up opposite the other five and charging one another, and it was held in the Hippodrome, as Xenophon states clearly."[7]

Euandria

From among these events, turn now to the *Euandria.* When not used as a proper noun (capitalized here), the word meant "abundance of men, especially of good men and true; physical fitness as a subject of contest, manly in spirit, manliness."[8] The abstract noun (lowercased here) consequently offers little with which to compose a picture of an actual contest called *Euandria.* The same is true of the few circumstantial references to *Euandria* in literature. Inscriptions supply a context but no description. In a few inscriptions, the *Euandria* appears as a Panathenaic event in the early fourth century (*IG* II[2] 2311); and in the second century,

as an event in the Theseia (*IG* II² 956, line 48; 957, lines 26–35). When *Euandria* is listed as a competition in inscribed lists of awards or winners, its place as rubric is immediately below the headings *pyrrhichistai* and *euoplia*. It is an event in which picked men from each *phyle* compete. Expenses of training and presentation were met by private contribution: it was a liturgy, as was also the dithyrambic chorus (*kyklios khoros*) which competed at the Panathenaia. A prize for the winning *phyle* in the early fourth century was an ox and 100 drachmas (*IG* II² 2311); ca. 330 it was a shield (Aristotle, *Constitution of the Athenians* 60).[9] But what did the picked men of a *phyle* do to win their prize? A variety of learned answers to this question reflects an uncertain state of evidence. The *Euandria* is represented in modern studies sometimes as a beauty contest and sometimes as a contest to determine which tribe has the most handsome men, or again (improbably) as an event in which a contestant bearing shields tumbles on or from the rumps of two horses, or as a kind of military display, or as an unknown event with affinities to the "heavy" events, namely boxing, wrestling, and pankration.

It will be appropriate now to review the pictures and texts from which these speculations arise. First, the beauty contest: Athenaeus 13.565 has Myrtilos say, "I myself praise beauty. In fact in the *Euandria* they appoint the most beautiful males and have them <perform a function masked by the presumably corrupt> *protophorein*. And in Elis there is even a beauty contest" (*epaino de kai autos to kallos. kai gar en tais Euandriais tous kallistous egkrinousi kai toutous protophorein epitrepousin. en Elidi de kai krisis ginetai kallous*). He goes on to say that the man who wins first prize at Elis gets to do one thing, second prize another, third another.

The point is that good-looking men are distinguished in the *Euandria*, and their distinction is declared by their special charge, which I shall suggest below is to dance in the front rank (*protochorein*). A kind of ranking is implied in the process by which the best-looking are made prominent, but that ranking is not the end for which the contest was designed. Athenaeus' speaker remembers the *Euandria* and its good-looking men and then proceeds by a natural association to actual beauty contests—that is, contests where the whole point of the exercise was to choose and reward the best-looking. This transition has led some readers to call the *Euandria* a beauty contest, but what Athenaeus says does not justify the equivalence. That beautiful males compete in the *Euandria* is an observable and noteworthy feature of the contest, but it is not in Athenaeus' words a contest designed with an end of judging beauty.

Now to the conjecture that the *Euandria* was a "heavy" contest. The text cited in support is Xenophon, *Memorabilia* 3.3.12, and I would translate it as follows:

"Or don't you have this in mind, that whenever a single chorus from this city is formed, like the one being sent to Delos, no chorus from anywhere else is competition for this one, and in no other city is there brought together manpower (*euandria*) similar to that here." "You are telling the truth," he said. "It's a fact that the Athenians are not so much better in vocal display and in size and strength of body as they are in competitiveness."

Xenophon's words when translated this way provide no explicit evidence for a *Euandria* as one of the "heavy events." They may, however, provide a clue to the identity of the *Euandria* as chorus.

Before I elaborate, it will be necessary to consider a different way of translating the text, one that is taken to refer not to the quality *euandria* but to the contest *Euandria*. It goes something like this: "when a chorus is formed from this city . . . no chorus from elsewhere is competition for it, and there is not brought together in another city a *Euandria* like that here." "It's a fact that the Athenians are not so much better in vocal display [with reference to the chorus] nor in size and strength of body [with reference to the *Euandria*] as they are in competitiveness." This is a possible construction of the Greek, but it is not an obvious one for a reader who is not looking for *Euandria* with a capital *E*.[10] Without that capital *E*, Xenophon speaks of a single competitive entity, namely the chorus, one like that which is being sent to Delos. The single thing that makes such choruses winners is competitiveness, and not the seemingly obvious, usually invoked qualities such as vocal display and the size and strength of the men who make up the chorus. The chorus in question is a trained body of men or boys whose dancing and singing are assessed and ranked by judges. That is to say, dancing and singing are the essence of the contest. At the same time, it could be that tribes whose choruses were made up of big, strong, handsome men won more prizes. Note the conjunction of beauty and manly excellence in the opening words of Gorgias' *Helen*: "Manly excellence (*euandria*) is a city's proper adornment, beauty a body's" (*kosmos men polei euandria, kallos de somati*). Could Gorgias conceivably have been making an oblique reference to the predictable appearance of good-looking men in the front rank of the chorus called *Euandria*? If anyone ever did call the *Euandria* a "beauty contest" in antiquity—there is no explicit testimony that anyone ever did—it could have been an ironic commentary, a wry criticism of a judge's decision. The sense would be that the presentation at issue ought not to have been ranked on the basis of its participants' good looks.

A brief digression here will not be wholly irrelevant. Xenophon speaks of *thallophoroi*, handsome old men who carry branches in the Panathenaic procession. One scholar would like to identify the old men on the Parthenon frieze (north frieze, 27–43, *G&P* fig. 10) as *thallophoroi*:

he concedes that there are no green branches visible, which is perhaps a cautionary consideration; but still, the old men are nevertheless handsome, and so maybe they are after all the *thallophoroi*.[11] The basis for this muted but hopeful identification (quite apart from any questions concerning the subject of the frieze as a whole) appears to be a presumption that a modern Anglo-Saxon academic person controls what Xenophon, a Mediterranean soldier and farmer in a time millennia past, would have called *kalos*. Agreed, Classical Athens has shaped some of our aesthetic perceptions, but a question like "Who is the best-looking?" if uttered even within the enclosed world of a single family could hardly find a single, easy answer.[12]

A painted scene on a black-figure amphora is the springboard for a suggestion that the *Euandria* included tumbling by an armed acrobat, performing (at least for the moment) on the rumps of the horses.[13] I see no very persuasive way to support or reject this suggestion. I note that the *Euandria* is a team event, and the scene in question does not have the look of a team event. But an interpreter who wanted the painting to represent a team event could argue that the painting catches a single, possibly emblematic, moment, and the particularity of a single representation did not in this case allow for a team to be shown or indicated.[14]

To add another suggestion to those already considered, could *Euandria* be an alternate name for a particular chorus? Such a chorus, one supposes, would be expert at precision dancing, of a sort useful for hoplites to perform. Athenaeus (628d) apparently has such dancing in mind: "from the very beginning poets arranged dances for free men, and they used the dance-figures only to illustrate the theme of the song, always preserving nobility and manliness (*androdes*) in them." Again Athenaeus (628e): "For the kind of dancing practiced in those days by the choruses was decent, of great dignity, and as though it represented the evolutions of men under arms. And therefore Socrates in his verses declares that those who dance best are best in military matters; he says, 'Whoever honors the gods best with dances are the best in war.' For the art of dancing was virtually like armed maneuvers, and a display, not merely of discipline (*eutaxia*) generally, but also of care taken for the body."

It is natural, given the foregoing observations, to remark the pyrrhic dance, which is named in various lists as a Panathenaic contest. It sounds as though it must have been vigorous throughout. Athenaeus (630d) says that it is fast, and that it is a warlike dance. It is danced by boys in armor. "War needs speed for the pursuit, and also in the case of the vanquished, so they can retreat and not stay and not feel

shame as cowards." A dance in which a team displaying another sort of synchronization was the object could be another, different event.

Consider now two large blocks found near the Athenian Acropolis (Figs. 4.1–4.2).[15] They join to form two-thirds of a monumental base for a sculptural group, which is known as the Atarbos base, after the name of the presumed dedicator. Each of the two blocks has a relief sculpture on its front vertical face, along with an inscription on the upper moulding (*IG* II² 3025). The block on the left, designated (*a*) here has only recently been moved out of the storeroom and into the lobby of the Acropolis Museum. It shows in relief seven robed, beardless males. They stand facing right: one group of four followed by a space and then a group of three. A robed female stands at their head. The block on the right, designated (*b*), also has a relief, this one showing eight men, naked, with shields. They step off lightly to the right in two groups of four. At their immediate left, there stands a robed female figure, very much like the one on block (*a*).

A continuous moulding runs along both blocks above the reliefs. On moulding (*a*) the inscription has been restored to commemorate victory with a cyclic chorus. The surviving letters on block (*b*) with a few letters restored commemorate victory with *pyrrhichistai*. Atarbos' name is complete; his identity as dedicator is restored. Enough letters are preserved to justify the restoration Kephisodoros as eponymous archon. The date is accordingly 366/5 or 323/2.

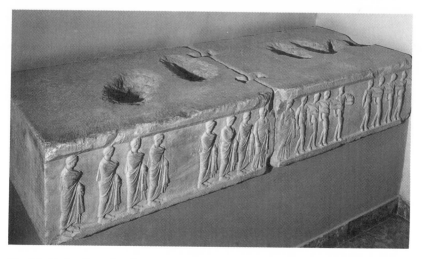

Fig. 4.1. Atarbos Base, fourth century. Athens, Acropolis Museum 1338 (Photo: C. Mauzy)

Fig. 4.2. Detail of Fig. 4.1. (Photo: C. Mauzy)

Consider now the cyclic chorus, securely attested as a Panathenaic contest made possible by liturgy (Lysias 21.1–2, 4). The robed figures of block (*a*) are associated in some essential way with the young men of block (*b*). Here a word needs to be said concerning the restored word [*pyrrikh*]*istais*. The dancers on (*b*) are naked. Athenaeus (630d) says the pyrrhic dancers wear armor. Note also that the pyrrhic dance was sometimes called *kheironomia*—that is, gesticulation. Armed dancers in vase-paintings are shown brandishing weapons in jumps, and whirls, and stoops.[16]

Suppose the young men are not pyrrhic dancers, but are instead members of a chorus, the one represented on block (*a*), and they are walking off in step with shields they have won with their singing and dancing. Shields were prizes for the *phyle* victorious in the *Euandria* ca. 330 (Aristotle, *Constitution of the Athenians* 60), whereas *IG* II² 2311 of the earlier fourth century shows an ox plus 100 drachmas as prize for the same event. If the *Euandria* was a competition in which precision dancing was an element, one might risk an emendation at Athenaeus 13.565. For *protophorein* read *protokhorein*: that is, the most handsome dance in the front rank. There is a further possibility. If the young men of block (*b*) are *pyrrhichistai*, the conjunction of a chorus on block (*a*) with *pyrrhichistai* on block (*b*), both events having the same liturgist, recalls *IG* ² 2311, lines 72–76. There, prizes for three classes of *pyrrhichistai* are listed, and then, directly following, the *Euandria* is listed with the same prize. The passage from Xenophon's *Memorabilia* (cited above) named *euandria* as a quality associated with the chorus being sent to Delos. Can

it be that we have a case where there are two names for the same event? That the cyclic chorus that performed in the Panathenaia could also be called *Euandria*?

Demosion

The existence of team events peculiar apparently to Athens although not just to the Panathenaia, may have contributed to the use of a phrase one encounters in modern discussions of ancient Greek festivals. The phrase is "civic athletics." I find it troubling, and I shall try to explain why. The word "civic" in contemporary English/American speech can include the celebrations of religious life in a community, but mostly it designates a dimension of society's order that is other than "sacred." The *Oxford English Dictionary* has s.v. "civic": "of, pertaining, or proper to citizens. 2. of or pertaining to city, borough or municipality. 3. of or pertaining to citizenship; occasionally in contrast to *military, ecclesiastical*, etc. *Civic oath* . . . an oath of allegiance to the new order of things, demanded from citizens in the French Revolution."

Now when a student of antiquity uses the word "civic" to describe a function of Athenian life, he may justifiably take it for granted that state personnel, and state law codes, and state religious festivals are all comprehended in that broadly inclusive word. "Civic life," for instance, can be understood to include the religious beliefs, celebrations, sacrifices, laws, sacraments, and traditions of the polis—in short, all the life of the city. But a phrase like "civic athletics" postulates different athletics, a kind that are something else, something not civic. What would they be?

First, one asks what "civic" is meant to convey. What are "civic" athletics? What is "civic consciousness"? What is a "civic" festival? What word would a Greek use to talk about such things? An approximate translation of "civic" is *politikos*, but I have not seen the word joined with any of the Greek words for games, contests, or festivals. The word *demosios*, however, does appear at Argos in varying agonistic contexts: in 480 a state-owned colt (*demosios keles*) from Argos won at Olympia, and a state-owned four-horse chariot (*demosion tethrippon*) in 468.[17] In 420 there was a state stable at Argos (Isokrates 16.1), and the Spartan Lichas entered his chariot at Olympia in 420 as the state property of the Boeotians (Thucydides 5.50.1). These few attested uses of state ownership could surely be multiplied. When Luigi Moretti in his translation of a text which he dates 500–480 says "gare dei citaddini" for *damosioi aethloi*, he creates games in which only citizens could participate.[18] Games with such restrictions are well attested, to be sure, but Moretti does not adduce instances where such games are described as *demosioi*. It is tempting

therefore to see *demosioi aethloi* as games that were paid for by the state. Now, Athens may have paid for some parts of the Panathenaia, but other parts were privately funded as liturgies. The athletic contests are not styled *demosia*, nor are they *politika* or even *koina*. They are *hiera*, which in the early fifth century is used in contrast to *demosion* when property is at issue.

A festival, a consciousness, a competition that is *hieros* is neither public nor private (*idios*). The polarity *demosios/idios* is ubiquitous in Classical Greece, as is *tyrannos/idios*. But what is *demosion* can be at the same time sacred (*hieron*) although it need not be. The Argive games that are described as *demosioi* are not defined any more closely than that. They could have been open to all comers, or to all citizens,[19] or they could have been paid for by the state, to take just a few of the possibilities implicit in *demosion*. [Andokides] 4 (*Against Alkibiades*) 42 attests that *Euandriai* (possibly in the fourth century) were paid for by private persons as a liturgy. That particular contest therefore could be called private (*idios*), at least so far as its financing is concerned. But the competing entity is a *phyle*. Does that mean the contest is therefore "civic"? Not necessarily. A *phyle* is a part of one's family. In homicide cases, when the deceased has no family relation as close as cousin, his *phyle* can act as prosecutor (*IG* I³ 104). Are phyletic competitions therefore private? Yes, insofar as they are family. But they are sacred (*hieroi*) as elements of the festival, the Panathenaia. Perhaps we face what is essentially a Möbius strip—or a doughnut. You cannot locate any single place on its surface which is exclusively inside or outside. Homer Thompson speaks of "community consciousness," a less invasive description than "civic" and therefore to be preferred.[20]

In conclusion, the Panathenaia, a festival celebrating Athens and Athena, included among its competitions one which was called *Euandria*. This proper noun, a particularized extension of the abstract noun meaning "manly excellence," may have designated the cyclic chorus as it was performed at the Panathenaia, and later at the Theseia. A relief sculpture on a statue base from the Athenian Acropolis (see Figs. 4.1–4.2) may show one such chorus. Since the nature of the festival as defined by tradition combined both sacred and profane elements, the term "civic" is perhaps misleading when applied to any of its parts.

Notes

1. Davison, 1958, 23 n. 2.
2. Hellanikos, *FGrHist* 323A F 2; Androtion, *FGrHist* 324 F 2.
3. Plutarch, *Theseus* 24.3; Pausanias 7.2.1; scholion Plato, *Parmenides* 127a.

4. Moretti, 1953, nos. 16 and 12.

5. See Chapter 5 in this volume, by Donald Kyle.

6. Pritchett, 1987, 179–87.

7. Vanderpool, 1974, 311.

8. H. G. Liddell and R. Scott, *A Greek-English Lexicon* (Oxford 1940), 9th ed., s.v. *euandria*.

9. See, however, Crowther 1985a, 286, who distinguishes between tribal and individual prizes.

10. This is clearly how Jacoby, *FGrHist*, note to Androtion 324 F 2, read the text.

11. Parke, 1977, 44. N. 25 cites Xenophon, *Symposion* 4.17; Aristophanes, *Wasps* 544 with scholion (= *FGrHist* 328 F 9); Hesychios s.v.; Eustathios, *Odyssey* 1557.25.

12. J.-Th. Papademetriou, "Some Aesopic Fables in Byzantium and the Latin West," *Illinois Classical Studies* 8.1 (1983) 133–34, cites various fables whose moral might be: "Si quis amat Ranam, Ranam putat esse Dianam."

13. Paris, Cabinet des Médailles 243, *CVA* 2 (France 10) pls. 88–89, cited by Davison, 1958, 42. Cf. J. Neils, "The Panathenaia and Kleisthenic Ideology," in Coulson and Palagia, 1994, 154, fig. 4.

14. The letters have been persistently read as *kalos toi kybisteitoi*, although the editio princeps has the correct reading, *kados*. One reader even referred to this as a *kalos* inscription (see Reed, 1987, 61).

15. Acropolis Museum 1338; Casson, 1921, 240–42; R. Horn, *Stehende weibliche Gewandstatuen in der hellenistischen Plastik* (Rome 1931) 16–17, pl. 4.1; Brouskari, 1974, 20, pl. 5.

16. Poursat, 1968, *passim*.

17. *Oxyrrhynchos Papyrus* 222, cited in D. Lewis, "Public Property in the City," in O. Murray and S. Price, eds., *The Greek City from Homer to Alexander* (Oxford 1990) 258.

18. Moretti, 1953, no. 10.

19. In Hellenistic inscriptions we find such stipulations: see e.g. *IG* II2 957.

20. Thompson, 1961, 229. Cf. Steven H. Lonsdale, *Dance and Ritual Play in Greek Religion* (Baltimore, London 1993) 16–17. The Theseia has a better claim to be called "civic" in that its *agonothetai* were appointed by a hand-vote in the *ekklesia*, in contradistinction to the *athlothetai* of the Panathenaia, who were chosen by allotment, hence by god. Also, the eponym of the Theseia was a hero and founder of the state rather than a god.

5

Gifts and Glory
Panathenaic and Other Greek Athletic Prizes

Donald G. Kyle

One of the most distinctive features of Greek athletics, in addition to nudity, was prize giving. From at least Homer's Achaeans to the late Roman empire, Greeks gave an astounding variety of prizes, from wreaths to money, from women to oil.[1] Almost any Greek community or group, from city-states at home to mercenaries abroad, instinctively arranged prizes when holding games.[2] Etymologically and historically, "athletics" presupposed prizes (*athla*) and "prize-givers" (*athlothetai*).[3] In short, Greeks could not imagine life without athletics, nor athletics without prizes.

Not earned like contracted wages or seized like war spoils, prizes were things won by struggle (*agon*)—proofs of prowess, symbols of superiority, and tokens of triumph. I define an athletic prize (*athlon*) as an object (or creature) of material and/or symbolic worth put up at the site of a contest (*agon* or *athlos*) and awarded to a victor for outstanding physical performance. I distinguish *prizes* from symbolic *honors*, such as the herald's announcement of victory or the winner's right to erect a statue at Olympia, honors which later supplemented the original prize.[4] I also distinguish prizes given at the site of the games from symbolic honors and material *rewards* awarded to victors upon return to their homelands.[5] Significantly, the early critic Xenophanes focused on the newer, civic custom of state rewards rather than on the

106

older, pre-civic custom of on-site prizes.[6] Hallowed by mythology and Homer, the custom of giving prizes was too venerable to be vulnerable. Even Plato, critical of much about athletics, acknowledged that games needed prizes: victors in his militaristic contests were to get on-site prizes, but civic rewards were for the guardians, the "athletes of war."[7]

The most renowned Greek prizes, of course, were the simple wreaths of foliage given at the Panhellenic "crown" games, but many "local" or "chrematitic" games offered valuable material prizes.[8] In this chapter I reexamine and revise the history of athletic prize giving from the use of *ad hoc* valuable items in early private games to symbolic wreaths in Panhellenic games to what may be termed "self-declaratory" prizes. Self-declaratory prizes are those prepared—that is, adapted or designed—objects which clarify their nature and origin via images and inscriptions. Sixth-century Athens combined earlier prize traditions to produce the most artistically significant local prizes, inscribed Panathenaic amphoras filled with olive oil.

Traditionally, we have studied Greek athletic prizes in terms of their significance for the *winners* rather than for the *donors* of the prizes. Influenced by modern ideologies (e.g. capitalism, Marxism, Olympism), perhaps quixotically, sport historians have debated the impact of valuable prizes on the sociology of ancient athletics.[9] In modern America prize donors and even Presidents hustle to locker rooms to bask in the glory of victors, but in ancient Greece victors went to the donors to receive their prizes; prizes did not bear an athlete's name unless he put it there himself. Greeks knew that before any contest began, some donor voluntarily had to "put up" a prize.[10] Along Greek lines, then, we should also examine prize giving from the donor's viewpoint.

Greeks referred to prizes (*athla*) and also rewards as gifts (*dora*) rather than wages (*misthos*) because the ideology of early Greek prize giving was that of gift giving.[11] Greek gift or prize giving was public, honorific, communicative, and competitive. Gifts and prizes were *not* given altruistically or disinterestedly without implications for status or obligation. As Hesiod says (*Works and Days* 355): "Give to one who gives, but do not give to one who does not give." Reciprocity or return giving, materially in kind or symbolically in honor (or status recognition), was always expected.[12] Individuals exchanged gifts, for example, in *xenia* or "guest-friendship" or "ritualized personal relations," an enduring relationship between peers. Especially before (but also after) the emergence of states, such ties provided useful networks of hospitality and support.[13] In other situations, ones of *megaloprepeia,* where wealthy individuals made lavish, competitive expenditures in ways that benefited or flattered the

community (e.g. dedications, sacrifices, chariot victories), or *euergesia*, where individuals gave financial gifts or endowments to the city (e.g. to fund education, athletics, or buildings), donors voluntarily gave gifts to the community and in return gained recognition of their status in the social hierarchy.[14] Accordingly, early Greek prize giving must be understood as socially embedded: by giving prestigious gifts to outsiders, and by the conspicuous distribution of surplus goods to community members, leaders "networked" and reinforced their status claims in public ceremonies (e.g. festivals, funerals, and weddings).[15]

By the late Dark Age or early Archaic period, athletic prize giving had emerged from earlier forms of gift giving to become a distinct social and civic institution, but old, heroic gift-exchange models and values persisted in the minds of donors, whether individual or corporate. The wreath prizes given at Panhellenic sanctuaries were exceptional in being god-given gifts of purely symbolic worth, but gift-giving dynamics still applied. As states developed, they institutionalized gift giving to shift donor rights and glory from wealthy individuals to the corporate state.[16] First, by *aristeia*, or gifts and honors given by communities to individuals, states recognized and rewarded benefactors of various sorts.[17] The *aristeia* paradigm applies to state rewards for (citizen) Panhellenic victors rather than to on-site athletic prizes (for citizen or foreign victors).[18] Seeking even more donor glory, states also soon established (or reorganized) athletic festivals at home by offering both material and symbolic civic prizes. Like earlier donors, states confronted a peculiarity of prize giving: since prizes were put up before contests, and major games were open in whole or in part, the recipients of agonistic gifts could not be predicted.[19] Donors had to seek results from putting up as well as from awarding prizes. As we will see, Panathenaic amphoras of oil, as Athenian civic athletic prizes, used images and script to ensure benefits for the donor-state whether won by citizens or foreigners.

Earliest Contests and Homer

History and anthropology show *sport* to be an early and universal human activity. Its origins predate any evidence for itself, thereby inviting all manner of theorizing. The history of *athletics*, however, is shorter and sounder in that athletics, sport with prizes, tend to leave behind more evidence. The ancient Near East clearly had sporting activities and possibly the precursors of athletic prizes, but the Greeks developed the first athletic prize festivals.[20] Mycenaean art suggests that early Greeks boxed, raced chariots, and ran, and we now generally accept the existence of occasional Bronze Age funeral games with valuable

prizes.[21] Attempts to identify prizes in Mycenaean art have been futile because our images of early prizes come from later literature and art, not from any Mycenaean prizes themselves.[22] Bronze Age prizes probably can be assumed in some form, but the abundant tripods and cauldrons of Homeric athletics, the amphoras of Athens, and, in fact, all Greek prize iconography, are post-Mycenaean.

Although the collapse of Mycenaean civilization brought a scarcity of prestige goods (from war booty or trade), Dark Age Greeks gave gifts and prizes. Scenes of boxers, chariot races, and also, less frequently, wrestlers and possibly foot races on Late Geometric vases suggest funeral contests, but depictions of prizes remain uncertain.[23] For example, a late Geometric (ca. 720–700) kantharos (Fig. 5.1) on either side shows panels with two horses tethered to a tripod lebes.[24] Certainly horses and tripods were known as prizes in Homer (see below) and the scene here may refer to contests, but the context remains uncertain. Until at least

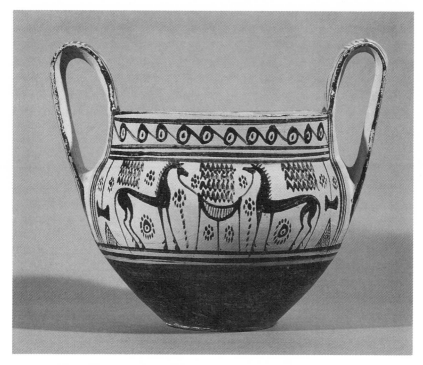

Fig. 5.1. Attic Late Geometric kantharos, ca. 720–700. Zurich, Leo Mildenberg collection (Photo: Cleveland Museum of Art)

the late Dark Age, athletic prizes were not a distinct category of objects designed and produced for athletic ends.

The earliest account of Greek games and prizes, Homer's testimony, shows Dark Age customs,[25] and certain of the prizes suggest the eighth century.[26] The normal but not the only occasion for athletics was the funeral of a great man like Patroklos, when, in a personal and basically secular fashion, an *athlothetes* might set up *ad hoc* prizes to initiate contests.[27] Diverse prestige goods became valuable prizes: "cauldrons and tripods, and horses and mules and the powerful high heads of cattle and fair-girdled women and grey iron" (*Iliad* 23.259–61; R. Lattimore trans.).[28] A far cry from the Classical Greek emphasis on single, first-place victors, most—not all—Homeric competitors, and even some non-competitors (Nestor), got prize-gifts.[29]

The formalized announcement and awarding of athletic prizes, so prominent in Homer's narrative of the games, derive from gift-giving rituals.[30] Prizes allowed the peaceful redistribution of a dead man's goods or the formation or renewal of social ties. Dramatically, the games for Patroklos were an elaborate device whereby Achilles could give gifts of reconciliation or recompense (*apoina*) to the Achaean leaders from whom he had alienated himself, notably by refusing their gifts of reconciliation earlier.[31] Achilles seems to invite anyone to compete, but social deference affected entrance into the games and kept out the *hoi polloi*.[32] Achilles shows his main aim by beginning the games with a formal invitation to Agamemnon concerning gift-prizes: "Son of Atreus and all you other strong-greaved Achaians, these prizes are in the place of games and wait for the horsemen [i.e. await you]" (272–73).[33] Achilles' prize giving goes on and on until finally Agamemnon stands for the javelin, and Achilles ceremoniously gives him a gift-prize in recognition of his excellence (890–94).[34] Now the games can and do end.

Homer's epics reveal personal, noninstitutionalized gift giving as a time-honored custom in Greek society. Arguing more about the prizes than about winning, Homer's athletes sought prizes for their prestige value, and donors offered prizes as gifts to honor the dead, to glorify themselves, and to establish, restore, or improve social relationships.[35] In this aristocratic society, gift-prizes were offered spontaneously and irregularly in contexts of funeral games, hospitality, and suitor contests.[36] To initiate a contest any valuable object sufficed as a prize: neither athletics nor prizes had yet differentiated out from the matrix of social relations and prestige gifts. Prizes were kept as treasures and not dedicated by victors, and Homer's athletes were neither wreathed nor nude. Greek athletic prize giving was not yet fully emergent, for the most illustrious home of athletic prizes, the athletic festival, was still

in its infancy. Although this early chrematitic prize tradition continued for centuries, it came to be overshadowed by the rise of the Panhellenic games.

Panhellenic Games

Hindsight has led most ancient and modern writers to assume distinctive and illustrious origins for the Olympic games because of how distinctive and illustrious they later became, but early Olympic history is now being rewritten. Earlier suspicions about the Olympic victor list and about the conflicting foundation legends are now being confirmed by archaeologists who reject the stories about the earliest games, even those of 776. Some now downdate the first significant games at the site to ca. 700–680. They see earlier finds of bronze figurines and tripods not as prizes but as votive dedications in early preathletic cult activity.[37] Although tripods are often depicted as prizes in later vase-paintings (Fig. 5.2),[38] the numerous tripods found at Olympia were probably simply prestige votives. Large tripods were intrinsically valuable and impressive metal dedications in a metal-poor era.[39] The medium was the message. Some may have been prizes won elsewhere and dedicated at Olympia, but, until they are inscribed, tripods at Olympia are more safely interpreted as dedications than as prizes.[40] Accordingly, Phlegon's account of a shift from valuable prizes to wreaths at Olympia is properly rejected as influenced by Homer or as a corruption from a tradition about Delphi.[41]

The historical Olympic prizes probably always were simply wreaths, but wreaths may not always have been simply prizes. David Sansone suggests that athletes' wreaths were ritualistic survivals from Paleolithic hunters' camouflaging headdresses and screens, but Homer's athletes lacked wreaths, and wreaths were not specific to athletics. They turn up in almost any scene of supplication or celebration.[42] Moreover, recent archaeological opinion suggests that cult rituals long predated athletics at Olympia. Athletics probably developed as a supplement to earlier cult gatherings at Olympia,[43] and wreaths, probably in use long before athletic contests, were ceremonial trappings for initiations or rites of passage, rituals often involving nudity. When athletics were combined with nudity, foliage and fillets gained additional functions as emblematic decorations or signifiers: iconographically they labeled certain athletes as victors (Figs. 5.2–5.3). As Lucian's Solon explains, "They [wreaths] are tokens of victory and a way to recognize the victors."[44] A recent study dates the introduction of athletic nudity to the late eighth century and sees it as the norm by the sixth.[45] Is it merely coincidental that this

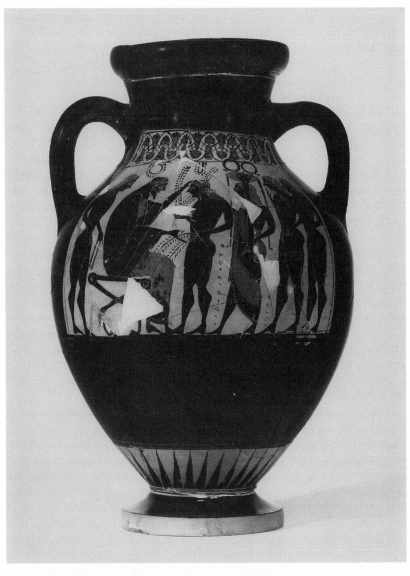

Fig. 5.2. Attic black-figure amphora by the Painter of Berlin 1686, ca. 540. Washington, D.C., Smithsonian Institution, Department of Anthropology 136415A (Photo: Smithsonian)

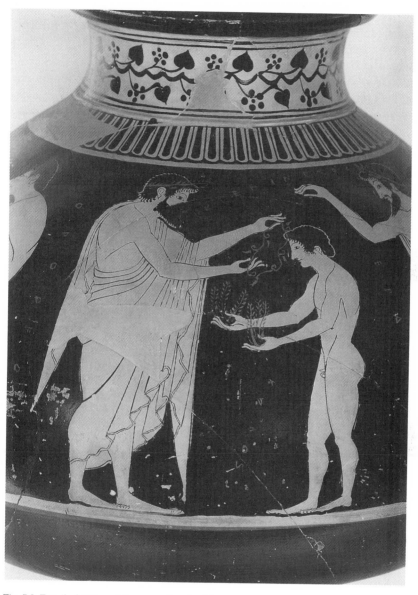

Fig. 5.3. Detail of Attic red-figure psykter by Oltos, ca. 520–510. New York, The Metropolitan Museum of Art 10.210.18, Rogers Fund, 1910 (Photo: Museum)

113

corresponds chronologically to the introduction and spread of Panhellenic games and wreath prizes?

Whether due to nudity, vegetation magic, or hunting rituals, sacred wreath prizes, shrouded in ritual, were seen, like victories themselves, as gifts from the gods.[46] Perhaps the gods gave them in return for athletic gift-services, but they were given through human agents, the *Hellanodikai*, for whom gift-giving dynamics applied.[47] In Aristophanes' *Plutus* (585–89) Poverty argues that Zeus must be poor because he just gives olive wreaths at the Olympic games.[48] In fact, Zeus, or early Olympia as a rustic sanctuary in underdeveloped Elis, was relatively poor. Elian noble clans may have had the resources to donate valuable prizes, but out of regionalism they would have opposed any one group's monopolizing the donor honor and, in effect, laying claim to the interstate sanctuary.[49] Also, with the institutionalization of regular games, unreciprocated giving of expensive prizes made little aristocratic sense.[50] Like the collegial principle of the *Hellanodikai*, the use of wreath prizes was neutral and diplomatic, as well as economical.[51] Hence, wreaths persisted even after Elis became a state and corporate donorship became possible.

Homer's silence about Olympia suggests that any eighth-century Olympic games were localized and less noteworthy than aristocratic funeral games.[52] Not all Homeric athletics were funerary, but funeral games had the greatest prizes. Describing Achilles chasing Hektor, Homer (*Iliad* 22.158–66) contrasts greater and lesser games:

> It was a great man who fled, but far better he who pursued him
> rapidly, since here was no festal beast, no ox-hide
> they strove for, for these are prizes that are given men for their running.
> No, they ran for the life of Hektor, breaker of horses.
> As when about the turnposts racing single-foot horses
> run at full speed, when a great prize is laid up for their winning,
> a tripod or a woman, in games for a man's funeral,
> so these two swept whirling about the city of Priam
> in the speed of their feet, while all the gods were looking upon them.[53]

Elsewhere, Homer mentions funeral games for a tripod in Elis,[54] games of the more illustrious class; but the early Olympics, if they crossed Homer's mind, were of the lesser class.

The earliest truly open or Panhellenic games, then, with their inexpensive prize giving, represent a sacral, lesser, and more obscure tradition, an epiphenomenal addition to rustic cult activity at Olympia. The crowning irony is that the ancient (and early modern) Olympics, which began as an aberration from the norm, later became the model for other Panhellenic games and also, to a lesser degree, for state games.

Adding to the irony, the success of the fledgling Olympic games was aided by the addition of equestrian events (closer to the earlier, more prestigious, clothed tradition),[55] and also, as suggested below, by the development of state rewards which enhanced the benefits of Olympic victory.

Although the Panhellenic "circuit" (*periodos*) of crown games became the most revered Greek games, it is important to realize that the older tradition of aristocratic chrematitic prize giving did not die out.[56] For example, around 700 Hesiod won a tripod in a musical contest in some funeral games in Chalkis and later dedicated it to the Muses back in Boeotia.[57] Aristocratic (mostly funeral) games, social events emphasizing the donation of prizes, connected Dark Age and Archaic prestige prize giving, but, in the process, aristocrats and their athletics adapted to new polities and new forms of communication.[58]

In the Archaic period (ca. 750–500), tripods and wreaths were used as prizes and they symbolized prizes or victory in art (see Fig. 5.2), but we cannot identify any artifact *per se* as an athletic prize until the rediscovery of writing. Although on-site honors expanded over time, the Panhellenic games were ritualistically "stuck" with mute, biodegradable wreath prizes; but when the revival of literacy brought new means of self-promotion, the organizers of private games adapted. Self-declaratory prizes began when nobles started recording their prize giving on the prizes given. In fact, the earliest known Greek inscription, found on a late Geometric vase of ca. 750–725, apparently refers to a dancing or jumping contest.[59] Nothing in the vase's shape or decoration says "prize." This was an *ad hoc* prize upon which the donor scratched an inscription to indicate its new function when it was put up. By the seventh century writing appeared more and more on personal athletic equipment, victor dedications, and prizes.[60] Similar to seventh-century examples from the Athenian Acropolis, an inscribed late sixth-century lebes from Kyme reads: "I was offered as a prize at the [funeral] games of Onomastos the son of Pheidileos."[61] Donor inscriptions on prizes would later spread from private funeral games to state games, but before that the initial or transitional stage in civic gift giving seems to have involved rewards, not prizes.

Apparently, before institutionalizing their own civic athletic festivals and offering *prizes*, states first introduced civic *rewards* for their Panhellenic victors. Aware of expensive (i.e. chrematitic) as well as symbolic (i.e. Panhellenic) prizes elsewhere, early states at home replicated and combined material and symbolic honors. Rather than on-site prizes given by the state, the gifts of money, free meals (*sitesis*), receptions, and front-row seating at public events (*prohedria*) given to victors at

home were *aristeia*, communal rewards or gifts of gratitude as corporate adaptations of earlier gift traditions.

Consider the athletic history of ancient Kroton and Sybaris. In effect an expansion franchise, Kroton won rapid and resounding success in international competition in the sixth century, perhaps via civic expenditure on rewards to recruit foreign athletes.[62] A contemporary, Xenophanes criticized such gifts as a general Greek custom.[63] An inscription of ca. 600 from nearby Sybaris records an Olympic victor's dedication of a tithe of his prize (*athlon*). The dedication must have been part of a valuable reward, not a tenth of a wreath.[64] Later in the sixth century (ca. 512), seeking to be the home of great games as well as great athletes, Sybaris instituted its own games with valuable prizes; it tried to compete with Olympia by using money to draw off athletes to Italy.[65] It seems, then, that states first offered rewards as a cheaper and convenient way to encourage athletes to represent them at the great games.[66] Then, somewhat later, as states prospered, they set up state prize games at home and tried to attract foreign competitors.

More common than the crown games at Panhellenic sanctuaries, so-called local or "civic" games were established by aristocratic state leaders familiar with both Panhellenic stephanitic and private chrematitic traditions.[67] In the era of state formation, emerging states incorporated athletic games and festivals within city life to respond to and to promote civic consciousness.[68] Games and prizes offered earlier on an irregular, humble or clan basis (in funerary or heroic contexts) were expanded, "nationalized," and institutionalized on a civic basis. While the Olympic model influenced the organization of such contests, founders of state games, following aristocratic traditions and civic goals, selected and designed a range of prizes which combined cultic symbolism and material worth.[69] Such patterns in prize giving can best be detected by examining the relatively well-documented Panathenaic games at Athens.

Panathenaic Games

Despite theories about funeral games and the cult of the heroized dead, and the possible testimony of Geometric art,[70] the history of the earliest athletics at Athens remains uncertain until the seventh century, when Athens housed both athletic victors and political turmoil. Athletics at Athens, however, were still a clan or regional matter until Solon legislated civic rewards for Panhellenic victors. His initial civic action helped prepare the way for the Great Panathenaic games.[71]

Athletic games at the Panathenaia prior to 566 cannot be proven, and processions and military displays seem more likely.[72] By the 560s,

however, a more assertive Athens was ready to declare its status through grand athletic games and prizes. By then aristocratic Athenians had personal knowledge of stephanitic and chrematitic prizes, and vase-paintings were explicitly labeling scenes and objects by means of dipinti. For example, a fragment of a vase of ca. 580–570 by Sophilos (*G&P* fig. 5), one of the earliest Athenian painters to add inscriptions to his vases, declares its depiction of Patroklos' games; and a black-figure dinos of ca. 560 from the Athenian Acropolis, which depicts the games of Pelias, labels a prize LEBES.[73]

In 566 Athens added contests to an older festival to form the Great Panathenaia. Prizes of sacred oil in decorated and inscribed amphoras, masterpieces of communication, were introduced, and inscriptions from the Acropolis refer to a *dromos* (whether a racecourse or a race) and an *agon* organized by a board of civic officials.[74] In the evolution of Greek prizes from miscellaneous items used as *ad hoc* prizes to self-declaratory prizes, these Panathenaic amphoras were an eclectic and yet innovative development as civic, self-declaratory prizes of material and symbolic value.[75] The motives of those responsible are suggested by the earlier history of Greek athletic prize giving, by the design and elements of the early Panathenaics, and by contemporary Athenian history.

Power and decision making in the early 560s still rested with the social elite. Aristocrats, men who knew their Homer and whose descendants patronized Pindar, in effect ran the state. The purposes behind the design of the amphoras are intelligible from their viewpoint as a combination of the general traditions of elite athletics and gift giving within the specific context of Athens.[76] W. R. Connor has told us to be attentive to popular concerns, but, as H. W. Pleket points out, in athletic matters the masses embraced the sporting ideology of their leaders.[77] Some credit the events of 566 to Peisistratos, but he was not yet tyrant;[78] and, although Solon was still alive, he played no known role in 566. The archon of the year, Hippokleides, tends to be underestimated (from Herodotos 6.129) as a dancing fool, but he was a member of an agonistic family and Herodotos calls him "the wealthiest man" in Athens. Hippokleides perhaps just responded to the desire of Athenians, rich and poor, for a popular forum for ceremony and recreation.[79] We usually view the emergence of cities in terms of politics and war, but athletics also expressed and encouraged civic consciousness. Panathenaic prizes were given to reward victors, certainly, but also to promote the interests of the state. Perikles' later claim that Athens gave gifts freely, without any thought of return benefits, is rhetorical, not realistic.[80] Led by men with old, nonaltruistic gift-giving notions, Athens gave prizes agonistically to rival other states and to earn honor, which could bring economic and political benefits.

Gift-prizes were given collegially by representatives of the corporate
state in *xenia* fashion to establish relationships and in *euergesia* fashion
to declare the status of Athens.[81]

The earliest known Panathenaic prize, the Burgon amphora of ca. 560,
is pre-canonical:[82] the front (Fig. 5.4) bears a warlike Athena and a prize
inscription (see below), and the reverse (Fig. 5.5) shows an equestrian
event. The canonical decorations (Fig. 5.6) appear later in the sixth cen-
tury: with the prize inscription, the front panel shows Athena between
Doric columns supporting cocks, and the reverse shows some athletic
activity. These vases compound several aspects of Athena: the sacred oil
recalls her contest against Poseidon; the vase recalls Athena as a goddess
of crafts (Ergane); her warlike appearance shows her as a protectress
(Pallas or Promachos); the columns may refer to some temple; the cocks
may suggest Athena as a bird goddess; the inscription suggests Athena
Polias; and the athletic scenes recall Athena as Nike or Hippia. Indeed,
could there be a more effective combination of images to glorify the
goddess of the polis and its games?

Although the Panathenaic games are usually classed as "non-crown"
games, crowns and fillets also were officially given at Athens.[83] Prize
lists, however, do not record such crowns, because at Athens crowns
were only temporary symbolic decorations. A relevant insight may come
from Perikles' Funeral Oration (Thucydides 2.46.1), which contrasts his
words (the speech) with substantial actions done to honor the dead,
such as raising their children at state expense: "the state thus offers a
valuable crown (*ophelimon stephanon*) in these contests." In other words,
Perikles and Athens supported materially valuable benefits as well as
ceremonial honors for victors and heroes.[84] When games were added
to festivals at Athens, they had wreaths as at Olympia, but they also
adopted the tradition of valuable prizes.[85] The result was the valuable
and sacred Panathenaic oil, the fruit as well as the foliage of the olive.

Originally the prize olive oil came from sacred trees and was thus
the gift of Athena,[86] but, like Zeus' wreaths, the oil was administered by
leaders familiar with earlier prize traditions. The idea of giving a local
product as a prize was widespread, and inspiration may have come from
the prizes of grain in the ancient games at Eleusis;[87] but the decision
to give the oil in large quantities, rather than token amounts, reflects
Solonian economic policies.[88] It also meant that symbolic prizes gained
material value.[89] A Panathenaic men's *stadion* victor was awarded 120
vases of oil, worth perhaps the equivalent of $67,800, and the vases
themselves were of some value.[90]

The amphoras' decoration was carefully designed with prize giving
in mind. Others have discussed aspects of the depiction of Athena—for

Fig. 5.4. Obverse of the Burgon amphora, ca. 560. London, British Museum B130 (Photo: Courtesy of the Trustees of the British Museum)

example, whether it refers to a statue on the Acropolis or mythologically to a certain incident, such as the Gigantomachy.[91] I merely note that on the earliest known vases, the flat-footed Archaic Athenas (see Fig. 5.4) seem to refer, simply and directly, to the cult of Athena as a martial goddess. On the reverses, athletic scenes help clarify the history

Fig. 5.5. Reverse of Fig. 5.4. (Photo: Courtesy of the Trustees of the British Museum)

and techniques of events; and, since the scenes on official prize vases correspond—however generically—to events in the games, depictions on official vases provide sound evidence for the existence or introduction of types of events in the program (see *G&P* fig. 58). Without ceramic or other corroboration, we should be cautious about reconstructing early programs from expanded programs in later inscriptions.[92]

Fig. 5.6. Detail of Panathenaic prize amphora by the Berlin Painter, ca. 480–470. Hood Museum of Art, Dartmouth College, Hanover, NH c.959.53, gift of Mr. and Mrs. Ray Winfield Smith, class of 1918 (Photo: Museum)

The design and decoration of the Panathenaics by the state of Athens represent a significant innovation in the history of prizes. A step beyond *ad hoc* prestige goods or orally dependent crowns, Panathenaic amphoras were fully self-declaratory. The images on the amphoras containing the prize oil indicated which games and what types of events were involved. The beautiful, clear messages were intelligible even to people on the fringes of the Greek world.

Yet, with communication beyond Athens in mind, Athens went even further. Perhaps influenced by inscriptions on funeral game prizes or on column dedications, the state added an official prize inscription: *ton Athenethen athlon* (see Fig. 5.6).[93] The inscription was an original element and a major indication of the thinking behind the prize.[94] The wording is simple but not incidental: the Athenians wanted an explicit ethnic reference.[95] Given its purposefulness, I agree with Jenifer Neils that the inscription is the *sine qua non* of official prize vases.[96] Amphoras that look like prize vases, but tend to be smaller and lack the prize inscription, should remain classified as "pseudo-Panathenaics" or "amphoras of Panathenaic shape."[97] Official prizes "speak" for themselves and emphasize origin (donor) rather than ownership (victor). Ultimate ownership was an unpredictable matter of victory, and glorification of the victor, beyond the awarding of the prize, was a matter for his family and friends.[98] Athens' concern was with ensuring its donor-honor and any potential benefits for the state.

Like inscriptions on stone, the prize inscriptions show Athens moving from orality to script communication;[99] the great difference was that the amphoras with their messages were marketable and transportable. Athens not only allowed the selling of sacred oil, it desired it.[100] Athens knew what Pindar later voiced in the opening lines of *Nemean* 5: that statues were glorious but sedentary, whereas songs—and amphoras—could travel. Scholars who see the minority of Athenians in later victory lists at Athens as evidence of Athenian athletic decline miss the point by focusing on recipients over donors.[101] The distribution of Panathenaics from South Russia to Cyrene testifies to success in giving—not failure in winning—prizes.[102]

To conclude, consideration of the earlier history of Greek athletic prize giving helps explain the design and purposes of Panathenaic amphoras. The complete Panathenaic prize—oil, amphora, two panels, and inscription—was a brilliant combination of elements, a hybrid prize for hybrid games. The prize vessel attached sacred and civic references to prize oil, producing a compound prize that was eminently both sacred and civic, symbolic and valuable. Like Athens' Archaic owl coins, Panathenaics were articulate packagings of valuable commodities.[103] These

transportable civic symbols publicized Athens as powerful, divinely favored, and wealthy. Games brought people to Athens, but prizes took Athens abroad.

Notes

Versions of this chapter were presented at "Athens and Beyond," a symposium at Dartmouth College, and as the Maxwell C. Howell Honorary Address to the North American Society for Sport History in 1992. For suggestions, I wish to thank Jenifer Neils, T. F. Scanlon, D. J. Geagan, A. E. Raubitschek, and Allen Guttmann.

1. Like nudity (e.g. Thucydides 1.6.5; Plato, *Republic* 5.452c), the custom of stephanitic prizes was used to demonstrate Greek ethnicity. The *locus classicus* is Herodotos 8.26: when Arcadian deserters questioned before Xerxes speak of the Olympic games and wreath prizes, the Persian Tigranes expresses amazement that men would compete only for *arete* and for no material reward. As Kurke, 1991, 4, notes, the Persian here expresses an aristocratic Greek attitude. Lucian's *Anacharsis* (*Anacharsis* 9–10, 16) echoes Herodotos and also mocks the donation of stephanitic prizes: "I am sure that those who offer them take pride in their generosity."

2. Agonism and prizes were woven into the fabric of civic festivals; e.g. see Hamilton 1992, 10–26, on the choes contests (formal and informal) in the Anthesteria. Even leisure games might involve prizes. Hegesander of Delphi *apud* Athenaeus 11.479d says that the popularity of the game of *kottabos* led to the introduction of prizes (*kottabeia*) into symposia. See S. G. Miller, "Round Pegs in Square Holes," *AJA* 76 (1972) 78–79, and B. A. Sparkes, "Kottabos," *Archaeology* 13 (1960) 202–7. Mercenaries: Xenophon, *Anabasis* 1.2.10, 4.8.25–28.

3. Scanlon, 1983, 155, comments: "The specialized meaning of one particular derivative [of *aethlos*], *aethlon*, "prize," and its widespread use in early Greek literature perhaps indicate the great importance of this one aspect of all toil and contest in the Greek concept, namely the reward."

4. I make this distinction to clarify historical changes rather than to suggest ideological discontinuity. As Kurke, 1991, 35–41, and others have said, material prizes and symbolic honors were perfectly intraconvertible as symbolic capital in what she terms the economics of *kleos* and *nostos*.

5. Honors on site and rewards at home are surveyed in Buhmann, 1972, 53–82, 104–37.

6. Xenophanes (*apud* Athenaeus 10.414a–c; frag. 2 West, Diehl; Miller, 1991, no. 167) repeatedly mentions "the city" and rejects a list of state rewards including meals, gifts, and *prohedria*. See below. As Young, 1984, 165, points out, "In ancient Greece, when a few critics such as Xenophanes and Socrates objected to the large financial rewards heaped upon athletes, it never occurred to them to question the athletes' own right to accept those rewards."

7. Plato, *Laws* 8.829b–c, 832e.

8. Rather than the traditional stephanitic versus chrematitic dichotomy, Pleket, 1975, 54–71, identifies crown, sacred crown, and local games, but his typology reflects later formal terminology. Roller's works, 1981 a–b, emphasize the early importance and the continuity of private, especially funeral, games. Within "local" or *epichoric* games, I distinguish between private and state or civic games.

9. On the influence of prizes and rewards on social mobility, see Young, 1984; Pleket, 1974, 1975; *idem*, "The Participants in the Ancient Olympic Games: Social Background and Mentality," in Coulson and Kyrieleis, 1992, 147–52; and Kyle, 1987, 102–23, 145–54.

10. The putting up of prizes, usually noted with some version of *tithemi*, meant they were physically present, as in the games for Patroklos, and not just offered or promised.

11. See Pleket, 1975, 74–89, on prizes and on the persistence of the athletic value system of Pindaric *kaloikagathoi*.

12. The ideas of Marcel Mauss and Karl Polanyi have contributed enormously to our understanding of the symbolic economy of gift exchange and the embeddedness of the economy in Archaic societies; in general, see Humphreys, 1978, 63–75, or Austin and Vidal-Naquet, 1977, 8–18; on Homer, see Finley, 1954, 61–65; Donlan, 1982; and R. Seaford, *Reciprocity and Ritual: Homer and Tragedy in the Developing City-State* (Oxford 1994) 13–25. For an insightful application to Pindar, see Kurke, 1991, 87–107, esp. 92–97. Early athletic prize giving suits models of reciprocity better than those of redistribution or (market) exchange. I suggest below that athletic prizes emerged as specialized gifts in the late Dark Age; even when instituted by the state as corporate donor, prizes were neither simply political nor simply economic. What Kurke shows about poets and victors applies also to donors: they operated in traditional networks of overlapping reciprocal honorific obligations. Over time a *misthos* model was emerging, but athlete, poet, and donor retained the traditional ideology of *charis*.

13. In a thorough treatment, Herman, 1987, shows that *xenia* ties predated states but that states came to incorporate and use them in *proxenia*. Cf. Walbank, 1978. Herman, 1987, 6: "The city framework superimposed itself on the [*xenia*] network . . . yet it did not dissolve it . . . dense webs of guest-friendship . . . continued to act as a powerful bond between citizens of different cities and between citizens and members of various apolitical bodies." Morgan, 1990, 218–20, discusses the changing relationship of the institution with sanctuaries. The corollary of *xenia* within states, *philia* had the same value system.

14. On *megaloprepeia* and the athletic ideology of *epinikia*, see Kurke, 1991, 163–256. In the *euergesia* model, donors gave prizes to the end of providing public entertainments for Hellenistic and Roman communities. On euergetism and the sociology of gift giving, and its distinctiveness from potlatching, gift exchange, the redistribution of goods, etc., see Veyne, 1990. Patronage seems a less suitable paradigm for Greece and especially for Athens; see Millet, 1989.

15. The *xenia* model is clearly the earliest and broadest one, but other models should also be considered to include early situations in which a local donor

might give prizes for games open to the whole community and not just his social peers. *Megalapropeia* and mature *euergesia* properly belonged in civic contexts, but certainly they had pre-civic precursors analogous to potlatching.

16. Herman, 1987, on *xenia*; Kurke, 1991, on *epinikia*; and Morgan, 1990, on dedications all discuss the interplay of individual (or *oikos*), class, and civic concerns, but the significance of prizes and donor dynamics in the era of state formation has been understudied. The rise of both the polis and Panhellenism affected gift giving. States might interfere with euergetism by imposing sumptuary laws, liturgies, or taxes, or they might appropriate gift giving to themselves at the civic level; see below. Panhellenism increased the range of outsider athletes via increasingly open games.

17. States gave *aristeia*, in both material and symbolic form—e.g. money, crowns (usually gold ones), citizenship, *proxenia*, honorific decrees, etc.—to honor individual heroes and benefactors in military, economic, and agonistic matters. On later inscribed decrees honoring officials, often with crowns sculpted in relief, see G. B. Hussey, "Greek Sculptured Crowns and Crown Inscriptions," *AJA* 6 (1890) 69–95. On military *aristeia*, awards for valor, such as those given by Agesilaos to contingents in his army, especially those in Herodotos, see Pritchett, 1974, 276–90. Thucydides 4.121.1 notes that, when he liberated them, the people of Skione decorated Brasidas publicly with a crown as a liberator, and privately with garlands "like an athlete." On the *aristeia* awarded after Salamis by Sparta to Eurybiades (olive crown) for valor and to Themistokles (crown, carriage, encomium, escort) for "wisdom and cleverness" in Herodotos 8.123.1–2 (and Plutarch, *Themistokles* 17.1–2), see B. Jordan, "The Honors for Themistocles after Salamis," *American Journal of Philology* 109 (1988) 547–71.

18. See below. State rewards were offered but not physically put up on site, and they were not always or routinely won.

19. The nature of the prize donation probably influenced the degree of openness of a given set of games. Early private games with material prizes probably were invitational or (implicitly) socially exclusive. Later, truly "open" games developed in neutral or Panhellenic sanctuaries and had symbolic prizes. Local games held by states and offering material prizes donated by the corporate state might be partially or fully closed to other Greeks.

20. Harold D. Evjen, "The Origins and Functions of Formal Athletic Competition in the Ancient World," in Coulson and Kyrieleis, 1992, 95–104, gives a balanced survey of evidence and scholarship on early sport in the Near East and Greece (updating Evjen, 1986), but his definition of "athletics" (95) unfortunately omits consideration of prizes. Decker, 1992, 62–66, discusses the mention of prizes (meat and some unspecified items) given to runners by a Pharaoh of the Nubian twenty-fifth dynasty on the "Running Stela of Taharqa" of the seventh century, but these seem to have been informal prizes and the document falls late in the history of Egyptian sport. J. Puhvel, "Hittite Athletics as Prefigurations of Ancient Greek Games," in Raschke, 1988, 26–31, feels that games suit the aristocratic warrior culture of the Hittites. He suggests that at least six of the eight events from Patroklos' games have parallels in Hittite texts, but he

does not make a strong case for institutionalized athletic prizes along the lines of later Greek practices. Arguably, the earliest prizes, spontaneous, irregular, and indistinct, were not unique to Greece; but, among others, Poliakoff, 1987, 104, and Young, 1984, 172–73, have noted that Greece became distinctive when prizes and athletics were regularized and institutionalized (i.e. with the Olympic cycle and civic festival calendars).

21. A thirteenth-century funerary larnax from Tanagra (Thebes, Archaeological Museum 1) bears scenes of a funeral, chariot racing and single combat, a man and goats in the context of a hunt or sacrifice, and bull-leaping. Such scenes suggest elaborate funeral games, but no prizes can be identified. See Tzachou-Alexandri, 1989, no. 13; Decker, 1982–83.

22. Rystedt, 1986, asserts the existence of runners and possibly spear-throwers as motifs in Mycenaean figurative vase-painting. On Mycenaean boxing and chariot tracing, see Kilian, 1980; W. Decker, "Zum Wagenrennen in Olympia: Probleme der Forschung," in Coulson and Kyrieleis, 1992, 129–31; G. Mylonas, "The Figured Mycenaean Stelai," *AJA* 55 (1951) 134–47. Rystedt notes a depiction of a jug near a supposed spear-thrower (her fig. 22, krater from Aptera Crete of fourteenth or thirteenth century), and also a bowl or cup in the hand of a man who may be a runner by her interpretation (chariot krater from Enkomi Cyprus); but she admits (n. 25), "In both cases, we can, however, not exclude that the vases denote rather libations or votive offerings."

23. See Roller, 1981b, 114–15, for examples. She takes these as representations of actual practices, not epic, but she also cautions that not all such Geometric scenes need be funerary.

24. Zurich, Leo Mildenberg Coll. See *Animals in Ancient Art from the Leo Mildenberg Collection*, exh. cat., ed. A. P. Kozloff (Cleveland 1981) 93–95, no. 74 (J. Neils).

25. Roller, 1981 a, 11–12, feels that contests in Homer and Hesiod correspond to contemporary historical games: i.e. they were held by a family or friend, valuable prizes were set out as an incentive, and nobles, sometimes from afar, competed. Roller sees such games as part of a long earlier tradition, and she emphasizes that a historical funeral game tradition continued after this eighth-century Homeric practice.

26. Colin Renfrew, "The Minoan-Mycenaean Origins of the Panhellenic Games," in Raschke, 1988, 17, sees Homer's emphasis on cauldrons as appropriate for the eighth or seventh century, when they were regularly dedicated at Olympia: "But the cauldron on tripod legs was not a prominent feature among the bronze vessels of the Mycenaean period." Moreover, the use of iron (as the *solos* prize in *Iliad* 23 and as axes for the archery contest in *Odyssey* 21) "suggests a fully flourishing iron age once again appropriate to the time of Homer but not at all to the Mycenaean period, in which iron objects, although known, were exceedingly rare and very small in size."

27. Homer, *Iliad* 23.257–890. See below on *Iliad* 22.158–66. In certain contexts games with prizes were customary but perhaps not automatic. In *Iliad* 23.257–59, people were turning to go away until Achilles kept them there and brought out prizes to indicate that games would be held.

28. As Finley, 1954, 129, declares, gifts had prestige value for their intrinsic worth, and *ipso facto* "treasures" (*keimelia*) were potential prizes: there were no cowrie shells.

29. Gardiner, 1910, 14, 20, says every competitor got a prize, but in the weight throw four men compete for one iron prize. See Willis, 1941, 411, on the *solos* as pre-Homeric. On Agamemnon's uncontested victory, see below.

30. Donlan, 1982, discusses gifts and calculated generosity in Homeric culture as an example of a "low-level" or "immature" chiefdom. He interprets Homeric gifts as redistributions of goods in potlatch fashion by chieftains to reinforce leadership, a redistribution crucial to charismatic leadership. A chieftain's distribution of meat or his giving of gifts from surplus, especially war booty, was a means of social control and alliance adjustment. However, Donlan does not discuss athletic prizes.

31. Including "prize-winning horses" which had already won valuable prizes earlier: *Iliad* 9.123–27, 265–69. In Phaiakia a demonstration or performance becomes a test of true athletic prowess, hence prizes/gifts become required (*Odyssey* 8.97–255, 387–97). Kurke, 1991, 108–16, shows that Pindar analogized *apoina* to the victory celebration; but in Phaiakia, because athletic prizes were not yet fully emergent, the recompense gift also functions as an athletic prize.

32. Some of Achilles' several invitations to competitors seem more open (e.g. "Come ye who would contend for this prize": *Iliad* 23.707, 753, 831) than others (e.g. "We invite two men, *the best among you* [my emphasis], to contend for these prizes": 23.659, 802). The *demos* had been dismissed earlier, and only those "close" to Patroklos were asked to remain (23.159–63, 236). Aristocrats like Achilles did not give prestige gifts to just anyone. In Kurke's terms (1991, 94), this would have been a "top rank" gift-giving situation; the donor would not want to "trade down" with people who could not reciprocate at the same level. Achilles' words (274–75) as donor show that he also was accustomed to the role of recipient: "Now if we Achaians were contending for the sake of some other hero, I myself should take away the first prize to my shelter."

33. Agamemnon is also mentioned in the invitation to the boxing contest: 23.658.

34. Agamemnon "wins" even without the usually demanded demonstration of *arete*. Achilles wants to give him a gift without a contest, lest chance or the gods create problems.

35. Herodotos 6.126–30 shows that Kleisthenes of Sikyon was familiar with such old aristocratic traditions; in Agariste's suitor contest there was one "winner," but Kleisthenes as host and *agonothetes* gave a gift of silver to each loser "for his desire to take a wife from my house and for his sojourn away from home" (A. D. Godley trans.).

36. *Iliad* 23. 618–19: "This, aged sir, is yours to lay away as a treasure in memory of the burial of Patroklos." Cf. the great prizes to honor Achilles' burial in *Odyssey* 24.85–94. In Ithaka Antinoos offers a prize for the impromptu boxing match of Iros and Odysseus (18.43–49).

37. See Alfred Mallwitz, "Cult and Competition Locations at Olympia," in Raschke, 1988, 79–109, citing the evidence of wells; cf. Hugh M. Lee, "The

'First' Olympic Games of 776 B.C.," in Raschke, 1988, 110–18. Peter Siewert, "The Olympic Rules," in Coulson and Kyrieleis, 1992, 113–17, supports Mallwitz's argument for athletics at Olympia as a later addition by noting epigraphical evidence for the separation of agonistic and ritual spheres in the administration of the cult and the games. Siewert also discusses an inscribed law (of the last quarter of the sixth century) concerning infractions in wrestling at Olympia, and he suggests that a bureaucracy with written records did not arise at Olympia until the first half of the sixth century. On the Olympic site, see Coulson and Kyrieleis, 1992, 19–57. On the Olympic Register, see Peiser, 1990, with bibliography. On tripod dedications, uncertainty about early games, and the significance of Olympia's interstate sanctuary status for its success, see Morgan, 1990, 43–48, 90–92.

38. Tripod prizes in art: Webster, 1972, 152–54, and Lee (supra n. 37) in Raschke, 1988, 116 n. 12.

39. The tripod shape has ritual associations with sacrifice, but tripods were popular as dedications or prizes because they represented an impressive amount of metal. See Morgan, 1990, 194–200, on the economics of dedication, the issue of metal shortages, and the desire for metals for the manufacture of prestige goods.

40. Robertson, 1992, 229 n. 28, suggests that tripod-cauldrons were prominent at Olympia because they were used to cook sacrificial meat served to victors and officials.

41. See Pleket, 1975, 58. Phlegon, *Olympiades* 1.10 is rejected by Fontenrose, 1978, his Q6, PW 490–91, as an unhistorical narrative giving Delphi credit for the establishment of the sacred games. The tradition of a chrematitic to stephanitic shift at Delphi (Pausanias 10.7.2, 5, 6.14.10; *Marmor Parium* 53–54 concerning 590 B.C. is usually accepted; see J. Fontenrose, "The Cult of Apollo and the Games at Delphi," in Raschke, 1988, 125, 138 n. 12; O. Picard, "Delphi and the Pythian Games," in Tzachou-Alexandri, 1989, 70–72; and Young, 1984, 113 n. 9 on the testimonia. Since music was a specialized and remunerated profession earlier than athletics, it is possible that the earlier tradition of musical contests with material prizes was extended to the introduction of athletics in 586. The circumstances in 586 were unusual, however, with the availability of windfall booty from the First Sacred War for prizes. By 582 the Olympic model of crowns was adopted for the Pythian contests, both musical and athletic.

42. Sansone, 1988, 83–88. Strabo 8.3.30 says that at the time of the Trojan War, either there were no games in which a crown was the prize or, if there were, they were not famous. On wreaths and crowns: Hyde, 1921, 148–60; Jüthner, 1898; Gardiner, 1916; Groton, 1990. On wreaths and fillets on athletic sculpture, see Serwint, 1987, 107–16.

43. See above. Also see Rose's still essential study of 1922.

44. Lucian, *Anacharsis* 10 (S. G. Miller trans.).

45. McDonnell, 1991. Also see Crowther, 1982; J.-P. Thullier, 1988; and Bonfante, 1989, who sees athletic nudity at Olympia as of ritual origin but not as a late development.

46. Rose, 1922, 180. Wreaths were picked from the sacred trees (*moriai*) of Zeus at Olympia; see Pindar, *Olympian* 3.10–12; Pliny, *Natural History* 16.9, 12.

In the case of a nondecision or draw, a "sacred victory" (*hiera*), the gifts were given (i.e. given back) to the donor god: Gardiner, 1910, 206. A plaque from a statue of Troilos, *Hellanodikes* and Olympic victor of 372, is inscribed: "I was *Hellanodikes* at Olympia at the time when Zeus granted me my first Olympic victory with prize-winning horses and then my second in succession, again with horses. Troilos was the son of Alkinoos"; Moretti, 1953, no. 48; Tzachou-Alexandri, 1989, no. 116. On victory as divine *charis*, and on sacred crowns as god-given *agalmata* or *keimelia* in Pindar, see Kurke, 1991, 104–5.

47. Siewert (supra n. 37) in Coulson and Kyrieleis, 1992, 115, suggests that judges at Olympia were originally called *diaitateres* but were renamed *Hellanodikai* in the fifth century.

48. Chremylos replies that Zeus keeps wealth for himself and only gives trifles (*lerois*, 589). See Groton, 1990. Pausanias says that Herakles held a race for the Kouretes and crowned the victor with a branch of wild olive, and he remarks (5.7.7) on the availability of the wild olive: they had plenty of it, so much that they slept on piles of it.

49. As Mauss, 1967, 31, suggests, in gift economies material gifts were never fully separated from the identity of the men who exchanged them. Any noble givers of valuable prizes at Olympia, especially prior to the emergence of a state, would have expected to receive personal prestige, at least, from the giving. The competitive nature of such expenditure would invite rivalry and complications for the sanctuary. Sacred wreath prizes diffused such tensions.

50. Cf. *Odyssey* 13.13–15: when Alkinoos orders the Phaiakian nobles each to give Odysseus a tripod and a cauldron (without hope of gifts in return), he adds that they can be reimbursed by taxing the people.

51. In explaining why the Dorian Hexapolis became a Pentapolis, Herodotos (1.144) says that in the games of Triopian Apollo victors who won tripod prizes were not to take them from the temple but were to dedicate them there. Halicarnassus was excluded from temple privileges when one of its athletes took his prize home. This story may record an attempt by the sanctuary to offer the same valuable prizes over and over again to avoid both an economic drain and problems of regionalism.

52. Early games at the interstate sanctuary of Apollo on Delos are attested by the *Hymn to Delian Apollo* 146–62, but the poem does not mention prizes. By the time prizes (silver *phialai*, tripods, palms) are known from later references, the festival had become eclectic. See Ringwood Arnold, 1933.

53. Young, 1984, 112, says this passage applies to actual practice in Homer's lifetime and shows that foot races for prizes (sacrificial victims or ox-hides) were well known, but that the greatest prizes were for equestrian events at funeral games. Cf. *Iliad* 23.640: the greatest prizes were left for the chariot race in the games for Amarynkeus held by Epeians at Bouprasion near the Alpheios River. *Iliad* 22.159 possibly suggests that the original prizes in non-top-rank gift-prize situations (i.e. nonequestrian cultic games open to the whole community) were portions of sacrificial meat or hides; cf. Xenophon, *Anabasis* 4.8.25–28 (hides), and Pausanias 5.16.3 (meat at the Heraia). The giving of cattle and meals for team events at the Panathenaia is intriguing (see below).

54. *Iliad* 11.698–701: Augeias of Elis stole four horses and a chariot sent by Neleus of Pylos to compete for a tripod.

55. The clothing of mature charioteers may be related to age; young jockeys were nude. Davies, 1984, 103–5, makes the very reasonable suggestion that the expansion of equestrian contests in the Archaic period was influenced by aristocrats seeking more opportunities for self-display as their traditional political bases were being undermined.

56. See Morgan, 1990, 212–23, on the significance for the sanctuaries of the rise of the Panhellenic circuit. Finley, 1954, 129, and others repeat the traditional suggestion that wreaths "took the place" of valuable prizes. Roller, 1981a, details evidence for the continuity of funeral games and (13 n. 1) lists athletic festivals believed in antiquity to have begun as funeral contests. Roller, 1981b, discusses works of art depicting funeral games—e.g. the Amphiaraios vase of the early sixth century and the Kynosarges Proto-attic amphora.

57. Hesiod, *Works and Days* 654–59, thus provides our earliest literary reference to the dedication of a prize tripod, and that dedication was not at the site of the victory. Hesiod says these games for Amphidamas had "many prizes"; also see *Theogony* 435–38 on athletic prizes.

58. As Finley, 1954, 130, notes, Homeric gifts often had genealogies or histories to enhance the glory of the donor and recipient. Such histories, however, were dependent on oral transmission. Stoddart and Whitley, 1988, 764–66, explain that in seventh- and sixth-century Athens, aristocrats used inscriptions to demonstrate their wealth and piety, and artisans used them to advertise their skills.

59. "Whichever of all the dancers (*orcheston*) now skips most nimbly": Athens, National Museum 192; Jeffery, 1990, 68–69; Tzachou-Alexandri, 1989, no. 194 with bibliography. Beazley, 1986, 7, points out that this inscription was added by incision after the completion of the vase, and he dates the vase to no later than the end of the third quarter of the eighth century. Early scripts were used as mnemonic aids and to declare the ownership, function, or contents of objects; e.g. see Johnston, 1983. Neils, in *G&P* 195 n. 1, with bibliography, collects examples of vases used as prizes in informal contests in dancing or woolworking.

60. On victor dedications and the dedication of athletic equipment, see Rouse, 1902, 160–63; Jeffery, 1990, *passim*; and Raubitschek, 1939. Dedications of athletic votives and equipment at Nemea are discussed by Miller, 1990, 38–39, including an inscribed bronze plaque (of ca. 500 from Sikyon) recording the dedication of a statue of a horse to Zeus.

61. Jeffery, 1990, 238, no. 8 on p. 240, pl. 47. Fragments of bronze cauldrons and tripod bowls with Boiotian inscriptions identifying them as prizes at funeral games suggest that Athenians (names unknown) traveled to private funeral games: see A. G. Bather, "The Bronze Fragments from the Acropolis," *JHS* 13 (1892–93) nos. 62–64 on p. 129, pl. VII. Roller, 1981a, 2–5, discusses such finds in their funeral game context. Cf. Tzachou-Alexandri, 1989, no. 33: a bronze hydria of the second quarter of the fifth century, a prize from Phthia from games in honor of the hero Protesilaos.

62. On the development of Kroton's athletic "stable" from ca. 588 to the 480s, see Young, 1984, 131–41, who (133) sees "strong circumstantial evidence that . . . these western Greek colonies recruited athletes and paid them handsomely." It must have been startling and instructive for mainland states like Athens to see this colony come to dominate competition in running. Although Athens won at least five victories in running at Olympia in the seventh century, including Kylon's *diaulos* win, we know of no Athenian victory in running during the period of Kroton's predominance. Athenians still went to Olympia, but apparently they competed primarily in equestrian events.

63. See above. Xenophanes was writing ca. 525 and had traveled to Italy. His focus was on Olympic victory, which, he adds, did not fill the state's coffers. On Xenophanes' comment that an athlete gets "a (lump sum) payment that will be a treasure to him," Young, 1984, 131–32, feels that *doron* "denotes a payment of substantial value." Cf. Euripides' more general criticism of any honoring/crowning of athletes, and of their lifestyle: *Autolykos* fr. 282, discussed in Kyle, 1987, 128–31 Euripides suggests that athletes cannot manage the wealth they acquire, and, echoing Xenophanes' sentiment, he says, "We ought rather to crown the good man and the wise man" (S. G. Miller trans.).

64. Miller, 1991, no. 160: "A gift. Kleombrotos son of Dexilaos having won at Olympia and having promised a prize of equal length and width [?] to Athena, dedicated a tithe." *Supplementum Epigraphicum Graecum* 35.1053; Jeffery, 1990, 456, no. 1a, pl. 77.

65. Athenaeus 12.522a, c–d. Held in non-Olympic years, the Great Panathenaia was not meant to compete with Olympia: Athens encouraged Athenian competition in the Olympics, and it also encouraged Athenian and foreign competition in the Panathenaia. Athens wanted to rival other states, not Panhellenic Olympia. Cf. Burkert, 1985, 106, who repeats the traditional view that city festivals like the Panathenaia and the Heraia at Argos "strove to attain an equal status [with the Panhellenic circuit games] without quite succeeding." On state rewards at Athens, see below.

66. State rewards and honors became institutionalized after the emergence of states, and they were for citizens only. By contrast, the Olympic and Panhellenic prizes could be won by any free Greek regardless of his citizenship. Citizens of Elis could compete and athletes could shift their allegiances (e.g. Pausanias 6.13.1). Prizes were always put out first and always awarded, but state rewards were given by a state only if one of its citizens was victorious. State rewards were given unpredictably and infrequently, but holders of open games had to provide prizes for every event for every games.

67. "Civic" is used herein as defined in Kyle, 1987, 2, as designating "athletics with a significant degree of state involvement, such as in the official administration of contests, prizes and facilities." For reservations about such usage, see Chapter 4 in this volume, by Alan Boegehold.

68. On the correlation of the process of state formation with the spread of Panhellenic and state games, see Morgan, 1990, 191–234.

69. Pindar and the scholia frequently mention chrematitic and stephanitic prizes; e.g. *Nemean* 10.22–48 in a few lines mentions "a contest of bronze" at

Argos, Panhellenic crowns, silver wine cups from Sikyon, the cloak of Pellene, and "countless prizes of bronze impossible to reckon." On local games, see Pleket, 1975, 56–57; Klee, 1918, 20–70; and Crowther's 1985b bibliography, 532–54, covering about a hundred cities and including L. Robert's epigraphical works on Asia Minor and I. Ringwood Arnold's works on games of the mainland.

70. Scholars suggest that contests at Athens evolved from funeral games and the cult of the heroized dead into festivals to major deities; e.g. see Thompson, 1961, 231; but cf. Robertson, 1992, 95–96, 205. Roller, 1977, 6–46, and 1981a, sees the funeral game tradition as old and distinct; the nonfuneral Panhellenic games took on funeral associations. She feels that civic athletic festivals (related to hero cults) superseded the old tradition of funeral games at Athens. Also see Morgan, 1990, 205–12.

71. In this, as in his other reforms, Solon was acting for the state and establishing positive civic-oriented policies; see Kyle, 1984.

72. G. Ferrari, "Menelās," *JHS* 107 (1987) 180–82, discussing a Proto-attic stand from Aegina, revives the idea of possible contests (choruses and horse races) in the pre-566 festival. On horsehead and possible Proto-Panathenaic amphoras, see Kyle, 1987, 22–24.

73. Tzachou-Alexandri, 1989, nos. 25–26; M. Kilmer, "Sophilos and Literacy," *AJA* 98 (1994) 340.

74. On 566: Marcellinus, *Vita Thukydides* 2–4; Eusebius, *Chronica* on Ol. 53.3–4; see Kyle, 1987, 24–29. That contests were an appropriate but not essential part of the early festival seems to be suggested by the tradition that games were added to an existing festival. Eusebius is sometimes taken to mean that gymnastic contests were added to earlier equestrian games, but Shapiro, 1989, 19, rejects this for lack of ceramic evidence: "the whole idea of competitions as a central element of the festival was new" in 566. On the inscriptions: Raubitschek, 1949, nos. 326–28; Robertson, 1992, 108. Raubitschek, 359–64, and G. Welter, "Vom Nikepyrgos," *AA* (1939) 12–14, associated the establishment of a cult of Athena Nike on the Acropolis with the reorganization of 566. Mark, 1993, redates the altar in question to 580–560.

75. Panathenaic tribal prizes, bulls and money for feasting, may derive from earlier traditions, as in the Heraia at Olympia, which offered a crown and a portion of the flesh of the sacrificial victims as prizes. Just as the chieftain in a primitive culture symbolically distributes meat at a sacrifice or feast, now the state of Athens was the donor and distributor. On *sitesis*, and possible roots in meals for the guests of Athenian kings, see Bowra, 1938, 274. The nature of the prizes may be old, but giving them on a tribal basis probably is related to Kleisthenes' reforms. Musical prizes were precious metal crowns and money, perhaps because musical professionalism predates athletic. On nonindividual events, see Boegehold's chapter in this volume and J. Neils, "The Panathenaia and Kleisthenic Ideology," in Coulson and Palagia, 1994, 151–60.

76. Modern antielitism should not make us underestimate the role of the aristocracy. The polis may have been somewhat egalitarian in its concept of citizenship, but aristocrats led in public life and asserted their status via their

lifestyle. Athletic display, as competitor or patron, was especially important in the changing era of hoplites, assemblies, and new economic groups: see Starr, 1992, 17–42; Donlan, 1980, 35–75, 95–111. On aristocrats, Pindar, and social reintegration, see Kurke, 1991, *passim*. On Pindaric ideology, in brief, see Lee, 1983.

77. Connor, 1987; Pleket, 1975, 74–89.

78. Peisistratos: scholiast on Aelius Aristides, *Panathenaicus* p. 189.4 (3.323 Dindorf); on the problems, see Davison, 1958, 26–29; Robertson, 1992, 90–92. K. Rhomiopoulou, "The Panathenaic Festival," 41, in Tzachou-Alexandri, 1989, revives the idea of Peisistratos as responsible, with Hippokleides as his "friend." Cf. Williams, 1985, 30, who credits Peisistratos with enlarging the Panathenaia into the Great Panathenaia: "It also seems likely that he was responsible for the institution of special amphorae to hold the oil won by the victors." Shapiro, 1989, 2, 18–21, 41, 165, is judiciously cautious and suggests that the most distinctive influence of the tyranny may have been on the musical performances.

79. Elimination or diminution of cults and celebrations would be awkward but expansions would be popular. Robertson, 1985, 295 n. 124: "We need not look for any correlation with political vicissitudes at Athens. Public festivities were not transformed by manifesto, and Peisistratus and his sons had no economic or sectarian policy of promoting certain deities over others, but followed the usual pattern of aristocratic patronage and display." If a political motive is sought, it is readily available in the rivalry of "Shore" and "Plain" (and soon "Hill"): Hippokleides perhaps was making a popular overture in competition with the Alkmeonids, as he had competed with Megakles at Sikyon.

80. Thucydides 2.40.4–5; cf. Hesiod above.

81. As noted above, gifts could not be disassociated from the men who gave them, so emerging states had to associate those men with the state, i.e. as institutionalized representatives of the state's corporate donation to the local community and to the community of states. On the offices of *hieropoioi* and *athlothetai* at Athens, see Davison, 1958, 31–33; Nagy, 1978. Nagy, 1992, presents the *athlothetai* as well suited for depiction on the Parthenon frieze; however, see Chapter 9 in this volume, by Evelyn Harrison.

82. See the discussion by Neils, *G&P* 29–30, 39–40.

83. See Valavanis, 1990, 325–59 on official prize ceremonies. Similarly, Argos gave both bronze shields and myrtle wreaths; Ringwood Arnold, 1937. Pleket, 1975, 57, discussing "sacred crown games," uses examples from Peloponnesian sites as well as Athens to show that many games gave both wreaths and valuable prizes. Cf. Rhomiopoulou (supra n. 78) in Tzachou-Alexandri, 1989, 46: "The only purely symbolic prizes were the favours given unofficially to victorious athletes by their relatives and admirers: these included sprigs of olive, palm-leaves, and ribbons to be tied round the winners' heads, arms or legs." A fifth-century epigram for Nikoladas refers to winning both crowns and amphoras of oil at Athens; see Ebert, 1972, no. 26 lines 3–4; also a second-century A.C. epigram from Magnesia refers to "the sacred wreath of the Pana-thenaia"; Moretti, 1953, no. 71 line 7, cited in Tzachou-Alexandri, 1989, 211.

Unofficially, spectators, friends, lovers, and would-be lovers decorated victors on their own; see Giglioli, 1950. See the discussion in Tzachou-Alexandri, 1989, no. 199, of *ARV*² 32, 3, which probably depicts an unofficial decorating of a victor.

84. Thucydides' collocation perfectly articulates the overlap of symbolic and material gift-giving models. Panhellenic wreaths brought the greatest glory, but Isokrates (50.45–46) still claimed that Athens' contests had the "greatest prizes."

85. There were no crown prizes in Homer, but the frequency of scenes of tripods plus wreaths shows that chrematitic games had picked up wreaths by the sixth century. E.g. the Chest of Kypselos (Pausanias 5.17.9–11) belongs dramatically prior to the second half of the seventh century, but vase-painting parallels date to the sixth; on the chest figures were identified by inscriptions, as on vases, spectators were depicted (as on the Sophilos fragment), there were tripod prizes (as on the François vase), and (5.17.10) Iphiklos is winning the foot race and "Akastos is stretching out with the wreath."

86. Aristotle, *Constitution of the Athenians* 60.2. Athena gave the oil, the *techne* of the potter, and even the victory itself, as in *Iliad* 23.769–83. In what Kurke, 1991, 96–97, calls the "metaphysics of gift exchange," the association of prizes with gods or heroes makes them "top rank" gifts with a temporal and cosmic dimension.

87. Measures of corn and barley as prizes at Eleusis: Hyde, 1921, 20; Rouse, 1902, 150–51. In the Oschophoria young men with vine branches raced for the prize of the *pentaploa* drink: see Kadletz, 1980; Robertson, 1992, 124–25. On wine and crowns as the prizes in the official choes contest: Hamilton, 1992, 10–14. Sansone, 1988, 95–102, surveys ancient explanations of why oil was associated with preparations, exercise and cleansing, and suggests a derivation from early hunters' use of oil to mask their scent.

88. E.g. the promotion of oil exportation, stimulation of the pottery industry, civic recognition of athletic victors. Such prizes also were consistent with Solon's general aims of *eunomia* and civic consciousness.

89. Possibly amphoras were not needed before 566 because, if any oil was awarded, it was in small quantities. Perhaps early victors got a special wreath and a special bit of oil as a decoration and an anointment.

90. Young, 1984, 127. For estimates of the value of new (6 obols) and used (2.4–3.7 obols) vases, see Neils in *G&P* 46. R. M. Cook, *JHS* 107 (1987) 167, rejects Webster's (1972, 52, 62) idea of a second-hand market, but the repair and the use of Panathenaics in graves and dedications indicates that they were treasured even after the oil was used up. Shapiro, 1989, 18, is correct that, technically and originally, the vases "of course were not the prize itself, but only containers of the prize olive oil" (Aristotle, *Constitution of the Athenians* 60.4, says the prize for gymnastic and equestrian games was "oil"), but container and contents did come to be seen as a combined prize. Cf. Pindar, *Nemean* 10.35–36: "in earth baked by fire came the olive oil in richly painted vases" (J. E. Sandys trans.).

91. See Neils' excellent review in *G&P* 30–38.

92. Hamilton, in Chapter 6 in this volume, properly notes that, while it is a common assumption, we are not certain that a victor received prize amphoras depicting the specific event in which he was victorious. Following G. R. Edwards, 1957, Hamilton suggests that athletic victors got a mixture of vases depicting various scenes. While the exact historicity of every specific detail (e.g. of athletic technique, stage of proceedings, depiction of participants) can be questioned, the depictions of contests on official, inscribed prize vases remain invaluable evidence for the Panathenaic program. Clearly the art and iconography of Panathenaics should not be read in a superficial, literalist fashion. Ancient sport—and its depiction and recording—was significantly different from modern sport; see Guttmann, 1984, 15–55, and cf. Carter and Krüger, 1990. Tracy and Habicht, 1991, publish the largest known fragment of Panathenaic victor lists (from 170, 166, 162 B.C.) and discuss other second-century lists (*IG* II² 2313–17), but they caution (200, 217–18, 235) that equestrian programs varied more than gymnastic ones, and that programs were expanded in the second century.

93. Vertically inscribed columns: e.g. Raubitschek, 1949, nos. 1–2, from the first half of the sixth century. The Burgon amphora adds *emi*, but this was dropped as unnecessary, like early specifications in writing of the event (usually a race) or age category; see Neils in *G&P* 40–42, on inscriptions on Panathenaics.

94. *Aethla* is used for both prizes and games in Homer, so *athlon* could be taken as "of the prizes" or "from the games"; Beazley's "a prize from the games at Athens," 1986, 81, captures the (intentional?) ambiguity.

95. Cf. A. H. Smith, "The Tomb of Aspasia," *JHS* 46 (1962) 253–57: the inscription of ca. 440 (Smith pl. xiv) on a fifth-century lebes, transliterated from the Argive script by Smith, says: *[h]e[ras] A[r]ge[i]as emi ton awethlon*, "I am one of the prizes of Argive Hera"; on such prize bronzes from Argos: Jeffery, 1990, 164. For more inscribed ethnics on fifth-century prizes from civic games: *ibid.* 85, 93, 367, and cf. 176.

96. Neils in *G&P* 42. Hamilton, 1993, argues that on fourth-century prizes archons' names "were official only in the sense that they were part of that year's design," and further that, similarly, the prize inscriptions were "equally decorative and so should not be used as *the* criterion for marking prize Panathenaics." Hamilton, 1992, 127–34 and app. 7, 231–40, makes the same argument, adding the variable of chronology to the criteria of shape, size, iconography, and inscription. He suggests that while 45 percent of 62 sixth-century Panathenaics are uninscribed, official Panathenaics are very likely to be inscribed after the sixth century. Does this reflect a "settling" of the canon in the last quarter of the sixth century?

97. See various explanations of amphoras of Panathenaic shape in Hamilton, 1992, 131–32 nn. 32, 35; Shapiro, 1989, 32–36; and Neils in *G&P* 38–39.

98. Athenian state rewards and honors (*aristeia*) were for Athenian victors at the Panhellenic circuit games, not at the Panathenaia. Although given for both first and second place, individual Panathenaics apparently do not indicate which they were given for; victors might have wished this, but Athens' donor

aims were served without it. Neils in *G&P* 42, suggests that *stadion andron nike* on Munich 1451 was added "possibly to differentiate it from the prize for the runner-up"; but, if so, it was unusual in doing this. Such inscriptions probably refer to the event, not the placement. She also suggests (46) that a few undersized but inscribed vases were for boy victors or second-place winners, but *IG* II² 2311 indicates fewer, not smaller, vases for such athletes.

99. Since Panathenaic vases were new as prizes and differed from earlier prize iconography, the inscription helped clarify their function and origin. However, literacy probably was quite limited in Archaic Athens, a predominantly oral culture, and inscriptions were used as a supplement, not a substitute, for other forms of communication. On the debate over ancient orality and literacy, *inter alia* see Thomas, 1989; W. V. Harris, *Ancient Literacy* (Cambridge 1989).

100. Athenian victors gained an additional privilege along with their prize oil: scholion on Pindar, *Nemean* 10.36. Vos, 1981, 41 and n. 49, prefers the idea that of private citizens only victors could sell the sacred oil, not the idea that winners could export their oil tax-free; cf. Young, 1984, 126. Neils in *G&P* 38, notes that features of the amphoras "derive from the undecorated coarseware commercial jars used to transport wine and oil overseas"; and she suggests (44) that pseudo-Panathenaics of ca. 550–500 possibly were made as containers for the state's exporting of the excess oil from the *moriai*, and that the image of Athena labeled this special product, but that such labeling was dropped with the shift from the collection of oil from specific trees to a tax per olive orchard.

101. E.g. Gardiner, 1910, 235.

102. Vases were distributed both by sales abroad by Athenian victors and by being taken home by foreign victors; see Neils' argument in *G&P* 48–50 for finds in South Italy and North Africa being from tombs of actual victors, and Chapter 6 in this volume.

103. Coins declare a state's autonomy, and prizes declare its status as host and *agonothetes*. When states, like Athens, became well established, they asserted their claim to status via open games, valuable prizes, and coinage. The design of the Panathenaics indicates economic ambitions abroad in addition to their roles in prize giving, local celebration, and self-assertion at Athens. Panathenaics are like the early owl tetradrachms (introduced in Athens in the fourth quarter of the sixth century) in that both bifacial objects used standardized national iconography as well as an inscribed ethnic. On the coins, see Kroll, 1981; Kraay, 1956. The owls used the iconography of Athena on their obverse and the inscribed ethnic on their reverse; the amphoras started with and kept both on their obverse. Both the coins and the amphoras were intended to help promote the foreign export of surplus commodities (the silver of Laurion, oil, and pottery). Both Panathenaics and owl coins are found abundantly abroad, and both came in large denominations or quantities; Johnston, 1987, sees 1,400 vases per Great Panathenaia as a minimum estimate.

6

Panathenaic Amphoras
The Other Side

Richard Hamilton

There are three classes of information for the prizes given at the Pana-
thenaic games: inscriptions, testimonia, and vases. Since the inscriptions
are late and the testimonia are meager in the extreme, it is not surpris-
ing that scholars studying the games have turned to the Panathenaic
amphoras, which exist in large numbers and extend for more than two
hundred years, beginning in the mid-sixth century.[1] The Aristotelian
Constitution of the Athenians tells us that such amphoras filled with olive
oil were given as prizes to victors in the athletic and equestrian com-
petitions at the Great Panathenaia, and it is natural to suppose that the
event depicted on the reverse of an amphora represented the event for
which it was the prize. Still, we are learning not to trust "nature" in the
study of Greek vases, and a calculating examination of the Panathenaics
will provide some surprising anomalies.

First we must ask precisely which vases were given as prizes, since
there are hundreds of amphoras of Panathenaic shape, some black-
figure, some red-figure, some large, some small, some even miniature,
with a variety of decoration on either side. Scholars have long been
agreed that the prize vases are the ones with the inscription "(one) of
the prizes from Athens" on the front (see Fig. 5.6) and only those. There
are almost two hundred extant vases so inscribed; they are all black-
figure, and all have the same basic picture on the front—an armored

Athena brandishing a spear and striding left between two Doric columns surmounted by cocks. Most of these vases are over 60 cm. high, whereas the uninscribed black-figure Panathenaics are usually under 50 cm.[2] The uninscribed vases are not only shorter; they often vary the canonical front in some obvious way—there are no columns or only one; the columns are Ionic, not Doric; they support owls, vases, disks, or even panthers instead of cocks; Athena strides right instead of left; she is accompanied; she has no aegis[3]—and scholars have concluded that the uninscribed Panathenaics were not awarded as prizes but were made "for the market."[4] The twenty or so inscribed Panathenaics that are under 60 cm. present a problem, but there may be an historical explanation.[5] Even if there is none, we need not conclude that the inscription is misleading but simply that the vase itself was not the official prize but rather the container for the prize.[6] On the other hand, there are a number of uninscribed Panathenaics that seem to be perfectly regular except for the lack of an inscription.[7] I have argued that here chronology is a key factor: early Panathenaics are often uninscribed; late ones are always inscribed.[8] Once again, though, the inscription is a good guide; it seems that no inappropriate vases have it even if some appropriate vases lack it.[9]

The challenge to the efficacy of the inscription is greater when we consider the events depicted on the reverse. Chapter 60 of the Aristotelian *Constitution of the Athenians* tells us that "the prizes are money and gold for winners of the musical contests, shields for the contest in manliness, and olive oil for the athletic contests and horse races." This testimony is confirmed by a fourth-century inscription (*IG* II[2] 2311) which lists various events and their prizes: gold crowns and money for musicians and amphoras of olive oil for horsemen and athletes.[10] Still, there is one inscribed but undersized Panathenaic amphora showing a musician (St. Petersburg 17295),[11] and the usual way of resolving this contradiction has been to say that the prizes for musicians changed after the reestablishment of democracy in 403 and that the inscription is precisely the record of that change.[12] The chronology is a bit shaky;[13] moreover, there are other anomalous inscribed Panathenaics besides St. Petersburg 17295. I know of five exceptions in all:

(*a*) St. Petersburg 17295: kitharode or kitharist (54.0 cm.)
(*b*) London B 131: mule cart (63.7 cm.)
(*c*) London B 132: mule cart (63.1 cm.)
(*d*) Madrid 10901: hoplite fight (48.0 cm.)

(e) Zoullas collection: man with two shields, servant holding a third (65.8 cm.; *G&P* no. 46)

The Zoullas amphora has most recently been interpreted as an illustration of the hoplite run and therefore appropriate to a prize vase,[14] but earlier suggestions include the *euandria* or the pyrrhic dance, neither of which was awarded oil, and its thematic similarity to the explicitly labeled acrobat on the uninscribed Panathenaic in the Cabinet des Médailles even led Dietrich von Bothmer to suggest that "perhaps there was a competition involving two shields at the Great Panathenaea."[15] Regardless of which interpretation is correct, their multiplicity shows how unconventional the representation is.[16] Similarly, scholars have tried to explain away the two London amphoras either as actually showing horses rather than mules (or an artist's mistaken rendering of horses) or as an evanescent Panathenaic event, much like the mule cart race at Olympia.[17] The Madrid vase has been discounted because it is smaller and the inscription is *on* the column, not *by* it.[18]

Still, this is only at most five anomalies in almost two hundred vases, and two of those five are not full-size. Moreover, they are widely different in subject, one representing a musical event, one pair an equestrian event, and two not representing events at all.[19] We could add another six or seven inscribed Panathenaics that show the victor being crowned, which, while not inappropriate for oil events, is certainly not confined to them, since all victors were crowned.[20] Finally, there are at least two inscribed Panathenaics that mix bearded and beardless competitors, even though they are listed separately on the inscription and presumably always were separate.[21]

These are all minor anomalies though, since the vast majority of inscribed Panathenaics do show events for which amphoras were the prize. Thus, we find only boxing, wrestling, running, horse riding, chariot driving, pentathlon, and, on the fourth-century vases, shooting the javelin from a horse ("quintain"), and all of these are listed in the fourth-century prize list (*IG* II² 2311) with oil awards;[22] and conversely they do not show events for which amphoras were not awarded, such as rhapsodes, aulodes, torch race, or pyrrhic dance, though we find all of these represented on other vase shapes.[23]

Much more serious is the systematic distortion we can sometimes see. In the appendix I have listed all the inscribed Panathenaic amphoras for which I could find an illustration. When divided into early and late groups (sixth to early fifth century and late fifth to early fourth, beginning with the Robinson group), they show pronounced changes in

both event and contestant over time. The numbers are shown in Table 6.1 (the plus sign adds doubtful cases).

Thus equestrian events go from being 36 percent (37/104) to 15 percent (9/62); bearded competitors go from 66 percent (69/104) to 8 percent (5/62).[24] Both changes are statistically significant.

The decrease in equestrian representations has been explained in terms of social change. Donald Kyle argued that "economic hardships in this era [404–355] may explain a drastic reduction in the number of equestrian victors."[25] But later he qualified his findings: "Always in association with the wealth of an upper class, hippotrophy seems to have decreased with the fortunes of Athens in Period Four. Its revival in Period Five [355–322] shows its strong appeal to status-conscious men of wealth."[26] Yet the supposed lapse in Period Four does not seem particularly significant, as we can see by comparing Kyle's list of Athenian equestrian victors with Davies' list of Athenian competitors in two-horse and four-horse contests at Panhellenic games (Table 6.2).[27]

Most noticeable is the high percentage of equestrian victories in the sixth century, which may be more the result of a difference in sources

Table 6.1. Events and Contestants on Inscribed Panathenaics

	Competitor			Event						
	Beard	Beard-less	"Boy"	Run-ning	Box-ing	Wrest-ling	Chariot Race	Rid-ing	Pentath-lon	Other
Early (104)	68+1	30+2	5+1	27	9+1	12	26	11	10	7
Late (62)	5	49+1	4	12	9	17	8	1	1+1	13

Table 6.2. Equestrian Victors by Period

Period	Kyle Equestrian	Kyle Athenian	% Athenian	Davies
I (up to 594)	5 (5)	0 (0)	0%	0
II (594–490)	12 (21)	9 (10+4)	75%	11[a]
III (490–404)	22 (40)	7 (12+2)	35%	4
IV–V (404–322)[b]	38 (50)	13 (13)	32%	7

Sources: The figures under "Kyle" are "actual" Athenian equestrian victors as listed in Kyle, 1987, chap. 4, with "probable" victors in parentheses.

[a] Actually to 486.

[b] Kyle's Period IV (404–355) and Period V (355–322) have been combined to allow comparison. Period IV: 2/11 (2/17). Period V: 11/27 (11/33).

than a difference in economic conditions: in the fourth century we have inscriptions; in the sixth century we have folktales.[28]

At the same time, Kyle noted that according to T. B. L. Webster, horses appear with considerably less frequency on Attic vases after the mid-fifth century.[29] If this is true, and a sampling of the Beazley Archive database suggests it is so, the illustrations on the prize Panathenaics may be part of a more general iconographic trend, whether economically based or not (Table 6.3).[30]

The great increase in representations of unbearded competitors seems likewise to be part of a more general trend, often noted in handbooks. Interestingly, the number of smaller (= "boy") competitors does not change significantly over time: 6/105 early; 4/62 late.[31] This suggests that the change from bearded to beardless is stylistic more than social.[32] In any case, the presence or absence of a beard says nothing about whether the event was for "beardless" boys (or youths) or men, any more than the disappearance of riders in the fourth century marks the disappearance of riding events.[33]

The conclusion is obvious: the extant illustrations do not reflect the distribution of prizes. If anything, the inscribed victory lists lead us to expect a rise in equestrian events, but the vases show a precipitous drop. According to *IG* II² 2311, boy victors should receive about half the number of amphoras that men victors do, but the vases show them receiving about a tenth.[34] Ninety percent of the extant late prize amphoras

Table 6.3. Illustrations on Panathenaics

Illustration	Webster	Beazley Archive[a]
Horse		
black-figure	437	459 (3%)
red-figure	287	512 (2%)
Chariot		
black-figure	"lots"	1,983 (12%)
red-figure	22	577 (2%)
Athlete		
black-figure	199	120 (1%)
red-figure	1,371	1,438 (5%)
Total		
black-figure 16,240		
red-figure 28,722		

[a]The sampling was done in early July 1993; I am grateful to Dr. Donna Kurtz for access to the database.

show beardless athletes, even though it is inconceivable that 90 percent of the vases were given to youths.[35] This conclusion is confirmed by the distribution of archons' names on the fourth-century vases, for they come from any of the four years in the Panathenaic cycle, suggesting that the vases were made over the course of the cycle rather than at one time.[36] A similar fluidity is observable in the variety of hands evident on the inscribed Panathenaics of any given year.[37] Given this variability in time of production and craftsman, we can hardly expect careful coordination of illustrations so that the sixty amphoras given to the youth winning the dash, for example, will show runners. Not surprisingly, several events were painted on vases in a given year.[38] On the other hand, there are too many inscribed Panathenaics to suppose that only one was painted for each prize. A victor, therefore, was liable to get a mixture of illustrations, displaying the Panathenaia in all its glory rather than only in his specific event.[39]

This conclusion may find some support in an early fifth-century Tarentine grave containing inscribed Panathenaic amphoras showing pentathlon, chariot race, and boxing.[40] Since it is unlikely that the deceased was victorious in all these disparate categories, it is reasonable to conclude that as victor he received a mixed set. On the other hand he may not have been a victor at all but rather a collector.[41] Such appears to be the case with the Athenian buried in the Lembesi-Porinou Street along with at least ten fourth-century Panathenaics whose archon names span more than two decades, much too long a period for one athlete to be active.[42] Other groupings of Panathenaics only complicate the issue:

(a) Fragments of another fourth-century set were found scattered in the lower floor of a building in Rhodes, apparently all from the same year and all painted by the same hand with the same chariot scene on the reverse. At least one of the fragments had the name Nikagoras later painted on it in Rhodian letters, and, since we know a Rhodian named Nikagoras won in many hippic competitions at this time, including those at Athens, it is possible, as Jiří Frel and Panos Valavanis argue, that these Panathenaics are dedications by the victor.[43]

(b) Nine Panathenaics dated by archon name to 362 and 358 were found in three pits in an Eretrian house destroyed about 260, eight showing wrestling, one showing the pankration. Frel thinks they all belonged to the victor; Valavanis believes they had been imported by a trader to sell in the local market.[44]

(c) Eight Panathenaics found in an Athenian street corner show different competitions but are all by the same painter and have the same

archon name, and Frel and Valavanis conclude they were discards from a potter's workshop.[45]

Despite their importance only one of these groups has been published and so no firm conclusions can be drawn. Still, the variety of combinations is striking: one grave had Panathenaics with mixed contests; another grave had Panathenaics with the same contests; one street had Panathenaics with mixed contests; another street had Panathenaics with the same contests.[46] Thus, although one cannot claim that the Tarantine grave proves that the victor was awarded a medley of illustrations, it does at least show that the idea of a mixed set was not repugnant.

More generally, the marked change in the popularity of events represented on the reverse—along with noncanonical events (quintain, *apobate*) and noncanonical representation of events (victor, defeat)—joins the large number of changes that have been noticed on the obverse of the fourth-century Panathenaics: replacement of the owl on the column with figures (probably statues); archons' names; political shield devices (Tyrannicides, Nike); Athena's stance and drapery. These changes are spread over decades, and so it is difficult to believe that the decoration of Panathenaics was strictly controlled by the state.[47]

Appendix: Prize Panathenaic Vases

The vases in the following appendix are arranged following the chronology given in Beazley, 1943. Amphoras subsequently attributed to the same painters are included; attributions are mentioned only when not Beazley's. The vases are as listed in *ABV* unless otherwise noted. Three catalogues are abbreviated: *B* = Brandt, 1978; *E* = Eschbach, 1986; *S* = Smets, 1936. Brandt supersedes Smets, who supersedes Brauchitsch, 1910. Height is noted in parentheses only when under 60 cm.

Key for events: *p* = pankration, so distinguished from wrestling only when it is clear (e.g. Naples 81294); *b* = biga, two-horse chariot distinguished from the usual four-horse chariot; *h* = hoplites; *m* = mule cart; *ap* = *apobates*; *q* = quintain; *v* = victor.

Findspots are coded as follows: Attica (*a*), Greece (*g*), Italy (*i*), and "other" (*o*). I am grateful to the editor for many improvements to the list.

Appendix: Prize Panathenaic Vases

	Competitor		
	Beard	Beardless	"Boy"
6th Century			
Burgon Group			
B1 London B 130		x	
New York 1978.11.13 (Nikias)[48]	x		
Lydos (and Related)			
B20 Florence 97779 (58)	x		
Exekias and Group E			
B23 Karlsruhe 65.45 (59.6)	x		
Swing Painter and Circle			
Malibu, Getty 86.AE.71[49]		x	
B26 Munich 1451	x		
Euphiletos Painter			
B35 London B 134	x		
B36 Leyden xv i 77 (= PC 8)[50]	x		
B37 Boston 99.520	x		
B38 Munich 1453	x	x	
B39 New York 14.130.12	x	x	
B40 Amsterdam 1897[51]		x	
B41 Bologna PU.198 (side B)	x		
B43 Munich 1452	x		
B47 Milan, Galleria Geri[52]			
Lysippides Painter (and Related)			
B28 Nauplion 1		x	
B29 Vulci 64220		x	
B30 New York 56.171.5[53]	x		
Michigan Painter and Related			
B63 Vatican 374	x	x	
B64 Munich 1454	x		
B65 Compiègne 986			
B66 Havana ex Lagunillas[54]	x		
B69 Louvre F 278		x	
B70 Basel Cahn	x		

Running	Boxing	Wrestling	Chariot Race	Riding	Pentathlon	Other	Findspot
			b				a
x							
			x				i
		x					
		x					
x							
					x		i
					x		i
x							i
x							i
x							i
x							i
						h	i
			x				i
						h	i
				x			g
x							
			x				
					x		i
x							
						h	i
						h	
	x						i
			x				

Appendix continued on following pages

	Competitor		
	Beard	Beardless	"Boy"
Painter of Warsaw Panathenaic[55]			
B56 Warsaw 198605	x		
B58 Louvre F 274		x	
B60 St. Petersburg 1510 B		x	
Painter of Copenhagen 99			
B48 Copenhagen 99 (= 797)	x		
Antimenes Painter (and Related)			
B54 Boulogne 441	x		
B55 New York 56.171.4[56]	x		
B57a Taranto 12220		x	
B61 London B 136	x		
B80 Compiègne 987[57]			
B81 Louvre F 273[58]	x		
Leagros Group			
B71 New York 07.286.80		x	
B72 Sparta (53)	x		
B73 Taranto 9887 (= 4595)	x		
Group of Vatican G23			
St. Petersburg 4262 (46)	x		
Brussels R 229 (44)		x	

5th Century

	Beard	Beardless	"Boy"
Kleophrades Painter (and Related)[59]			
Madrid 10900	x		
Louvre F 279	x		
San Simeon, Hearst 9400[60]	x		
New Haven, Yale 1909.12	x		
New Haven, Yale 1909.13	x		
New York 07.286.79	x		
Munich 1456	x		
New York 16.71	x		
Leyden PC 6[61]	x		
Louvre F 277	x		
Norwich 26.49	x		

			Event				
Running	Boxing	Wrestling	Chariot Race	Riding	Pentathlon	Other	Findspot
			x				
				x			i
				x			i
x							i
		x					i
			x				
		x					i?
					x		
			x				i
			x				i
				x			i
			x				g
			x				i
x							
x							
			x				
			x				
			x				
			x				
			x				
			x				i
					x		i
		p					i
		p					i
x							
x							

Appendix continued on following pages

Appendix: Prize Panathenaic Vases (*continued*)

	Competitor		
	Beard	Beardless	"Boy"
Paris market (Kyoto)		?	?
Louvre F 276	x		
London B 131	x		
London B 132	x		
Toledo 1961.24	x		
Mayence (Mainz), Univ. 74 (52.7)	x		
Basel BS 494	x		
Malibu, Getty 77.AE.9	x		
Taranto 115473[62]	x		
Taranto 115474[63]	x		
Taranto 115472[64]	x		
Isthmia IP 1172[65]	x		
Tolmeia[66]			x
New York, Zoullas[67]	x		
Sikelos			
B75 Naples 112848	x		
B76 Geneva MF 151	x		
Eucharides Painter (and Related)			
London B 133		x	
Toronto 350 (= 919.5.148)		x	
New York 56.171.3[68]		x	
Painter of Berlin 1833 (and Related)			
Berlin 1833	x		
Munich 1455	x		
Leyden PC7[69]		x	
Paris, Cab. Méd. 244		x	
Berlin Painter; Achilles Painter			
Castle Ashby 13	x		
Wocaw 142346[70]		x	
Vatican 375		x	
Berlin 1832	x		
Hanover, Dartmouth c.959.53[71]	x		
Karlsruhe 69.65[72]	x		
Melbourne, Geddes[73]	x		
Bologna 11		x	x

			Event				
Running	Boxing	Wrestling	Chariot Race	Riding	Pentathlon	Other	Findspot
					x		
	x						
			b,m				i
			b,m				i
		p?					
			x				
			x				
			x				
			x				i
					x		i
	x						i
x							g
					x		o
						h	
		x					i
x.							
				x			i
				x			
				x			
	x						i
		x					i
				x			i
				x			i
x							i
				x			i
x							i
x							i
		x					
x							
			x				
x							i

Appendix continued on following pages

Appendix: Prize Panathenaic Vases (*continued*)

	Competitor		
	Beard	Beardless	"Boy"
Bologna 10 (not 12)	x		
Naples RC 184 (50)		x	
S74 Reggio			
Harvard 60.309[74]		x	
Taranto 4601[75]		x	
Aegisthus Painter			
Naples Stg. 693		x	x
Group of Compiègne 985			
Compiègne 985 (51.5)		?	

UNATTRIBUTED BUT DATED ADDENDA TO BEAZLEY'S LISTS

6th Century

	Beard	Beardless	"Boy"
S24 Würzburg 171		x	
B84 ex Basseggio	x	x	x
B82 Erlangen I 517a[76]	x		
S35 Naples market[77]			
S37 Naples 81294[78]	x		
Leyden II 1681	x		
B83 Geneva MF 150 (47.4)[79]	x		
Kerameikos PA 443 (Frel 7)	x		

Early 5th Century

	Beard	Beardless	"Boy"
S38 Naples 81293[80]	?		
S70 Frankfurt am Main St V2[81]	x		
S72 London B 143 (44)[82]	x		
S73 Berlin 3979[83]	x		
Athens NM 451 (55)[84]			x
S89 Athens NM 452 (= CC 757)		x	
?Berlin 1831 (Gardiner GAS 422)	x		
Marseilles 3067		x	

Event							
Running	Boxing	Wrestling	Chariot Race	Riding	Pentathlon	Other	Findspot
x							i
					x		i
x							i
x							a
	x						i
	(x)					v	i
x							i
			x				i
	x						
	x						
			x				
		p					
					x		
x							
x							a
						h	i?
x							
						h	i
		x					
		x					a
				x			a?
	x						
	x						o

Appendix continued on following pages

Appendix: Prize Panathenaic Vases (*continued*)

Later Vases

	Competitor		
	Beard	Beardless	"Boy"
Late 5th Century			
Robinson Group			
Athens, Agora P 10007	x		
Baltimore 1960.55.3 (53.4)[85]		x	x
Harvard 1959.128 (50.2)[86]		x	x
Mississippi 1977.359 (53.4)[87]		x	
Oxford 1952.548[88]			
Copenhagen 3606[89]		x	
Kuban Group			
London 1903.2–17.1 (57)		x	
St. Petersburg 17553		x	
London B 606	x		
London B 605		x	
Copenhagen 13812[90]		x	
Herakleion 26554[91]		x	x
Herakleion 26555[92]		x	
Hildesheim Group			
Hildesheim 1254		x	
Hildesheim 1253		x	
4th Century (in chronological order)			
E3 Thessaloniki 34.267			
E5 Polygyros, Museum 8.29		x	
E10 Detroit 50.193	x		
E12 Berlin 3980		x	
E13 Oxford 572 (= 1911.257) (56.3)			
E15 Alexandria 18239 (52)		x	
E16 Brussels A 1703		x	
E17 London B 604		x	
E18 New York 56.171.6[93]		x	
E19 London B 603		x	
E27 Athens, NM 20048[94]		x	
E28 Athens, NM 20047[95]		x	
E29 Athens, NM Eretria 14813[96]		x	

Running	Boxing	Wrestling	Chariot Race	Riding	Pentathlon	Other	Findspot
			x				a
		x					a
		x					a
	x						
			x				
		x					
						q	o
	x						o
			x				o
					?		o
				x			
						v	o
	x						o
			x				o
x							o
	x						o
	x						o
x							o
						q	o
			x				a
						v	o
x							o
		p					o
x							o
		x					o
						v	g
		x					g
		x					g

Appendix continued on following pages

Appendix: Prize Panathenaic Vases (*continued*)

	Competitor		
	Beard	Beardless	"Boy"
E38 Athens, NM 20046[97]		x?	
E39 Eretria Museum 14815[98]		x	
E42 Athens, NM 20049[99]		x	
E43 Athens, NM 20044[100]		x	
E44 Athens, NM 20045[101]		x	
E45 Eretria Museum 14814		x	
E49 Paris, Cab. Méd.246			
E56 Alexandria 18238		x	
E57 Louvre MN 706		x	
E58 Harvard 1925.30.124[102]		x	
Malibu, Getty 79.AE.147[103]		x	
E63 London B 607		x	
E64 Munich 7767[104]		x	
E65 London B 608		x	
E66 Paris, Cab. Méd. 247		x	
E67 Volos KA 4266/91[105]		x	
E68 London B 609		x	
E69 London B 610	x		
E70 Sèvres 7230		x	
E71 London B 611		x	
E72 Berlin 3981		x	
E74 Louvre MNB 3223		x	
E75 Cab. Méd. 248		x	
E76 Once Lemaire		x	
E77 Louvre MN 704		x	
E79 Louvre MN 705		x	
E80 St. Petersburg		x	

DATELESS LATE VASES (fragments are presumably inscribed)

	Competitor		
	Beard	Beardless	"Boy"
Athens, Agora P19531[106]			
Athens, 3rd Ephor. A3882/6374 (55+/-)[107]			x
Eleusis, Museum[108]		x	
Eleusis, Museum[109]			
Kerameikos PA 136 fr.[110]		x	
Kerameikos PA 156 fr.[111]		x	
Taranto fr.[112]	x		

Running	Boxing	Wrestling	Chariot Race	Riding	Pentathlon	Other	Findspot
		x					g
		x					g
		x					g
		x					g
		x					a
		x					g
			b				
x							o
						v	o
	x						i
						a	
	x						i
				x			a
						h	i
		x					
x							
x							g
		p					i
x							o
x							o
x							o
	x						o
						h	
		x					o
						h	o
						v	o
x							o
			b				a
						h	a
	x						a
x							a
			x				a
						v	a
		x					i

Notes

1. Kyle, 1987, 33, calls them "a major source for the Panathenaic Games."
2. Both groups are listed and discussed in Hamilton, 1992, 127–34, 231–40.
3. If we combine the lists of Brandt, 1978, 12, Kotsidu, 1991, 95ff., and Neils, *G&P* 44, we have the following oddities. (*a*) One column: London market [Sotheby's, 21.vi.84, no. 402], EKV B1. (*b*) No columns: London B 141 [*CVA* 1 pl. 6.1], London B 144 [*ABV* 307.59; Shapiro, 1989, pl. 12a], Basel market [Shapiro, 1989, pl. 12b], Tampa 86.24 [*G&P* no. 41], Bonn 43 [Shapiro, 1989, pl. 13b], Heidelberg 73.3 [Shapiro, 1989, pl. 11e], Liverpool 56.19.28. (*c*) Ionic columns: London B 135 [*CVA* 1, pl. 3.1]; London B 136 [*CVA* 1, pl. 3.2a–b]; Princeton 1950.10 [*G&P* no. 44]. (*d*) Columns with dinoi: Cabinet des Médailles 243 [*G&P* fig. 23]. (*e*) Columns with owls: Liverpool 56.19.23 [ex Norwich 8; Brandt, 1978, f, p. 12]; Austin 1980.32 [ex Castle Ashby; *G&P* no. 17]; Kerameikos PA 1 [Frel, 1973, fig. 11]; Agora P 24661 [M. B. Moore and M. Z. P. Philippides, *Attic Black-Figured Pottery, Agora* 23 (Princeton 1986) no. 319]; Brussels 232 [*CVA* 1, pl. 14.2]; London B 138 [*CVA* 1, pl. 4.3]. (*f*) Columns with pithoi: Norwich 2 [*ABV* 300.17]. (*g*) Columns with panthers: Copenhagen 3672 [*ABV* 307.58; Böhr, 1982, pl. 88]; Liverpool 56.19.18 [*G&P* fig. 51]. (*h*) Athena facing right: London B 139 [*CVA* 1 pl. 5.3]; Beverly Hills market [Böhr, 1982, pl. 173]. (*i*) Athena accompanied: London B 144 [supra]; Oxford 1965.117 [Shapiro, 1989, pl. 14a]; Basel market [supra]; Bonn 43 [supra]; Liverpool 56.19.27. (*j*) Athena lacks aegis: Naples [Brandt, 1978, pl. 13c–d].
4. Valavanis, 1987, 469 n. 9; Kotsidu, 1991, 92. Neils, *G&P* 44, astutely notes that the pseudo-Panathenaics "end at the beginning of the fifth century, when black-figure is on the wane for all large vases with the exception of the prize amphoras" and that the preponderance of boxing scenes on uninscribed Panathenaics "may indicate a market preference." I find it difficult to pinpoint the disappearance of the uninscribed Panathenaics (the latest being London B 612) and wonder if their popularity is related more to the popularity of their shape than their decoration: whereas the number of kraters and hydrias increases from black-figure to red-figure (hydrias from 616 to 918, as listed in the Beazley Archive in 1993; kraters from 227 to 2,622), the number of amphoras decreases (2,204 to 1,094), and we find hardly any listed in *ARV*² for the late fifth or fourth centuries (6 and 2 respectively) and only 267 for "Classic" painters. Shapiro, 1989, 33, follows Webster in assuming that some of the pseudo-Panathenaics (Bonn 43, Cabinet des Médailles 243, London B 144, Basel Market [Böhr, 1982, pl. 91]) were commissioned by the victor, "since on each vase the particular event is depicted."
5. Kotsidu, 1991, 90 f., accepts the explanation of Vos, 1981, 38, that specific historical conditions explain the few prize Panathenaics shorter than 60 cm. There are, however, a number of reasons why Vos' theory will not work: the vases, except for the two with archons' names, cannot be precisely dated; the fourteen examples are evenly spread over the whole chronological range rather than clustering around one critical point; most important, other prize Panathenaics by the same painter are not similarly short: see Hamilton, 1992, 131 n. 35.

Still, the attempt to relate the amphoras to historical events is understandable: the Peloponnesian War, for example, with its sieges and plagues in Athens should have affected the games, and there is a gap in prize amphoras from about 430 to about 400. At the same time, however, there is considerable evidence for the Great Panathenaia during those years: Xenophon's *Symposion* mentions Autolykos' victory in 422; Lysias 7 mentions the games of 410, while Thucydides 5.47 and *IG* II² 304 imply the games of 418. This still leaves the Archidamian War (431–422 B.C.) without games (see *CVA* Robinson p. 47), but there is no noticeable gap in the annual Great Dionysia during those years. Also, the gap in inscribed Panathenaics starts around 460, not 430.

6. So that the prize of "sixty amphoras of olive oil" listed in *IG* II² 2311 might be packaged in seventy (or fifty) amphoras. The inscription, then, describes the oil, not the vase.

7. Those with heights over 50 cm. include: Halle 560 [*ABV* 120]; Boston 01.8127 [*ABV* 260]; Berlin 1831 [*ABV* 274]; Villa Giulia [*ABV* 286]; London B 612 [*ABV* 414]; Getty 86.AE.71 [*G&P* no. 36]; Toronto 915.24; Liverpool 56.19.23; Louvre F 280; London B 135; Richmond 60.45; Naples [Brandt, 1978, pl. 12g]; Villa Giulia 63573. On most of these the decoration is unexceptional (except the owls on column on Liverpool 56.19.23, the wrestlers over dinos on Getty 86.AE.71).

8. "That is, the inscription became more and more an expected element in the standard Panathenaic design" (Hamilton, 1992, 133). Similarly, the archon's name that appears on fourth-century Panathenaics balancing the game inscription only gradually becomes canonical (Hamilton, 1993).

9. The actual words of the vase, "[one] of the prizes from Athens," suggest, at least to me, that the painter was conscious of his product as a marketable item. That is, since the inscription says "from Athens," not "at Athens," it expects to be read in a non-Athenian context. It is at best a product label, prepared for a middleman. This *may* be a guarantee of the contents, but it may be considerably less. It is not written *for* the games but for *after* the games. See Chapter 5 in this volume, by Donald Kyle.

10. It does not list the shields for manliness. Kyle, *G&P* 95, explains that "probably there was a tribal prize and also individual shield prizes for winners," but this does not solve the problem, since both prizes should have been listed on the inscription, as they are with the boat race. It seems more likely that the prize changed from tribal to individual in the forty years between the inscription and the Aristotelian text. Another inscription (*IG* II² 334) suggests that the Lesser Panathenaia was reorganized in the 330s, and Tracy, 1991, 146, notes that in the second-century Panathenaic listings, only winners of oil prizes are listed. This could be an accident of survival but may indicate the disappearance of the tribal events. The contest for manliness is put at the end of *IG* II² 2311 but comes second in the Aristotelian text, which also suggests that there has been a change.

11. It belongs to the Robinson group, four of whose seven inscribed Panathenaics are undersized (see above n. 5). I leave aside the Hellenistic fragment of a prize Panathenaic found in the Agora (P 8522) showing a kitharist, which is in white-ground rather than black-figure.

12. Brauchitsch, 1910, 126; Hönle, 1976, 243; Valavanis, 1987, 475; Kotsidu, 1991, 88.

13. Valavanis, 1987, 476–80, notes that the inscription dates twenty years later than 403 and places the supposedly crucial change in oil gathering somewhere between the two dates, yet we have evidence for the change in prize as early as 402. One of the records of the Treasurers of Athena, *IG* II² 1388 A 36, mentions a crown weighing 85 drachmas dedicated by the city as *niketeria* for a kitharode, and this is connected by Davison, 1958, Valavanis, 1987, Kotsidu, 1991, and others with the kitharodic victory crowns mentioned in *IG* II² 2311.

14. See *G&P* 35.

15. Bothmer, 1983, 67.

16. The prominent shield blazon of a running hoplite is a strong argument for the most recent interpretation (Tiverios, 1987; *G&P* 175), but his interpretation of the action (testing which shield feels best) seems unlikely: one would not hold two shields at once, and the assistant would certainly not be readying a third. (Since the protagonist is not helmeted, he cannot be expecting to run immediately.) One prize Panathenaic, Bologna PU 198, has the hoplites running by a basket of some sort (certainly not an oil container as suggested in *CVA* Bologna 2), but they are clearly in a hoplite race nonetheless.

17. See Kyle, 1987, 187 for discussion and literature.

18. Brandt, 1978, 9 n. 5; Neils, *G&P* 40. It presumably is an illustration of *hoplitomachia*, to the popularity of which Plato attests in his *Laches*. See Kyle, 1987, 182.

19. Compare the "inappropriate" events depicted on the uninscribed Panathenaics, almost all of which are musical: London B 139: kitharist (35.5 cm.); Cabinet des Médailles 243: acrobat with two shields on horse (37 +/- cm.); St. Petersburg 1911.12: piper (48 cm.); Baltimore, 48.2107: kitharist (43 cm.); Bonn 43: aulode (39 cm.; Shapiro, 1989, pl. 13.); Louvre E84: kitharist (45 cm.); Norwich 1 (= Liverpool 56.19.18): rhapsode (ca. 44 cm.); Oldenburg XII.8250.2: rhapsode (40.5 cm.); Louvre F 282: kitharist (39 cm.); Bologna Pell. 14: kitharist (40 cm.); Reggio 4224: kitharist (ca. 40 cm.).

20. Valavanis, 1990.

21. Three inscribed Panathenaic amphoras, do this: Munich 1453, New York 14.130.12, and Vatican 374. We find boy/beardless/man categories in the fourth-century *IG* II² 2311; they go back to the early fifth century, as we can see from Pindaric odes for victorious boys (*Olympian* 8, 10, 11; *Pythian* 10, 11; *Nemean* 5, 6, 7, and probably *Olympian* 14 and *Nemean* 4). One ode mentions winning as a boy in the Panathenaic games (*Olympian* 9.88).

22. One other event has recently been found on a prize Panathenaic now in the Getty Museum (79.AE.147, *G&P* fig. 58): the *apobate* (leaping in armor to and from a chariot), which is not listed in the extant portion of the inscription but would presumably be among the equestrian events, which the *Constitution of the Athenians* tells us were awarded oil prizes.

23. For rhapsodes and aulodes, see Shapiro, *G&P* 53–75; for torch race and pyrrhic, see Kyle, *G&P* 94–96. I think it is revealing that only in the fourth century do we find the nongeneric events *apobate* and quintain.

24. Three of the five late bearded competitors drive chariots (see Neils, *G&P* 46) but the bearded charioteer is less consistent a pattern than the beardless rider (see London B 130, Kerameikos PA 136, Athens, NM 452 [CC757]). If we consider only events in which boys competed (wrestling, boxing, pentathlon, stadion)—that is, events where the beard carries meaning—we find a similar distribution: early = 41 with beard, 12 without; late = 3 with beard, 35 without.

25. Kyle, 1987, 118. Webster, 1972, 193, suggested a different possibility, that the riding had become professionalized, but we know of jockeys from the beginning (cf. Phintis, *Olympian* 6, and the "jockeys" on the vases).

26. Kyle, 1987, 122.

27. Many in Kyle's list are events confined to Athenians, which makes his figures less useful for the Panathenaic games.

28. On the other hand, Kyle's dates fit neatly with the argument of Spence, 1994, 217 ff. that the cavalry's prestige declined after the massacre at Eleusis by the cavalry of the Thirty and rose again after the cavalry success at Mantinea in 364.

29. Kyle, 1987, 52.

30. Though Boardman, 1989, 220, notes "the virtual disappearance of palaestra and other athletic scenes" in Late Classical red-figure.

31. I do not count "jockeys" (all riders are small).

32. Brauchitsch, 1910, 137, noted that hoplites are bearded only early; and later beardlessness was under "den Einfluss der Mode," since representations of beardlessness are common in the fourth century.

33. The editor has suggested to me that findspot might be important. Indeed, the known proveniences of the early prize amphoras are usually Italian (51 of 61, 84 percent), often Vulci, and the late ones are usually not Italian (5/51, 1 percent), and often Attic (11/51 versus early 6/61). But this would be an important factor only if one locale showed a decidedly different preference over time, which seems not to be the case, though the numbers are so small as to make any conclusion moot (Table 6.4).

Table 6.4. Riding Events and Bearded Competitors on Panathenaics by Findspot and Date

Decoration	Findspot			
	Italian	Athenian	Greek	Other
Horses				
early	17/51[a]	2/5	2/3	0/2
late	0/5	4/11	0/7	2/28
Beard				
early	29/51	1/5	2/3	0/2
late	2/5	1/11	0/7	2/28

[a] That is, out of 51 Italian vases, 17 show horses.

34. Johnston, 1987, 129, calculated 216 amphoras for boys, 276 for youths, 396 for men, and 295 for equestrian events.

35. Another change is in the "other" category: in the early group this is almost entirely confined to hoplite runners, who hardly ever appear later.

36. See Hamilton, 1993 for full discussion.

37. See Eschbach, 1986, 109, 142, 145, and 152.

38. Hamilton, 1993, 245.

39. Hence the appropriateness of showing a victor being crowned without any indication of the event. This idea goes back at least to Edwards, 1957, 328 n. 29.

40. Tomb C at Taranto; see Lo Porto, 1967; Neils, *G&P* 49.

41. So Frel 1992, but his argument that their unpitted condition shows that these vases never contained oil has not won acceptance. C. G. Koehler, "Handling of Greek Transport Amphoras," *Bulletin de Correspondance Hellénique*, Suppl. 13 (1986) 52 n.15, argues that the absence of pitting shows that potters lined Panathenaics in the fourth century and later.

42. At least in the hoplite race, which is depicted on one of the vases and perhaps on all of them. The finds are unpublished but the chronological range is clear from those catalogued in Eschbach, 1986, nos. 20–22 (366 B.C.), no. 55 (344 B.C.).

43. Frel, 1992, 131–32; Valavanis, 1991a, 17. Two problems: there appears to be nothing to suggest that the site was a sanctuary; apparently the inscription(s) contain only the name, which is not the usual form of a dedication.

44. Valavanis' arguments against ownership by the victor are as follows: (1) there are two different sets of Panathenaics, one dating to the archon Charikleides (362) and the other to the archon Kallimedes (358); (2) they were awarded for two different events, wrestling and pankration; (3) similar amphoras were found in a nearby house and this makes a disproportionate number of Panathenaics for Eretria; (4) one of the vases was marked with an owner's sign. One might object that the victor could win in more than one Panathenaic festival, and a wrestler presumably could compete in the pankration also. We need to know more about the other Panathenaics to evaluate the third argument and more about owners' signs to evaluate the fourth.

45. At the corner of Ahileos and Plateon streets. Frel, 1972, 289 n. 2; Valavanis, 1991a, 17.

46. However, both sets of Panathenaics found in houses (Eretria, Rhodes) show the same contests. We may recall that the auctioned contents of Alkibiades' estate included over a hundred Panathenaics: see W. K. Pritchett, "The Attic Stelai," *Hesperia* 22 (1953) 251.

47. As assumed, for example, by Tiverios, 1974, 142; Valavanis, 1987, 469; Shapiro, 1989, 33 ff.; Kotsidu, 1991, 98.

48. Metropolitan Museum of Art, *Greece and Rome* (New York 1987) 37–39.

49. *CVA* Malibu 1 (USA) 23 pl. 21.

50. I interpret as a servant the unbearded naked individual holding two javelins and facing the others.

51. *CVA* The Hague 1 (Netherlands 1) pl. 1.4/5; formerly The Hague, Scheurleer.
52. *Studies in Honour of A. D. Trendall* (Sydney 1979) pl. 44.1/2.
53. = San Simeon, Hearst 12249.
54. Olmos, 1990, 43.
55. Ca. 520, Bothmer *CVA* New York 3 (USA 12) p. 33. This group is assigned to the circle of the Antimenes Painter by Brandt, 1978.
56. Formerly San Simeon, Hearst (*ABV* 291).
57. "Antimenean?" Brandt, 1978, no. 80.
58. "Antimenean?" Brandt, 1978, no. 81.
59. See now Matheson, 1989.
60. = Hillsborough, Hearst 3974; ex Prince Albrecht, S164.
61. xv i 79 (= PC 6 = II 1632).
62. Lo Porto, 1967, pls. 35–36.
63. Lo Porto, 1967, pls. 33–34. Side B is not by the Kleophrades Painter.
64. Lo Porto, 1967, pl. 37.8.
65. *Hesperia* 27 (1958) pl. 15a.
66. M. Vickers and J. M Reynolds, *Archaeological Reports* 18 (1971–72) 39, fig. 14A/B.
67. *G&P* no. 46; Sotheby's 13.xii.82, no. 221.
68. = San Simeon, Hearst 9844.
69. = xv i 78 = II 1630.
70. = Goluchow, Czartoryski 164.
71. *G&P* no. 39.
72. *CVA* Karlsruhe 3 (Germany 60) pl. 19.
73. Sotheby's, 14.vii.87, no. 408; B. Cohen and H. A. Shapiro, eds., *Mother City and Colony: Classical Athenian and South Italian Vases in New Zealand and Australia* (Christchurch 1995) 2–4, no. 1.
74. Ex Baltimore, Robinson.
75. = 4706. Lo Porto, 1967, pls. 40–41.
76. Brandt, 1978, pls. 14–15.
77. = Warsaw 198605? B 85.
78. *CVA* Naples 1 (Italy 20) pl. 1.1/3.
79. *CVA* Geneva 2 (Switzerland 3) pl. 57; Brandt, 1978, 83.
80. *CVA* Naples 1 (Italy 20) pl. 3.1/3.
81. *CVA* Frankfurt 2 (Germany 30) pl. 41 (44.9, 45 S).
82. *CVA* London 1 (Great Britain 1) pl. 5.2a/b.
83. *JHS* 1 (1880) pl. 6b; Gardiner, 1910, 444.
84. = CC 754; Tzachou-Alexandri, 1989, no. 162.
85. *CVA* Robinson 1 (USA 4) pls. 31.1, 33.1.
86. *CVA* Robinson 1 (USA 4) pls. 31.2, 33.5.
87. *CVA* Robinson 1 (USA 4) pl. 33.6.
88. = Oxford 1966.935.
89. Attributed to the Kleophon Painter by Christiansen, 1981, figs. 1–4.
90. *CVA* Denmark 8 pl. 318 (63.5).

91. Valavanis, 1990, figs. 1–8.
92. Valavanis, 1990, figs. 9–12.
93. = San Simeon, Hearst.
94. Valavanis, 1991a, pl. 35a and *passim*; Tzachou-Alexandri, 1989, no. 234.
95. Valavanis, 1991a, pl. 35b and *passim*; Tzachou-Alexandri, 1989, no. 233.
96. Valavanis, 1991a, pl. 36a and *passim*.
97. Valavanis, 1991a, pl. 52 and *passim*.
98. = Eretria 5381. Valavanis, 1991a, pl. 53 and *passim*.
99. Valavanis, 1991a, pl. 58 and *passim*.
100. Valavanis, 1991a, pl. 44 and *passim*.
101. Valavanis, 1991a, pl. 45 and *passim*; Tzachou-Alexandri, 1989, no. 178.
102. Not New York as in Eschbach.
103. *G&P* fig. 58; Valavanis, 1991a, pl. 86, 87; *Archaeological News* 10 (1981) 91.
104. Maul-Mandelartz, 1990, pl. 29.2.
105. Tzachou-Alexandri, 1989, no. 138.
106. Valavanis, 1991a, pl. 91.
107. Tzachou-Alexandri, 1989, no. 143.
108. Valavanis, 1991a, 225 no. 6, pl. 67.
109. Valavanis, 1991a, 226, no. 7, pl. 69.
110. Frel, 1973, fig. 22.
111. Frel, 1973, fig. 24; Valavanis, 1991a, pl. 75; Tzachou-Alexandri, 1989, no. 200.
112. Lo Porto, 1967, 94.

7

Shield Devices and Column-Mounted Statues on Panathenaic Amphoras
Some Remarks on Iconography

Michalis Tiverios

As is widely known, Panathenaic amphoras of the fourth century are distinguished by the fact that the prize vases made in any one year—that is, during the tenure of a particular eponymous archon—all display on their main face the same type of statue, mounted on columns flanking the goddess Athena. As for the reasons that dictated the depiction of these particular statues, it is highly probable that there is some link, albeit perhaps only apparent, between these statues and the eponymous archons.[1] The criteria by which these statues were chosen are unknown, nor do we know whether such criteria remained in place for the whole of the fourth century. We are likewise ignorant of the particular reasons that led to the presence of these statues on Panathenaic prize vases. Furthermore, their significance is obscure, and is it not known who was responsible for choosing them, although it was probably the current eponymous archon. These column-mounted statues first appear about 400,[2] when they replace the cocks previously found in this position, and the appearance of the statues constitutes one of the first changes to be seen in the iconography of Panathenaic vases during this period. Such changes to trophies produced by the state are certainly to be linked to the change undergone by the Athenian constitution immediately after the "descent of Thrasyboulos with the exiles from Phyle and the Piraeus" and after the expulsion of the Thirty.[3] This change, according

to Aristotle (*Constitution of the Athenians* 41.2), was the last that the Athenian constitution was to know until his own day.

However, this feature of a symbol—that is, its repeated depiction on Panathenaic vases of the same year—is not, I believe, entirely without precedent in the previous history of such vases. Something similar can be seen in the repetition, observable from the end of the sixth century,[4] of Athena's shield device on Panathenaic amphoras produced by the same vase-painter.[5] Hitherto researchers have usually suggested that the repetition of the same shield device was due to the initiative of the vase-painters.[6] Some scholars have considered the possibility that, in certain cases, the shield devices stood for the name of the potter.[7] Yet one wonders what point there would have been in such an oblique reference to the potter when so few observers were in a position to decipher it. Nor can such careful attention to the shield device be attributed to artistic reasons—that is, to some presumed liking on the part of the painter for the particular shield device in question. Were this so, we would surely notice the same feature in the rest of the painter's output, and not just on his Panathenaic amphoras. Moreover, the choice of the iconography on vases produced by the government certainly cannot have rested in the hands of the craftsmen of the Kerameikos. It must rather have been the job of the officials of the Athenian state who were charged with conducting the grand civic festival, the Great Panathenaia.[8] If this was indeed so, the choice of device to adorn the shield of Athena on Panathenaic amphoras must have been made with, at the very least, the agreement of the state, since moreover the shield devices seem to have had a particular significance, as we shall see below. Recently John Boardman has rightly maintained that the repeated use of the shield device was imposed by the officials responsible for commissioning the production of the Panathenaic vases.[9] Nevertheless, Boardman's explanation of the repeated use of shield devices is not entirely convincing. In his view, the state's order for the production of Panathenaic vases was lodged with various vase-painters. Thus the officials, in order to check that each vase-painter had indeed produced the agreed quantity of vases, stipulated the device to be used on the shield of Athena, with the result that the shield device also functioned as a distinguishing mark of the painter. This came about, Boardman maintains, because the vase-painters were obliged to repeat the particular shield device on all of the Panathenaic vases that they produced, with the result that the shield device came, as it were, to constitute their trademark.

The primary objection to this theory is that it is very difficult to assert on stylistic grounds that the order for the production of the

Panathenaic vases for any one year was in fact lodged by the state with more than one pottery workshop. It is, for example, impossible to be certain that the roughly contemporary Panathenaic amphoras now in Geneva (MF 151 and MF 150), which display different shield devices and are themselves the work of different vase-painters, were produced in the same year.[10] Even if we could be sure that they were, however, one cannot exclude the possibility that the two painters in question belonged to a single workshop that had undertaken, sometime toward the end of the sixth century, to fulfill the state's order for the production of Panathenaic vases. Such seems to be the case with three Panathenaic amphoras dated to the end of the fifth century, two of which are today located in Hildesheim (1253 and 1254) and one of which is in the British Museum in London (B605; Fig. 7.1). On all three vases, the devices on the shield of Athena consist of the later statuary group depicting the Tyrannicides and were executed by two vase-painters.[11] It seems, then, that there is no reason to suppose that it was usual in any one year for the state to place the order for Panathenaic vases with more than one workshop. In fact, the perennial laws of the marketplace suggest that the state was more likely to have gained a better price if it lodged the order for the amphoras required for any one year with a single workshop.

Boardman's view prompts a further observation. Had the state required that the name of the manufacturers be inscribed on the vases, then we would expect the name of the owner of the workshop to be written directly and clearly onto the vases, rather than in some cryptographic form. This, of course, is not the case. We do admittedly have a very few Panathenaic vases that bear the names of such workshop owners, although these inscriptions are found on vases for other reasons.[12] Thus, although Boardman is surely right not to see any link between the potters and the repeated use of the same device on the shield of Athena on the prize vases produced by the same painters, the explanation he offers to account for the repetition is not very convincing.[13]

As I have already hinted above, in the quest for a better explanation we now turn to a somewhat similar feature to be observed on Panathenaic amphoras of the fourth century. Here we have repeated use on Panathenaic amphoras produced in the same year of the same type of statue, mounted on the columns on the main face of the vase. This feature in particular, so I, together with others, believe, is connected with the eponymous archons.[14] A passage of Aristotle's *Constitution of the Athenians* offers an explanation for why the Panathenaic vases produced in any one year had to be easily recognizable. Clearly, the vases of any one year were rendered distinguishable chiefly by the

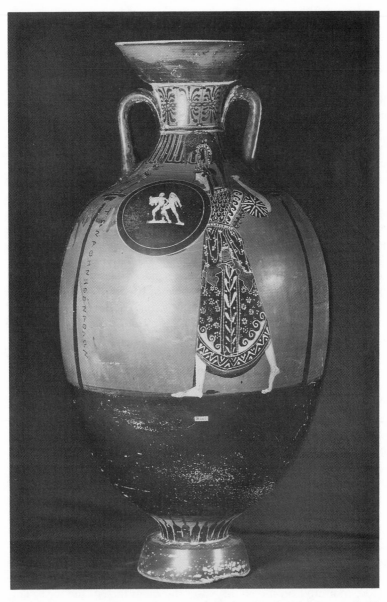

Fig. 7.1. Panathenaic prize amphora, dated 403. London, British Museum B 605
(Photo: Courtesy of the Trustees of the British Museum)

166

presence of the inscription denoting the name of the eponymous archon and furthermore by the presence of the statues on the columns. Aristotle states the following:

The olive oil is gathered from the sacred olive trees. It is levied by the archon from the owners of the farms on which the sacred olive trees stand, three *hemikotylia* from each plant. . . . Having accordingly gathered the oil accruing in his year, the archon hands it over to the *tamiai* for the Acropolis, and the archon is not permitted to go up to the Areopagus until he hands over all the oil to the *tamiai*. Aristotle, *Constitution of the Athenians* (60. 2–3)

This passage makes it clear that the job of supervising the collection of the oil entailed the ability to check at any given moment the amount of oil that each eponymous archon had handed over to the *tamiai* of the goddess on the Acropolis. Such supervision would not have been possible had there not been on the vases some form of distinguishing mark, such as inscriptions recording the names of the archons. Such identification would have been particularly difficult at the time of the celebration of the Great Panathenaia, when the harvest of olive oil had been gathered in, the fruit of three seasons and the work of three archons. It is quite reasonable to suppose that such rigorous supervision took place at an earlier period too. We do not know whether it was the eponymous archon who handed over the oil to the *tamiai* of the goddess during the fifth century. However, the fact that the name of the eponymous archon is recorded on Panathenaic amphoras for the first time at the beginning of the fourth century[15] suggests that the archons were first charged with the duty of collecting the olive oil consequent upon the changes in the Athenian constitution that followed the expulsion of the Thirty Tyrants.[16] Aristotle says (*Constitution of the Athenians* 60.2) that the city *formerly* sold the produce—that is, before the time when the eponymous archons assumed the job of gathering the three *hemikotylia* of olive oil from each plant.[17] It is thus highly likely that Aristotle is referring to the possible imposition at this time upon the eponymous archon of the duty of collecting the Panathenaic olive oil. Despite its difficulties, this passage can only mean that the city leased out the holy olive trees to a private citizen or citizens, with the obligation, of course, that the lessees supply as much olive oil as was required, shortly before the celebration of the Great Panathenaia.[18]

It is highly probable that the leasing out of the sacred groves was performed on behalf of the Athenian government by the *poletai*, officials who had been in existence since the time of Solon.[19] It is also possible that the lessees were not obliged to render an amount of oil every year, and that they may have done this only when the festival of the Great

Panathenaia was approaching. Up to that point, they may have been able to store the oil destined for the Great Panathenaia in their own homes. Nevertheless, the state itself probably had to check on the existence of the olive oil required for the festival every year, rather than simply relying on the good will of those leasing the trees, however conscientious the latter may have been, and however rigorous the penalties may have been in the event of the agreement's being broken.[20] The only way of ensuring a successful outcome in the business of collecting the olive oil was, of course, to be aware each and every year of how much Panathenaic olive oil had been gathered. Thus, even should the harvest one year turn out to be poor, there would have been time to face any incipient difficulties. It was for exactly this reason that Panathenaic amphoras were probably made every year during the sixth and fifth centuries, as we know they were made during the fourth century.[21]

To whom did the lessees of the holy olive trees hand over their Panathenaic oil in the sixth and fifth centuries? In view of the explicit testimony of Aristotle (*Constitution of the Athenians* 60.3), there is nothing to exclude the possibility that they handed it over to the same body of officials to which the eponymous archon handed over the oil in the fourth century—namely, the *tamiai* of the goddess.[22] According to Aristotle, this body was made up of ten members, one drawn from each tribe; before the installation of the democracy, the number may have been only eight. They were chosen by lot from the *pentacosiomedimnoi*, and one of the ten was chosen to be chairman, again by lot. But how were the amounts of olive oil that the various lessees handed over to the *tamiai* checked? Such an inventory was made possible by means of the device on the shield of Athena on the Panathenaic amphoras that contained the oil. I suggest that these shield devices had some connection with the lessees of the holy olive trees and served the same function as the inscriptions recording the names of the eponymous archons found on Panathenaic vases of the fourth century. In my view, Panathenaic vases of the sixth and fifth centuries that were produced by a single workshop and that bore the same shield device contained oil that had been handed over by the same lessee.[23]

If this view is correct, then on the basis of the evidence afforded by the surviving amphoras from the sixth century, I assume that the lessees of the olive trees during the first years of the Great Panathenaia were many in number and perhaps changed over short periods. This is to be concluded from the variety of devices found on the shields of Athena on Panathenaic vases up to the decade 520–510.[24] And it is possible that the large number of lessees was due to the fact that the holy olives were scattered throughout Attika.[25] Possibly this prompted the invention of a

practical and speedy method for checking whether the amounts of olive oil that had been handed over by the lessees at a given time to the *tamiai* were indeed of the volume stipulated by the terms of the lease. Thus, I suggest, in view of the necessity of ascertaining the volume of olive oil, it was decided to use shield devices. On the basis of the evidence afforded by extant Panathenaic amphoras, it seems that from 520 to 510 the number of lessees declined strikingly, while during the first half of the fifth century there seems frequently to have been only one lessee, who may possibly have leased the trees for an extended time.

That this may have been the case is suggested by two facts. First, during this period great variety is no longer evident in the devices on the shield of Athena. Second, the first Panathenaic amphoras produced by the same vase-painter or workshop on which the shield of Athena consistently displays the same device begin to appear at this time, although the vases are not contemporary with each other.[26] The decline in the number of lessees from 520 to 510 may have been caused by changing circumstances, for during this later period oil, instead of being collected from all the sacred olive trees, may have been collected from trees in a particular area only, such as the Academy, which was certainly the case, for example, in the fourth century. It is known that by then the Athenians were also resorting to the use of nonsacred olive trees to make up the required amount of oil.[27] However, there are cases where the Panathenaic oil was supplied over a long period by the same lessee, as revealed by the many surviving Panathenaic vases produced by the Kleophrades Painter and his workshop that are not contemporary with each other.[28] Here, possibly, it was not so necessary to employ shield devices as distinguishing marks to check up on the amounts of olive oil handed over to the *tamiai*, since the oil was supplied to the state from one source alone. Shield devices must have been of use in the way that I have suggested above—namely, whenever more than one source in any one year supplied the Panathenaic oil. Nevertheless, the use of the same, single device probably continued even when only one source supplied the oil to the state precisely because this close link between shield device and lessee had become canonized.

As for how the shield devices were chosen, we can only offer suggestions. It is not, for example, out of the question that the lessees of the holy olive trees were Eupatrids (it was anyway mainly they who were the owners of the plots of land on which the sacred olive trees stood) and therefore not unlikely that they chose ancestral emblems, whose existence is known from written sources,[29] for shield devices. When the same device occurs on Panathenaic amphoras that are not contemporary with each other, this may mean that the oil stored in

them came either from the same lessee or from two different lessees who belonged to the same aristocratic family whose family emblem was the device in question.[30] The habit of employing family emblems as devices on the shield of Athena on Panathenaic vases may have been particularly popular during the Archaic period. Nevertheless, after the installation of the democracy at the end of the sixth century, along with the abandonment, observable in many cases, of the distinguishing symbols of the old timocratic regime, it is possible that other criteria dictated the choice of device. Thus, for example, in 403 the Tyrannicide Group (see Fig. 7.1) was chosen as a shield device, no doubt because recent events had rendered it a particularly topical and popular subject.[31] It is possible that the choice of well-known works of sculpture in particular, of which the Tyrannicide Group may be the first example, explains why these emblems moved from the shield of Athena to the columns, thus displacing the cocks. This move, as Panos Valavanis observes,[32] created a more realistic picture, as statues mounted on columns had long been known in Athens as elsewhere.[33]

During the first years after this change, statues mounted on columns played the same role as the shield device of Athena on older Panathenaic amphoras.[34] However, the combination of column with statue was considered so successful that it remained even when the statues depicted on the columns had lost their significance. They lost their significance when the Panathenaic oil was no longer gathered by the lessees of the holy olive trees and when their place was taken by the eponymous archons. These statues consequently no longer represented anything, and the name of the eponymous archon written on the Panathenaic vases now facilitated the inspection of the amounts of olive oil that were handed over by the archon to the *tamiai* of the goddess.[35] Nevertheless, the statues remained on the columns on Panathenaic vases, by nature more conservative as regards their decoration. Just as in the past the custom had been for the shield devices to change whenever the lessee who handed over the Panathenaic oil to the *tamiai* of the goddess changed, so now the statues changed whenever the official charged with gathering the oil changed—namely, the eponymous archon. It is possible that the eponymous archons themselves chose the types of the statues (Fig. 7.2) that adorned the Panathenaic amphoras during their year of service.[36]

They must surely have chosen works of art that for various reasons were of current interest.[37] However, time passed and the statues on the vases, their original significance forgotten, remained chiefly as decoration. In the final decades of the fourth century, when the job of collecting the Panathenaic oil was about to pass into the hands of the *tamias* of the

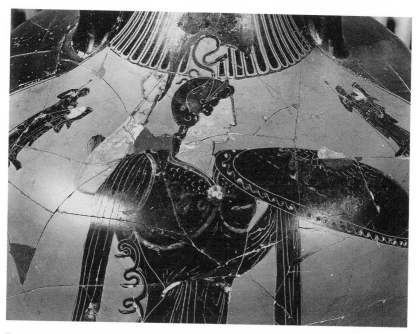

Fig. 7.2. Detail of Panathenaic prize amphora, dated 360/59. Athens, National Museum 20046 (Photo: P. Valavanis)

stratiotika,[38] there occur cases in which the same statue is repeated on Panathenaic vases of different eponymous archons.[39]

When the emblem of the lessee of the holy olive trees moved from the shield of Athena to the column on the main side of the Panathenaic vases, the shield device naturally lost its original significance. Moreover, when the names of the eponymous archons began to be written upon the vases, it was no longer necessary for Panathenaic vases belonging to a particular year to bear the same shield devices.[40] The shield itself is rendered more and more in a three-quarter view or in profile, so that the area occupied by the shield device is severely restricted.[41] Finally, in the fourth decade of the fourth century, the fact that Athena herself faces completely to the right (see Fig. 7.2), so that no shield device can be depicted at all, apparently presented no problem.[42]

All the views that I express here are based upon what Aristotle tells us about the Panathenaia in the *Constitution of the Athenians* and upon extant Panathenaic amphoras. As for the latter, we should bear in mind that we have only a small fraction of the total number of vases produced in antiquity, much less, in fact, than one percent,[43] a

fact that classical archaeologists, and, indeed, archaeologists of every period, should not forget. Always, or nearly always, our work rests upon a volume of ancient remains that is remarkably small in comparison with what once existed, which sad realization should warn us against expressing conclusions that are intransigent and maxims that are unbending.

Notes

This article, originally published in Greek in *Egnatia* 2 (1990) 31–42, owes a great deal to conversations with my colleague, Dr. Panos Valavanis. For the translation of the article into English, I must thank Dr. Andrew Farrington, who is also responsible for the translations from ancient Greek. Material added to the footnotes since the writing of the original article is introduced in square brackets.

1. On this subject, for various views and discussion, see Eschbach, 1986, 164–65; Valavanis, 1987, 474.
2. See Valavanis, 1987, 470–74. See also Valavanis, 1990, 337.
3. See in particular Valavanis, 1987, 467–70, esp. 469, 474–76.
4. For this, see Brandt, 1978, 15–16.
5. Matheson, 1989, 98 n. 5.
6. See, for example, Beazley, 1986, 86.
7. See, for example, M. Robertson, "The Gorgos Cup," *AJA* 62 (1958) 64; L. Schnitzler, "Vom Kleophrades-Maler," *Opuscula Atheniensia* II 56. As for the types of statue on columns found on Panathenaic vases of the fourth century, it has been suggested that they may be distinguishing marks of the workshops that produced them. On this, see Eschbach, 1986, 165.
8. Valavanis, 1987, 469, 474–76.
9. Boardman, 1974, 168. Frel's formulation of the situation (1977, 70) is unclear: "As Pegasos appears on all Panathenaics attributed to Epiktetos II [Kleophrades Painter], it seems that it must have served as a kind of official trademark, not only of the painter, but also of the potter who turned all of his Panathenaics."
10. Brandt, 1978, 15 and pls. 10–11.
11. See Beazley, 1943, 453, 454–55, and *ABV* 411, 4 and 412, 1–2 (middle).
12. See Tiverios, 1974, 142–43 n. 3. See for a more plausible view, Valavanis, 1987, 469 n. 9; M. Tiverios, "Apo ta attika keramika ergasteria," *Epistimonike Epeterida Philosophike Schole Panepistimiou Thessalonikis* 20 (1981) 381.
13. Boardman's view is considered tenable also by Brandt. See Brandt, 1978, 16.
14. See Valavanis, 1987, 474. Also Eschbach, 1986, 164–66 for various other views regarding the subject. See also below and n. 36.
15. Valavanis, 1987, 468.
16. Valavanis, 1987, 474 ff., 476–77, 477 ff.
17. Valavanis, 1987, 478 ff.

18. Valavanis, 1987, 478 with discussion and bibliography.

19. See Rhodes, 1981, esp. 552–55.

20. That those renting tracts of holy ground who defaulted were heavily punished is suggested by the imposition of very heavy penalties for those who destroyed the holy olives. See Aristotle, *Constitution of the Athenians* 60.2: "and they used to condemn [them] to death."

21. Brandt, 1978, 17, holds the opposite view.

22. For this body, see Rhodes, 1981, esp. 549–51.

23. See e.g. Brandt, 1978, 7–8, for such amphoras. See also below and n. 28.

24. For Panathenaic amphoras and their shield devices up to the end of the sixth century, see Brandt, 1978, 3–9. See also A. Vaerst, *Griechische Schildzeichen vom 8. bis zum ausgehenden 6. Jh.* (Diss., Salzburg 1980) 170 ff., 183 ff., 268 ff., 270 ff., 273 ff., 280 ff., 315 ff. For shield devices, see G. H. Chase, *The Shield Devices of the Greeks* (Chicago 1979); L. Lacroix, "Les 'blasons' des villes grecques," *Etudes d'Archéologie Classique* 1, 1955–56, (1958) 91–114.

25. See Mommsen, 1898, 78 ff. See also Rhodes, 1981, 672–74.

26. See Brandt, 1978, 7–8, 15–16. As is well known, the Panathenaic amphoras of the Eucharides Painter display a snake as Athena's shield device; those of the Kleophrades Painter, a Pegasos; and those of the Berlin Painter and the Achilles Painter, a gorgoneion. The Panathenaic amphoras of the Achilles Painter are a continuation of those produced by the Berlin Painter and indicate that the lessee of the holy olive trees who chose the gorgon's head as his shield device had leased the trees for a long period. The fall in the number of lessees appears to coincide with the installation of the democracy. [It is furthermore possible that some sacred olive trees were burned during the Persian invasion.] The Panathenaic amphoras of the Leagros Group, of the Michigan Painter, and of the Painter of the Havana Owl are the first to display shields that feature the same device. I am not sure, however, that these belong to the penultimate decade of the sixth century (see Brandt, 1978, 20), and not to the final decade.

27. On this, see Rhodes, 1981, 672–74, and also Mommsen, 1898, 78 ff.

28. On the Panathenaic amphoras of the Kleophrades Painter, see Matheson, 1989, 95–110, especially appendix, 110–12.

29. It is possible, for example, that the Alkmeonids employed the *triskelis* as their emblem (see Seltman, 1924, esp. XVIII 21 ff., 33 ff., 80; H. R. W. Smith, "New Aspects of the Menon Painter," *University of California Publications in Classical Archaeology* 1/1 [1929] 55 ff. and n. 6); the Eteoboutades may have used the ox (see Seltman, 49, 81, 87; D. M. Robinson, "Unpublished Greek Vases in the Robinson Collection" *AJA* 60 [1956] 10, no. 10; K. Schefold, *Götter und Heldensagen der Griechen in der spätarchaischen Kunst* [Munich 1978], 158). See also Plutarch, *Alkibiades* 16, who mentions, when referring to the shield of Alkibiades, "the making of a gilded shield, which, however, instead of bearing a device of his ancestors, displayed an Eros bearing a thunderbolt." Moreover, Pausanias 5.25.9 states, "The figure with the cock on the shield is Idomeneus, the offspring of Minos. The story is that the race of Idomeneus is descended from the Sun, the father of Pasiphae. They say that the bird is sacred to the Sun and that it announces when the sun is about to rise."

30. For example, the Panathenaic amphora in Naples, Museo Archeologico Nazionale 112848, bearing an incised inscription (ancient?) by the painter Sikelos, and another amphora in Geneva, Musée d'Art et d'Histoire MF 151, also connected with Sikelos, display a Pegasos on the shield of Athena (see Brandt, 1978, 8, nos. 75, 76), like the certainly later Panathenaic vases of the Kleophrades Painter.

31. Valavanis, 1987, 470 and n. 13 for bibliography.

32. Valavanis, 1987, 470.

33. On this, see bibliography in Eschbach, 1986, 3 n. 19. The first extant examples of Panathenaic amphoras showing statues mounted on columns represent Nikai, which have been associated with the Nike of the statue of Athena Parthenos by Pheidias. See Valavanis, 1987, 470, and esp. 472 and n. 17.

34. Previously scholars believed that the introduction of statues on Panathenaic vases coincided with the beginning of the habit of writing the name of the eponymous archon on the vases. Now it has been shown that the two innovations did not appear at the same time: the statues mounted on columns antedate the names of the eponymous archons. See Valavanis, 1987, 468.

35. The first certain extant name of an eponymous archon on a Panathenaic amphora is that of Pytheas (380/79). See Valavanis, 1987, 468 and n. 7. As for when the eponymous archons first collected the oil, perhaps after 395, see Valavanis, 1987, 479. The archon Polemon (312/1) is the latest archon currently known to have gathered the Panathenaic oil. On this see Valavanis, 1987, 480 and n. 64 for bibliography.

36. See also Eschbach, 1986, 166. Beazley, 1986, 89, in connection with these statues, notes, "The 'symbols' . . . may be compared, roughly, to the 'symbols' on coins."

37. Eschbach, 1986, 166–69.

38. Edwards, 1957, 331–36.

39. Eschbach, 1986, 145–46, 147–48. The Panathenaic vases in question are those of the archons Hegesias (324/3) and Kephisodoros II (323/2). See also Eschbach, 1986, 162; Valavanis, 1987, 472 n. 17, 474.

40. Valavanis, 1991a, 92–95.

41. Valavanis, 1991a, 82–83, 90–92. See also Eschbach, 1986, pl. 14.2.

42. Thanks to Panathenaic vases found at Eretria, we now know that Athena was depicted facing right in 360/59, during the period of service of the archon Kallimedes. See Valavanis, 1991a, esp. 79–84. [A Panathenaic amphora recently acquired by the J. P. Getty Museum and to be published by M. True provides evidence that Athena is already standing to the right on vases dated to the archonship of Charikleides (363/2). See Acquisitions 1993, *J. Paul Getty Museum Journal* 22 (1994) 62–63, n 8.]

43. See Tiverios, 1974, 153 n. 56. As for the quantity of Panathenaic amphoras that were required for the Panathenaia of the fourth century, I had previously arrived at a figure of about 1,200 (see Tiverios, 1974, 147 and n. 29). Johnston, whose calculations are more precise than mine, arrives at a figure of at least 1,423; see Johnston, 1987, 125–29.

PART III
ART AND POLITICS

8

Pride, Pomp, and Circumstance
The Iconography of Procession

Jenifer Neils

The Parthenon frieze, a 524-foot-long by just over 3-foot-high band of relief sculpture, has been called the best-known but least well understood work of Greek art. However, unlike much of Greek art, we do know a fair amount about the frieze's context—that is, its location, its approximate date, and its designer. It was originally situated over the porches and along the top of the cella walls of the Parthenon, some 40 feet above the level of the stylobate. Its date can be established within a ten-year period by means of building accounts which inform us that the temple was begun in 447/6, and nearly finished in 438/7, when its cult statue was dedicated at the Greater Panathenaia of that year. Presumably its designer was Pheidias, who no doubt oversaw the entire sculptural program of the Parthenon as well as the chryselephantine colossus of Athena inside. Beyond these basic facts, there is general agreement that the frieze with its 370-some participants represents a procession, but the nature of the procession, its time and place, and the identity of its participants are frequently debated among scholars.[1]

Given the many and sometimes contradictory interpretations of the frieze, it is important to try to determine how it would have been viewed and understood by Athenian observers in the fifth century.[2] To do this, we must turn to other monuments representing religious processions in order to shed light on the nature and meaning of the Parthenon's

177

procession. Classical scholars have found it helpful to use Attic vases, which are preserved in such large numbers and are often inscribed, as evidence for the iconography of incomplete or otherwise obscure works of sculpture. When the sculpture is also Athenian, the methodology is especially appropriate.[3] Therefore, by looking at related Attic vase-paintings it may be possible to establish what to ancient Athenians constituted the essential elements of a religious procession, and then proceed to see what evidence there might be for the Panathenaic procession in particular.

But for a moment let us revert to processions in general, and to the "Pride, Pomp, and Circumstance" of my title specifically, in order to establish some universals regarding processions. Religious rituals are as old as art itself, as seen in carved vessels from the temples of the ancient Near East, in the wall-paintings of Egyptian tombs, and in the frescoes of Aegean palaces of the Bronze Age. The "circumstance" or ceremony is normally a ritual involving the bringing of gifts, sacrificial or otherwise, to a deity. In these cult representations, piety is demonstrated by the worshippers who approach the shrine or its god on foot. Since size is directly proportional to importance, the deity or deities are always larger than their devotees. As for "pomp," ostentation and display play a prominent role in procession, whether they come in the form of musical accompaniment, elaborate dress, or aristocratic conveyances, like horse-drawn chariots. The element of pride is often conveyed by the communal spirit of the event; it is not the solitary worship of one individual before his god, but involves the entire community, men, women, and children, from the high priest or king to the lowly stable-boy. Religious processions as such continue well into later Western art, where the gifts are equally costly, the apparel magnificent, the conveyances equestrian, and the crowd multitudinous, as in the sumptuous Italian Renaissance representations of the Adoration of the Magi. Even today we academics dress up in fancy archaic costumes and process on foot in honor of Holy Wisdom.

Turning to Greece, one finds fairly consistent imagery for the religious procession. One of the best examples, the late sixth-century wooden plaque from Pitsa (Fig. 8.1), shows wreathed and robed women carrying branches led by two male musicians, a pipe-player and a lyre-player.[4] Ahead of them a third youth, actually a young boy, leads the sacrificial victim, a ewe. Heading the procession is the *kanephoros*, or basket-bearer, who also holds an oinochoe for libation in her right hand. The three women are named, suggesting that these are real persons who took part in the cult of the Nymphs to whom the plaque is dedicated.[5] The destination of this group is the blood-stained altar at the far right. The

Fig. 8.1. Wooden plaque from Pitsa, sixth century. Athens, National Museum 16464 (Photo: Museum)

taller, less well preserved figure at the far left is probably an older male, since he appears to be wearing only a himation. Thus we have a community of worshippers of all sexes and ages in festive dress, accompanied by music, bearing gifts, and solemnly approaching their destination, the altar of the deity. Although not Attic, this plaque gives us one of the best impressions of a cult procession in Archaic Greece. And since it preserves its color, it reminds us of an important element in this display—namely, expensively dyed and woven garments, Sunday best if you will.

Similar scenes, but without color, can be found on Attic vases, many of which were dedicated on the Acropolis. A late sixth-century red-figure loutrophoros from the Acropolis (Fig. 8.2)[6] shows draped men and women carrying branches, led by a flute-player named Lykos. Ahead of them a youth with branches drives a sacrificial sow, and a fourth male with an oinochoe leads the way. Again we are shown what appear to be contemporary Greeks involved in a cult ritual. A well-known lekythos by the Gales Painter in Boston shows a *kanephoros* leading the procession.[7] She is followed by youths with branches herding sacrificial cows decked with *stemmata* or woolen fillets. Although on these vases the deity in whose honor the procession is held is not specified, the destination is indicated by a column adorned with a fillet at the right, presumably indicating the god's sanctuary. The female victims most likely indicate a female deity, although vase-painters can be notoriously sloppy in this matter, as for instance on a late fifth-century chous at Harvard (*G&P* no. 52),[8] where the procession is abbreviated even further. Here we see simply two youths bringing a bull to sacrifice as indicated

Fig. 8.2. Attic red-figure loutrophoros related to Phintias, ca. 500. Athens, National Museum 636 (drawing after Graef-Langlotz)

by the *stemma* dangling from its horns. This particular image is clearly derived from the Parthenon frieze; its inspiration is slab 41 on the south side, where, however, the animals are heifers.

While red-figure artists are content to provide an abbreviated version in which merely a basket-bearer or a victim is enough to indicate the nature of the event, the earlier black-figure vase-painters provide more specifics. On a fragmentary lekythos from the Acropolis (Fig. 8.3),[9] we are shown not only the musician, victim, *kanephoros*, branch-bearer, and filleted column, but also a flaming altar and the deity beyond it, in this case a striding Athena. Interestingly she is in the pose associated with the Panathenaia since the mid-sixth century—namely, the canonical figure depicted on every Panathenaic prize amphora (see Figs. 5.4 and 7.1). Might this be the artist's subtle way of suggesting that the procession is that which took place on 28 Hekatombaion? Artistically one of the finest examples of this procession to Athena appears on the name-vase of the Painter of Berlin 1686 (*G&P* Fig. 34a).[10] The goddess stands with spear poised beyond her altar, which is approached by a woman bearing myrtle branches and three men leading an ox. The other side of the amphora (*G&P* Fig. 34b) shows the latter part of the procession, four musicians: two youths playing the pipes, and two older male kitharists.

They are dressed for the occasion in elaborately decorated robes, but unfortunately the letters surrounding them are nonsense and so do not identify the participants.

The earliest and most complete procession to Athena appears on one side of a black-figure band cup of the mid-sixth century in a private collection (Fig. 8.4).[11] To date it represents the closest parallel in vase-painting for the Parthenon frieze, and given the number and variety

Fig. 8.3. Attic black-figure lekythos, ca. 500. Athens, National Museum 2298 (drawing after Graef-Langlotz)

Fig. 8.4. Attic black-figure band cup, ca. 550. London, private collection (Photo: D. Widmer)

of its participants, it surely depicts a major state festival. At the far left Athena is only half preserved, but her shield and the snakes of her aegis secure her identity. Between her and the flaming altar stands a grown woman, presumably a priestess. She reaches for the hand of a cloaked man holding a branch who leads the procession. He is followed by a younger female *kanephoros*. The sacrificial victims compose the *trittoia*, better known in Roman art as the *souvetaurelia*: bull, sow, and sheep. The musicians are next, two pipe-players and a kitharist. Three draped men carrying branches are followed by three hoplites, armed with helmets, shields, and spears. Among them is a draped male turned to the right, whom we might identify as a marshal, since he faces in the opposite direction. Finally, emerging from the handle is a horseman with a spear. On the north frieze of the Parthenon, we have a similar, but not identical, line-up: riders, marshals, chariots, elders (possibly carrying branches), musicians, pitcher-bearers, tray-bearers, sheep, cattle, and, turning the corner to the east, women carrying sacrificial implements, draped men, and deities. It has been suggested that the *apobatai* on the frieze, who are sometimes armed, are the Classical equivalent of the hoplites on the cup. The major differences come on the east frieze, where we find an assemblage of fourteen Olympian deities, and a unique scene in the center, usually referred to as the "peplos incident," a key image to which we shall return.[12]

Thus far the ample vase-painting evidence for an elaborate procession to Athena corroborates the identification of the Parthenon frieze as a religious procession, since all the essential elements are in place, but in a more expanded form, given the great expanse of the surface to be covered. That it represents the Panathenaic procession is the most plausible explanation, since the Panathenaia was the most important religious festival of Athena in the city. Moreover, the presence of heifers and sheep as the sacrificial victims jibes with what we know from an old Athenian law which prescribed a ewe for Pandrosos whenever Athena received a cow. The same combination of victims is shown at the altar of Athena on a black-figure hydria by the Theseus Painter in Uppsala.[13] Unfortunately, Pausanias (1.24.5), who tells us the subject of the pediments, fails to mention even the existence of the frieze. Since all of the surviving ancient testimonia on the Panathenaia are later than the vases and the frieze, they tend to cause problems for scholars, rather than helping to clarify the frieze. For instance, scholia and late lexica tell of metic girls as hydria-carriers, whereas those on the frieze who carry water jugs are clearly male (*G&P* fig. 15). Erika Simon has tried to reconcile this inconsistency by identifying the male *hydriaphoroi* as the annual winners in the torch race carrying their bronze prize vessels, one

of which we see near the altar of Athena on a red-figure krater at Harvard (*G&P* 179, no. 50). Since the torch race was an annual contest, there would be four winners at each Great Panathenaia.[14] Such an ingenious solution is not really necessary, since we have vase-painting evidence for male water-carriers, both on a hydria by Phintias[15] and on a fragmentary pelike by the Pan Painter (Fig. 8.5).[16] On this latter vase, the male hydria-carrier, who reaches down to pick up his hydria, thus anticipating the pose of the fourth *hydriaphoros* on the frieze, is preceded by a *kanephoros*, and so the artist is clearly referring to a religious procession. That it is one that took place along the Panathenaic Way is perhaps indicated by the three herms on the other side of the vase, which could refer to the area of the herms at the northwest entrance to the Athenian Agora.[17]

Unfortunately there are few vase-paintings which unequivocally de-pict the Panthenaic festival, other than the monumental prize vases, which tell us a great deal about the athletic and equestrian contests, but little about what we know to have been the high point of the festival, the presentation of the peplos to Athena. Only occasionally will a vase-painter provide a dead giveaway, as for instance the Aegisthus Painter, who placed a Panathenaic-shaped amphora prominently between a musician and a branch-bearer.[18] Since the vase on which this scene is depicted is also a Panathenaic-shaped amphora, it reinforces the connec-tion. It is useful to look to other red-figure (i.e. nonprize) Panathenaic-shaped amphoras for allusions to the festival. On one such amphora in Munich,[19] for instance, two youths are processing to a sanctuary. One carries a pinax, or painted plaque, the other a Panathenaic amphora on his shoulder (*G&P* fig. 29). Although to our eyes the vase that he carries looks much too small to be a prize vessel, its small size may be the result of artistic necessity. A Panathenaic amphora is carried in similar fashion by a wreathed youth on a later and fragmentary red-figure Panathenaic-shaped amphora found in the Athenian Agora.[20] The vase shows a procession of six youths, all wearing himations and crowned with olive wreaths. The first seems to be a flute-player, and the inscription XPYΣ indicates that he might be the contemporary Athenian musician Chrysogonos, as suggested by Judith Binder.[21] He is followed by two youths carrying a flat basket or *skaphe* between them. On the other side, as we have seen, one of the three youths carries a Panathenaic amphora on his shoulder. Above his head is an inscription which can be read as "Eupompos," an appropriate name for a processional figure. Given the single olive tree on the other side, we are probably meant to interpret the setting as the Acropolis, and the musical accompaniment and offering basket certainly suggest a cult scene. Although this evi-dence is limited, it does corroborate what we have observed on other

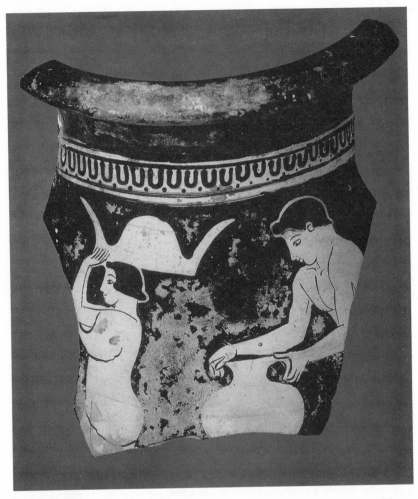

Fig. 8.5. Attic red-figure pelike by the Pan Painter, ca. 470. Paris, Louvre Cp10793 (Photo: M. Chuzeville)

vases—namely, that Athenians were used to seeing painted depictions of their contemporaries in procession to the Acropolis having to do in some way with the Panathenaia.[22]

We can find similar scenes on black-figure vases, although the mode of transport is different. On a skyphos by the Theseus Painter (*G&P* 181, no. 53),[23] two men in a religious procession carry what must be a filled amphora. Whether it was meant to contain wine for the feast or prize olive oil is not determinable, but it is certain that we are witnessing

a cult scene. The Aristotelian *Constitution of the Athenians* (60.2) states that it was the duty of the archon to collect the prize olive oil from the landowners.

Prize oil (or "liquid gold" as one of the students at Dartmouth referred to it) in Panathenaic vases is but one element that distinguishes the Panathenaia from other festivals. Another is the peplos. The ultimate purpose of the Panathenaic procession was to bring a newly woven robe or peplos to the goddess Athena. This peplos was begun nine months before at the festival known as the Chalkeia. Two of the four girls between the ages of seven and eleven known as the *arrhephoroi* were chosen to begin the weaving of the robe. It was presented to the goddess annually at the Panathenaia. A similar ceremony is described by Homer (*Iliad* 6.303) when Hecuba and the Trojan women lay a robe on the lap of the statue of Athena at Troy, following the instructions of Hektor (6.269–75):

> But go yourself to the temple of the spoiler Athene,
> assembling the ladies of honour, and with things to be sacrificed,
> and take a robe, which seems to you the largest and loveliest
> in the great house, and that which is far your dearest possession.
> Lay this along the knees of Athene the lovely haired. Also
> promise to dedicate within the shrine twelve heifers,
> yearlings, never broken, if only she will have pity. (R. Lattimore trans.)

The cult statue of Athena Polias, a venerated olive-wood *xoanon*, was actually dressed in this robe, ten months later at the festival known as the Plynteria.[24] These last two duties, presenting the robe and later dressing the statue in it, were the special privilege of women belonging to the Attic clan Praxiergidai.

At the very center of the east frieze of the Parthenon, we see five persons taking part in a ceremony involving a rectangular piece of cloth (Fig. 8.6). The three at the left are draped women, two of whom carry *diphroi* or stools on their heads. At the left a bearded man assists a child in folding the cloth. If we turn to other media like vase-painting to seek parallels for such a scene, they are nonexistent. There are few vases that show a woman's garment being folded, whereas numerous examples exist of athletes in the palaestra folding their himations.[25] The only vase that might actually depict the peplos being brought to Athena is a black-figure Panathenaic-shaped amphora in New York by the Princeton Painter (*G&P* fig. 14).[26] Again we see the Panathenaic Athena standing before her flaming altar. An aulos-player stands in front of her, and a woman behind her holds a wreath and transports a rectangular object on her head. Beazley and others have suggested that this might be the peplos, for it resembles the garments more often seen carried in wedding

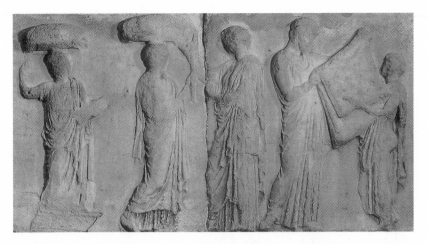

Fig. 8.6. Peplos scene, east frieze of the Parthenon (31–35). London, British Museum (Photo: Alison Frantz collection, American School of Classical Studies at Athens)

processions.[27] However, we cannot be absolutely certain of the object's identity.

But might there have been other ways of alluding to the peplos, without actually showing it being presented to the goddess, a scene which male vase-painters may not have taken an interest in, or even have observed? We know that the peplos was produced by a special group of women known as the *ergastinai*, with the assistance of the two young *arrhephoroi*. A composition that suggests this grouping of two young weavers with nine older female textile workers is the well-known lekythos in New York by the Amasis Painter (*G&P* fig. 66).[28] Semni Karouzou first suggested that the scene was the weaving of the Panathenaic peplos, and others have concurred.[29] This interpretation is supported by the decoration on the shoulder, where eight female dancers and four youths approach a seated woman with a wreath, who could well be an enthroned goddess. Although Dietrich von Bothmer believes the figures to be dancing, their poses are different from those of the dancers on the companion lekythos, which depicts a wedding on the body.

Perhaps another vase can add weight to the argument. A black-figure amphora in the Louvre (Figs. 8.7–8.8)[30] also pairs an elaborate depiction of woolworking with a seated goddess, in this case Athena. The obverse shows seven women, all wreathed and richly dressed, involved in woolworking, while on the other side Athena is seated in the center flanked by a pair of divinities on each side (Hermes and a woman

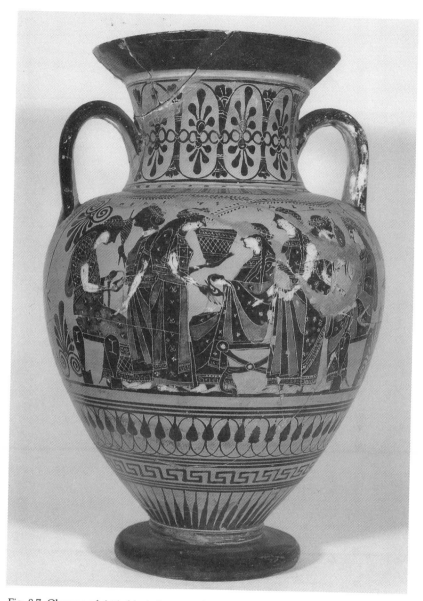

Fig. 8.7. Obverse of Attic black-figure neck amphora of the Three-Line Group, ca. 520. Paris, Louvre F 224 (Photo: M. Chuzeville)

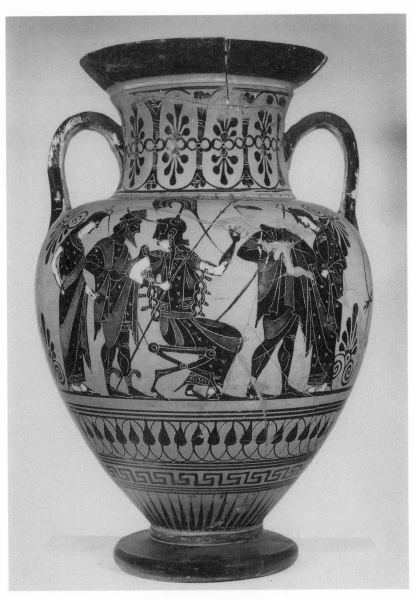

Fig. 8.8. Reverse of Fig. 8.7

behind, Poseidon and a woman in front). If there is a connection between the two sides of this vase, as often is the case, then we might interpret it as Athena awaiting her birthday gift, which is being prepared by the women on the other side. Such multi-figured scenes of female textile workers are a rarity in Attic vase-painting,[31] and so it is not unrealistic to consider them as representations of a special, perhaps religious event. As on this vase, so on the east frieze, the textile scene is juxtaposed to a seated Athena (Fig. 8.9). Perhaps the fact that the sculpted Athena has removed her aegis indicates that she is preparing to receive a new garment.

This peculiar removal of Athena's aegis suggests a particular nuance which I perceive in the frieze and which convinces me that it must represent the Panathenaic procession. It pertains to one of the acts vital to a proper *pompe* or procession—namely, that of dressing up. A vase-painting that serves to remind us of the importance of dress at

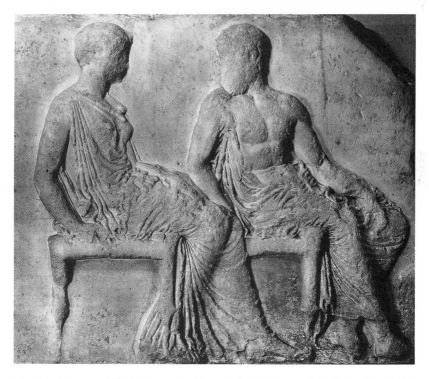

Fig. 8.9. Athena and Hephaistos. East frieze of the Parthenon, (36–37). London, British Museum (Photo: Alison Frantz collection, American School of Classical Studies at Athens)

the Panathenaia is the famous red-figure stamnos in Würzburg (G&P fig. 13),[32] which depicts the slaying of Hipparchos by Aristogeiton and Harmodios, an event which Thucydides tells us took place at the Panathenaia of 514. The tyrant's brother Hipparchos was to be a marshal, and so carries a staff, is wreathed, and wears an elaborately fringed himation. We know that the Athenians went to considerable expense to dress up for the procession. The metics, for instance, wore purple himations and carried silver and gold *skaphai*. Such splendid color is unfortunately lost to us in bichrome Attic pottery and in sculpture that is now devoid of paint. But the elaboration in the decoration of such festal robes is surely reflected in other vase-paintings, notably the processions on the François vase (see Fig. 1.2) or the dinos by Sophilos in the British Museum (Fig. 8.10). This vase and others like it feature a procession of divinities to a wedding, but it would not be surprising if such colorful, rhythmic displays were inspired by contemporary religious processions witnessed every 28 Hekatombaion by Athenian vase-painters. The altar at the head of this cavalcade, Dionysos carrying a leafy branch, as well as the musical accompaniment provided by the Muses, all suggest a religious procession.

 Another clue about the role of dressing in Athenian cult processions is offered by an early fourth-century oinochoe in New York (Fig. 8.11).[33] Here in the center is a woman in the act of adjusting her pink dress—in fact, dressing. At her right a sacrificial basket (*kanoun*) rests on the ground, and further along Eros leans down to tie his sandal. We might at first think her to be Aphrodite, but the inscription gives us her name: *Pompe*. As the personification of religious procession, she is portrayed in what must be her most characteristic pose, that of dressing, of getting ready for the festival, in this case in honor of Dionysos, who sits at the right.

 If we now return to the frieze, it is possible to find similar attention paid by the sculptor/designer to the act of dressing, which I would interpret as a somewhat veiled reference to Pompe. At the very beginning of the north flank one notices, for instance, a boy tying his master's belt (XLII.136) and a youth adjusting his wreath. Further along one of the elders turns conspicuously toward the viewer and readjusts his wreath (X.38; G&P fig. 10). These gestures are even more concentrated among the gods. Hera's gesture of opening her veil, while characteristic of her wifely role, seems particularly conspicuous here. Like the elder just mentioned, she too turns full-front to accentuate her gesture. Perhaps the pose is intended to recall her famous dressing scene in the *Iliad* (14.178–86):

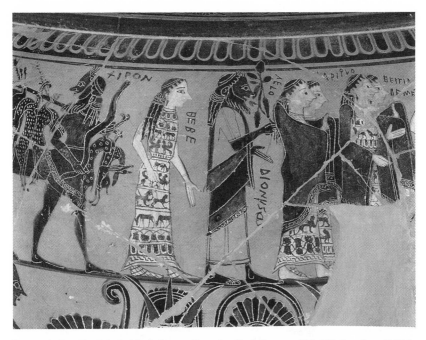

Fig. 8.10. Detail of Attic black-figure dinos by Sophilos, ca. 580–570. London, British Museum GR1971.11.1.1 (Photo: Courtesy of the Trustees of the British Museum)

> [She] dressed in an ambrosial robe that Athene
> had made her carefully, smooth, and with many figures upon it,
> and pinned it across her breast with a golden brooch, and circled
> her waist about with a zone that floated a hundred tassles,
> and in the lobes of her carefully pierced ears she put rings
> with triple drops in mulberry clusters, radiant with beauty,
> and, lovely among goddesses, she veiled her head downward
> with a sweet fresh veil that glimmered pale like the sunlight.
> Underneath her shining feet she bound on the fair sandals.

Next to Hera, Iris, Nike, or Hebe, although not well preserved, can be seen with her left arm raised to her head, in a gesture of tying up her hair. If Ira Mark is correct in his reconstruction, she also holds a fillet in her right hand.[34] Hence she is performing her toilet. As we have seen, Athena clasps her aegis in her lap. Some scholars feel she is protecting her virginity from her neighbor Hephaistos, but might she be in the act either of dressing or, more likely, undressing as if in preparation for

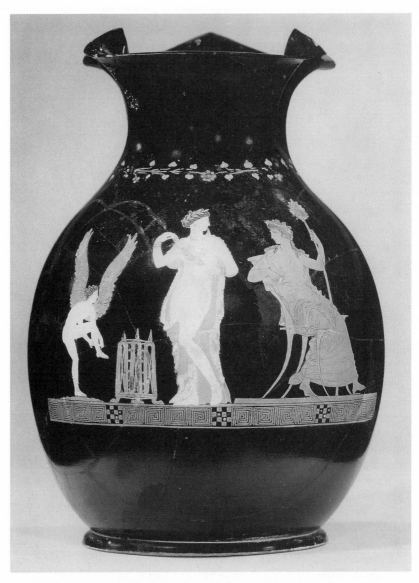

Fig. 8.11. Eros, Pompe, and Dionysos. Attic red-figure oinochoe by the Pompe Painter, ca. 350. New York, The Metropolitan Museum of Art 25.190, Fletcher Fund, 1925. All rights reserved, The Metropolitan Museum of Art (Photo: Museum)

her new garment? Apollo, as Evelyn Harrison has so astutely noted, has his thumb hooked into his himation, as if he too were adjusting his garments.[35] His sister Artemis is clearly pulling up her slipped chiton, in a gesture which is not characteristic of her. These allusions to dressing, subtle as they may be, would not have been lost on the Athenian audience which itself robed for the ceremony.[36] Finally Eros is equipped with a specific accoutrement of the religious procession, the parasol. We see how it is carried on a red-figure lekythos in Paestum by the Brygos Painter.[37] Here a young girl, possibly an *arrhephoros*, is shown bearing olive branches, while her attendant, presumably the daughter of a metic, carries a parasol to shade her from the sun. Thus, the gestures and attributes of the gods allude in subtle ways to *pompe*, and thereby reinforce the theme and festive spirit of the frieze.

As has long been noted, certain themes echo throughout the sculptural program of the Parthenon. For instance, the Centauromachy appears both in the south metopes and on the sandals of the Parthenos. The Amazonomachy appears in the east metopes and on the shield of the statue. Likewise the theme of dressing that I perceive in the frieze is echoed on the base of the Athena Parthenos. This gilded relief sculpture depicted the birth of Pandora, and while there is not much evidence for the base, we encounter the theme in vase-painting. Painted images by the Tarquinia Painter and the Niobid Painter make it clear that Athena and Hephaistos dress the newborn goddess, just as Hesiod describes the scene in the *Works and Days* (72).[38] This birth, attended by all the gods, in turn echoes the birth of Athena in the east pediment. The divine assemblies in turn reiterate the assembly of Athenians on the frieze.

In effect the theme of the peplos can be seen in all of the imagery of the east end of the Parthenon—from the robing of Pandora, to the peplos presentation on the frieze, up to the Gigantomachy in the metopes, the very theme woven into the peplos, and finally to the raison d'être of the Panathenaia, the birth of the goddess in the east pediment. The assembly of Olympians participates in this imagery at all levels, thus reinforcing the notion that all the gods are concerned for the affairs of Athens.

The words of Anton Moortgat, describing one of the earliest extant cult processions on a vase from Uruk, could equally well apply to the Parthenon frieze:

It is difficult to decide whether this frieze was intended to represent a mythical event . . . or whether it was meant to represent a cult ceremony. . . . However, we may perhaps come nearest to the truth if we simply avoid this sharp distinction between Myth and Reality. The protohistorical world of Sumer, as it came to maturity in Uruk, is indeed in every direction—sociological/ political as well as religious/artistic—a union of the sacred world of the gods and the profane

world of humans, of the real and the metaphysical, of nature and the abstract: in some ways it was a golden age, in which the life of the gods and the life of humans still intermingled. Man, not yet as an individual separated from his community, has through his princes ["Eponymous Heroes"] the closest possible relationship with the gods, and has in a way taken part in eternal life.[39]

If we could do away with our modernist distinction between myth and reality, we could view the Parthenon frieze as a timeless union of the divine and human and a celebration in stone of the golden age of Athens.

Notes

1. The most recent publication of the frieze is that of Jenkins, 1994. See also Robertson and Frantz, 1975; Brommer, 1977.
2. On the ancient viewer and the Parthenon frieze, see Osborne, 1987; R. Osborne, "Democracy and Imperialism in the Panathenaic Procession: The Parthenon Frieze in Context," in Coulson and Palagia, 1994, 143–50.
3. A number of Acropolis sculptures are actually represented in Attic vase-painting, e.g. the Brettspieler (see D. L. Thompson, "Exekias and the *Brettspieler*," *Archeologica Classica* 28 [1976] 30–39), and Athena and Marsyas (see Boardman, 1985, figs. 61–64).
4. Athens, National Museum 16464, van Straten, 1995, 57–58, fig. 56.
5. On the names, see D. A. Amyx, *Corinthian Vase-Painting of the Archaic Period* (Berkeley 1988) 604–5.
6. Athens, National Museum, Acropolis 636; ARV^2 25, 1: related to Phintias. I believe that this vase is an early work of the Berlin Painter. See van Straten, 1995, 205, no. V67, fig. 20.
7. Boston, Museum of Fine Arts 13.195; ARV^2 35–36, 1: Gales Painter. See van Straten, 1995, 206–7, no. V74, fig. 17.
8. Cambridge, Harvard University Art Museums 1959.129; G&P 181, no. 52; van Straten, 1995, 207, no. V76.
9. Athens, National Museum, Acropolis 2298; Shapiro, 1989, 30, pl. 10a; van Straten, 1995, 197, no. V19, fig. 3.
10. Berlin, Staatliche Museen 1686; ABV 296, 4; G&P 55, fig. 34; van Straten, 1995, 197, no. V21, fig. 4.
11. Simon, 1983, 63, pls. 16.2 and 17.2; Shapiro, 1989, pl. 9a–b; G&P 54, fig. 33; van Straten, 1995, 203, no. V55, fig. 2.
12. The association of this cup with the Panathenaic festival has been challenged because (1) the Promachos is not a cult image, (2) the peplos is not shown, and (3) the *trittoia* was not the official sacrifice at the Panathenaia. For a summary of the arguments, see van Straten, 1995, 15–17. To these objections, we can state that vase-painters did not generally depict cult images, but were used to seeing and depicting on vases the Promachos type, which appears on

Panathenaic prize amphoras and was clearly associated with the festival. The peplos is never shown in procession, except possibly on the Princeton Painter's amphora in New York (*G&P* fig. 14). The sacred laws stipulating the sacrifices to Athena (*IG* 2² 334) are dated 335/4 and 330/29, and so tell us nothing about the sixth century. Given the considerable elaboration of the procession on this band cup, one cannot imagine that it depicts anything but the newly reorganized festival of Athena.

13. Uppsala, University 352. See C. Melldahl and J. Flemberg, "Eine Hydria des Theseus-Malers mit einer Opferdarstellung," *Acta Universitatis Uppsaliensis, Boreas* 9 (1978) 57–79; van Straten, 1995, 202, no. V50, fig. 5.

14. Simon, 1983, 64.

15. London, British Museum E 159; *ARV*² 24, 9.

16. Paris, Louvre C 10793; *ARV*² 555, 92; van Straten, 1995, 250, no. V308.

17. Thompson and Wycherley, 1972, 94–96.

18. Once Margam Park, destroyed in World War II with frr. now in Reading; *ARV*² 506, 25; *AJA* 63 (1959) pl. 86, figs. 41–42; Valavanis, 1991b, 497, figs. 4a–b.

19. Munich, Antikensammlungen 2315. *ARV*² 299, 2: Painter of Palermo 1108; *CVA* Munich 4 (Germany 12) pls. 190, 4–5, and 191; Valavanis, 1991b, 491, figs. 2a–b.

20. Athens, Agora Museum 10554. Published by P. E. Corbett, "Attic Pottery of the Later Fifth Century from the Athenian Agora," *Hesperia* 18 (1949) 306–8, pls. 73–74.

21. See Valavanis, 1991b, 494.

22. Cf. also the vase from Larisa published by Tiverios, 1989, where many of the athletes seem to be historical Athenians. Also illustrated in *G&P* 61, figs. 39a–b. Corbett (supra n. 20) believes that we might be seeing the *athlothetai* transporting the prize olive oil from the Acropolis to the award ceremony. Valavanis, 1991b, interprets these scenes as victory processions in which the Panathenaic victor and his friends are on the way to the Acropolis to dedicate a tithe to the goddess. Since the scenes are all-male and lack the *kanephoros*, this seems likely.

23. Tampa Museum of Art 86.52; *ABV* 704, 27*ter*: Theseus Painter; *G&P* 40, 191, no. 53; van Straten, 1995, 201, no. V44.

24. See Mansfield, 1985, 371–79, and Chapter 2 in this volume by Noel Robertson.

25. Women folding garments: Louvre CA 587 (*ARV*² 1094, 104: Painter of the Louvre Centauromachy); once Agrigento, Giudice 77 (*ARV*² 1204, 6), and a lost stamnos by the Copenhagen Painter (*ARV*² 257, 17). The numerous representations in Attic red-figure vase-painting of athletes in the palaestra holding forth their himations as if to fold them or put them on begin with the two on Euphronios' calyx-krater, Berlin 2180 (*ARV*² 13, 1). Some other examples include: Oxford 1911.621 (*ARV*² 212, 2: near Apollodoros); Boston 01.8038 (*ARV*² 376, 93: Brygos Painter); ex Hunt coll. (Bothmer, 1983, 70–71, no. 11: early Triptolemos Painter); Tarquinia RC 1915 (*ARV*² 818, 27: Telephos

Painter); Copenhagen, National Museum 204 (*ARV*[2] 869, 64: Tarquinia Painter); Berkeley 8/4581 (*ARV*[2] 974, 31: Lewis Painter); Copenhagen, Ny Carlsberg 2716 (*ARV*[2] 1272, 44: Codrus Painter). I thank Elfriede Knauer for bringing three of these vases to my attention.

26. New York, Metropolitan Museum of Art 53.11.1; *ABV* 298, 5; *G&P* 25, fig. 14. A fragment of a black-figure belly amphora in Frankfurt (Liebighaus 524) shows a woman with a similar object on her head followed by a man carrying a vessel on his shoulder; while it is identified as a wedding procession, it could represent the Panathenaic procession. See *CVA* Frankfurt 2 (Germany 30), pl. 58, 2.

27. See J. H. Oakley and R. Sinos, *The Wedding in Ancient Athens* (Madison 1993) e.g. fig. 71.

28. New York, Metropolitan Museum of Art 31.11.10; *ABV* 154, 57; D. von Bothmer, *The Amasis Painter and His World* (Malibu 1985) 185–87, no. 48; *G&P* 108, fig. 66a–b.

29. S. Karouzou, *The Amasis Painter* (Oxford 1966) 44; Webster, 1972, 123.

30. Paris, Louvre F 224; *ABV* 320, 5: Three-Line Group. See *CVA* Louvre 5 (France 8), pl. 57.7, 9, 11.

31. Another elaborate textile scene involving seven (?) women within a Doric colonnade appears on an unpublished (?) black-figure amphora in Cerveteri, 67429.

32. Würzburg, Martin-von-Wagner-Museum L 515. *ARV*[2] 254, 5: Copenhagen Painter; *G&P* fig. 13.

33. New York, Metropolitan Museum of Art 25.190; Brendel, 1945; Metzger, 1965, 66, no. 18, 60 with bibliography; M. Robertson, *The Art of Vase-Painting in Classical Athens* (Cambridge 1992) 288, fig. 291.

34. Mark, 1984, 289–342, esp. 306, fig. 1. The gesture is similar to that of Hebe on the epinetron by the Eretria Painter (*ARV*[2] 1250, 34).

35. E. B. Harrison, "Apollo's Cloak," in G. Kopcke and M. B. Moore, eds., *Studies in Classical Art and Archaeology: A Tribute to Peter Heinrich von Blanckenhagen* (Locust Valley, N.Y., 1979) 91–98.

36. Ridgway, 1981, 82, comments, "It is certainly remarkable, given the propensity for nakedness in Classical art, that even the most revealed bodies on the frieze should have some indication of clothing, however scanty, and this 'prudery' must have iconographical meaning, especially in comparison with the predominantly naked Lapiths of the South metopes. Since the draped grooms show that nakedness cannot be taken as a sign of youth on the frieze, should we assume that clothing distinguished human from heroic or legendary characters?" On male dress in fifth-century Athens, see Geddes, 1987.

37. *ARV*[2] 384, 212; *AJA* 58 (1954) pl. 68.5. On the function and meaning of the parasol, see M. C. Miller, "The Parasol: An Oriental Status-Symbol in Late Archaic and Classical Athens," *JHS* 112 (1992) 91–105, pls. 1–6.

38. For Pandora on the base of the Athena Parthenos, see now L. Berczelly, "Pandora and Panathenaia," *Acta ad archeologiam et artium historiam pertinentia* 8

(1990) 53–86; J. M. Hurwit, "Beautiful Evil: Pandora and the Athena Parthenos," *AJA* 99 (1995) 171–86. For possible fragments from this base, see E. B. Harrison, "The Classical High-Relief Frieze from the Athenian Agora," in Kyrieleis, 1986, 109–117.

39. A. Moortgat, *The Art of Ancient Mesopotamia* (London 1969) 13.

9

The Web of History
A Conservative Reading of the Parthenon Frieze

Evelyn B. Harrison

A conservative reading naturally goes together with a conservative attitude toward the text that is being read.[1] In the case of the Parthenon frieze, we must try to keep all of it in view, and that is not always easy. In antiquity, the west frieze (Fig. 9.1) was the first to confront the visitor to the Acropolis of Athens, whether he was a man from the city or a stranger coming from elsewhere. It is here that he would see the beginning of the story that the frieze has to tell.

This view no longer greets the tourist, and with good reason. The blocks have been taken down and placed indoors to protect them from the accelerating damage of the weather and the chemicals it carries. They will be replaced with casts, as the metopes of the east front have already been.

Meanwhile, two important cast collections, one in the Skulpturhalle in Basel and one in the Acropolis Study Center in Athens, have made it possible to study the friezes of all four sides in sequence, including the many fragments that have been identified, some of which are widely scattered in various European museums.[2]

When the parts of the west frieze that have been removed from public view are eventually placed on exhibit in a museum open to all, it will be easier than ever before for scholars to study certain details of these reliefs. Until then, it may well be more difficult. There will necessarily

Fig. 9.1. West frieze of the Parthenon, in situ. (Photo: Alison Frantz collection, American School of Classical Studies at Athens)

be more reliance on old photographs and old scholarship.[3] None of this should be thoughtlessly thrown away, but the very accessibility of information via computerized aids presents the student with a daunting amount of prior opinion, as well as of earlier records of fact. This is true of the Parthenon as a whole, not only the frieze. Any simplified view is likely to be welcomed with relief.

But I think it would be a pity if the close study of details should come to seem unimportant because one cannot always personally verify them. These are the words of the language that the sculpture speaks. Though we may get a great deal of pleasure out of looking at the reliefs even without knowing their language, it is like enjoying the rhythms and sonorities of poetry in some exotic tongue that we cannot hope to understand.

What I find disturbing about some recent writings on the Parthenon frieze, especially in the English language, is their cavalier treatment of iconographical clues. This trend began with John Boardman's article in 1977 in the Festschrift for Frank Brommer.[4] Boardman assumed unity of time and place for the whole frieze and read it all as the celebration of the Panathenaic festival in 490, shortly before the Battle of Marathon, when the Persians were already on their way toward Greece. He says we

are meant to see here the heroic dead of Marathon celebrating their last Panathenaia. His clinching argument is that in the cavalry and chariot sections, which take up so much of the total length, we have exactly 192 participants. To arrive at this number Boardman has to count the little boys who help the riders to get ready but not the skilled charioteers on whom much of the success of the races depends.[5]

As the 192 Athenians who fell at Marathon were hoplites, not cavalry, he has to assume that the frieze heroizes mature footsoldiers into young riders in token of the official heroization of those who lost their lives. In this he violates what seems to me to be the first law of iconography: that a depiction ought *in some way* to look like what it represents. I do not mean to say that Boardman has no eye for detail; we owe to him any number of keen observations that have enriched our understanding of Greek vase-painting and sculpture. Rather, he seems here to be playing a game, the game called "Parthenon," and playing it deuces wild.

More recently, two articles have tried to do away with the most widely accepted identification of the ten standing men who flank the groups of seated gods in the east frieze (Figs. 9.2–9.3). Most of us see in them the Eponymous Heroes who gave their names to the Ten Tribes in the new democratic constitution of Kleisthenes.[6] In 1985 Ian Jenkins began by detaching figure no. 18, in the southern group of six Heroes, from the man with whom he is conversing, his gesturing hand overlapping the chest of his companion.[7] To Jenkins, no. 18 must be a marshal, leading the females behind him. He has not noticed that leading the procession is something that these so-called marshals never do. They stay in their appointed places and give signals to those who move.[8]

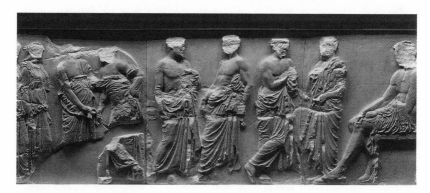

Fig. 9.2. Six Eponymous Heroes. Cast of east frieze of the Parthenon (18–23). Basel, Skulpturhalle (Photo: D. Widmer)

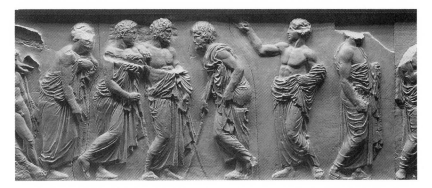

Fig. 9.3. Four Eponymous Heroes. Cast of east frieze of the Parthenon (43–46). Basel, Skulpturhalle (Photo: D. Widmer)

Having separated off no. 18 from the group, Jenkins is left with only nine standing men. If only nine, they cannot be tribal heroes, and if no. 18, a mortal official, is on such intimate terms with one of the group, they too must be mortal officials. So he revives an earlier proposal that these are the nine archons. But he still has a problem. Jenkins accepts, and I would agree with him, that the King Archon, the Basileus, appears elsewhere (see Fig. 8.6). He is the man in the central scene involved in the handling of the folded cloth that most of us call the peplos. So the nine men flanking the gods become eight archons and their secretary! You can see how unreal the game is becoming.

In 1992, Blaise Nagy accepted Jenkins' designation of no. 18 as a marshal but not his identification of the other figures.[9] His own is no more persuasive, for he would see here the *athlothetai*, officials who would not have served as beardless youths any more than the archons would.[10] Five of the ten disputed figures are bearded and five beardless. Moreover, one of the bearded ones is extremely elderly, unlikely for that reason to have held one of the offices mentioned.[11]

The representation of a conspicuously old man together with a beardless youth and a mature bearded man is a sign that three generations are being shown. This is appropriate to the Heroes; we can feel sure that the very old man is Kekrops, the most ancient of the Eponymoi.[12] The pair next to him should be those nearest to him in time: the fatherly man Erechtheus, the youth on whose shoulder he leans Pandion. I would take the outermost of this northern group of Heroes to be Aigeus, the father of Theseus, bearded as he always is, because fatherhood is his main role in myth.[13] Elizabeth Pemberton has pointed out that these four are the

only kings among the Heroes.[14] All four ruled on the Acropolis, and three had cults there.[15]

The status of the ten men as ancestors of the Demos explains their place next to the gods as well as the sticks on which they lean. It also explains their lack of any occupation directly related to cult or festival. Like the gods, they are favoring and symbolic presences, not actors in a drama.

Once we have accepted them as the Eponymoi, it is impossible to give the name of Erechtheus to the grown man of the central scene (see Fig. 8.6), as Chrysoula Kardara did many years ago[16] and Joan Connelly has again proposed.[17] This central scene is the most important to us today as we consider the Panathenaia. Over two hundred years ago, James Stuart identified the folded cloth depicted here as the Panathenaic peplos that was presented every year to Athena.[18] Before we agree to reject this reading, we ought to look carefully.

First, it is important to recognize that the cloth is being folded, not unfolded. Think of yourself folding up a sheet after you have taken it out of the dryer. You can do it by yourself, but if you have a little helper it will be easier to get the edges and corners even. From the thickness of the already-folded mass of cloth, we can guess that the two figures here are making the last fold. The man holds up the cloth in his two hands with part of it flapped over, rotating it down until the thick fold is in line with the selvages below. The child is smoothing out the wrinkles and helping to bring the corners together. The artist has indicated the folds and single edges so precisely that we can tell the exact order of the folding. Color will have helped the distant viewer. The oblong piece of cloth is first folded in two lengthwise, second again lengthwise, and only third crosswise. That is how we see it here. In the upper part one can make out the U-shaped lines: a thick edge outside, representing a fold, and thin ones inside, which are the single borders of the cloth. In the lower portion all the selvages are together at the bottom. These would have been at the side when the garment was put on.

If the line of the second lengthwise fold is taken as the overfold-line of the peplos, the overfall will be one-third the length of the dress, about right for the so-called Argive peplos that is worn by both Hera and Athena on the Parthenon frieze, not long enough for the belted overfall of the Athena Parthenos.[19] This may explain why we have the two lengthwise foldings before any cross-folds. The first folds are more sharply impressed into the cloth, but, except for the bottom fold, their lines will not be visible in the smooth areas of the dress once it is put on. The overall size of the cloth depicted appears to be about right for a grown woman, too big for a child.

In short, this really seems to be Athena's peplos. It is not being opened up for inspection by the Basileus,[20] and it is not being got ready to be donned by one of the participants in this scene.[21] In the sensitive and beautifully written text to the publication of Alison Frantz's photographs in 1975, Martin Robertson observed, "The folded cloth will then be the *old robe*, its four-year service finished, implying the timeless repetition of the ritual."[22] I completely agree that the picture is timeless in this way, but it is hard to think that the old rather than the new peplos should take the spotlight. If we remember that the gold ornaments worn by the Ancient Image are listed in surviving inventories of the temple in which the statue stood,[23] we can understand that a Panathenaic peplos becomes a part of Athena's Treasury as soon as it is given to her, not only when it is put away in storage with the peploi of bygone years. So this act of folding is the official rite of acceptance of the peplos by Athena. The Basileus, the ritual successor of the ancient kings, having inspected it and found it worthy, now registers it as property of the goddess. At the appropriate time—we do not know exactly when or where—it will be handed over to the Praxiergidai, the women who dress the statue.

The folded peplos will be left in the hands of the child, whose right hand is already under it. Brommer took this child to be a temple boy.[24] Though Stuart thought it should be a girl because he knew of the role of the *arrhephoroi* in the weaving of the peplos,[25] all the readable signs in the picture say "boy." Thus the idea of a girl did not last long. How has it come to be revived? Pars' drawing for Stuart, published in 1787,[26] erroneously shows a round pin or button on the shoulder in an area where in fact no surface is preserved except for the bottoms of a few deepcut straight lines. This seems to have misled Robertson, who writes that "the pronounced Venus rings suggest a girl, which, perhaps, as girls wove and carried the robe, one might expect. . . . The child wears a garment fastened on both shoulders. . . . The Doric chiton or peplos was so fastened."[27] But this is not a peplos, and it is not fastened on either shoulder. Though the right shoulder is hidden, we can see that this is a draped himation with a triangular overfall in front. On the left shoulder we can just make out a straight horizontal line and straight slanting lines above.[28] A vase-painting in New York (Fig. 9.4) shows the same draping, which is made clear by the black border stripe.[29] A colored border stripe will have made it equally clear on the frieze. The himation is worn like this by both male and female figures. The difference is that females *never* wear it without a chiton underneath. Robertson's comparison of the boy with the little girl on a gravestone in New York is misleading.[30] This child is alone with her pets in the sheltered courtyard of her home. Even so, the amount of bare flesh shown is very discreet. On the frieze the bare

buttocks of the child are obvious enough to identify the figure from a distance as a boy. Precise profiles and anatomical analyses of modern grownups such as Boardman has published to support Robertson are iconographically irrelevant to the Greek artist's depiction of children.[31]

Likewise, the so-called Venus rings have nothing to do with Venus. These are wrinkles in the tender skin of a well-nourished child. Compare a bronze Dionysos from Roman Spain,[32] or, closer to home, the fragment of a boy's head from the Athenian Agora, where the outline of the hair in front of the ear shows that it is male.[33]

Brommer found only one reference, and that a late one, to a temple boy of Athena in Athens.[34] But we have a beautiful description of an archetypal temple boy in the *Ion* of Euripides. In the prologue Hermes tells how the secret child of Apollo by the Athenian princess Kreousa was brought up in the temple at Delphi. When he grew up, the Delphians made him guardian of the god's gold and faithful treasurer of everything.[35] When the play begins he is living out a holy life in the palace (*anaktora*) of the god. This picture is drawn from the Attic iconography of the child Erichthonios and the King Erechtheus who is his grownup aspect.[36]

The Erichthonios-like boy in the frieze is not old enough to be a guardian of gold, but just because he is so young he can preserve the purity of the most intimate possessions of the goddess. Although we have no text to describe the duties of the Athenian temple boy as Ion

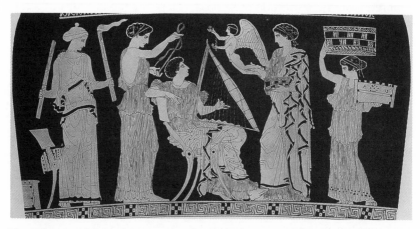

Fig. 9.4. Attic red-figure lebes gamikos by the Washing Painter, ca. 440–430. New York, The Metropolitan Museum of Art 16.73, Rogers Fund, 1916. All rights reserved, The Metropolitan Museum of Art (Photo: Museum)

describes his, we can think of him as the fosterling and intimate of Athena like Erichthonios. It would be this boy who could enter into the secret place, open otherwise only to women and not to be depicted on this frieze, where the unsullied new garment is delivered to the women who will dress the goddess.

When the idea of fertility is personified as a child in Greek art, it is always as a boy. Peplos and child belong together, for the peplos, like a baby, took nine months to produce.[37] Various customs in which a small boy plays a role in wedding rituals favor the fertility of the marriage. The fertility of the Athenian People, their herds, and their crops was ensured by a sacred marriage between Dionysos and the wife of the Archon Basileus, the Basilinna. It is generally agreed that the Archon took on the role of Dionysos in this annual ritual, and this is why a number of scholars have thought that the stately woman next to the Basileus is his wife.[38] Dorothy Thompson, in her wonderful article on the "Persian Spoils in Athens" in the Festschrift for Hetty Goldman, says of the girl to the left of the central scene: "In her hand this *diphrophoros* carries an object, much damaged, that has been hard to identify. But the outline against the background is clearly that of the foot of a low stool, surely the footstool that always rests beneath the feet of a king. The man, then, who has been variously identified, can be no other than the descendant of the kings of Athens, the Archon Basileus; the woman must be the Basilinna, his wife."[39]

It is natural to think that the two *diphrophoroi* are the *arrhephoroi*, the girls in service to Athena whose name means "carriers of secret things." The actual Arrhephoria was a secret mission that is not depicted here, but the act of carrying is the attribute of these girls, and their role in starting the weaving of the peplos justifies their presence in the peplos scene. Walter Burkert connects the Arrhephoria with the legend of the daughters of Kekrops, to whom Athena entrusted the basket that contained Erichthonios.[40] Even more than the daughters of Erechtheus, the daughters of Kekrops are the archetypal king's daughters, the *parthenoi par excellence*. But the wife of Kekrops is a shadowy figure, who has the same name as his oldest daughter; Erechtheus and Praxithea are the archetypes of king and queen.

When the man and woman take their seats on the *diphroi* which the girls are bringing them, they will become a couple like Zeus and Hera. Zeus, with his feet on a footstool, leans back on his throne like a bridegroom awaiting his bride, and Hera, seated beside him, opens her veil to him. This is not the only nuptial pair of the frieze, for the depiction of Hephaistos and Athena (see Fig. 8.9) clearly alludes to the curious nonmarriage that begot Erichthonios. We have noted that

Athena's peplos is like Hera's; she even has the same sexy triangle of exposed flesh under the arm, though otherwise her attitude to her companion is more closed than open.

There is one more couple on the frieze that is suggestive of marriage, though in a surprising way. Demeter and Dionysos sit opposite one another with their legs overlapping. Egyptologists have noted that a similar scheme is used in Egyptian art to depict the intercourse of the Pharaoh's mother with a god from whom the king takes his divinity.[41] We are reminded that Herodotos equates Osiris with Dionysos and Demeter is often assimilated to Isis, but I know of no specific tradition of a sacred marriage of Demeter and Dionysos. Here is a puzzle that needs more work.[42]

I have one general comment on the mood of the peplos scene. When she learned of Connelly's interpretation, the archeologist Maria Shaw said to me, "I just can't believe that anything tragic is going on; these people look so ordinary, as if they were doing something that they do all the time." This strikes me as a very important point. Our iconography of the myths of human sacrifice in Greek art is very limited, but in what we have the sorrow and foreboding of the participants play an important role. It is said that in portraying the sacrifice of Iphigeneia the late fifth-century painter Timanthes displayed so much sorrow in the faces of the others present that when he came to paint the father, Agamemnon, the only way to show greater grief was to cover his face entirely. We have reflections of this in Roman art, on the altar of Cleomenes,[43] and in Roman painting.[44] And look at the faces of Iolaos and the young sons of Herakles on a South Italian vase (Fig. 9.5) depicting the *Herakleidai* of Euripides as they mourn the sacrifice of the brave daughter who willingly offered her life to save them and the Athenians who defend them.[45] This tragedy is closer in time to the Parthenon than the *Erechtheus*.

Before we move on to the figures in procession, we should also note that the peaceful attitudes of the gods on the Parthenon frieze differ markedly from those of gods in scenes where they assemble to concern themselves with a battle.[46] On the east frieze of the Siphnian Treasury at Delphi,[47] they lean forward and gesture, while Zeus in the center is actually using the scales of fate to discover the outcome. On the so-called Theseum (Fig. 9.6), Zeus leans forward and looks as though he is about to throw a thunderbolt with his right hand, and Athena seems to have held her helmet in her left hand, as she sometimes does when she is rushing to take part in a conflict.[48] In the east frieze of the Temple of Athena Nike, the gods are quiet, but Athena stands ready with her shield on her arm, and the almost-lost figure of Ares probably did the

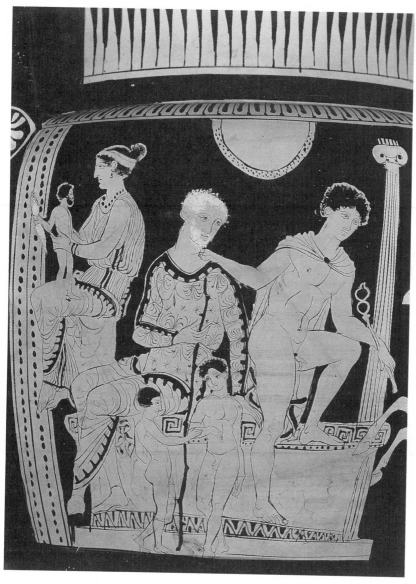

Fig. 9.5. Detail of Early Lucanian red-figure column krater of the Policoro Group, ca. 400–390. Berlin, Staatliche Museen 1969.6 (Photo: Museum)

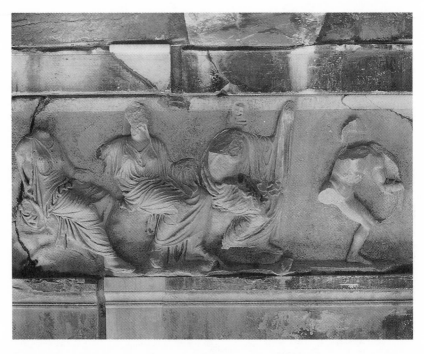

Fig. 9.6. Seated deities. East frieze of the so-called Theseum (Photo: American School of Classical Studies at Athens: Agora Excavations)

same.[49] It is very striking that in the Parthenon frieze the two principal Athenian war-gods, Athena and Ares, have neither their shields nor their helmets. Athena's role as the protector of the city is amply shown elsewhere on the Parthenon.[50] In the frieze she is the fostering mother of the Athenian People.

The still pool, the reservoir of strength at the timeless center of the east frieze, is fed by the streams of Athenian history embodied in the processions of the west, north, and south. I have written about this elsewhere and have space here for only the briefest of résumés.[51] The great majority of the participants are very young, because in each age the young represent the purest potential, and the success of the state depends on the use it makes of this potential. We are told that Perikles thought of himself in a fatherly relation to the Demos, allowing them to develop freely while learning to control their harmful impulses.[52] Throughout these splendid cavalcades we see young men learning to control spirited horses as they learn to control themselves, not forcing them into a single pattern but letting them show their mettle in the most

admirable way. Jerome Pollitt has made an important point in reminding us of the special interest of Perikles in the cavalry as part of the army,[53] and we must always remember that Athena was a tamer of horses, but horsemanship is in itself a beautiful metaphor for the schooling in self-control of the young citizen-to-be.

At the beginning of the west frieze horses are being caught and bridled; the action starts and stops and starts again. Different places seem to be indicated, rocky hills, a stream across which a horse is led with difficulty. There is a sense of coming together from separate locations. There is one figure of truly heroic stature, a bearded rider controlling a magnificent rearing horse. He braces himself against a rocky slope as Theseus braces himself in vase-paintings when he controls the bull of Marathon.[54] Brommer noted that he had metal sandal-straps, surely golden.[55] I would say that this *is* Theseus, and that Bernard Ashmole was right when he said the figure is like an allegory of government.[56] We understand that all the figures in this part of the frieze are being brought together from different places to join a cavalcade that represents the unification of Attika by Theseus. There was a festival in commemoration of this, the Synoikia, which took place not long before the Panathenaia.[57]

The west frieze, then, represents early times. The heroes depicted may stand for the *gene*, the clans that traced their origins to the oldest heroes. On the north, where the number four repeats itself in the sacrificial victims, the water-carriers, the musicians, and the elders, the reference must be to the time before Kleisthenes, when the four Ionian Tribes were the basic division of the People. On the south there are ten victims, ten chariots, and ten groups of riders, each of whom is distinguished by a particularity of dress. Here is the Athens of the Democracy, contemporary with the Parthenon itself. Boardman said he could not imagine the Athenians looking up at the frieze and saying, "There we go,"[58] but here I think we can.

Time exists here, but in the broadest sense. Although the Panathenaia provides the framework and the idea of magnificence, it does not seem possible that everything we see was part of the Panathenaia, just as many things which we know were in the Panathenaia are missing. Luigi Beschi is doubtless right that we have here a representation of the idea of *heorte*, festival, with the Panathenaia as the expression of its deepest meaning.[59]

The processions of women on the east side are continuous with the processions on the adjacent long sides. In the gesture of the marshal who beckons from his place beside the northern Heroes to the women approaching the southern Heroes from the south, we see the people of contemporary Athens being called to join their ancestors in the worship of the ancestral gods. The one who beckons to the southern procession

and the one next to him facing the northern procession are both young and seem, like the "marshals" who mark the corners of the frieze, to be stationary. They represent the last point that the worshippers will pass before entering the area of the altar and the sacrifice. The two men who confront the first two pairs of maidens are mature: Carrey shows the first as bearded, and while the second is unclear in Carrey's drawing, both men have strongly veined hands. We may call these men officials; they are surely over thirty.

The man facing the first two maidens is holding something in his hand, holding it high as if to give rather than to receive it. Though the identity of this object has been disputed, I am convinced that is a *kanoun*, the basket carried in sacrificial processions, and that these maidens are indeed *kanephoroi*.[60] The maiden who is ready to receive the *kanoun* has passed the test of worthiness administered by the official addressing the next pair of maidens. The gesture of his left hand shows that he is speaking. Probably he is asking the maiden's name and those of her father and mother. Perhaps his right hand held a tablet containing a list, suspended by a string that would have been attached by the two holes visible next to his hand.

The *kanephoroi* were beautiful and virtuous young women of marriageable age. In the time of the tyrants, it was the tyrant himself who stood on the Acropolis receiving the procession and who could have the sister of Harmodios sent away after she had been invited as a *kanephoros*, claiming that she was unworthy.[61] By replacing the ruler with an anonymous official who simply asks the ritual question, this representation democratizes the religious observance. But that is not all. The acceptance of marriageable young women by the two young men who admit them to the altar can symbolize for the viewer the core of Athenian identity and the whole future of the polis: a citizenship based on legitimate and fruitful marriage.

In 451, a few years before the program of the Parthenon frieze was formed, Perikles had issued a decree limiting Athenian citizenship to those whose mothers as well as fathers were Athenian citizens.[62] This is why the women are of such great importance here. There are many of them, too many to be counted at a glance, just as the number of males on the other side is too great to be tracked by the moving eye of the spectator. As Keats sensed, this is a picture of a folk.

Connelly's reading may move us with the story of the heroism of the daughters of Erechtheus and their brave mother, suggesting that this sacrifice for the city's good is the central narrative of the frieze. T. B. L. Webster writes: "Clearly the heroism of a girl or boy was good theatre,"[63]

but the Parthenon frieze is not a drama; it is a pageant. It stands for the greatness and continuity of Athena's city as the representations on her peplos stand for its great deeds. A probable relationship of the metopes of the Parthenon to the pictures on the peplos has often been suggested. In the Gigantomachy we see Athena's strength in battle, while the other metopes invoke the parallel of the city's victory against the Persians. We need not think that only the Gigantomachy was portrayed on the peplos. Brave Athenians of the past were called "worthy of the peplos." If their images did not appear there, their spirit did. So the tradition of the peplos, the sum of its many yearly parts, stands as a record of the continuing greatness of the people of Athens. The more we see of the details of the Parthenon frieze, the more we realize how wrong those were who have seen it all as preparation and anticipation of something about to happen. Everything here is ongoing; everything is process. The future rests in the actions of all the people.

Notes

1. This chapter is the only slightly altered text of a paper read at a symposium at Princeton University on September 18, 1993, in connection with the exhibition *Goddess and Polis* at the Princeton Art Museum. I had been invited to speak after Joan Connelly, presenting my own "contrasting" interpretation of the Parthenon frieze. The only account in print of Connelly's reading was the abstract (Connelly, 1993) of an earlier version of the lecture she gave in Princeton; it is now fully published in Connelly, 1996, which appeared after the submission of this chapter.

2. See Brommer, 1977 for the most complete catalogue of Parthenon frieze fragments.

3. In addition to Brommer, 1977, see Jenkins, 1994, which provides a recent overview intended for the museum visitor as well as for scholars. The continuous photographic documentation is made easier to follow by a most welcome consecutive renumbering of the slabs and figures. We can hope for general agreement on Jenkins' slab numbers; the total number of figures is not absolutely certain.

4. Boardman, 1977. See also Boardman, 1984, which covers some of the same ground.

5. Boardman, 1977, 48.

6. For the most complete and reasoned treatment of the Eponymoi, see Kron, 1976. See also Harrison, 1979b; Kron, 1984.

7. Jenkins, 1985.

8. Note particularly that no one proceeds ahead of the maidens in the northern half of the east frieze. They are received by standing male figures who face the oncoming procession.

9. Nagy, 1992.

10. For the age requirements for Athenian civic officials, see Rhodes, 1981, 116, and the other passages referred to in the index under "age requirements." Rhodes concludes that "over thirty was, in the classical period, the age require- ment for jurors, bouleutai and probably most regular officials." Although most of our information comes from Aristotle, we cannot dismiss the thirty-year age requirement as a development of the fourth century. Thirty years of age was already a minimum for officials chosen to oversee the Herakleian games at Marathon in the early fifth century. See *IG* I^3 2, no. 3, lines 3–10. It is not certain whether these overseers are the *athlothetai* mentioned in the same inscription or appointed by them, but the games are evidently sponsored by the whole of Athens, since the overseers are to be chosen three from each tribe (lines 5–6). We can hardly imagine that the *athlothetai* of the Panathenaia could serve at a younger age. Nagy does not discuss the question of age requirements. Men of thirty or over would not be represented as beardless in Classical Greek art, though warriors or athletes in their twenties could be shown as beardless men. See the references to *andrias ageneios* in the inventories of bronze statutes on the Acropolis, Harris, 1992, 648–52 (many of these will have represented gods or heroes).

11. This bent old man, whose shod foot is overlapped by the foot of Aphro- dite, seems to have inspired images of grandfathers on Attic gravestones of the fourth century. Strikingly similar is the figure of Littios, whose epitaph declares that he lived ten decades. See Meyer, 1989, pl. 8, 1.

12. Kekrops is shown with white hair on the red-figure hydria in Pella depicting the contests of Athena and Poseidon. See Delivorrias, 1987, 205.

13. See Kron, 1976, 127–40, pls. 15–18.

14. Pemberton, 1976, 114.

15. Kekrops, Erechtheus, and Pandion.

16. Kardara, 1961, 115–29.

17. Connelly, 1993; *eadem*, 1996.

18. Stuart and Revett, 1787, 12.

19. See the diagram of the "Argive" peplos in *G&P* 111, fig. 70.

20. Gauer, 1984, 223, argues that the man is inspecting the cloth. He contends that his action, as well as the whole scene, including the gods, is to be located in the Agora.

21. Connelly, 1993, interpreted the cloth as a shroud for the child, whom she identifies as a girl, the youngest Erechtheid, who is to be sacrificed in order to save the city.

22. Robertson and Frantz, 1975, 11.

23. Kroll, 1982. See 68–69 for the references to the inscribed accounts.

24. Brommer, 1977, 269–70.

25. Stuart and Revett, 1787, 12–13.

26. *Ibid.* pl. 23.

27. Robertson and Frantz, 1975, unnumbered page following fig. 4, the peplos scene.

28. The two slanting lines seem to be chiseled grooves. The horizontal line,

which appears to be a break, may well represent the line of the projecting edge of the mantle, which has broken off. The whole shoulder area above this line is battered.

29. Lebes gamikos by the Washing Painter, New York, Metropolitan Museum of Art 16.73. *ARV*² 1126, 6; Boardman, 1989, fig. 207.

30. Robertson, 1975, page after fig. 4.

31. Boardman, 1988, 10, fig. 1.

32. *Los Bronces Romanos en España*, exh. cat., Ministerio de Cultura (Madrid 1990) 259, no. 180.

33. E. B. Harrison, "The Classical High-Relief Frieze from the Athenian Agora," in Kyrieleis, 1986, pl. 119. 2.

34. Brommer, 1977, 269–70.

35. Euripides, *Ion* 28–56. See Immerwahr, 1972 for the manner in which Euripides constantly evokes images of Athenian sites, myths, and rituals in the Delphic setting of the *Ion*.

36. See Kron, 1976, 37–39 for the original identity of Erechtheus and Erichthonios. Although later genealogies separate the two, Erichthonios never appears in Attic vase-painting as a grownup, nor does Erechtheus appear as a child.

37. Deubner, 1932, 31.

38. *Ibid*. 100–102. Simon, 1983, 97, believes that the priest of Dionysos rather than the Basileus played the role of Dionysos in the ritual. She would identify the woman in the peplos scene as the priestess of Athena Polias: Simon, 1982, 128. Her argument is that the Basilinna is not recorded to have any role in the Panathenaia. I would argue that the priestess of Athena, as a member of an old aristocratic *genos*, would be out of place in the company of the annually changing Basileus, the ritual leader of the Democracy.

39. Thompson, 1956, 290. For the footstool carried by a small girl attending a woman, compare a large fourth-century grave monument in Rhamnous: V. Petrakos, *Rhamnous* (Athens 1991) 36, fig. 23.

40. Burkert, 1966.

41. H. Brunner, *Die Geburt des Gottkönigs* (Wiesbaden 1964) 35–38.

42. The fourth-century red-figure Tyszkiewicz hydria in Lyon depicts Demeter and Dionysos sitting apart with their backs toward the center while their heads turn to gaze with great intensity at one another. Persephone stands between them holding up two torches whose flames unite. All this suggests the symbolism of marriage. Metzger, 1965, 37, no. 18, pl. 17.

43. G. Mansuelli, *Galleria degli Uffizi: Le sculpture* (Rome 1958) 145, inv. 612, p!. 116 a–d.

44. Wall-painting in Naples from the House of the Tragic Poet at Pompeii. A. Stenico, *Roman and Etruscan Painting* (New York 1963) fig. 87.

45. Red-figure Early Lucanian column-krater in Berlin, Staatliche Museen 1969.6, related to the Policoro Group: Trendall and Webster, 1971, 87, no. III.3.21.

46. One of Connelly's arguments for assuming that the frieze depicts an event in time of war was that when an assembly of gods appears in Greek architectural friezes, they are generally watching a battle.

47. Stewart, 1990, pls. 192–94.

48. Von Bockelberg, 1979, pl. 11; Dörig, 1985, pl. II, figs. 18–19, 21–22.

49. See Harrison, forthcoming. The two male legs between Athena and Zeus should be those of Ares, whose shield, carried on his left arm, will have projected into the empty space above the knees of Zeus.

50. On the shield of Athena Parthenos and in the west pediment. In the east metopes she fights with the other gods to preserve the order of the universe.

51. Harrison, 1984; Harrison, 1989.

52. This point was made by Barry Strauss in a paper in the symposium on Greek Democracy at New York University in 1992. Cf. Theseus' speech in the *Suppliants* of Euripides, lines 442–55.

53. Pollitt, forthcoming.

54. Cf. the cup by the Codrus Painter, London, British Museum E 84. ARV^2 1269, 4; Boardman, 1989, fig. 240. Theseus seems to have had the same pose in South Metope III of the so-called Theseum; though the leg is broken away, the rock and the trace of the foot remain: Morgan, 1962, pl. 75a. In the Nike Parapet, a Nike struggling to control a bull braces her foot against a rock in the same way: Brouskari, 1974, 158, no. 7098, fig. 334.

55. Brommer, 1977, 13.

56. Ashmole, 1972, 122.

57. Deubner, 1932, 36–38; Simon, 1983, 50.

58. Boardman, 1977, 43.

59. Beschi, 1984, 192.

60. Boardman, 1988, pl. 5, 4–5, has published the clearest pictures of this object, which, though Boardman himself argues against it (11–13), appears easy enough to restore as a *kanoun* of the shallow sort with low, looped attachments at the sides (which could have been fastened in metal to some of the drilled holes; the man's right hand may be grasping one of the small feet). Though Boardman objects to the small size, it does not seem that one can judge from vase-painting whether it is impossible, especially since part of the width is hidden. For further discussion of the *kanoun* and *kanephoroi* in general, see Roccos, 1995.

61. Aristotle, *Constitution of the Athenians* 18.3. For commentary see Rhodes, 1981, 230–31. The *Constitution of the Athenians* places Hippias on the Acropolis to receive the Panathenaic procession at the time of the murder of Hipparchos by Harmodios and Aristogeiton. Rhodes comments (231) that this is "more logical" than placing him "outside in the Kerameikos" as Thucydides (6. 57.1–2) does. Neither account is free of confusion, and we do not know what people believed at the time of the Parthenon, but both give a picture of the tyrants controlling the Panathenaic procession. The rejection of Harmodios' sister took place at the Panathenaia according to the *Constitution of the Athenians* and "in some sacrificial procession" according to Thucydides.

62. Boegehold and Scafuro, 1994, 57–66.

63. Webster, 1967, 104.

10

Democracy and Imperialism
The Panathenaia in the Age of Perikles

H. A. Shapiro

In the more than one-thousand-year history of the Panathenaia, we usually recognize only one fixed point: 566, the year the festival was reorganized and the distinction between the yearly celebration and the four-yearly Greater Panathenaia first established. From this point on, apart from certain modifications, additions, and adjustments, the festival is thought to have preserved its essential character and function until well into the Roman period. Yet any festival that, like the Panathenaia, was so central to the civic ideology of the polis must have taken on many different meanings and associations in different historical periods. The religious significance of the festival may have been relatively fixed and unchanging, but its political importance was surely not.

To test this hypothesis, I would like to focus in this brief chapter on that period in the middle and third quarter of the fifth century when Perikles was the dominant political figure in Athens. This raises particular questions about the role of the festival, and of civic religion in general, in a radical democracy and, perhaps even more interesting, their role in a city that had recently become the capital of an empire.

By the middle of the fifth century these were the two salient and, to some, paradoxical features of Classical Athens: a free and open democratic society at home and an empire abroad, often ruthlessly enforced on unwilling subject cities.[1] Perikles himself seems to have

215

had no difficulty justifying both democracy and empire to his fellow Athenians, as he does most notably in the Funeral Oration. It was the Panathenaic festival, I would argue, that was the most visible symbol of this ideological duality of Periklean Athens.

In the Funeral Oration, as reported by Thucydides, when Perikles defends the Athenian taste for the finer things in life, as against the dour and regimented Spartan system, he specifically mentions the prevalence of games and sacrifices at Athens (2.38). It is usually assumed that he has the Panathenaia chiefly in mind. Just how important these games and sacrifices were in sustaining the democracy of the Classical period we learn best not from Perikles himself but, ironically, from that disgruntled contemporary of Perikles whose vehemently antidemocratic sentiment has earned him the nickname Old Oligarch. "The Athenian *demos*," he writes, "realizes that it is impossible for each of the poor to offer sacrifices, to give lavish feasts, to set up shrines, and to manage a city that will be beautiful and great, and yet the *demos* has discovered how to have sacrifices, shrines, banquets, and temples. The city sacrifices at public expense many victims, but it is the people who enjoy the feasts and to whom victims are alotted" (2.9, trans. G. W. Bowersock). We may recognize here a reference to the sacrifice of hundreds of oxen at the great altar of Athena on the Acropolis, with which the Panathenaia culminated, and the distribution of meat to the populace in the Kerameikos.[2] In Perikles' time, this largesse of the state no doubt came to be regarded as a symbol of the privileged status of those who resided in the most powerful city in the Aegean world. The restrictive Citizenship Law of 451/50, sponsored by Perikles himself, can best be seen as a direct response to the ever more sought-after privileges of being an Athenian citizen as the city's power and prosperity grew.[3] The Old Oligarch's allusion to shrines and temples and a beautiful city must refer to the Parthenon and other buildings that were going up on the Acropolis even as he was writing.[4]

Taken out of context like this, the passage quoted above might almost sound like high praise, but within the larger context of the treatise, it is clear that the author means it as a scathing indictment of a city where the *demos* (elsewhere the author calls them *ochlos*, "rabble") have usurped all the privileges and enjoyment that properly belong only to the upper class—and have done so literally at the expense of the upper class. Earlier, with an apparent reference to the games at the Panathenaic festival, he writes, "At least the *demos* think themselves worthy of taking money for singing, running, dancing, and sailing in ships, so that they become wealthy and the wealthy poorer" (1.13). The reference must be to the exceptionally valuable prizes awarded at the Panathenaic games—

for example the 140 jars of olive oil for the winner in the two-horse chariot race, or the gold crown worth 1,000 drachmas plus 500 drachmas in cash for first place in the competition for kitharodes.[5]

The intimate connection between democracy and imperialism did not escape the jaundiced eye of the Old Oligarch either. He writes, with almost grudging admiration, "By virtue of their naval power, the Athenians have mingled with various peoples and discovered all types of luxury. Whatever the delicacy in Sicily, Italy, Cyprus, Egypt, Lydia, Pontus, the Peloponnese—all these have been brought together into one place by virtue of naval power" (2.7). In other words, as long as her empire kept Athens prosperous and well-fed, democracy was deemed to be a great success. This may sound a bit cynical, especially when we have recently celebrated the 2,500th anniversary of the birth of democracy in Athens, but I suspect that Thucydides, the original master of *Realpolitik*, would agree.[6]

The fact that the empire was founded upon naval power, as the Old Oligarch emphasizes, had far-reaching consequences for Athenian society. For the rowers of the fleet, drawn primarily from the lowest property class, or *thetes*, soon recognized their own indispensable position and no doubt flexed their political muscle in the Assembly and the courts. They also expected to reap the benefits of the empire built upon their labors.

Some time in the fifth century, the huge peplos woven for the Greater Panathenaia began to be displayed as the sail of a ship wheeled up the Acropolis.[7] The date of this innovation is not known—perhaps soon after the naval victory over the Persians at Salamis in 480[8]—but it is reasonable to suppose that the practice took on added significance with the growth of Athens' naval empire. In mythological and religious terms, the same development is reflected in the sudden importance of the cult of Poseidon, alongside that of Athena, on the Acropolis from the middle of the fifth century.[9]

The Panathenaia was a combination of many different elements, including large-scale animal sacrifices, feasting, processions, and a wide range of contests for athletes and musicians. I shall consider only a few of these elements and ask how each of them was adapted during the fifth century to suit the image that Athens, as both democracy and imperial capital, wished to project.

Musical contests may have occupied the first day of the festival,[10] and the evidence of vase-painting suggests that those for kithara-players, flute-players, and singers were all on the program from the time of the reorganization in 566, since all can be found on black- and early red-figure vases of the middle and later years of the sixth century.[11]

By the Periklean period, however, certain changes in their iconography have become conspicuous. Fluttering Nikai are now an almost indispensable accompaniment of musical victors. The victor himself is seldom seen actually performing, but instead stands quietly receiving his accolades,[12] not unlike today's Olympic victor on the podium, listening to his national anthem. These vases not only reflect the allegorizing tendency of High Classical art, but also seem for the first time to elevate the victorious musician to a heroic stature equal to that of athletic victors. We may sense the influence of Perikles' adviser, the musical theorist Damon, behind this new prominence of the professional musician.[13]

When first introduced in 566, musical and rhapsodic contests may well have been held outdoors, in the Agora, with the performers on an improvised raised platform, or *bema* (in some early depictions it simply looks like a table, *G&P* no. 18),[14] and the audience seated on temporary wooden bleachers, the same *ikria* used for dramatic performances before the creation of the Theater of Dionysos on the south slope of the Acropolis. But the delicate sounds of aulos and kithara are better appreciated indoors, as Perikles must have recognized when he built Athens' first enclosed concert hall, or Odeion, adjacent to the Theater of Dionysos.[15] Often vase-paintings of the Periklean period include a prominent Doric column behind musical performers, to suggest the setting in the new Odeion.[16] That Perikles should have undertaken such a building project, when he had so many seemingly more important ones to occupy him, suggests how central was the role of music and poetry in the life of the city. The claim that the arts flourish best in a democracy, and not in a rigid oligarchy like Sparta's (or even under the patronage of tyrants) is central to Perikles' ideology in the Funeral Oration. We need only recall the famous words: "We love beauty but without extravagance; we love wisdom but without softness" (Thucydides 2.40).

In this same context I would see the celebrated portrait statue of the poet Anakreon, set up in no less prominent a location than the Acropolis in the middle of the fifth century (Pausanias 1.25.1). At this time, Anakreon himself had been dead for nearly half a century, and one might have thought his close association with the Peisistratid tyrants would have tarnished his reputation under the democracy. Yet the statue is probably to be connected with the circle around Perikles himself—it stood beside a statue of Perikles' father, Xanthippos.[17] There is nothing in Anakreon's verse that would suggest he was being honored as a patriotic Athenian or one who (like Simonides) celebrated the glory of Athens. Rather, he wrote private, occasional poetry, mainly for the symposium, and it is as a model symposiast that he is depicted.[18] It was purely as a

professional musician and man of letters that he was beloved in Athens: a role-model for the musicians who competed at the Panathenaia and the poets whose works they performed.

Days two and three were given over to athletic competitions, and on day four a variety of equestrian contests were held. To judge from the evidence of the prize amphoras, all these contests were on the program from 566. In the Athens of Perikles, however, this combination of events seems to reflect another of the paradoxes of Athenian society. On the one hand, some of the individual gymnastic contests, such as running or boxing, that did not require a great investment in equipment or training, could well be seen as embodying the democratic ideal, offering men and youths of all social and economic classes the chance to compete for rich rewards. In contrast to the Olympic games, where the athletes seem mainly to have come from the leading aristocratic families of the cities they represented, Panathenaic athletes were truly a cross-section of Athenian society. This did not escape the keen eye of such careful observers as the Berlin Painter, who, on his prize amphoras (e.g. *G&P* no. 24), goes out of his way to portray athletes of different ages and physical types, who do not always live up to the ideal of aristocratic perfection.[19]

Yet at the same time, the equestrian events would appear to be a striking reminder of the aristocratic society of Archaic Greece, when the owning of horses was the status symbol *par excellence*. The aristocratic connotations of horses and horsemanship may, however, have been somewhat mitigated when Perikles took the major step of increasing the size of the Athenian cavalry from 300 to 1,000.[20] No longer strictly an élite institution of the upper-class families, the cavalry was now to be a focus of civic pride for all Athenians—surely one of the reasons for their prominence on the Parthenon frieze.[21]

Day five was given over to the tribal contests. These represent the most important innovation in the Panathenaia during the more than a century from the reorganization of the festival in 566 to the time of Perikles, as well perhaps as the most direct reflection of the democratic spirit.[22] Kleisthenes must have seen an opportunity to solidify the identity of the new tribes by adding to the Panathenaic games several team events for which the prizes would be awarded to the whole tribe rather than to an individual. Wealthy members of each tribe were expected to finance the training and equipment for these events as a token of civic pride. In the Periklean period, for the first time we find vases that refer specifically to a victory by a particular tribe, indicating that the strong tribal identity that Kleisthenes hoped to inculcate had, a half-century later, indeed become a reality.[23] For all the tribal contests, the

prize consisted of a sum of money and a bull, clearly intended to provide a communal feast at which the winning tribe celebrated its victory.

At the climax of the festival, the *pompe*, or procession, brought a new peplos to the ancient image of Athena. The route of the procession was no doubt fixed by ancient tradition.[24] But as the shape of the city gradually changed and new buildings and other monuments arose, so too must the meaning of the procession have changed, taking on new connotations from the cityscape through which it passed. John Camp has recently made the intriguing suggestion that the initial laying out of the Agora as a civic center, archaeologically datable to just before the middle of the sixth century, may have been a direct response to the reorganization of the Panathenaia in 566.[25] The open square provided the perfect parade ground, midway between the Dipylon Gate, where the procession assembled, and the Acropolis that was its goal.

The procession entered the Agora at its northwest corner, not far from where the modern visitor enters the American excavations. But the Agora through which the procession moved in Perikles' day was very different from the Agora a century, or even half a century, earlier.[26] The entrance at the northwest was now flanked on both sides by prominent symbols of the democracy: on one side the Royal Stoa (Pausanias 1.3.1–2), where Ephialtes had put on display the laws of Solon and where the archons took their oath of office,[27] and on the other, the Stoa Poikile, not in itself a political structure but most famous for its great patriotic frescoes celebrating victories from Athens' recent and distant past, at Marathon and over the Amazons.[28] A little further along, the procession passed the Altar of the Twelve Gods, which, as a recent investigation by Laura Gadbery has shown, was probably not destroyed by the Persians in 480 and required only moderate renovation in the late fifth century.[29] The tyrannical associations of this sanctuary (the altar had been set up by Peisistratos' grandson and namesake in 522/1) were certainly eclipsed by now by its religious significance, its civic importance as the central milestone for all of Attika, and especially by its reputation as a place of refuge and asylum (hence its nickname in the Classical period, the Altar of Pity). In the later fifth century, democratic Athens' claim to being a place of refuge for the oppressed and despised was often dramatized on the tragic stage, as in Sophokles' *Oedipus at Colonnus*, Euripides' *Medea* (Aigeus' offer of sanctuary to Medea) and his *Suppliants*, in which Theseus, as the just king, somewhat anachronistically proclaims the virtues of Athenian democracy (403–8).

Not far from the Altar of the Twelve Gods stood the monument to the Tyrannicides, Harmodios and Aristogeiton. Though its exact location is unknown, and ancient authors give what seems to be conflicting

testimony, most of the evidence indicates that these statues also stood alongside the Panathenaic Way, at a prominent spot near the middle of the Agora.[30] The deed that the statues commemorated, the murder of Hipparchos, had taken place at the Panathenaia of 514, at a sanctuary, the Leokoreion, which has as yet not been identified.[31] It should, however, be along the route of the procession as well, since Hipparchos was acting as a marshal at the fateful moment, and it seems to me a reasonable speculation that the statues were put up at or near the very spot where he was cut down. As the Tyrannicides' legend grew and was embellished in the course of the fifth century, they came to be regarded as the founders of the Athenian democracy.[32] Thus in the time of Perikles, the Panathenaia would have been seen as a birthday celebration not only for the city goddess, but for the democracy as well. By standing alongside the Panathenaic Way, Harmodios and Aristogeiton could, as it were, participate in the very procession that had given them the opportunity to strike the first blow for democracy. The direct association of the festival, the Tyrannicides, and the democracy is perhaps best expressed on a series of prize amphoras (see Fig. 7.1) that can, with some probability, be dated to the Panathenaia of 402, the first after the fall of the Thirty Tyrants and the restitution of the democracy.[33] Athena displays the Tyrant-Slayers as her shield device.

Who participated in the procession? The name *Panathenaia* means, literally, "all the Athenians," and though we need not imagine that the entire population took part, it is true that all segments of the population were represented: young and old; women and men; citizens, metics, and slaves. For Perikles, this must have been the living manifestation of his idealized vision of Athenian democratic society, a cosmopolitan melting pot in which everyone had a share of the benefits and took pride. A closer look at what ancient writers tell us of the make-up of the procession has recently led some scholars to question this rosy picture.[34] Although it is true that metics and freed slaves were represented, the roles they were assigned were clearly subservient to those of the Athenian citizens.[35] And the choice of which citizens would take part was not entirely democratic either. The older men who carried olive branches, for example (the *thallophoroi*), were chosen for their good looks, and the *kanephoroi* were daughters of the finest families.[36] In other words, the aristocratic bias so ingrained in Greek society and the privileged status of the Athenian male citizen were clearly visible in this procession that was a microcosm of the whole population of Attika.

The idealized image of Athens that the Parthenon frieze projects—a well-ordered, prosperous, and harmonious society enjoying the favor of the Olympian gods—accords perfectly with Perikles' own claims for

the city, as reported to us by Thucydides and Plutarch. A more difficult question, however, is whether the frieze also deliberately announces that other side of Athens' image: the imperial capital. A series of inscriptions informs us that during the period when Athens started to clamp down on her allies, from the 440s on, as a token of its loyalty each city was required to send a cow and a set of armor to the Greater Panathenaia.[37] The animal was obviously for the great sacrifice; the armor perhaps went into the Treasury of Athena that was eventually housed in the back room of the Parthenon. If this tribute was personally escorted to Athens by envoys of each city who marched in the procession, we might hope to identify them on the Parthenon frieze, but there are no passages that seem to fit the bill. On the other hand, we know that the annual tribute money from the allies was due in Athens at a different time of the year, when the Greater Dionysia were held,[38] and it seems unlikely that non-Athenians marched in the Panathenaic procession, at least not in an official capacity. Some scholars have pointed to similarities between the Parthenon frieze and the friezes that decorated the audience hall of the palace of Xerxes at Persepolis, one of whose main themes is the tribute carried in stately procession by representatives of the Persian king's far-flung subjects.[39] But I believe this comparison misses a crucial point about the ideology of Periklean Athens, which never explicitly acknowledged its imperialist nature in the iconography of public monuments. Democratic Athens saw herself as the utter antithesis of the despotic Persian empire that had tried, and failed, to enslave the free Greek cities. It was sufficient to impress the allies who visited Athens with the magnificent new temples on the Acropolis, financed at least in part by their annual contributions to the League,[40] without actually portraying those allies as humble subjects. They certainly got the message.

In the end, what made the Panathenaia the most visible symbol of empire was not sparkling new temples or big parades or lavish prizes, but Athena herself. By carefully promoting cults of Athena throughout the Aegean,[41] the Athenians had, at least since the middle of the fifth century, elevated their own city goddess, the Polias, to the status of "Reichsgöttin."[42] This, her principal festival, accordingly took on added significance as well. The Panathenaia may never have quite reached the status of a Panhellenic festival, like the four crown games, but in the increasingly polarized world of mid-fifth-century Greece, a world about to explode in catastrophic civil war, the ideal of Panhellenism must have seemed increasingly hollow. Perikles convinced the Athenians that they had gone to war to defend a particular way of life (a claim we may find harder to accept in the post-Vietnam, post-Cold War era), and that way of life was nowhere more clearly and compellingly expressed than in the yearly festival of Athena.

Notes

Earlier versions of this paper were presented in Athens, Bonn, Würzburg, Heidelberg, Bryn Mawr, and Dunedin. I thank the audiences on those occasions for many clarifications, as well as Jenifer Neils for the invitation to include it in this volume.

1. On this paradoxical situation see most recently M. Ostwald, "Freedom and the Greeks," in R. W. Davis, ed., *The Origins of Modern Freedom in the West* (Stanford 1995) 54–55.

2. Parke, 1977, 46–47.

3. See most recently A. L. Boegehold, "Perikles' Citizenship Law of 451/0 B.C.," in Boegehold and Scafuro, 1994, 57–66, with earlier references.

4. G. W. Bowersock, "Pseudo-Xenophon," *Harvard Studies in Classical Philology* 71 (1966) 33–38, argues for a date for the Old Oligarch's work in the aftermath of the ostracism of Thucydides son of Melesias in 443.

5. For a convenient summary of some of the prizes, as recorded in an early fourth-century inscription, see *G&P* 16.

6. Cf. Thucydides 2.38, where Perikles expresses a very similar sentiment: "Then the greatness of our city brings it about that all good things from all over the world flow in to us, so that to us it seems as natural to enjoy foreign goods as our own local products" (R. Warner trans.).

7. On the Panathenaic ship see most recently J. Tobin, "Some New Thoughts on Herodes Atticus's Tomb, His Stadium of 143/4, and Philostratus *VS* 2.550," *AJA* 97 (1993) 87–89.

8. Mansfield, 1985, 68–78. A much later date has also been suggested: cf. *G&P* 22 and n. 40.

9. See L. H. Jeffery, "Poseidon on the Acropolis," in *Praktika: XII International Congress of Classical Archaeology* 3 (Athens 1988) 124–26, who, however, goes too far in claiming that Poseidon's cult did not exist on the Acropolis at all before this time. See my comments in Shapiro, 1989, 101–2. On the contest of Athena and Poseidon, first attested on the west pediment of the Parthenon, see O. Palagia, *The Pediments of the Parthenon* (Leiden 1992) 40. For the role of Poseidon-Erechtheus on the Acropolis and in the Erechtheion, see R. M. Frazer, "Notes on the Athenian Entry, *Iliad* B 546–56," *Hermes* 97 (1969) 262–64.

10. I follow here the order of events suggested by J. Neils in *G&P* 15.

11. I have discussed these scenes in *G&P* 61–69.

12. Cf. the examples illustrated in Tzachou-Alexandri, 1989, 207, no. 95, and 317, no. 202.

13. On Damon see A. Barker, *Greek Musical Writings* I (Cambridge 1984) 168–69.

14. E.g. the amphora New York, Metropolitan Museum of Art, 1989.281.89; *G&P* 63, no. 18.

15. See *G&P* 20. For the possibility that musical performances took place indoors before the building of the Odeion, see Tiverios, 1989, 50–51.

16. E.g. the pelike London, British Museum, E354; *ARV*² 1119, 5; *Jahrbuch des Deutschen Archäologischen Instituts* 76 (1961) 69.

17. T. Hölscher, "Die Aufstellung des Perikles-Bildnisses und ihre Bedeutung," *Würzburger Jahrbücher für die Altertumswissenschaft* 1 (1975) 191, who argues that Perikles himself put up this statue, along with that of his father Xanthippos nearby.

18. See P. Zanker, *Die Maske des Sokrates* (Munich 1995) 30–33, discussing the well-known statue in Copenhagen (30, fig. 12), which is usually assumed to be a faithful copy of the portrait statue on the Acropolis.

19. Cf. the amphora in a New York private collection, *G&P* 84, no. 24. The older, balding runner brings up the rear.

20. Bugh, 1988, 39–52.

21. See N. Himmelmann, "Der Parthenonfries im Kleinen," *Frankfurter Allgemeine Zeitung*, August 5, 1992; Bugh, 1988, 77–78. Their presence in the frieze could also reflect the practice, attested by Xenophon (*On Horsemanship* 3.2), of the cavalry riding around the Agora as part of festival processions (presumably including the Panathenaia), saluting the various shrines of the gods.

22. J. Neils, "The Panathenaia and Kleisthenic Ideology," in Coulson and Palagia, 1994, 151–60.

23. E.g. the bell-krater London, British Museum, 98.7–16.6; *ARV*2 1333, 1, celebrating a victory of the tribe Antiochis; cf. Webster, 1972, 44. Cf. Raubitschek, 1949, 475–76, on the evolution of Athenian names in the fifth century, as the demotic gradually replaced the patronymic.

24. On the route see *G&P* 18.

25. J. M. Camp, "Before Democracy: Alkmaionidai and Peisistratidai," in Coulson and Palagia, 1994, 10.

26. See T. L. Shear, Jr., "*Isonomous t'Athenas Epoiesaten: The Agora and the Democracy*," in Coulson and Palagia, 1994, 226–45.

27. J. M. Camp, *The Athenian Agora* (London 1986) 53–56, 101–4. Shear (supra n. 26) 236–37, now dates the initial construction of the Royal Stoa to the very end of the sixth century.

28. T. L. Shear, Jr., "The Athenian Agora: Excavations of 1980–1982," *Hesperia* 53 (1984) 5–19; for the paintings see Castriota, 1992, 76–89.

29. L. Gadbery, "The Sanctuary of the Twelve Gods in the Athenian Agora: A Revised View," *Hesperia* 61 (1992) 447–89.

30. R. E. Wycherley, *Agora 3: Literary and Epigraphical Testimonia* (Princeton 1957) 93–98.

31. Thucydides 6.57.3. See Thompson and Wycherley, 1972, 121–23; Kron, 1976, 199–200.

32. M. W. Taylor, *The Tyrant Slayers*, 2nd ed. (Salem, N.H., 1992) 77–95, on the Tyrannicides in the second half of the fifth century. Cf. my comments in "Religion and Politics in Democratic Athens," in Coulson and Palagia, 1994, 123–24.

33. Three examples are illustrated in Beazley, 1986, pl. 99, 2–4.

34. I owe some of these ideas to an unpublished paper by W. R. Connor, delivered at the Dartmouth Panathenaia symposium in 1992. Some related ideas were presented by Lisa Maurizio, in a paper on "The Panathenaia: Processing

Athenian Notions of Status and Identity," at the Center for Hellenic Studies in August 1995 (publication forthcoming in 1997).

35. See Parke, 1977, 43–45.

36. Sources on the *kanephoroi* and *thallophoroi* are collected by Parke, 1977, 193 nn. 24–25. The high status of the *kanephoroi* is clearest in the famous story that Hipparchos insulted Harmodios by uninviting his sister to be a *kanephoros* in the procession (Thucydides. 6.56.1).

37. The "Kleinias Decree": *IG* I² 66; Meiggs and Lewis, 1969, no. 46.

38. See S. Goldhill, "The Great Dionysia and Civic Ideology," *JHS* 107 (1987) 60–62; P. Krenz, "Athens' Allies and the Phallophoria," *Ancient History Bulletin* 7.1 (1993) 12–16.

39. M. C. Root, "The Parthenon Frieze and the Apadana Reliefs at Persepolis: Reassessing a Programmatic Relationship," *AJA* 89 (1985) 103–20. Cf. Castriota, 1992, 184–94, 226–29.

40. See L. Kallett-Marx, "Did Tribute Fund the Parthenon?" *Classical Antiquity* 8 (1989) 252–66, who cautions against the assumption that this was the case, and against the resulting view of the Parthenon as a "monument to Athenian imperialism."

41. See J. P. Barron, "Religious Propaganda of the Delian League," *JHS* 84 (1964) 35–48.

42. I. Kaspar-Butz, *Die Göttin Athena im klassischen Athen* (Frankfurt 1990) 185–87.

Abbreviations
Bibliography
Indexes

Abbreviations

AA	*Archäologischer Anzeiger*
ABV	J. D. Beazley, *Attic Black-figure Vase-painters.* Oxford 1956
AJA	*American Journal of Archaeology*
AM	*Mitteilungen des Deutschen Archäologischen Instituts: Athenische Abteilung*
AntK	*Antike Kunst*
ARV²	J. D. Beazley, *Attic Red-figure Vase-painters.* 2nd ed. Oxford 1963
CVA	*Corpus Vasorum Antiquorum*
EAA	*Enciclopedia dell'Arte antica 1–7.* Rome 1958–73
FGrHist	F. Jacoby, *Die Fragmente der griechischen Historiker.* Berlin 1923–
G&P	J. Neils et al., *Goddess and Polis: The Panathenaic Festival in Ancient Athens,* exh. cat., Hood Museum of Art, Dartmouth College. Hanover, New Hampshire. Princeton 1992
IG	*Inscriptiones graecae*
JHS	*Journal of Hellenic Studies*
LIMC	*Lexikon Iconographicum Mythologiae Classicae.* Zurich and Stuttgart 1981–
ML	*Ausfürliches Lexikon der griechischen und römischen Mythologie,* ed. W. H. Roscher, 1–4. Leipzig 1884–1921
PCG	R. Kassell and C. Austin, eds., *Poetae Comici Graeci.* Berlin 1983–
RE	*Realencyclopädie der klassischen Altertumswissenschaft,* ed. A. F. von Pauly and G. Wissowa. Stuttgart, 1893–1980

229

Bibliography

Ashmole, B. 1972. *Architect and Sculptor in Classical Greece*. New York.

Austin, C. 1970. "De nouveaux fragments de l'*Erechthée* d'Euripide," *Recherches de Papyrologie* 4, 11–67.

Austin, M. M., and P. Vidal-Naquet. 1977. *Economic and Social History of Ancient Greece: An Introduction*. Berkeley.

Beazley, J. D. 1943. "Panathenaica," *AJA* 47, 441–65.

Beazley, J. D. 1986. *The Development of Attic Black Figure*, rev. ed., ed. M. Moore and D. von Bothmer. Berkeley.

Beschi, L. 1969. "Contributi di topografia ateniese," *Annuario della Scuola Archeologica di Atene e delle Missioni Italiane in Oriente* 45–46, 511–36.

Beschi, L. 1984. "Il Fregio del Partenone: Una proposta di Lettura," *Atti dell'Accademia Nazionale dei Lincei: Rendiconti*, serie VIII, vol. 39, 173–95.

Boardman, J. 1974. *Athenian Black Figure Vases*. London.

Boardman, J. 1977. "The Parthenon Frieze—Another View." In *Festschrift für Frank Brommer*, ed. U. Hockmann and A. Krug, 39–49. Mainz.

Boardman, J. 1978. *Greek Sculpture: The Archaic Period*. London.

Boardman, J. 1984. "The Parthenon Frieze." In *Parthenon-Kongress, Basel*, ed. E. Berger, 210–15. Mainz.

Boardman, J. 1985. *Greek Sculpture: The Classical Period*. London.

Boardman, J. 1988. "Notes on the Parthenon East Frieze." In *Kanon: Festschrift Ernst Berger*, (ed. M. Schmidt. *AntK* Beiheft 15), 9–14. Basel.

Boardman, J. 1989. *Athenian Red Figure Vases: The Classical Period*. London and New York.

Bockelberg, A. von. 1979. "Die Friese des Hephaisteion," *Antike Plastik* 18. Berlin.

Boegehold, A. L., and A. C. Scafuro, eds. 1994. *Athenian Identity and Civic Ideology*. Baltimore.

Boersma, J. S. 1970. *Athenian Building Policy from 561/0 to 405/4 B.C.* Groningen.

Böhr, E. 1982. *Der Schaukelmaler. Kerameus* 4, Mainz.

Bonfante, L. 1989. "Nudity as Costume in Greek Art," *AJA* 93, 543–79.

Bothmer, D. von. 1983. *Wealth of the Ancient World*, exh. cat., Kimbell Art Museum, Fort Worth.

Bowra, C. M. 1938. "Xenophanes and the Olympic Games," *American Journal of Philology* 59, 257–79.

Brandt, J. R. 1978. "Archaeologia Panathenaica I: Panathenaic Prize-Amphorae

from the Sixth Century B.C.," *Acta ad archaeologiam et artium historiam pertinentia* 8, 1–24.

Brauchitsch, G. von. 1910. *Die Panathenäischen Preisamphoren.* Leipzig.

Brendel, O. J. 1945. "Procession Personified," *AJA* 49, 519–25.

Brommer, F. 1977. *Der Parthenonfries.* Mainz.

Brouskari, M. 1974. *The Acropolis Museum: A Descriptive Catalogue.* Athens.

Buchholz, H. G., ed. 1987. *Ägäische Bronzezeit.* Darmstadt.

Bugh, G. R. 1988. *The Horsemen of Athens.* Princeton.

Buhmann, H. 1972. *Die Sieg in Olympia und in den anderen panhellenischen Spielen.* Munich.

Bundgaard, J. A. 1976. *Parthenon and the Mycenaean City on the Heights.* Copenhagen.

Burkert, W. 1966. "Kekropidensage und Arrhephoria," *Hermes* 94, 1–25.

Burkert, W. 1977. *Griechische Religion.* Stuttgart.

Burkert, W. 1985. *Greek Religion,* trans. J. Raffan. Cambridge, Mass.

Calame, C. 1977. *Les choeurs de jeune filles en Grèce archaique. Filologica e critica* 20. Rome.

Camp, J. M. 1984. "Water and the Pelargikon." In *Studies Presented to Sterling Dow.* 37–41. Durham, N.C.

Carpenter, R. 1929. *The Sculpture of the Nike Temple Parapet.* Cambridge, Mass.

Carter, J. M., and A. Krüger. 1990. *Ritual and Record: Sports Records and Quantification in Pre-Modern Societies.* Westport, Conn.

Casabona, J. 1966. *Recherches sur le vocabulaire des sacrifices en grec.* Aix-en-Provence.

Casson, S. 1921. *Catalogue of the Acropolis Museum.* Cambridge.

Castriota, D. 1992. *Myth, Ethos and Actuality: Official Art in Fifth-Century B.C. Athens.* Madison.

Christiansen, J. 1981. "En graesk Sportspokal," *Meddelelser fra Ny Carlsberg Glyptotek* 37, 28–50.

Connelly, J. B. 1993. "The Parthenon Frieze and the Sacrifice of the Erechtheids: Reinterpreting the Peplos Scene," *AJA* 97, 309–10 (abstract).

Connelly, J. B. 1996. "Parthenon and *Parthenoi*: A Mythological Interpretation of the Parthenon Frieze," *AJA* 100, 53–80.

Connor, W. R. 1987. "Tribes, Festivals and Processions: Civic Ceremonial and Political Manipulation in Archaic Greece," *JHS* 107, 40–50.

Cook, A. B. 1940. *Zeus: A Study in Ancient Religion* III. Cambridge.

Coulson, W., and H. Kyrieleis. 1992. *Proceedings of an International Symposium on the Olympic Games, 5–9 September 1988.* Athens.

Coulson, W. D. E., O. Palagia, et al., eds. 1994. *The Archaeology of Athens and Attica under the Democracy.* Oxford.

Crowther, N. B. 1982. "Athletic Dress and Nudity in Greek Athletics," *Eranos* 80, 163–68.

Crowther, N. B. 1985a. "Male Beauty Contests in Greece: The *Euandria* and *Euexia*," *L'Antiquité Classique* 54, 285–91.

Crowther, N. B. 1985b. "Studies in Greek Athletics, Part One," *Classical World* 78.5 (special survey issue).

Crowther, N. B. 1991. "The Apobates Reconsidered (Demosthenes lxi 23–9)," *JHS* 111, 174–76.

Davies, J. K. 1984. *Wealth and the Power of Wealth in Classical Athens*, Salem, N.H.

Davison, J. A. 1958. "Notes on the Panathenaea," *JHS* 78, 23–42.

Decker, W. 1982–83. "Die mykenische Herkunft des griechischen Totenagons," *Stadion* 8–9, 1–24.

Decker, W. 1992. *Sports and Games of Ancient Egypt*, trans. A. Guttmann. New Haven.

Delivorrias, A., et al. 1987. *Greece and the Sea*, exh. cat., Greek Ministry of Culture and the Benaki Museum, Athens.

Deubner, L. 1932. *Attische Feste*. Berlin.

Donlan, W. 1980. *The Aristocratic Ideal in Ancient Greece*. Lawrence.

Donlan, W. 1982. "The Politics of Generosity in Homer," *Helios* 9.2, 1–15.

Dörig, J. 1985. *La Frise est de l'Hephaisteion*. Mainz.

Dugas, C., et al. 1924. *Le Sanctuaire d'Aléa Athéna à Tégée au IVe siècle*. Paris.

Ebert, J. 1972. *Griechische Epigramme auf Sieger an gymnischen und hippischen Agonen*. Berlin.

Edwards, G. R. 1957. "Panathenaics of Hellenistic and Roman Times," *Hesperia* 26, 320–49.

Ermatinger, E. 1897. *Die attische Autochthonensage bis auf Euripides*. Berlin.

Eschbach, N. 1986. *Statuen auf panathenäischen Preisamphoren des 4. Jhs. v. Chr.* Mainz.

Evjen, H. D. 1986. "Competitive Athletics in Ancient Greece: The Search for Origins and Influences," *Opuscula Atheniensia* 16.5, 51–56.

Finley, M. I. 1954. *The World of Odysseus* (rev. ed. 1977). New York.

Floren, J. 1987. *Die griechische Plastik* I. Munich.

Fontenrose, J. 1978. *The Delphic Oracle*. Berkeley.

Fraser, P. M., and E. Matthews. 1987. *A Lexicon of Greek Personal Names* I. Oxford.

Frazer, J. G. 1898. *Pausanias' Description of Greece* I–VI. London.

Frel, J. 1972. "Quelques Noms d'Archontes sur les Amphores Panathenaïques," *Revue Archeologique*, 285–90.

Frel, J. 1973. *Panathenaic Prize Amphoras*. Kerameikos Book no. 2. Athens.

Frel, J. 1977. "The Kleophrades Painter in Malibu," *J. Paul Getty Museum Journal* 4, 63–76.

Frel, J. 1992. "The Grave of a Tarentine Athlete," *Taras* 12, 131–34.

Gardiner, E. N. 1910. *Greek Athletic Sports and Festivals*. London.

Gardiner, E. N. 1916. "The Alleged Kingship of the Olympic Victor," *Annual of the British School at Athens* 22, 85–105.

Gauer, W. 1984. "Was geschieht mit dem Peplos?" In *Parthenon-Kongress, Basel*, ed. E. Berger, 220–29. Mainz.

Geddes, A. G. 1987. "Rags and Riches: The Costume of Athenian Men in the Fifth Century," *Classical Quarterly* 37, 307–31.

Giglioli, G. Q. 1950. "Phyllobolia," *Archeologia Classica* 2, 31–45.

Green, R. 1962. "A New Oenochoe Series from the Acropolis North Slope," *Hesperia* 31, 82–94, pls. 28–32.

Groton, A. H. 1990. "Wreaths and Rags in Aristophanes' *Plutus*," *Classical Journal* 86, 16–22.

Guttmann, A. 1984. *From Ritual to Record: The Nature of Modern Sports.* New York.

Hamilton, R. 1992. *Choes and Anthesteria: Athenian Iconography and Ritual.* Ann Arbor.

Hamilton, R. 1993. "Archons' Names on Panathenaic Vases," *Zeitschrift für Papyrologie und Epigraphik* 96, 237–48.

Hansen, H. 1990. *Aspects of the Athenian Law Code of 410/09–400/399 B.C.* New York.

Harris, D. 1992. "Bronze Statues on the Athenian Acropolis: The Evidence of a Lycurgan Inventory," *AJA* 96, 637–52.

Harrison, E. B. 1977. "Alkamenes' Sculptures for the Hephaisteion," parts 1, 3, *AJA* 81, 137–78, 411–26.

Harrison, E. B. 1979. "The Iconography of the Eponymous Heroes on the Parthenon and in the Agora." In *Greek Numismatics and Archaeology: Essays in Honor of Margaret Thompson*, ed. O. Mørkholm and N. Waggoner, 71–85.

Harrison, E. B. 1984. "Time in the Parthenon Frieze." In *Parthenon-Kongress, Basel*, ed. E. Berger, 230–34. Mainz.

Harrison, E. B. 1989. "Hellenic Identity and Athenian Identity in the Fifth Century B.C." In *Cultural Differentiation and Cultural Identity in the Visual Arts, Studies in the History of Art*, ed. S. Barnes and W. Melion, 41–61. Washington, D.C.

Harrison, E. B. Forthcoming. "The Glories of the Athenians: Observations on the Program of the Frieze of the Temple of Athena Nike." In *Interpretation of Architectural Sculpture in Greece and Rome, Studies in the History of Art*, ed. D. Buitron-Oliver. Washington, D.C.

Heberdey, R. 1919. *Altattische Poros-Skulptur.* Vienna.

Hedreen, G. M. 1992. *Silens in Attic Black-figure Vase-painting.* Ann Arbor.

Henderson, J. 1987. *Aristophanes: Lysistrata.* Oxford.

Herman, G. 1987. *Ritualized Friendship and the Greek City.* Cambridge.

Herter, H. 1973. *RE* Suppl. 13, 1046–1238, s.v. Theseus.

Hönle, A. 1976. "Athenische Politik zur Bauzeit des Pompeion und die Neuordnung der Panathenäen," *Kerameikos* 10, 240–45.

Humphreys, S. C. 1978. *Anthropology and the Greeks.* London.

Humphreys, S. C. 1983. *The Family, Women, and Death.* London.

Hyde, W. W. 1921. *Olympic Victor Monuments and Greek Athletic Art.* Washington, D.C.

Iakovides, S. E. 1962. *He Mykênaikê Akropolis tôn Athênôn.* Athens.

Immerwahr, H. 1972. "Athenaikes eikones ston 'Iona' tou Euripidou," *Ellenika* 25, 277–97.

Jahn, O, and A. Michaelis. 1901. *Arx Athenarum*, 3rd ed. Bonn.

Jameson, M. H. 1991. "Sacrifice before Battle." In *Hoplites: The Classical Greek Battle Experience*, ed. V. D. Hanson, 197–227. London.

Jameson, M. H. 1994. "The Ritual of the Athena Nike Parapet." In *Ritual, Finance,*

Politics: Athenian Democratic Accounts Presented to D. Lewis, ed. R. Osborne and S. Hornblower, 307–24. Oxford.

Jeffery, L. H. 1990. *Local Scripts of Archaic Greece* (rev. ed.). Oxford.

Jenkins, I. 1985. "The Composition of the So-Called Eponymous Heroes on the East Frieze of the Parthenon," *AJA* 89, 121–17.

Jenkins, I. 1994. *The Parthenon Frieze*. London and Austin.

Jeppesen, K. 1987. *The Theory of the Alternative Erechtheion*. Aarhus.

Johnston, A. 1983. "The Extent and Use of Literacy: The Archaeological Evidence." In *The Greek Renaissance of the Eighth Century B.C.: Tradition and Innovation*, ed. R. Hägg, 63–68. Stockholm.

Johnston, A. W. 1987. "*IG* II² 2311 and the Number of Panathenaic Amphorae," *Annual of the British School at Athens* 82, 125–29.

Judeich, W. 1931. *Topographie von Athen*, 2nd ed. Munich.

Jüthner, J. 1898. "Siegerkranz und Siegerbinde," *Jahrbuch der Österreichischen Archäologischen Instituts* 1, 42–48.

Jüthner, J. 1965, 1968. *Die Athletischen Leibesübungen der Griechen* 1–20. Vienna.

Kadletz, E. 1980. "The Race and Procession of the Athenian Oschophoroi," *Greek, Roman and Byzantine Studies* 21, 363–71.

Kardara, C. 1961. "Glaukopis: O Archaios Naos kai to thema tes zophorou tou Parthenonos," *Archaiologike Ephemeris* 61–158.

Kearns, E. 1989. *The Heroes of Attica. Bulletin of the Institute of Classical Studies of the University of London* Suppl. 57. London.

Kearns, E. 1990. "Saving the City." In *The Greek City*, ed. O. Murray and S. Price, 321–44. Oxford.

Kiilerich, B. 1989. "The Olive-tree Pediment and the Daughters of Kekrops," *Acta ad archaeologiam et artium historiam pertinentia* 7, 1–21.

Kilian, K. 1980. "Zur Darstellung eines Wagenrennens aus spätmykenischer Zeit," *AM* 95, 21–31.

Klee, T. 1918. *Zur Geschichte der gymnischen Agone an Griechischen Feste*, repr. 1980. Berlin.

Koenen, L. 1969. "Eine Hypothesis zur Auge des Euripides und tegeatischen Plynterien," *Zeitschrift für Papyrologie und Epigraphik* 4, 7–18.

Kotsidu, H. 1991. *Die musischen Agone der Panathenäen in archaischer und klassischer Zeit*. Munich.

Kraay, C. M. 1956. "The Archaic Owls of Athens: Classification and Chronology," *Numismatic Chronicle*, 43–68.

Kraemer, R. 1992. *Her Share of the Blessings: Women's Religions among Pagans, Jews, and Christians in the Greco-Roman World*. New York.

Kroll, J. H. 1981. "From Wappenmünzen to Gorgoneia to Owls," *American Numismatic Society Museum Notes* 26, 1–32.

Kroll, J. H. 1982. " The Ancient Image of Athena Polias." In *Studies in Athenian Architecture, Sculpture and Topography Presented to Homer A. Thompson. Hesperia* Suppl. 20, 65–76.

Kron, U. 1976. *Die Zehn attischen Phylenheroen. AM* Beiheft 5. Berlin.

Kron, U. 1984. "Die Phylenheroen am Parthenonfries." In *Parthenon-Kongress, Basel*, ed. E. Berger, 235–44, pls. 17–19. Mainz.

Kurke, L. 1991. *The Traffic in Praise: Pindar and the Poetics of Social Economy*. Ithaca.

Kyle, D. G. 1984. "Solon and Athletics," *Ancient World* 9, 91–105.

Kyle, D. G. 1987. *Athletics in Ancient Athens*, repr. 1993. Leiden.

Kyrieleis, H., ed. 1986. *Archaische und klassische griechische Plastik*. Akten des Internationalen Kolloquiums vom 22–25 April 1985 in Athen. Mainz.

Lambrinudakis, W., and M. Wörrle. 1983. "Ein hellenistisches Reformgesetz über das öffentliche Urkundenwesen von Paros," *Chiron* 13, 283–368.

Lee, H. M. 1983. "Athletic Arete in Pindar," *Ancient World* 7, 31–37.

Lefkowitz, M. R. 1986. *Women in Greek Myth*. Baltimore.

Lefkowitz, M. R., and M. Fant, eds. 1992. *Women's Life in Greece and Rome*, 2nd ed. Baltimore.

Lehnstaedt, K. 1970. *Prozessionsdarstellungen auf attischen Vasen*. Diss., Munich.

Lewis, D. M. 1955. "Notes on Attic Inscriptions," *Annual of the British School at Athens* 50, 1–36.

Lo Porto, F. G. 1967. "Tombe di atleti tarentini," *Atti e Memorie della Società Magna Grecia* 8, 31–98.

Loraux, N. 1981. *Les enfants d'Athéna*. Paris.

Loraux, N. 1986. *The Invention of Athens*, trans. A. Sheridan. Cambridge, Mass.

Loraux, N. 1987. *Tragic Ways of Killing a Woman*, trans. A. Forster. Cambridge, Mass.

Loraux, N. 1993. *Children of Athena*, 2nd ed., trans. C. Levine. Princeton.

Luppe, W. 1983. "Die Hypothesis zu Euripides' 'Auge,'" *Archiv für Papyrusforschung und verwandte Gebiete* 29, 19–23.

Mansfield, J. M. 1985. *The Robe of Athena and the Panathenaic Peplos*. Diss., Berkeley.

Mark, I. S. 1984. "The Gods in the East Frieze of the Parthenon," *Hesperia* 53, 289–342.

Mark, I. S. 1993. *The Sanctuary of Athena Nike in Athens: Architectural Stages and Chronology*. *Hesperia* Suppl. 26. Princeton.

Matheson, S. B. 1989. "Panathenaic Amphorae by the Kleophrades Painter," *Greek Vases in the J. Paul Getty Museum* 4, Occasional Papers on Antiquities 5, 95–112.

Maul-Mandelartz, E. 1990. *Griechische Reiterdarstellungen in agonistischem Zusammenhang*. Frankfort.

Mauss, M. 1967. *The Gift: The Form and Reason for Exchange in Archaic Societies*, trans. I. Cunnison. New York.

McDonnell, M. 1991. "The Introduction of Athletic Nudity: Thucydides, Plato and the Vases," *JHS* 111, 182–92.

Meiggs, R., and D. M. Lewis. 1969. *A Selection of Greek Historical Inscriptions to the End of the Fifth Century B.C.* Oxford.

Metzger, H . 1965. *Recherches sur l'Imagerie athénienne*. Paris.

Meyer, M. 1989. "Alte Männer auf attischen Grabdenkmälern," *AM* 104, 49–82, pls. 8–11.

236 Bibliography

Mikalson, J. 1991. *Honor Thy Gods*. Chapel Hill.
Miller, S. G. 1990. *Nemea: A Guide to the Site and Museum*. Berkeley.
Miller, S. G. 1991. *Arete: Greek Sports from Ancient Sources*, 2nd ed. Berkeley.
Millet, P. 1989. "Patronage and Its Avoidance in Classical Athens." In *Patronage in Ancient Society*, ed. A. Wallace-Hadrill, 15–47. London.
Mommsen, A. 1864. *Heortologie: Antiquarische Untersuchungen über die städtischen Feste der Athen*. Repr. Amsterdam 1968.
Mommsen, A. 1898. *Feste der Stadt Athen im Altertum*. Leipzig.
Moretti, L. 1953. *Iscrizioni agonistiche greche*. Rome.
Morgan, C. 1962. "The Sculptures of the Hephaisteion I," *Hesperia* 30, 210–19, pls. 71–76.
Morgan, C. 1990. *Athletes and Oracles: The Transformation of Olympia and Delphi in the Eighth Century B.C.* Cambridge.
Morris, S. P. 1992. *Daidalos and the Origins of Greek Art*. Princeton.
Nagy, B. 1978. "The Athenian Athlothetai," *Greek, Roman and Byzantine Studies* 19, 307–13.
Nagy, B. 1979. "The Naming of Athenian Girls: A Case in Point," *Classical Journal* 74, 360–64.
Nagy, B. 1992. "Athenian Officials on the Parthenon Frieze," *AJA* 96, 55–69.
Neils, J. 1987. *The Youthful Deeds of Theseus*. Rome.
Németh, G. 1994. "Hekatompedon-Probleme," *Zeitschrift für Papyrologie und Epigraphik* 101, 215–18.
Nilsson, M. P. 1955. *Geschichte der griechischen Religion* I, 2nd ed. Munich.
Olmos, R. 1990. *Vasos Griegos Coleccion Condes de Lagunillas*. Zurich.
Olmos, R., ed. 1992. *Coloquio sobre Teseo y la Copa de Aison. Anejos de Archivo Español de Arqueología* 12. Madrid.
Osborne, R. 1987. "The Viewing and Obscuring of the Parthenon Frieze," *JHS* 107, 98–105.
Parke, H. W. 1977. *Festivals of the Athenians*. London.
Parker, R. 1987a. "Festivals of the Attic Demes," *Boreas* 15, 137–47.
Parker, R. 1987b. "Myths of Early Athens." In *Interpretations of Greek Mythology*, ed. J. Bremmer, 187–214. London.
Parker, R. 1991. "The *Hymn to Demeter* and the *Homeric Hymns*," *Greece & Rome* 38, 1–17.
Pearson, A. C., ed. 1907. *Euripides: The Heraclidae*. Cambridge.
Peiser, B. 1990. "The Crime of Hippias of Elis: Zur Kontroverse um die Olympionikenliste," *Stadion* 16, 37–65.
Pélékides, C. 1962. *Histoire de l'éphébie attique*. Paris.
Pemberton, E. 1976. "The Gods of the East Frieze of the Parthenon," *AJA* 80, 113–24.
Pleket, H. W. 1974. "Zur Soziologie des antiken Sports," *Mededeelingen van het Nederlands Historisch Instituut te Rome* 36, 57–87.
Pleket, H. W. 1975. "Games, Prizes, Athletes and Ideology: Some Aspects of the History of Sport in the Greco-Roman World," *Stadion* 1, 49–89.
Poliakoff, M. B. 1987. *Combat Sports in the Ancient World*. New Haven.

Pollitt, J. Forthcoming. "The Meaning of the Parthenon Frieze." In *Interpretation of Architectural Sculpture in Greece and Rome, Studies in the History of Art*, ed. D. Buitron-Oliver. Washington, D.C.

Poursat, J.-C. 1968. "Les représentations de danse armée dans la céramique attique," *Bulletin de Correspondance Hellénique* 92, 550–615.

Pritchett, W. K. 1974. *The Greek State at War* II. Berkeley.

Pritchett, W. K. 1987. "The *Pannychis* of the Panathenaia." In *Philia epe eis Georgion E. Mylonan*, 179–87. Athens.

Raschke, W. J., ed. 1988. *The Archaeology of the Olympics: The Olympics and Other Festivals in Antiquity*. Madison.

Raubitschek, A. E. 1939. "Leagros," *Hesperia* 8, 155–64.

Raubitschek, A. E. 1949. *Dedications from the Athenian Akropolis*. Cambridge, Mass.

Reed, N. B. 1987. "The Euandria Competition at the Panathenia Reconsidered," *Ancient World* 15, 59–64.

Rhodes, P. J. 1981. *A Commentary on the Aristotelian* Athenaion Politeia. Oxford.

Rhodes, R. F. 1995. *Architecture and Meaning on the Athenian Acropolis*. Cambridge.

Richardson, N. 1974. *The Homeric Hymn to Demeter*. Oxford.

Ridgway, B. S. 1981. *Fifth Century Styles in Greek Sculpture*. Princeton.

Ringwood Arnold, I. 1933. "Local Festivals at Delos," *AJA* 37, 452–58.

Ringwood Arnold, I. 1937. "Shield of Argos," *AJA* 41, 436–40.

Robert, C. 1921. *Die griechische Heldensage* III 1. Berlin.

Robertson, M., and A. Frantz, 1975. *The Parthenon Frieze*. London and New York.

Robertson, N. 1978. "The Goddess and the Ingot in Greco-Roman Times," *Report of the Department of Antiquities*, Cyprus (Nicosia), 202–5.

Robertson, N. 1983. "The Riddle of the Arrhephoria at Athens," *Harvard Studies in Classical Philology* 87, 214–88.

Robertson, N. 1985. "The Origin of the Panathenaea," *Rheinisches Museum für Philologie* n.s. 128, 231–95.

Robertson, N. 1986. "Solon's Axones and Kyrbeis, and the Sixth-century Background," *Historia* 35, 147–76.

Robertson, N. 1988. "Melanthus, Codrus, Neleus, Caucon: Ritual Myth as Athenian History," *Greek, Roman and Byzantine Studies* 29, 201–61.

Robertson, N. 1991a. "Some Recent Work in Greek Mythology," *Échos du monde classique* n.s. 10, 57–79.

Robertson, N. 1991b. "Myth, Ritual, and Livelihood in Early Greece." In *Ancient Economy in Mythology*, ed. M. Silver, 3–34. Savage, Md.

Robertson, N. 1992. *Festivals and Legends: The Formation of Greek Cities in the Light of Public Ritual*. Toronto.

Robertson, N. 1993. "Athens' Festival of the New Wine," *Harvard Studies in Classical Philology* 95, 197–250.

Robertson, N. 1996. "Athena and Early Greek Society: Palladium Shrines and Promontory Shrines." In *Religion in the Ancient World: New Themes and Approaches*, ed. M. Dillon, 383–475. Amsterdam.

Roccos, L. J. 1995. "The Kanephoros and Her Festival Mantle in Greek Art," *AJA* 99, 641–66.

Roller, L. E. 1977. "Funeral Games in Greek Literature, Art and Life." Diss. University of Pennsylvania.

Roller, L. E. 1981a. "Funeral Games for Historical Persons," *Stadion* 7, 1–18.

Roller, L. E. 1981b. "Funeral Games in Greek Art," *AJA* 85, 107–19.

Rose, H. J. 1922. "The Greek Agones," *Aberystwyth Studies* 3, 1–14, reprinted in *Arete, the Journal of Sport Literature*, 3.1, 1985, 163–82.

Rosivach, V. J. 1991. "*IG* II² 334 and the Panathenaic Hekatomb," *La Parola del Passato* 46, 430–42.

Rougemont, G. 1973. "La hiéroménie des Pythia et les trêves sacrées d' Éleusis de Delphes et d' Olympie," *Bulletin de Correspondance Hellénique* 97, 75–106.

Rouse, W. H. D. 1902. *Greek Votive Offerings*, repr. 1976. Cambridge.

Roux, G. 1982. "Lôtis: le bain rituel d' Athéna à Delphes," In *Hommages à C. Delvoyes*, ed. L. Hadermann-Misguich and G. Raepsaet, 227–35. Brussels.

Rystedt, E. 1986. "The Foot-Race and Other Athletic Contests in the Mycenaean World: The Evidence of the Pictorial Vases," *Opuscula Atheniensia* 16.8, 103–16.

Sansone, D. 1988. *Greek Athletics and the Genesis of Sport*. Berkeley.

Scanlon, T. F. 1983. "The Vocabulary of Competition: *Agon* and *Aethlos*, Greek Terms for Contest," *Arete, the Journal of Sport Literature* 1.1, 147–62.

Schachter, A. 1981. *Cults of Boiotia* I. Bulletin of the Institute of Classical Studies of the University of London Suppl. 38.1

Schwyzer, E. 1939. *Griechische Grammatik* I. Munich.

Seltman, C. T. 1924. *Athens, Its History and Coinage before the Persian Invasion*. Cambridge.

Serwint, N. 1987. "Greek Athletic Sculpture of the Fifth and Fourth Centuries B.C.: An Iconographic Study." Diss., Princeton University.

Shapiro, H. A. 1986. "The Attic Deity Basile," *Zeitschrift für Papyrologie und Epigraphik* 63, 134–36.

Shapiro, H. A. 1989. *Art and Cult under the Tyrants in Athens*. Mainz.

Shapiro, H. A. 1993. *Personifications in Greek Art*. Zurich.

Simon, E. 1978. "Zwei Springtänzer: Doio Kubistetere," *AntK* 21, 66–69, pls. 17–18.

Simon, E. 1982. "Die Mittelszene im Ostfries des Parthenon," *AM* 97, 127–44, pls. 23–28.

Simon, E. 1983. *Festivals of Attica: An Archaeological Commentary*. Madison.

Simon, E. 1985. *Die Götter der Griechen*, 3rd ed. Munich.

Simon, E., M. Hirmer, and A. Hirmer. 1981. *Die griechischen Vasen*, 2nd ed. Munich.

Sissa, G., and M. Detienne. 1989. *La vie quotidienne des dieux grecs*. Paris.

Smarczyk, B. 1984. *Untersuchungen zur Religionspolitik und politischen Propaganda Athens im delisch-attischen Seebund*. Munich.

Smets, A. 1936. "Groupes chronologiques des amphores panathénaiques inscrites," *L'Antiquité Classique* 5, 87–104.

Spence, I. G. 1994. *The Cavalry of Classical Greece*. Oxford.

Starr, C. G. 1992. *The Aristocratic Temper of Greek Civilization*. New York.

Stevens, G. P. 1940. *The Setting of the Periclean Parthenon*. *Hesperia* Suppl. 3.

Stevens, G. P. 1946. "The Northeast Corner of the Parthenon," *Hesperia* 15, 1 -26.

Stewart, A. 1990. *Greek Sculpture: An Exploration*. New Haven and London.

Stoddart, S., and J. Whitley. 1988. "The Social Context of Literacy in Archaic Greece and Etruria," *Antiquity* 62, 761–72.

Straten, F. T. van. 1995. *Heira Kala: Images of Animal Sacrifice in Archaic and Classical Greece*. Leiden.

Stuart, J., and N. Revett. 1787. *The Antiquities of Athens*, II. Repr. London.

Thomas, R. 1989. *Oral Tradition and Written Record in Ancient Athens*. Cambridge.

Thompson, D. 1956. "The Persian Spoils in Athens." In *The Aegean and the Near East: Studies Presented to Hetty Goldman*, ed. S. Weinberg, 281–91. Locust Valley, N.Y.

Thompson, H. A. 1961. "The Panathenaic Festival," *AA* 76, 224–31.

Thompson, H. A., and R. E. Wycherley. 1972. *Agora 14: The Agora of Athens*. Princeton.

Thullier, J.-P. 1988. "La nudité athlétique (Grèce, Étrurie, Rome)," *Nikephoros* 1, 29–48.

Tiverios, M. 1974. "Panathenaika," *Archaiologikon Deltion* 29 (1), 142–53.

Tiverios, M. 1987. "Panathenaike Eikonographia," *Thrakike Epethrida* 7, 281–91.

Tiverios, M. 1989. *Perikleia Panathenaia*. Athens.

Tracy, S. V. 1991. "The Panathenaic Festival and Games: An Epigraphic Inquiry," *Nikephoros* 4, 133–53.

Tracy, S. V., and C. Habicht. 1991. "New and Old Panathenaic Victor Lists," *Hesperia* 60, 187–236.

Travlos, J. 1971. *A Pictorial Dictionary of Ancient Athens*. New York.

Trendall, A., and T. B. L. Webster. 1971. *Illustrations of Greek Drama*. London.

Treu, M. 1971. "Der Euripideische Erechtheus als Zeugnis seiner Zeit," *Chiron* 1, 115–31.

Tyrrell, W. B., and F. S. Brown. 1991. *Athenian Myths and Institutions*. New York.

Tzachou-Alexandri, O., ed. 1989. *Mind and Body: Athletic Contests in Ancient Greece*, exh. cat., National Archaeological Museum, Athens.

Valavanis, P. 1987. "Säulen, Hähne, Niken und Archonten auf panathenäischen Preisamphoren," *AA* 467–80.

Valavanis, P. 1990. "La Proclamation des Vainqueurs aux Panathénées," *Bulletin de Correspondance Hellénique* 114, 325–59.

Valavanis, P. 1991a. *Panathenaikoi Amphoreis apo ten Eretria*. Athens.

Valavanis, P. 1991b. "Tenella Kallinike . . . Prozessionen von Panathenäensiegern auf der Akropolis," *AA* 487–98.

Vanderpool, E. 1974. "Victories in the Anthippasia," *Hesperia* 43, 311–13.

Vermeule, E. T. 1974. "Götterkult." In *Archaeologia Homerica* III. Göttingen.

Vernant, J.-P. 1980. *Myth and Society in Ancient Greece*, trans. J. Lloyd. Atlantic Highlands, N.J.

Versnel, H. S. 1980. "Self-Sacrifice, Compensation and the Anonymous Gods." In *Le Sacrifice dans l'Antiquité. Entretiens Hardt*, 27, 136–85. Vandoeuvres-Genève.

Veyne, P. 1990. *Bread and Circuses: Historical Sociology and Political Pluralism*, abridged, trans. O. Murray. London.

Vian, F. 1951. *Répertorie des Gigantomachies figurées dans l'art grec et romain*. Paris.

Vian, F. 1952. *La Guerre des géants*. Paris.

Vos, M. F. 1981. "Some Notes on Panathenaic Amphorae," *Oudheidkundige Mededelingen uit het Rijksmuseum van Oudheiden te Leiden* 62, 33–46.

Walbank, M. B. 1978. *Athenian Proxenies of the Fifth Century B.C.* Toronto.

Walker, H. J. 1995. *Theseus and Athens*. New York.

Ward, A. G., ed. 1970. *The Quest for Theseus*. London.

Webster, T. B. L. 1967. *The Tragedies of Euripides*. London.

Webster, T. B. L. 1972. *Potter and Patron in Classical Athens*. London.

Wesenberg, B. 1995. "Panathenäische Peplosdedikation und Arrhephorie. Zur Thematik des Parthenonfries," *Jahrbuch des Deutschen Archäologischen Instituts* 110, 149–178.

Wilamowitz-Moellendorff, U. v. 1893. *Aristoteles und Athen*. Berlin.

Wilamowitz-Moellendorff, U. v., ed. 1926. *Euripides: Ion*. Berlin.

Williams, D. 1985. *Greek Vases: British Museum*. Cambridge, Mass.

Willis, W. H. 1941. "Athletic Contests in the Epic," *Transactions of the American Philological Association* 72, 392–417.

Wycherley, R. E. 1978. *The Stones of Athens*. Princeton.

Young, D. C. 1984. *The Olympic Myth of Greek Amateur Athletics*. Chicago.

Zeitlin, F. 1989. "Mysteries of Identity and Designs of the Self in Euripides' *Ion*," *Proceedings of the Cambridge Philological Society* n.s. 35, 144–97.

Ziehen, L. 1906. *Leges Graecorum Sacrae* II. Leipzig.

Ziehen, L. 1949. "Panathenaia," *RE* 36.2, 457–93.

Zuntz, G. 1955. *The Political Plays of Euripides*. Manchester.

Index of Ancient Authors

Aeschylus
Agamemnon 1297: 90*n49*
Eumenides 855: 37

Andokides
Against Alkibiades: 104

Apollodoros
Library 3.14.6: 82
3.15.4: 85
3.178: 42, 67*n35*
3.199: 76*n121*
3.203: 70*n59*

Aristeides
37 *Athena* 20: 47

Aristophanes
Birds 1551 (Scholion): 80
Fr. 746: 69*n51*
Frogs 407: 88
Knights 566c (Scholion): 81
Lysistrata 640–45: 79
1135: 71*n63*
Plutus 585–89: 114
Thesmophoriazousai 120: 71*n63*
289–91: 91*n58*
304–5: 88
352–53: 88

Aristotle
Constitution of the Athenians 10.107: 88*n4*
18.3: 214*n61*
41.2: 164
60: 98, 102, 137, 138
60.2: 134*n86*, 173*n20*, 185
60. 2–3: 167–68

60.4: 134*n90*

Athenaeus
12.522a, c-d: 131*n65*
13.565: 98
628d-e: 100
630d: 100, 102

Bakchylides
Dithyrambos 17 = 3.76–116 Snell: 21

Caesar
Civil War 3.105.3: 71*n70*

Cassius Dio
54.7.3: 47

Demosthenes
Against Neaira 69.73, 77: 81
Funeral Oration 60.27–29: 87

Dionysios of Halikarnassos
Roman Antiquities 1.30.3: 65*n3*
2.22.2: 60
7.72.7: 56
14.2.1: 37–38, 43

Euripides
Auge fr. 323a: 50, 72*n81*
Autolykos fr. 282: 131*n63*
Bacchae 224: 65*n3*
Erechtheus fr. 39: 55

Index

WISCONSIN STUDIES IN CLASSICS

General Editors
Richard Daniel De Puma and Barbara Hughes Fowler

E. A. THOMPSON
Romans and Barbarians: The Decline of the Western Empire

JENNIFER TOLBERT ROBERTS
Accountability in Athenian Government

H. I. MARROU
A History of Education in Antiquity
Histoire de l'Education dans l'Antiquité, translated by George Lamb
(originally published in English by Sheed and Ward, 1956)

ERIKA SIMON
Festivals of Attica: An Archaeological Commentary

G. MICHAEL WOLOCH
Roman Cities: Les villes romaines by Pierre Grimal, translated and edited by G. Michael
Woloch, together with A Descriptive Catalogue of Roman Cities by G. Michael Woloch

WARREN G. MOON, editor
Ancient Greek Art and Iconography

KATHERINE DOHAN MORROW
Greek Footwear and the Dating of Sculpture

JOHN KEVIN NEWMAN
The Classical Epic Tradition

JEANNY VORYS CANBY, EDITH PORADA,
BRUNILDE SISMONDO RIDGWAY, and TAMARA STECH, editors
Ancient Anatolia: Aspects of Change and Cultural Development

ANN NORRIS MICHELINI
Euripides and the Tragic Tradition

WENDY J. RASCHKE, editor
The Archaeology of the Olympics: The Olympics and Other Festivals in Antiquity

PAUL PLASS
Wit and the Writing of History: The Rhetoric of Historiography in Imperial Rome

BARBARA HUGHES FOWLER
The Hellenistic Aesthetic

F. M. CLOVER and R. S. HUMPHREYS, editors
Tradition and Innovation in Late Antiquity

BRUNILDE SISMONDO RIDGWAY
Hellenistic Sculpture I: The Styles of ca. 331–200 B.C.

BARBARA HUGHES FOWLER, editor and translator
Hellenistic Poetry: An Anthology

KATHRYN J. GUTZWILLER
Theocritus' Pastoral Analogies: The Formation of a Genre

VIMALA BEGLEY and RICHARD DANIEL DE PUMA, editors
Rome and India: The Ancient Sea Trade

RUDOLPH BLUM
HANS H. WELLISCH, translator
Kallimachos: The Alexandrian Library and the Origins of Bibliography

DAVID CASTRIOTA
Myth, Ethos, and Actuality: Official Art in Fifth-Century B.C. Athens

BARBARA HUGHES FOWLER, editor and translator
Archaic Greek Poetry: An Anthology

JOHN H. OAKLEY and REBECCA H. SINOS
The Wedding in Ancient Athens

RICHARD DANIEL DE PUMA and JOCELYN PENNY SMALL, editors
Murlo and the Etruscans: Art and Society in Ancient Etruria

JUDITH LYNN SEBESTA and LARISSA BONFANTE, editors
The World of Roman Costume

JENNIFER LARSON
Greek Heroine Cults

WARREN G. MOON, editor
Polykleitos, the Doryphoros, and Tradition

PAUL PLASS
The Game of Death in Ancient Rome: Arena Sport and Political Suicide

SUSAN B. MATHESON
Polygnotos and Vase Painting in Classical Athens

JENIFER NEILS, editor
Worshipping Athena: Panathenaia and Parthenon